The Mirror of the Gods

THE MIRROR OF THE GODS

Malcolm Bull

OXFORD
UNIVERSITY PRESS

2005

OXFORD
UNIVERSITY PRESS

Oxford New York
Auckland Bangkok Buenos Aires
Cape Town Chennai Dar es Salaam Delhi Hong Kong Istanbul
Karachi Kolkata Kuala Lumpur Madrid Melbourne Mexico City Mumbai
Nairobi São Paulo Shanghai Singapore Taipei Tokyo Toronto

Copyright © 2005 by Malcolm Bull

Published by Oxford University Press, Inc.
198 Madison Avenue, New York, New York 10016

www.oup.com

Oxford is a registered trademark of Oxford University Press

Library of Congress Cataloging-in-Publication Data
Bull, Malcolm.
The mirror of the Gods / Malcolm Bull.
p. cm.
Includes bibliographical references and index.
ISBN-13:978-0-19-521923-4
ISBN-10: 0-19-521923-6
1. Mythology, Classical, in art. 2. Gods, Greek, in art. 3. Art, Renaissance--Themes,
motives. I. Title.

N7760.B85 2005
704.9'4892'09024--dc22

2004063136

1 3 5 7 9 10 8 6 4 2
Printed in the United States of America
on acid-free paper

to Jill

Contents

Acknowledgements

I would like to thank the staffs of the Warburg Institute and the British Library in London, and of the Getty Research Institute in Los Angeles (especially my research assistant, Michael Schreyach). I am also greatly indebted to Elizabeth McGrath, whose detailed comments on the manuscript saved me from numerous errors; Tom Nichols, who read several chapters at an earlier stage and encouraged me to persevere; Chloe Campbell, who did the picture research, and Simon Winder, my wise and very patient editor at Penguin. The book is dedicated to Jill Foulston, without whom I could have written nothing at all.

Italy and Southern Germany in 1559

The Kingdom of Naples was under Spanish rule (as it had been since the early sixteenth century), while central Italy was governed by the popes. Rome itself was a small city, but it was also the residence of the papal court, and the villas of the cardinals eventually dotted the surrounding countryside. Within the papal states there was an independent court at Urbino ruled by the Montefeltro family until 1508 and then by the Della Rovere (who later moved to Pesaro). The Duchy of Ferrara was governed by its hereditary rulers the Este (who were also lords of neighbouring Modena) and did not come under direct papal control until 1598. Parma became papal territory in 1521, but in 1545 it was made into the independent Duchy of Parma and Piacenza under the Farnese.

The republic of Venice, which governed a large part of north-eastern Italy, maintained its independence from both the papacy and the Holy Roman Empire (ruled by the Habsburgs), but by 1559 the rest of northern Italy was under Habsburg dominion. The long struggle between the French monarchy and the Habsburgs had ended with the victory of the latter, and from 1535 Milan, formerly a Sforza duchy, was under their direct rule, passing to the Spanish branch of the family on the abdication of Charles V. Elsewhere, Habsburg dominion was mediated through local rulers – the Gonzaga in Mantua, and in Florence the Medici, whose restoration by imperial forces in 1530 put an end to the Florentine republic. Genoa remained a republic, though from 1528 it was under the control of the Doria family and allied to the Empire. As a port, Genoa had close ties with Spain and with Antwerp in the Low Countries.

The trade route north from Italy led to Augsburg, Nuremberg, and Prague. Augsburg had long been an imperial free city, dominated by rich merchant families, notably the Fuggers. In nearby Bavaria, the dukes were also significant patrons of the arts. Nuremberg was another free city, a major centre of trade and learning, sympathetic to the Lutheran reformation. It was from here that Emperor Rudolf II recruited many of the craftsmen who worked at his court in Prague, established in 1583.

Prologue

From the southern coast of Turkey, you can see the island of Cyprus. It looks beautiful, and sailors often try to land there, only to run aground on the treacherous reefs. Along the shore are scattered the remains of innumerable boats, 'some wrecked and half covered by the sand; others showing the poop and another the prow, here a keel and there the ribs'. It seems, Leonardo da Vinci continues, 'like a day of judgement when there should be a resurrection of dead ships, so great is the number of them'.[1]

Leonardo had never visited Cyprus, but he knew that this was the island of Venus, the goddess of love, and that its delights and dangers were hers. On the other side of the page he describes her garden – a meadow on the top of a rock, with a lake and a small thickly wooded island, and water flowing down into vases of granite, porphyry, and serpentine. It may have been this garden, filled with scented flowers, that the doomed sailors glimpsed across the waves. An ancient epigram had pictured the shipwrecked victims of Venus 'naked and needy . . . adrift in the open sea'. All desire is shipwreck, the commentators said. Clinging to their sorrows, tossed by storms, the life of unlucky lovers is a series of such disasters.[2]

Addressing the king of Cyprus in the prologue to his *Genealogia deorum gentilium*, a monumental treatise on the pagan gods written more than a century before Leonardo's jottings, Boccaccio tried to explain what was involved in his project. Collating the remains of the gods is like collecting the fragments of a great shipwreck dispersed along a vast beach; the author himself is like a novice sailor venturing onto the deep in a little boat to bring in this strange harvest from the shores of the Mediterranean. Boccaccio charts the progress of his voyage throughout the book, as his frail prow ploughs through 'the sea of errors' left by antiquity. Carried by the currents to the coasts of Egypt, Syria and Cyprus, he is sailing around Paphos, the city of Venus, when just as he is describing her charms a ferocious storm blows up. Amidst tumultuous waves, shattering gusts and total darkness, almost overwhelmed, he calls on Christ, who once calmed the waters and

I

saved Peter from the storm. The tempest is stilled, and Boccaccio sails away from Cyprus to continue his journey.[3] Had it not been for that desperate appeal, Boccaccio's little boat might have been one of those that Leonardo pictured half-buried in the sand.

Boccaccio's vision of himself saved from the treacherous waters of paganism was not new, for the imagery of shipwreck was particularly associated with idolatry. Tertullian had ended his treatise on the subject with a powerful image of the ship of Faith negotiating 'the reefs and inlets, the shallows and straits of idolatry'. The ship of Faith, her sails filled by the Spirit of God, navigates 'safe if cautious, secure if intently watchful'. But those who fall overboard are lost in a fathomless deep from which they cannot swim away; those who run aground face 'inextricable shipwreck', and those sinking in a whirlpool will never get a gulp of air, for 'all the waves suffocate; every current sucks down into Hades'.[4]

It was in just such a sea that the shipwreck of antiquity had occurred, for, as Augustine made clear, God's judgement on Rome was overwhelmingly an indictment of its idolatry and sexual immorality. So when Boccaccio presents his endeavour to his patron he deftly weaves all these strands together. Aligning the shipwreck of antiquity and the shipwreck of love, he turns the lost world of paganism into an inaccessible island as seductive and dangerous as that of the king for whom he writes.

In 1430, Poggio Bracciolini and his friend Antonio Lusco stood on the Capitoline hill in Rome and surveyed the desolate ruins around them. There was surely no better example of the mutability and cruelty of fortune. Of the ancient city that had once been the centre of the world, there remained only a few pathetic traces. The builders of Rome had probably imagined that such a great city would withstand every calamity, yet she too had become the victim of Fortune, who governs the rise and fall of kingdoms.[5]

Attributing the shipwreck of antiquity to Fortune subtly shifted the context within which it was viewed. Horace made Fortune 'mistress of the ocean', for, as Cicero said, when we enjoy a favourable breeze we reach a haven, and when she blows against us we are shipwrecked.[6] Petrarch and many others picked up the image, and from the mid-fifteenth century onwards Fortune is often personified as a nude woman on the sea. She looks rather like the goddess Venus herself, but she stands precariously on a boat, a ball, or even a dolphin, and holds a sail. The other common image of Fortune was derived from Boethius, who had pictured Fortune turning her wheel, deposing kings and raising up the humble. And in the Middle Ages, the variability of Fortune was often illustrated by four figures clinging to a

turning wheel, or by the inscription 'I will reign, I reign, I have reigned, I am without reign.'[7]

In *Fortuna*, the first of the early sixteenth-century tapestries known as *Los Honores*, the two images are combined. Fortune's wheel is in the centre, with the fortunate riding smoothly across the sea on the ascending side of the wheel, while on the other the unfortunate drown in the swirling waters of the storm, and sailors throw themselves overboard as their ships sink beneath the waves. Here, unlike the other tapestries in the series, all the figures are drawn from classical mythology and history, an indication that whereas sacred history had a direction and purpose, Fortune alone had governed the pagan world.

In the prologue to his lives of the Renaissance artists, Vasari attributes the end of Roman civilization to the turning of Fortune's wheel. The image suggests that if the wheel turned again, the arts that had once been destroyed would be revived. His optimism was widely shared. From the fifteenth century onwards, there is a new emphasis on the capacity of individuals to control their own destinies. Alberti complains about those who think themselves tossed by the stormy waves of Fortune when they are themselves to blame; Ficino notes that sometimes both the storm and the skill of the pilot bring a ship into port, for skill and fortune are sometimes in agreement. More robustly, Machiavelli insists that Fortune is a woman who will submit to the will of those who master her.[8]

In the centre of the nave in Siena cathedral, there is an early sixteenth-century marble pavement designed by Pinturicchio depicting an allegory in which a group of people on an island make their way up a winding path towards the figure of Wisdom, securely seated between two ancient philosophers. Below is Fortune, standing with one foot on a ball on the island and another on a little boat whose mast has been broken by the winds that still fill the billowing sail she holds over her head (Fig. 1). Fortune appears to have brought these people to the island; now they must turn their backs on her and ascend the mountain of Wisdom. But one man turns towards her; rather than trudging uphill towards the quiet repose offered by Wisdom, he seems willing to take his chances and sail out to sea with her once more.[9]

Poggio and his friend were not the first to survey the ruins. There is, as Lucretius once observed, a certain pleasure to be had in viewing a shipwreck from the safety of the shore,[10] and the shipwreck of antiquity was no exception. For later Christian observers there were two responses: an exquisite sense of loss at the destruction of Rome herself, and justified satisfaction in Christianity's triumph over the forces of evil represented by paganism.

1. *Fortuna* (detail), floor of Siena Cathedral, after Pinturicchio

The two could coexist, as they do in two poems by Hildebert of Lavardin (*c.* 1200), one of which mourns the past greatness of the city, while the other celebrates the submission of the city to the true God and the exchange of earthly for heavenly dominion.[11] Yet as time passed, the former sentiment began to predominate. The fourteenth-century poet Fazio degli Uberti pictured Roma, the personification of the city, lamenting the disappearance of her 'great, beautiful and noble monuments'.[12]

The emphasis in these early laments is as much on the loss of books and technical knowledge as on the destruction of statues – a concern reflected in Alberti's regret that Vitruvius was the only architectural writer to have survived 'that great shipwreck'.[13] But as antiquities came to be more highly valued, even the destruction of the pagan idols was seen as an understandable but disastrous mistake. Vasari complained that in the effort to extirpate everything that might give rise to error, Christianity had thrown down all the marvellous statues of the false gods, and so brought such ruin to the arts that they completely lost their direction.

The shipwreck metaphor suggests that the idols of the pagan world had perished in a single devastating storm, and in the later Middle Ages this was widely assumed to have been the case. According to the sculptor Ghiberti, the conversion of the empire to Christianity in the early fourth century had

caused such a hatred of idolatry that all the statues, paintings, and libraries of the ancient world were destroyed.[14] In fact, it had taken a long time. Despite the repeated sacks of Rome by northern barbarians, at the end of the fifth century most of the architectural and sculptural monuments of the ancient city, including eighty gilded and sixty-four ivory statues of the pagan gods, were still there. Many of the buildings survived for another millennium, gradually being stripped away as consecutive generations of builders reused the materials for new projects – a process accelerated by the revival of the city in the fifteenth century.[15] By then, however, the statues of the gods were no longer standing. No one really knew what had happened to them, though medieval writers routinely attributed their destruction to Pope Gregory the Great at the end of the sixth century, who 'in order that the seeds of the old heresies should not multiply caused all the heads and limbs of the statues of the demons to be broken'.[16]

Some statues just lay where they fell and were only gradually covered with earth, but others were probably buried by zealous Christians or perhaps by pious pagans. In either case, by the late Middle Ages the idea that the ancient gods had not merely fallen but had been buried was commonplace. So when they were accidentally exhumed they were sometimes reburied for fear of the demonic power they still possessed. Ghiberti tells the story of a statue with a dolphin, probably of Venus, inscribed with the name of the Greek sculptor Lysippos, that was found in Siena. Everyone admired it, and it stood above a public fountain until the Sienese lost a battle with the Florentines. At last they realized that it was their reverence for this indecent statue that had caused their misfortune. It was broken up and reburied in Florentine soil to transfer their ill-luck to the enemy.[17]

There was a close connection between literal and metaphorical burial. At the end of the *Genealogia*, Boccaccio finally brings his boat in to shore. His untiring voyage has taken him to the rocky coasts of the great sea, and all the islands under the sun. At last he is ready to step back onto dry land. But first he has to secure the boat with ropes and anchors, and protect her from the elements. To do this he must defend his work from the critics. He has not tried to resurrect the ancient gods. They, and their vile depravities, are not asleep but dead and buried for ever, 'crushed under the immovable weight of eternal damnation'.[18] A century or two later, if someone had untied Boccaccio's boat and pushed out to sea once more, could they have been so sure?

I

Sources

Around 1500, Francesco Maturanzio, a Perugian humanist, wrote to his friend the banker Alfano Alfani. He boasted that he had got hold of something 'more remarkable than anything you have seen from the whole of antiquity'. It was an ancient lamp still burning inside an urn[1] – a literal fulfilment of Walter Pater's claim that 'at the Renaissance, in the midst of a frozen world, the buried fire of ancient art rose up from under the soil'.[2] And why not? All over Italy bits of the ancient world were just lying about waiting to be discovered. To a discerning observer like the Byzantine scholar Manuel Chrysoloras, who walked around Rome in 1411 noting reliefs representing episodes from ancient myth,[3] the litter of antiquity even made a kind of sense, yet to most people, including the educated, it did not quite add up. Although there were continuities in literature, language and custom, the religion that bound these things together had been obliterated by Christianity. The challenge of the Renaissance was not the recovery of the past, but finding the spark that had given it life. The lamp still burning was a fantasy; the flame had to be rekindled.

This involved more than just reclothing the gods and heroes of antiquity with their antique forms; it meant finding new homes for them, and giving them new identities, and inventing new ways for them to relate to each other. Just working out who was who sometimes proved difficult. Classical reliefs and statues rarely came with labels attached, and even if they did, confusion could persist for centuries. For example, a pair of heroic figures with rearing horses had stood on the Quirinal hill in Rome since at least the twelfth century, possibly since antiquity. They bore the inscriptions OPUS FIDIAE and OPUS PRAXITELIS. In the Middle Ages, they were identified as statues of two prophets who bore these names, and it was Petrarch who pointed out that they might actually be the work of the ancient Greek sculptors Phidias and Praxiteles. Mid-sixteenth-century observers wondered whether both statues might not show Alexander and his horse Bucephalus, while in the 1590s the suggestion that they were the man-eating horses of

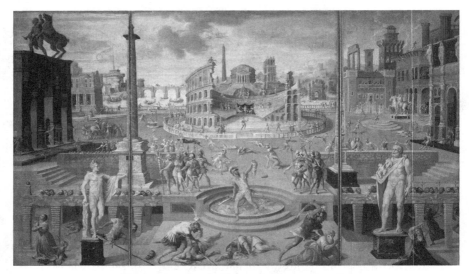

2. *Massacre under the Triumvirate*, Antoine Caron

Diomedes tamed by Hercules had some currency. It was not until the mid-seventeenth century that the pair were identified as the twin horsemen Castor and Pollux, the Dioscuri, or that it dawned on scholars that the statues probably were not by Phidias and Praxiteles themselves.

Some statues were recognized right away. The Laocoön group was discovered in 1506 in a Roman vineyard, and while still half-buried was identified by Sangallo and Michelangelo on the strength of a description by the Roman author Pliny. By the mid-sixteenth century there were about six to ten statues that everyone knew and admired. Benvenuto Cellini picked out the Laocoön, Cleopatra, the Apollo Belvedere, Commodus as Hercules, an unidentified Venus, and a *camillus* (then identified as a gypsy), and his opinion was probably fairly standard.[4] Thanks to prints published by Antoine Lafréry, even artists who had never been to Rome, like Antoine Caron, knew what they looked like. Caron's *Massacre under the Triumvirate* (Fig. 2) shows Hercules Commodus facing the Apollo Belvedere in the foreground, and one of the Dioscuri precariously positioned above the arch of Septimius Severus on the left. Yet many of the most famous statues, known to subsequent generations as the epitome of the classical tradition, were still undiscovered, and even those that had been were not necessarily widely known. Roman sketchbooks from the opening years of the sixteenth century mostly show reliefs rather than statues. There were a lot more statues around when Maarten van Heemskerck visited the city in 1532–6,

3. *Michelangelo's Bacchus in Jacopo Galli's Garden*, Maarten van Heemskerck

but they were just strewn about the courtyards and gardens of Roman palaces, and you would have had a hard job sorting them out (Fig. 3). Ulisse Aldrovandi's *Delle statue antiche* (1556) was the first gazetteer of the Roman collections. And only with Cavalieri's four books of prints published between 1561 and 1594 was there a visual record of all the most famous statues.

Of the 200 figures illustrated in Cavalieri's books about 60 per cent are identified as pagan gods and heroes, with Hercules being the most common. This amounted to something like a comprehensive repertoire of mythological figure types. Before its publication, however, it would have been quite difficult for any one person to get a sense of the full range. Artists and antiquarians put together their own collections of drawings and prints, but no one in the sixteenth century sought to work exclusively from classical models. On the contrary, they mixed classical and non-classical types quite freely. Even Raphael, the official inspector of Rome's antiquities, did so, and seventeenth-century classicists complained that although he might have been an angel compared with other painters, he was still an ass compared with the ancients.[5]

Supposing that you had classical models for every figure, how were you to put them together? Ancient reliefs provided some guidance because unlike

9

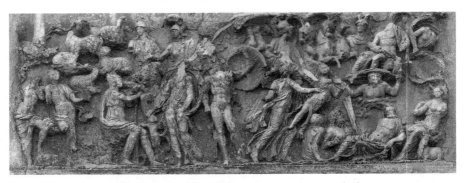

4. *Judgement of Paris*, Roman sarcophagus relief

statues they illustrated stories. But the range of subjects found in reliefs was limited. On the one hand there were the battle scenes and events from imperial history shown on Trajan's column and the triumphal arches of Rome; on the other there were sarcophagus reliefs where frequently depicted subjects included Bacchic processions, Diana and Endymion, and scenes from the story of Meleager. Sarcophagi were an important source, particularly in the fifteenth century when few classical statues were known. Yet the sheer profusion of figures often rendered the subject confusing. Other than Bacchic sarcophagi, almost the only sarcophagus reliefs to have a defining influence on representations of the same subject were those of the Fall of Phaethon and the Judgement of Paris (Fig. 4). But, as Marcantonio Raimondi's print after Raphael shows, the Judgement relief needed quite a bit of thinning out before the subject became legible (Fig. 129, p. 347).

Although fragmentary, sculpture was at least available to look at, whereas ancient painting was not. Around 1480, a series of subterranean rooms with painted ceilings and stuccoes was discovered in Rome on the site of Nero's Domus Aurea. The style of ornament found there, known as 'grotesque', had an immediate impact on interior and exterior decoration, although the figural panels were largely neglected until the seventeenth century. By that time, a far larger Roman work had been discovered, the Aldobrandini wedding, but almost no ancient paintings illustrating clearly identifiable mythological narratives were known until 1668. The influence of ancient painting apart from grotesques was therefore negligible. However, grotesque decoration remained popular for a century, and it was believed by some to be replete with symbolic meanings – a sort of mythological dream-world in which the stories had morphed into one another (Fig. 24, p. 82).

For both artists and antiquarians, ancient gems, medals and coins were

5. *Jupiter*, Philip Galle,
from Abraham Ortelius,
Deorum dearumque capita,
1573

of more importance. Not only were they far more numerous, but they circulated widely among collectors in Italy and later across Europe. In many cases, coins were probably a person's first point of contact with the material culture of antiquity. Interest focused on the portrait heads, but the reverses, depicting scenes and symbols of Roman life and religion, were eventually noted as well, and illustrated in numismatic books beginning with Enea Vico's *Imagini con tutti i riversi* of 1548. Later, Abraham Ortelius, the Antwerp cartographer and collector, published *Deorum dearumque capita* (1573) with Philip Galle's engravings of heads of the gods and goddesses taken from Roman coins and medals, accompanied (in the edition of 1602) by a mythographical commentary (Fig. 5). Coins were also frequently copied for decorative effect by painters, sculptors and manuscript illuminators, and in Correggio's Camera di San Paolo in Parma they provided the source for the figures in the lunettes.

Whereas coins were relatively cheap, ancient cameos and intaglios were enormously valuable. Until the sixteenth century, they were for many people the primary source of information about what classical art had actually looked like. In Angelo Decembrio's *De politia litteraria*, a dialogue set in the Ferrarese court of the 1440s, Lionello d'Este's discussion of ancient art

revolves around his gem collection.[6] Many gems, including some of the most prized items in the collection of Lorenzo de' Medici, depicted mythological scenes. Almost all were initially misidentified, but this did not prevent them from being reproduced. Ghiberti made a mount for the intaglio of Apollo and Marsyas, and a painting from Botticelli's workshop shows a woman wearing it as a pendant (Fig. 6). Donatello and his assistants copied many of them for circular reliefs in the courtyard of the Palazzo Medici; and thanks to the dissemination of plaquettes (small metal reliefs) and prints, they were later reproduced in a variety of other media by artists throughout Europe. Eventually illustrated catalogues, like Leonardo Agostini's *Le gemme antiche figurate* (1657), would reveal that a disproportionate number of the gems known in the period showed satyrs, maenads and other Bacchic figures.

Reading the works of these antiquarians, you have to wonder how the Renaissance in the arts ever happened. They are far more interested in inscriptions and coins than in statues or reliefs, and they give little indication of why an increased appreciation of the material legacy of antiquity should have produced the vibrant visual culture of the sixteenth century. In the case of mythological imagery at least, the relationship between the two is a complex one. The recovery, assimilation, and diffusion of antique art happens quite gradually, and yet at every stage the distribution of mythological imagery by subject and medium is wholly different. The fact that the Laocoön was universally admired did not make his story a popular subject for artists. Conversely, several genres in which mythological imagery is prominent, notably *cassoni* (painted wedding chests), illustrated editions of Ovid's *Metamorphoses* and maiolica (painted pottery), rise and decline with little reference to the antique. Even sculptors rarely tried to imitate the antique statues and reliefs they admired in the same media; the pagan gods appear most frequently not in the form of monumental carvings or stone reliefs but as bronze statuettes and plaquettes. Indeed, the very fact that mythological sculpture developed in Florence rather than Rome suggests it functioned as a substitute for genuine antiquities as much as a supplement to them.

There is, however, a clear link between the collection of antique art and the spread of mythological imagery. The Roman collections were the magnet that drew artists to Rome and inspired them to treat classical themes in their own work. And it was often the most enthusiatic collectors of antiquities who were anxious to commission contemporary artists to produce mythologies, either for a *studiolo* (a small study) such as that of Isabella d'Este,

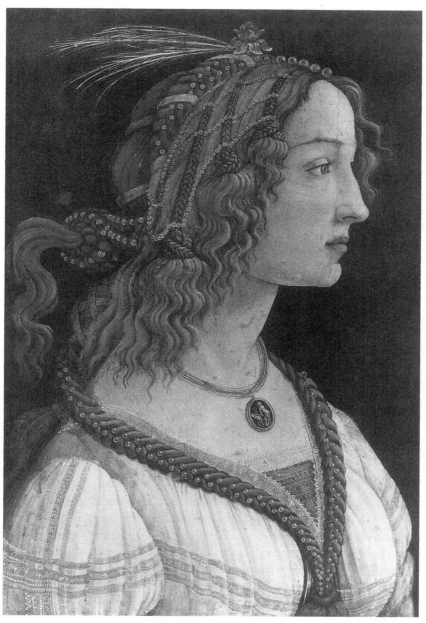

6. Portrait of a woman with intaglio of Apollo and Marsyas,
School of Botticelli

or else, later in the century, to decorate a gallery (such as those at the Palazzo Rucellai and the Palazzo Farnese in Rome) in which antique sculpture would be exhibited. Similarly, where antiquities were displayed outside, a garden or grotto was more likely to be given an iconographical scheme appropriate to the works within it. Rather than imitating antique models, mythological art often just provided antiquities with a suitable setting. It helped them feel at home.

One way to do this was to recreate lost works of classical art. Along with models to imitate, the ancient world had also left numerous descriptions of works of art that either no longer existed, or were only literary conceits in the first place. The *ekphrases* (detailed descriptions) of Pliny, Lucian, Philostratus and others proved to be almost as influential as the material remains of classical civilization. The visible legacy of antiquity was fragmentary and difficult to interpret, but with the help of literary sources it was possible to imagine what the work of classical artists had been like. This was especially important when it came to painting, for literature allowed painters to recreate works from an invisible gallery of ancient masterpieces. The most famous example, Botticelli's *Calumny of Apelles*, is the reworking of a painting described by Lucian and recommended to painters by Alberti as a model of narrative art.

Lucian's writings had been unknown in the medieval West, and came to Italy from Byzantium. There was something about Lucian's light-hearted fantasies that struck a chord in the Renaissance and he became a great favourite of the humanists. All the same, his influence on the choice of subject-matter was hardly comparable to that of Philostratus, whose descriptions of ancient paintings, almost all mythological, were circulating in manuscript from the beginning of the fifteenth century. Early attempts to recreate specific works described by Philostratus are difficult to identify, but Isabella d'Este's highly literary approach to the commissions for her *studiolo* may have been inspired by Philostratus's example, if not his actual descriptions, for she later commissioned an Italian translation which was consulted for the decoration of her brother's *studiolo* in Ferrara. And Philostratus, like many Greek authors, found a wider readership in France, where Blaise de Vigenère's translation and commentary appeared in 1578, with an illustrated edition in 1614 (Fig. 82, p. 226).

Pliny's *Natural History* did more than provide descriptions of lost works. It enabled people to identify newly discovered antiquities, such as the Laocoön and the Niobid group, with specific works and artists. Although this could result in optimistic misattribution, it served to forge a connection between the art worlds of antiquity and the Renaissance. The fragments of

antiquity were not just the relics of paganism but the products of an industry in which individual artists competed against one another in the imitation of nature and so won fame and the favour of princes. As a model for the aesthetic and social ambitions of the Renaissance artist, Pliny's *Natural History* was of central importance, and its integration of mythological subjects into that account helped to take the ancient gods out of the sphere of religion into that of competitive manufacture. The fact that they were idols made by human hands may once have served to discredit them; turned around, it showed how much a craftsman could achieve.

Almost anything that served to naturalize the demonic world of paganism helped its assimilation. Ancient historians were also potentially useful in this regard, especially Diodorus Siculus. His approach to the gods was similar to that of Euhemerus, the ancient writer who had argued that the gods were merely prominent mortals who had been deified after their deaths. This euhemerist interpretation of ancient religion had been enthusiastically adopted by early Christian writers like Lactantius, who sought to discredit the supernatural claims of paganism; and it was transmitted to the Middle Ages through Isidore of Seville. By placing the ancient gods within the frame of human history they could be incorporated into the same chronology as that of sacred and contemporary history. It is in this context that they appear within medieval chronicles as kings of places remote in time and space. But the rediscovery of Diodorus provided a wealth of new material that was used by those, like Annius of Viterbo and Jean Lemaire de Belges, who sought to establish closer connections between the world of ancient myths and western European history.

Following Virgil, the Trojan War was the natural starting-point for national mythologies, and the idea that the kingdoms of western Europe had, like Rome, been founded by fleeing Trojans was widely held and created an incentive for the use of the Trojan legend in both literature and history. The story of Troy was well known, especially in northern Europe, thanks to a series of vernacular works derived not from Homer but from two narratives attributed to Dares of Phrygia and Dictys of Crete which purported to be first-hand accounts of the Trojan War written by combatants from either side. Dares' *De excidio Troiae historia*, the more influential of the two in the West, began with the story of Jason and the Golden Fleece, and this pattern was passed on through a sequence of medieval imitators. Garbled and anachronistic though they often were, works like Benoît de Sainte-Maure's *Roman de Troie*, and Guido delle Colonne's thirteenth-century *Historia destructionis Troiae* kept the stories of the Trojan War,

the Judgement of Paris, and the Voyage of the Argonauts alive throughout the medieval period. Manuscripts were frequently illustrated and Raoul Le Fèvre's *Recueil des hystoires de Troyes* was printed with woodcuts (Fig. 32, p. 100). So when Jean Lemaire claimed to put the Trojan legend on a firmer historical footing in his *Illustrations de Gaule et Singularitez de Troye*, he mentioned inaccurate illustration as one problem his work would correct.[7]

Virgil's *Aeneid* was known throughout the Middle Ages and only increased in popularity in the Renaissance, yet it was Servius's fourth-century commentary rather than the poem itself that contributed most to the Renaissance understanding of mythology. Looking through Servius's text, this may seem surprising, for the mythological material is thinly scattered. Yet if you follow a thread stretching back from the Renaissance, you often end up with Servius, and a surprising amount of the lore of the ancient world was mediated through his work. The sixth book of the *Aeneid*, in which Aeneas visits the underworld, received particular attention from other commentators as well.

There were also important ancient commentaries on Homer, but these were little known in the Middle Ages and not until the mid-sixteenth century were they all in print. The poems themselves were more readily available, but although there was a Spanish paraphrase of the *Iliad* as early as 1445, vernacular translations were slow to appear elsewhere, and even then Homer did not enjoy the prestige that his priority later gave him. Hesiod suffered still greater neglect. Of rather more importance for the understanding of mythology in the Renaissance were the works of the now almost forgotten author Statius and the late antique commentary on his work by Lactantius Placidus.

Although there was no literary parallel to the exponential increase in the knowledge of classical antiquities, there were few important classical authors of whom Renaissance scholars were unaware. Some lost Latin poets, like Lucretius (whose *De rerum natura* was found in a German monastery by the Florentine manuscript-hunter Poggio Bracciolini) and Catullus, were rediscovered in the fifteenth century. Greek tragedies were translated into vernacular languages from the second quarter of the sixteenth century; poets like Anacreon, Callimachus, and Pindar were also available, although better known in sixteenth-century France than in Italy; even an obscure late antique epic like Nonnos's *Dionysiaca* was eventually edited and published.

Given the wealth of ancient literary sources available in the Renaissance, it is revealing that one late antique novel of dubious reputation, Apuleius's *Golden Ass*, had a greater influence on the visual arts than almost any other

classical text. The legend of Cupid and Psyche which lies at its centre had been known in the Middle Ages through Fulgentius, but in the fourteenth century Boccaccio got hold of a manuscript, reused a couple of stories in the *Decameron*, and included a discussion of Cupid and Psyche in his *Genealogia deorum*. Perhaps because Boccaccio had helped to popularize it, *The Golden Ass* was printed in Rome as early as 1469, and an Italian translation was already available in manuscript by 1481, for in that year Federico Gonzaga wrote to Ercole d'Este to ask if he could borrow it.[8] (Ercole replied that he could not part with it because he read it every day, but agreed to make him a copy of his own.) Niccolò da Correggio produced a verse translation of the story of Cupid and Psyche in 1491, and other versions in both verse and prose continued to appear throughout the century.

Ovid was the most influential source for the visual arts. His work was in no sense a discovery of the Renaissance, for it had been read throughout the Middle Ages. Early vernacular editions of the *Metamorphoses* routinely use medieval paraphrases and commentaries, and as subsequent translations often embroider their predecessors rather than re-translate the original text, the content of a vernacular Ovid often differs significantly from that of contemporary Latin editions (or modern translations). In both Italy and France, the first illustrated edition to appear in print was also the first translation, and although illustrations for vernacular translations were sometimes reused or revised for Latin editions, it was only for vernacular translations that new illustrations were routinely commissioned (see Appendix). Even so, the tradition of illustrated editions of Ovid was conservative. The woodcuts for the first Italian edition of 1497 (Fig. 112, p. 302) provided the model for those in Niccolò Agostini's verse translation of 1522, and indeed for every Italian edition until Lodovico Dolce's version of 1553, and for Latin editions until the end of the century. The woodcuts of the 1497 edition also had an impact in France where they informed Bernard Salomon's woodcuts of 1557, which in turn became enormously influential throughout Europe.

One effect of such textual and illustrative conservatism was that a single mistake could be perpetuated for centuries across a variety of contexts. According to Ovid, when Cephalus's dog Laelaps was pursuing the Teumesian fox both he and the beast he was pursuing were metamorphosed into marble as they ran. In Colard Mansion's *Ovide moralisé* (1484), *marbre* is given as *arbre* (following a mistaken caption to an earlier manuscript illustration). The error passed into the early French Ovid known as *La Bible des poetes* (1493), with the result that in *Le Grand Olympe* of 1539 – a

French prose edition that reused the text but supplied new illustrations –
Laelaps and his quarry are shown bounding around the countryside with
trees growing out of their necks. From here the motif entered the visual
repertoire quite independent of the mistranslation, and so in Salomon's
version of the death of Procris of 1557, Solis's reworkings of 1563, and
even in the print for Steinman's Latin edition of 1582, the animals appear
in the same form, save that Salomon's appear to be sprouting poplars (Fig. 7)
and Steinman's conifers – the difference between Lyons and Leipzig.[9]

Nevertheless, Salomon's series of woodcuts represented a watershed.
Produced in French, Dutch and later in Italian editions for an *Ovide figuré*,
where each woodcut was accompanied only by an eight-line verse summary,
the pocket-size volume had no allegories and contained not one word of
Ovid's poem. But Salomon's designs set a new standard of coherence and
skill, and from then on illustrated editions of Ovid were often image- rather
than text-led. Virgil Solis's reworkings of Salomon's prints (in which the
designs are reversed) appeared in a similar format, and later artists like
Hendrik Goltzius (Fig. 54, p. 150) and Antonio Tempesta (Plate III) often
produced freestanding sets of illustrations independent of the text. At the
same time, the number of illustrations to full-text translations was being
reduced. Anguillara's enduring Italian translation first appeared in 1561,
and from the edition of 1584 was illustrated with fifteen full-page engravings
by Giacomo Franco, each of which managed to show numerous incidents
from the relevant book within a single landscape (Fig. 92, p. 251). The
engravings were reused in Nicolas Renouard's new French translation, and
also provided the model for George Sandys's English version of 1632.

If the relationship of illustrations to a particular translation is usually
slight, their relevance to any moral or allegorical interpretations provided
is non-existent. Unlike Homer and Virgil, Ovid had not attracted serious
discussion in late antiquity. However, most Renaissance editions of the
Metamorphoses were accompanied by annotation of some kind. In the case
of the first vernacular editions, this was derived directly from late medieval
models. Later versions frequently reuse this material, but the extent and
nature of the commentary differs between countries and changes over
time. The direct interpretation of stories in terms of Christian doctrine
characteristic of medieval French moralized Ovids and *La Bible des poetes*
was not sustained. In 1559, Christianized interpretations of Ovid were put
on the Catholic church's index of prohibited books, but they were already
out of print in France and had never been popular in Italy or in Latin
editions. All most readers of Ovid were looking for was a straightforward
indication of the moral category into which each narrative fell. Antonio

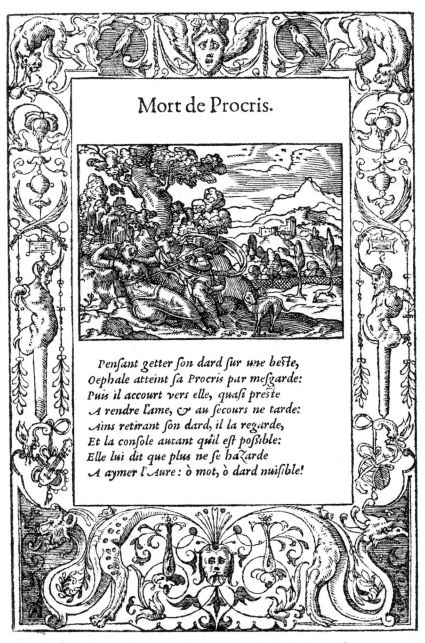

Mort de Procris.

Penſant getter ſon dard ſur une beſte,
Oephale atteint ſa Procris par meſgarde:
Puis il accourt vers elle, quaſi preſte
A rendre l'ame, & au ſecours ne tarde:
Ains retirant ſon dard, il la regarde,
Et la conſole autant qu'il eſt poſſible:
Elle lui dit que plus ne ſe hazarde
A aymer l'Aure: ò mot, ò dard nuiſible!

7. *Death of Procris*, Bernard Salomon, from Ovid, *Metamorphoses*, 1557

Tritonio's *Mythologia* (1560) helpfully provided an index – of the women loved by gods, the impious, the proud, the chaste, the brave, and the good-looking boys (to name some of the more populous categories).

Of Ovid's other works the most useful as mythological sources were the *Fasti* (based on the Roman calendar) and the *Heroides* (a sequence of letters from legendary women to their husbands). Both were printed with great frequency, and were illustrated with woodcuts in the early sixteenth century. But the *Fasti* did not appear in any vernacular language until Cartari's version of 1551, and its impact on the arts is correspondingly slight. Although used as a literary source for Botticelli and Piero di Cosimo in Florence, the *Fasti* remained more accessible to the iconographical adviser than the artist.

Specific interpretations of Ovid can often be traced back to the mythographers of late antiquity, but the traditions of commentary and mythography are rather more distinct than you might imagine. For one thing, even though ancient mythographers wrote about many of the same myths, none of them commented directly on Ovid's text. This distance was maintained. Giovanni del Virgilio's allegories of the *Metamorphoses* (*c.* 1370, but reused in the Italian edition of 1497) and Boccaccio's *Genealogia* may be contemporary but they are mutually independent. In the sixteenth century there is some overlap between the interests of Latin commentators and the mythographers, but the concerns of vernacular commentators only begin to converge with those of the mythographers in the early seventeenth century in works like van Mander's *Wtlegghingh* which is in effect a freestanding mythography structured as a commentary on the *Metamorphoses*.

In general, however, annotators and mythographers responded to different imperatives. Commentary on Ovid was governed by what the reader needed to know, mythography by what there was to know. And as the mythographies of the ancient world demonstrated, this was potentially limitless. However, classical mythographers like Hyginus or Cornutus were not read by anyone other than scholars, and Apollodorus's *Library* was little used before the mid-sixteenth century. Renaissance readers seem to have responded most readily to authors whose approach to the gods was light in tone and sceptical in approach: Palaephatus, an unknown Greek author whose *On Unbelievable Tales* was devoted to debunking the myths of antiquity by offering a natural explanation for everything, become popular in the mid-sixteenth century after his work was finally published in Latin. And Cicero's *De natura deorum*, which had been little read in the Middle Ages, was another beneficiary.

The great exception to this general neglect was the work of Fulgentius, a Christian writer of the late fifth century, whose *Mythologiarum libri tres* offered brief explanations of ancient fables in terms of etymology, natural processes, and social morality. He discusses only fifty fables, but almost all of them became common subjects in Renaissance art. Whereas most mythographies include huge amounts of information that proved redundant for succeeding generations, if you look at the list of subjects he covers you cannot help being struck by his hit-rate. Why this should be so is a mystery. Was he the author of his selection's success, or did he just happen to choose the same fables as Renaissance artists? Although more than a dozen editions of his original text appeared in the sixteenth century, it was never translated or illustrated. In fact, there is little evidence of iconographical programmes devised directly from it. His indirect influence was more important, perhaps because it was mediated both by later mythographies, and by the moralizers of Ovid. In general, mythographers and vernacular commentators drew on different sources, but Fulgentius is common to both. His was the one mythography you could not avoid.

Fulgentius's work, along with Servius's commentary on the *Aeneid*, the eighth book of Isidore of Seville's encyclopedic *Etymologiae*, and Lactantius Placidus's commentaries on Statius, provided the foundation for the earliest medieval compendia of classical myth, the so-called Vatican Mythographies. The first two of these date from the last two centuries of the first millennium, while the third is a much later work, the *Liber ymaginum deorum*, a twelfth-century text attributed to an unknown Albricus, perhaps the English philosopher Alexander Neckam. Albricus's account of the ancient deities also draws on two other late-antique authors: Macrobius (also the author of a commentary on Cicero's *Somnio Scipionis*), whose *Saturnalia* identified all the gods of the pagan world with the sun, and Martianus Capella, the author of *The Marriage of Mercury and Philology*, an extended allegorical fantasy the first book of which describes an assembly of the gods. Martianus was also the subject of numerous commentaries, notably that of Remigius of Auxerre.

Albricus's work was neither translated nor illustrated, but one way or another it informed every subsequent mythography. Petrarch read it and used it in the third canto of his poem *Africa*, while his friend Pierre Bersuire drew on both Albricus and Petrarch in his account of the appearance of the gods in a prologue to his *Ovidius moralizatus*. From these descriptions a distinctive iconography developed that lasted for two centuries. Bersuire's prologue was translated into French and published with woodcuts of the gods by Colard Mansion in his *Ovide moralisé* of 1484. But it also provided

the basis for two late fourteenth-century works: Évrart de Conty's commentary on *Les Eschez amoureux*, and the *Libellus de imaginibus deorum*. Although ostensibly a commentary on a recent allegorical poem, the former is an encyclopedic work in its own right, and contains the most substantial vernacular mythography of its time. The descriptions of the gods come straight from Bersuire, but the interpretations are much longer and free of his theological orientation. In the late fifteenth and early sixteenth centuries manuscripts of Évrart's work were illustrated with miniatures of some refinement, but the commentary was not published, and its subsequent influence was minimal. In contrast, the *Libellus* (often confusingly attributed to Albricus himself) went through many editions. Its success was probably due to its simplicity. Beginning with the planetary deities, the *Libellus* offers a short paragraph on the appearance of each god, and a brief account of the twelve labours of Hercules. It was all most people needed to know.

In Italy, especially in Florence, Boccaccio's *Genealogia deorum* provided an alternative source. Although today it is the least read of all Boccaccio's works, he considered it to be of great importance and devoted many years to its completion. Drawing heavily on all of Albricus's sources and on Albricus himself, Boccaccio did his best to make sense of the complex genealogy of the gods. But as he also allows for several gods of the same name, the result becomes enormously confusing. No subsequent mythographer followed his method of organizing material, yet Boccaccio's *Genealogia* retained its prestige and was to remain the most important mythological manual until the late sixteenth century. On the strength of his testimony a visual and literary iconography of a completely fabricated deity, Demogorgon, was developed. Its persistence in the face of scornful refutations by later mythographers is evidence both of the authority of Boccaccio and of the weight of tradition.

One reason why the *Genealogia deorum* held the field for so long was that new sources of information were slow to accumulate. The recovery of literary texts did not in itself necessarily lead to fresh mythological insights, for these were works that, even if little used in the Middle Ages, had often been known to the mythographers of late antiquity. The best people could do was to write short treatises entitled *De cognominibus deorum* which co-ordinated the confusing multiplicity of names by which the gods had been known in ancient times.[10] This was actually rather more helpful than might be supposed, for it allowed stories about individuals with different names to be grouped around a single deity. The concern with names of the gods is also evident in the first major mythography since Boccaccio: Lilio Gregorio Giraldi's *De deis gentium*, published in 1548. A peripatetic scholar

of Ferrarese origin, Giraldi had started out by writing booklets on Hercules and the Muses – both subjects already used in Ferrarese art. But although he may have been prompted by the arts, his mythological range vastly exceeded them. He tries to avoid allegorical speculation, and his book is the most scholarly of its kind – the first to make full use of ancient historians and geographers like Pausanias, whose *Description of Greece* provided a wealth of information about the ways in which the gods had been worshipped in their sanctuaries. And yet it was not quite the sort of thing that people needed. Densely packed with source material, it offered more to antiquarians than to laymen. For mythography to have any impact on artists it needed to be dumbed down.

Two other mythologies addressed a wider readership. Natale Conti's *Mythologiae* of 1551 was rich in interpretations both moral and scientific, while Vincenzo Cartari's *Le Imagini*, written in Italian and published in 1556, concentrated on their appearance and attributes. Unlike Giraldi's book, both Conti's and Cartari's went through many editions, and also appeared in translation and with illustrations. Only Cartari ever managed to rival Boccaccio as a source book for artists and their advisers, but Conti had the greater influence outside Italy. He was popular in France and a major source both for Juan Perez de Moya's *Philosophia Secreta* (1585) in Spain, and van Mander's Dutch commentary on Ovid of 1604.

Mythographies produced in other parts of Europe were largely derived from medieval or Italian sources. In the fifteenth century, French-speakers had Évrart de Conty on *Les Eschez amoureux* and Christine de Pisan's *Epistre Othea*, but they later made do with translations of Boccaccio, Cartari, and Conti. In Germany the earliest mythography was the handy *Theologia mythologica* (1532) of Georg Pictor, which – unusually – was illustrated with verses from fifteenth-century Latin poets like Marullo and Pontano. In contrast, Johann Herold's vernacular *Heydenweldt* (1554) is more scholarly, and gives an insight into the type of texts that a would-be student of mythology might need. Along with a short mythography, which uses the recent work of Giraldi to explicate the names and epithets of the gods, are translations of Diodorus Siculus, Dictys, and Horapollo. Herold might have employed the latest scholarship, but his illustrations were (save that of Venus) derived either from the old Colard Mansion woodcuts, or the descriptions in the *Libellus* (Figs. 8 and 9). When the antiquarian Johann Rosen used Herold's mythography for his book on Roman antiquities in 1583, he dispensed with them in favour of the reverses of antique coins.

Whereas vernacular commentaries on Ovid differ considerably, for most of this period there is no great disparity between the types of mythography

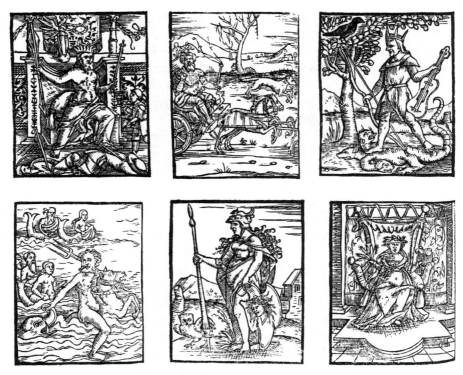

8. Gods (top: Jupiter, Mars, Apollo; bottom: Neptune, Minerva, Ceres),
from Johann Herold, *Heydenweldt*, 1554

that were available in different parts of Europe. However, if you compare
Baltasar de Vitoria's *Teatro de los Dioses de la Gentilidad* (1620), in which
the planetary deities are guided by angels, with Francis Bacon's *De sapientia
veterum* of 1609, you do get a sense of the intellectual divide that was
starting to develop between the North and the South. Bacon's sources were
often the same (notably Conti), but in place of traditional allegories he
offered light but pointed interpretations of mythology in terms of contem-
porary science, politics, and psychology. Yet the stories still pleased him,
for he had the outside doors of his house ornamented with 'the figures of
the Gods of the Gentiles'.[11] His book also appeared in English, and in 1619
it was translated into French by Jean Baudouin (who also produced his own
augmented edition of Conti).

Although moralization might help to make the fables of antiquity more
relevant to a contemporary reader, that could hardly compare with the

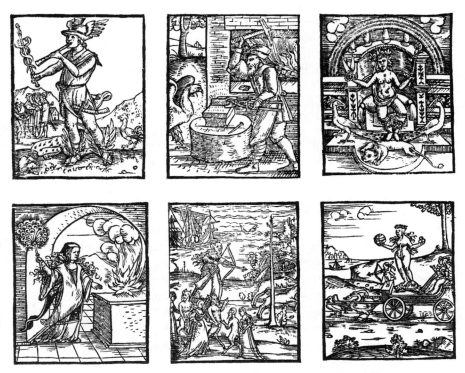

9. Gods (top: Mercury, Vulcan, Juno; bottom: Vesta, Diana, Venus),
from Johann Herold, *Heydenweldt*, 1554

precision and direct personal import of astrology. Astrology could suggest links between the gods and heroes of antiquity and the lives of modern individuals via the planetary and astral configuration at the time of a person's birth. The planets had been identified with Olympian deities since antiquity, and from the fourteenth century onwards they were increasingly prominent in iconography. The planets were conceived as governing the character and destiny of those people, known as their 'children', who were born under their influence. And there are numerous representations of the planets and their children in fifteenth-century manuscripts and prints, especially in Germany, from where they found their way to northern Italy. The planetary deities are depicted either as single figures standing within a circle, as in the Milanese manuscript *De Sphaera*, or else driving their chariots across the sky. In both cases they are accompanied by the signs of the zodiac over which they ruled (the day house and the night house, though the Sun only had the latter and the Moon the former):

Saturn: Aquarius and Capricorn
Jupiter: Pisces and Sagittarius
Mars: Aries and Scorpio
Venus: Taurus and Libra
Mercury: Gemini and Virgo
Sun (Apollo): Leo
Moon (Luna): Cancer.

Below, their children are engaged in appropriate activities. Saturn usually presided over a gloomy collection of agricultural workers, geriatrics, and beggars. The children of Jupiter were more fortunate – rulers, and aristocrats enjoying the hunt. Mars governed bloodthirsty warriors. The children of the Sun were often to be seen engaged in athletics, though they included rulers and prelates as well. Venus's children are always lovers being serenaded by musicians, whereas those of Mercury are engaged in a wide variety of activities – he presided over science, the arts and technology, which was taken to include painters and sculptors, and, later, merchants. The Moon governs the waters, and so her children go fishing or swimming. A set of Florentine engravings, probably by Baccio Baldini, proved particularly influential in disseminating this imagery in Italy (Fig. 10 – with Sagittarius in place of Gemini). His versions of the planets found their way into fresco cycles such as Pinturicchio's Borgia apartments in the Vatican and (without the children) Perugino's at the Collegio del Cambio in Perugia, as well as into illustrated editions of Hyginus's *Poetica astronomica*.

However, when the planetary deities first appeared in decorative cycles such as these the context was not mythological or even astrological but encyclopedic, for in the medieval West the Seven Planets had found their place alongside the Seven Liberal Arts (with which they were identified), the Apostles, the Prophets and Sibyls, the Theological and Cardinal Virtues, and the Labours of the Months. Between the Palazzo Ragione in Padua (*c.* 1420) and the Tempio Malatestiano in Rimini (*c.* 1450) and the cycles of Pinturicchio and Perugino (*c.* 1500), there is little iconographical, as opposed to stylistic, development. Later, the planets appear separated from the encyclopedic context, but they still had a vital role in the ordering of knowledge. In fact, they could help you understand almost anything. Doctors mapped them onto the organs of the body and the seven orifices of the face: Jupiter is the liver and the left ear.[12] Bodin applied them to political geography: Saturn and Venus govern southerners who are devoted to contemplation and lust; Mars and Diana the warriors and hunters of the North, and Jupiter and Mercury the people in the middle.[13] Lomazzo discovered

MERCVRIO E PIANETO MASCHVLINO POSTO NELSECONDO CIELO ET SECHO MAPERCHE LA
SVA SICITA EMOLTO PASSIVA LVI EFREDO CONQVEGLI SENGNI CH SONO FREDDI EVMIDO COG
LI VMIDI ELOQVENTE INGENGNIOSO AMA LESCIENSIE MATEMATICA ESTIVDIA NELLE DIVI
NASIONE A ILCORPO GRACILE COESCHIETTO ELBISO TTILI IRTATVRA CHONPIVTA DE
METALLI A LARGIENTO VIVO ELDI SVO E MERCOLEDI COLLA PRIMA ORA P · IS EZZ
LANOTTE SVA EDELDI DELLADOMENICHA A PERAMICO ISSOLE PER NIMICO AVENE
RE LASVA VITAOVERO ESALTATIONE EVIRGO LASV MORTE OVERO NVMILIAEION꠆
E PISCE HA HABITASIONE GEMNI DIDI VIRGO DINOTTE VA E IZ SENGNI IN ꟷ
DI COMINCIANDO DA VIRGO IN ZO DI E Z ORE VA VN SENGNO ←

10. *The Planet Mercury*, Baccio Baldini

them in the history of art: Leonardo was the Sun, and Titian the Moon; Mantegna was Mercury, Raphael was Venus, and Polidoro Mars; Michelangelo was Saturn, and Gaudenzio Ferrari was Jupiter. Gaudenzio, in case you are wondering, was Lomazzo's teacher, but the other identifications seem pretty much right.[14]

In numerical terms, the seven planetary deities fitted the encyclopaedic tradition rather better than they did the astrological one, but a way out of the awkward doubling of the signs of the zodiac with the gods was offered by a Roman work, Manilius's *Astronomica*, which was already known from manuscripts in Florence and Ferrara in the 1460s, and first published in 1472. Manilius identified each sign of the zodiac with a single Olympian deity:

Aquarius: Juno	Leo: Jupiter
Pisces: Neptune	Virgo: Ceres
Aries: Minerva	Libra: Vulcan
Taurus: Venus	Scorpio: Mars
Gemini: Apollo	Sagittarius: Diana
Cancer: Mercury	Capricorn: Vesta

It was in keeping with these identifications that the gods appear in the Sala dei Venti at the Palazzo Te in Mantua, and earlier in the Sala dei Mesi at the Palazzo Schifanoia in Ferrara (Plate I) where the month of April is represented by Venus receiving the submission of Mars in a triumphal barge drawn by swans, with Venus's children on the banks on either side; below is the sign of Taurus, and at the lower level, the courtly activities appropriate to the time of year.

Through their identification with the Olympians the planets could easily be supplied with attributes; the appropriate iconography for the stars was less certain. It was this that made Hyginus's *Poetica astronomica* such a valuable source, for it comprised a brief but engaging series of stories about mortals who had been turned into stars. This Hyginus was also assumed to be the author of the mythography, but the differing response to these works in the Renaissance is illuminating. Unlike the neglected *Fabulae*, the *Poetica astronomica* was enormously popular. It appeared in numerous illustrated editions from the late fifteenth century onwards, and enjoyed a particular vogue in early sixteenth-century France. Hyginus is the major source for astral iconography at the Villa Farnesina, and the Palazzo d'Arco in Mantua and the Palazzo Farnese at Caprarola (each of which contains a room with twelve narrative scenes determined by the signs of the zodiac). At Caprarola they are to be found in the Sala del Mappamondo and accompany an astral map of the heavens on the ceiling.

*

Manilius's scheme also influenced Marsilio Ficino, whose revival of Neoplatonism was responsible for the most ambitious attempts to make sense of the ancient gods (and perhaps the only one that went beyond the horizons of late antiquity). Ficino drew on Plato, the Hermetic texts (supposedly the work of the Egyptian sage Hermes Trismegistus), and the Orphic hymns, which were taken as the work of Orpheus himself. In these works, in which the protagonists of ancient myth appeared to be speaking for themselves, were the traces of the ancient theology which God had revealed not just to Moses but also to the other sages of antiquity. Using such sources, Ficino made repeated attempts to sort out the pagan gods in terms of highly abstract Neoplatonic categories like the One, the Mind, and the Soul.

Ficino himself appears to have had little interest in art, although others in his circle, like Poliziano, had more direct contact with art and entertainment, and therefore many people have supposed that Neoplatonic mysteries are concealed in the mythologies produced in fifteenth-century Florence. The cosmic speculations of Ficino do not seem well matched to the everyday decoration of wedding furniture, but Florentine Neoplatonism did eventually have a wide influence on ideas about love and divine inspiration, in Italy and elsewhere. Yet the form in which Neoplatonic ideas about mythology were most widely disseminated would have been in something like Leone Ebreo's *Dialoghi d'amore*, which went through twenty-five Italian editions between 1535 and 1607, and was translated into other languages as well.

The idea that there had been a single divine revelation to the entire ancient world was distinct from, but not incompatible with, the attempt to integrate classical mythology with Old Testament history. Obvious similarities, such as those between the stories of Noah and Deucalion, or Hercules and Samson, made it difficult to keep the narratives apart; since the euhemerist tradition suggested that the gods were no more than deified historical persons anyway, it was easy to extend this type of interpretation to cases where the parallels were rather less obvious – Bacchus and Moses, for example. In the early seventeenth century, interest in this type of interpretation increased enormously, and it eventually laid the foundations for the study of comparative religion.

Research of this kind, which drew on the work of ancient historians who had explored the links between the Greek and Egyptian gods, was in a tradition continuing that of late antiquity. But there was one form of symbolic interpretation, also inspired by Egyptian sources, that was new to the Renaissance. In 1419, a Florentine priest brought back fom his travels

a Greek manuscript of Horapollo's *Hieroglyphica*, a late Alexandrian work that attempted to interpret the written language of ancient Egypt as a set of symbols that contained hidden meanings. First published in 1505, the *Hieroglyphica* went through many editions in several languages, and inspired numerous imitators. Valeriano's *Hieroglyphica* of 1556 extended Horapollo's technique to other ancient sources, and Celio Curione added a chapter on mythological figures to the 1567 edition. Symbolic dictionaries became a prominent feature of late sixteenth- and seventeenth-century intellectual life. The most useful of them is potentially Antonio Ricciardi's *Commentaria symbolica* (1591), a reference work that combines material from antiquarian works with interpretations from mythographers and emblematists in an alphabetized list, though the many editions of Valeriano's work had a wider circulation, especially in northern Europe.

Many of these books were probably of more interest to scholars than to artists, but the assumption governing the interpretation of hieroglyphs, namely that seemingly disparate visual symbols could be conjoined to suggest moral or religious truths, also came to govern the production of emblems. Seen as the modern equivalents of ancient hieroglyphs, emblems usually conjoined a visual element with a motto and an explanatory inscription. In this respect they differed from *imprese*, which simply juxtaposed an image and a motto expressive (often rather obscurely) of an individual's identity (see, for example, Fig. 28, p. 92). Andrea Alciati, who published the first collection of emblems in 1531, conceived of them as something that could be used by craftsmen for things like hat badges or trademarks (see Fig. 70, p. 194). His book appeared in numerous augmented editions and the vogue continued throughout Europe until the end of the seventeenth century. Unlike *imprese*, which often portrayed everyday objects or animals, emblems frequently drew on classical texts (many of Alciati's epigrams are derived from the *Anthologia Graeca*) and motifs (sometimes the reverses of ancient coins). Although the role of gods was not central, about a quarter of Alciati's emblems use classical mythology and many other mythological emblems were invented by his successors.

Emblems often did little more than derive an obvious moral from the traditional attributes of the god or hero, but they also allowed a degree of creativity to their inventor. In 1552 Alciati's former student (and French translator) Barthélemy Aneau published *Picta poesis*, which was a sort of hybrid between an emblem book and an illustrated Ovid. It used many of Salomon's woodcuts from a handsome 1549 translation of the first three books of the *Metamorphoses* that Marot had started and Aneau had tried to complete, and paired them up with Aneau's verses to create the model

for the image-and-text pocket book later used (together with some of the same illustrations) for Salomon's influential *La Metamorphose d'Ovide figurée* of 1557.

The example of the emblematists also fostered the development of the alchemical emblem. Although alchemy was not a significant route for the transmission of mythology, late sixteenth- and early seventeenth-century alchemists were conscious that their science had affinities with classical myths. Those that involved gold, like Jason's quest for the Golden Fleece, or the golden apples of the Hesperides, were of particular interest, and several illustrations of the latter theme are shown on the title page of *Atalanta fugiens* (1618) – a collection of chemical emblems and epigrams by Michael Maier (Rudolf II's former court physician), all accompanied by fugues for readers to sing at home. Determined scholars could work their way through Maier's *Arcana arcanissima*, a systematic exposition of Egyptian and classical mythology.

More important for the visual arts was the revival of allegorical figures like those that had been popular in the late Middle Ages. The emblematists had taken a particular interest in antique personifications such as Occasio and Fortuna, and in 1593 Cesare Ripa published his *Iconologia*, a handbook of allegorical figures and their attributes that subsequently went through numerous illustrated editions and remained influential until well into the eighteenth century. Although Ripa's sources included Boccaccio, Cartari, and the Florentine intermezzi of 1589, as well as Valeriano, the straightforward transformation of a mythological figure into an allegorical personification is rare. In the first illustrated edition of 1603, only a handful of the figures are classical in both form and iconography, and a couple of those are taken directly from Roman medals. Indeed, Ripa's entire project is an implicit recognition of the difficulty of relying on the ancient pantheon to generate all the meanings needed by the early modern iconographer.

This sense that paganism was not the best source for characters and plots may also have extended to literature. There were, of course, frequent references to classical mythology within contemporary literature, both Latin and vernacular. Yet although writers sought to rival the classics in literary terms, they also tended to shy away from the mythological content of their antique models. This was sometimes an attempt to avoid the implication of outright paganism, but it was more often because no one presumed to surpass the ancients on their own terms. After all, who was going to write a better classical epic than Virgil? The accepted theme for ambitious narrative poetry was chivalry, not myth. So given that mythological tales were already

integral to late medieval literature, it is hard to claim that they achieved a new centrality in Renaissance narrative verse.

Mythology was more common in smaller forms – epigrams, eulogies, epithalamia, and lyric poetry. Similarly, when classical drama was revived, mythological themes were not usually the subject of the dramas themselves, just of the pastoral intermezzi between the acts – the notable exceptions being plays written for weddings, like Poliziano's *Orfeo* (1480) and Niccolò da Correggio's *Cefalo* (1487). In other genres too, pastoral provided the most congenial setting for mythology, even if (as in Poliziano's *Stanze per la giostra di Giuliano*, composed after the Florentine jousts of 1475) its mythological content came in the form of descriptions of a building's decoration. Despite the dramatic accumulation of mythological reference in occasional pieces like this, vernacular literature rarely had a direct narrative impact on the arts. It often just established the mood. In Sannazaro's *Arcadia*, a sequence of prose narratives and verses in which a group of shepherds sing of love and loss, the gods are not even protagonists, yet their presence is somehow taken for granted – so much so that the French translator had to supply notes to explain who they all were.

If pastoral described a space in which the gods could drop by without drawing attention to themselves, Petrarch's *Trionfi* had created a form in which they could take centre stage. His sequence of the Triumphs of Love, Chastity, Death, Fame, Time, and Eternity were presided over by allegorical figures rather than gods, but the Triumph of Love (Cupid) also included many mythological characters. The Triumphs themselves were depicted in various media in the Renaissance, but they also provided an appropriately classical vehicle for the pagan gods to ride back into town. In ancient art, the triumphal cart had been primarily associated with Bacchus (who had, after all, actually conquered India) but thanks to Petrarch it could be rented out to any mythological figure who needed to make an impression. Triumphs of the planetary deities were staged in Florence in 1490, and in the *Hypnerotomachia Poliphili* of Francesco Colonna (1499) four of Jupiter's lovers appeared in a sequence of triumphs, with their stories illustrated on the sides of the wagons.

The *Hypnerotomachia* was the first non-classical work to appear from the Aldine Press in Venice. It combined several forms in which mythology was common – the triumph, pastoral romance, and ekphrastic description – and was sometimes used as a literary source, although the woodcuts (see, for example, Fig. 68, p. 190) seem to have had more impact in France where they were reused for the French translation. It was in France, too, rather than in Italy, that mythology became central to vernacular literature, above

all in the work of the constellation of poets around Ronsard known as the Pléiade. They had acquired a familiarity with the Greek lyric poets under the tutelage of Jean Dorat, and the art of Fontainebleau, where Ronsard had been a page, provided a model for the creation of a new national style based on mythological themes. Members of the Pléiade were all involved in preparing programmes for royal festivities, and Pontus de Tyard may also have been responsible for some of the iconography at the Château d'Anet, built for Henry II's mistress Diane de Poitiers.

Tyard, who composed a sequence of poems about hypothetical paintings on the theme of rivers, was only one of the French poets who conceived of mythological narratives in terms of visual images. During his exile in France, Giovanni Battista Marino went one better, describing numerous paintings (mostly by living artists) in *La Galeria*. Whenever the poets described works of art, they tended to choose mythological subjects (so making mythology far more common in ekphrasis than it was in either contemporary decoration or verse) and Marino's selection was heavily weighted in favour of mythological themes. In his case these were also the subjects that interested him as a writer. In the eight mythological idylls of *La Sampogna*, and in his sprawling epic *Adone*, Marino produced poetry that, perhaps for the first time, rivalled that of the ancients in its expansive treatment of myth. He became the most famous European poet of his time, but his approach to mythology was contested. Even before the publication of *Adone*, Francesco Bracciolini had published *Lo Scherno degli dei* in which the gods become ridiculous. The more the reader knew of mythology the easier it was to make fun of it. Travesties of the *Metamorphoses* enjoyed some success in seventeenth-century France.

But just how much information would an average educated person have had at their disposal and how would they would have come by it? Even within education, the opportunities for acquiring a detailed knowledge of classical mythology were not necessarily numerous. From the fifteenth century onwards Virgil, rather than Ovid, was at the centre of the classical curriculum in Italian schools, and although the *Metamorphoses* had been widely taught in the Middle Ages, in the Renaissance they took second place to the *Heroides*. In late sixteenth-century Venice, for example, vernacular romances like Ariosto's *Orlando furioso* were far more likely to be on the syllabus than the *Metamorphoses* in either Latin or Italian. The *Metamorphoses* were increasingly something you read in your own time, rather than at school. Montaigne remembered sneaking off to read them when he was seven or eight.[15] His Latin was unusually good for his age, but his opinion

that Ovid's tales were particularly suited to children was probably widely shared, even though preachers sometimes complained about their erotic content. When children did learn about mythology in school, it was often from the study of Boethius's *De consolatione philosophiae,* which remained a set text until the late fifteenth century. At university, too, Ovid was no longer on the syllabus. Giovanni del Virgilio had lectured on the *Metamorphoses* at Bologna in the fourteenth century, but Ovid was not likely to be on the lecture list at the same university two centuries later. The popularity of handy reference works like Herman Torrentinus's *Elucidarius,* a dictionary of proper names from the ancient world, suggests that many people had difficulty keeping track of who was who.

For artists, most of whom knew little or no Latin, sources of information would initially have been even more meagre. The three most basic resources were classical antiquities, illustrated vernacular editions of Ovid, and mythographies. But the range of what was available changed significantly over time. In fifteenth-century Italy, for example, antique visual sources were limited to gems and a few reliefs; vernacular translations of Ovid were available only in manuscript, and illustrated (if at all) with pen drawings; mythographical texts like Boccaccio and the *Libellus* were all in Latin, and the gods (other than Bacchus and Hercules) were remembered chiefly as planets. If you look at the available visual sources you can get a sense of how little there was to work with, and this is one reason why artists often relied on humanist advisers (which, ironically, meant that textual sources were often more eclectic than in later periods) or on contemporary vernacular literature as mediating sources.

By the 1530s, German artists were still in pretty much the same position, but in Italy the situation had been transformed. Awareness of classical antiquities had increased enormously, and was being disseminated through prints from Rome. Illustrated vernacular editions of Ovid, notably the Agostini translation of 1522, were widely used; Apuleius was popular, and new sources of interpretation like the vulgar Neoplatonism of Leone Ebreo, or the emblem books of Alciati, were also becoming available. What now existed was a sort of minimum kit for a self-sustaining tradition of mythological art – an illustrated translation of the *Metamorphoses,* a vernacular source of mythographical information (whether in the form of a mythography or a commentary on Ovid or some other text), and access to Roman visual models (either directly through the artists dispersed by the Sack of Rome in 1527, or through prints). Italy had all this by the 1530s, but other countries arrived at this position more slowly. Ovid became available to the Dutch only in the 1550s, and it was not until much later (1604) that Karel

van Mander's interpretative *Wtlegghingh* appeared as the fifth book of his art encyclopedia *Het Schilder-Boeck*. In Germany, Wickram's Ovid appeared in 1545 (Fig. 121, p. 327), and Herold's *Heydenweldt* in 1554. In England, Stephen Batman's *The Golden Book of the Leaden Gods*, which included heretics alongside the pagan gods, was published in 1577, and an abridged version of Cartari in 1599, but the first illustrated Ovid was Sandys's translation of 1632. In Spain, a vernacular mythography and an illustrated Ovid appeared only in the late 1580s.

The decisive element here is the visual one. You can have everything else in place, yet without the visual stimulus nothing happens. Take the case of France. The literary sources available in French were second to none. Illustrated vernacular editions of Ovid with Bersuire's mythographical prologue were available from the late fifteenth century; an edition of Christine de Pisan's *Epistre Othea* with woodcuts was published around 1500; there was a French translation of Boccaccio long before one appeared in Italian; yet it is as a result of the influx of Italian artists working for Francis I at Fontainebleau that a tradition of mythological art developed. By itself, late medieval mythographical culture does not seem to have been enough. Even in the mid-sixteenth century, French artists tended to be more reliant on humanists than their Italian counterparts. Only in the seventeenth century, with Baudouin's augmented translation of Conti, Renouard's Ovid, and Vigenère's illustrated Philostratus, did they work entirely from vernacular sources.

In fact, Baudouin and Vigenère were so useful that an artist like Poussin, who worked in Rome, kept using them even though he knew some Latin and had access to Italian material as well. By then, most northern painters had spent time in Rome, where the aspiring artist was now surrounded by antiquities – although he did not necessarily need to draw them for himself when he could find them in books such as those by Cavalieri, Perrier, and Du Choul. Anguillara was still the Italian translation of choice, but it was Tempesta's prints (which introduced many of Salomon's Ovidian subjects to Italy) that had the greater influence. Several new mythographies were available, of which illustrated editions of Cartari were potentially the most useful. And if you needed them, there were also plenty of emblem books and Ripa's *Iconologia*. The esoteric knowledge that had once resided in untranslated texts, unpublished manuscripts, and unrecorded antiquities was now in the public domain.

All the same, it was not necessarily clear how all these things were meant to fit together. For one thing, the three main sources of mythological knowledge came from different places: antiquities from Rome, illustrated

Ovids from Venice, and (although Boccaccio's influence lingers in Florence) the mythographers from northern Italy. They did not really connect at a conceptual level either. Although Renaissance publishers often packaged mythology as a conjunction of an image, a text, and an interpretation, you will hardly ever find an antique statue juxtaposed with verses from Ovid and an interpretation drawn from Boccaccio or a later mythographer. Antiquarians devoted less commentary to statues and reliefs than they did to coins, while mythographers showed only marginally more interest in antiquities than the illustrators and annotators of Ovid. Unless you count grotesques, very few antique representations of metamorphosis were known in the Renaissance, and the mythographers were not much concerned with metamorphosis either, but rather with the names, etymologies, and attributes of the gods. Even when they discuss the same stories their interests differ.

Furthermore, there was no institutional context for the co-ordination of these diverse forms of knowledge. The only thing that bound them together was the visual arts themselves. The first French edition of the *Metamorphoses* had been the poet's bible; a century later it had become, as van Mander said, the painter's bible. And just as illustrations became the carriers for the myths of the *Metamorphoses*, so from the mid-sixteenth century onwards the transmission of mythography is increasingly the prerogative of art specialists: Cartari and van Mander were writing with artists in mind, and artists (Vasari, Lomazzo, Zucchi, van Mander and later Sandrart) turned themselves into mythographers either to explicate their own paintings, or else to equip other artists with the necessary background. Rather than being something literary or antiquarian that is external to art, mythology becomes an integral part of visual culture. From the late sixteenth century onwards, the visual sources of mythological art are usually earlier artistic works from the Renaissance, and the major literary sources are those produced for artistic use.

2

Objects

European palaces are now full of mythological imagery – statues, frescoes, tapestries, procelain, and paintings – but if you look closely most of these objects are of seventeenth- or eighteenth-century origin. In fifteenth-century Italy it was different. There, it was probably easier to kick a mythology than to see one, for the most likely place to find representations of scenes from classical myth was not at or above eye-level, but just above the floor, on the front of a *cassone*. Pairs of these large chests were presented on the occasion of a wedding, and may have played some part in the actual ceremony before being taken in procession to the matrimonial home, where they remained a prominent feature of the furniture. Vasari noted that the stories shown on them usually came from Ovid or other poets, and although early examples often have medieval themes like the Garden of Love, from about 1450 classical subjects predominate. By the end of the century, the subject-matter of *cassoni* was sufficiently notorious for Savonarola to complain that newlyweds would be more familiar with 'the deceit of Mars and the tricks of Vulcan' than with pious stories.[1]

Things may not have been quite as bad as Savonarola imagined: mythologies appear on only about a third of surviving *cassoni*, even though the preference for secular subjects is striking. There are panels depicting stories from the Old Testament concerning marriage (Solomon and the Queen of Sheba, Esther and Ahasuerus, Susanna and the Elders, and so forth), or other tales with strong anecdotal interest, but scenes from the New Testament and even the lives of the saints are conspicuously absent. There were probably several reasons for this. Marriage, in a society that still valued poverty and chastity, was the most secular of the sacraments, inextricably bound up with the temptations of money and sex. *Cassoni* themselves were functional pieces of furniture used for storage, and in some cases for sitting on. The elongated shape of the panel required multiple figures with a narrative to connect them, for which antique sarcophagus reliefs potentially provided a model. Above all, the function of *cassoni* meant that the most suitable

subjects were those dealing with men and women and the appropriate relations between them.

Yet even with its bias toward the secular, *cassone* painting did not necessarily turn to myth. The shape, and the example of antique reliefs, suggested battle scenes or linear triumphs in imitation of Petrarch's *Trionfi*; Boccaccio offered some pointedly misogynistic tales for those who wanted to remind young wives of their place; classical history provided exemplars of male heroism and female self-sacrifice. But it was mythology that offered the dramatic stories in which love makes the difference between life and death. The most frequently depicted mythological subjects – the Judgement of Paris; the Rape of Helen; Theseus and Ariadne; Orpheus and Eurydice; Diana and Actaeon; Jason and Medea, and Dido and Aeneas – do not have much in common except this: like the Triumph of Love itself, they are all reminders that erotic love can be the most important thing in the world. And the occasional presence of a full-length semi-naked figure of a man or woman painted inside the lid, sometimes labelled as Paris or Helen, suggests that the new couple might be expected to identify with their mythological predecessors as they rummaged through their possessions.

Cassone painting is regionally and temporally specific: it flourished chiefly in Tuscany (and to a lesser extent in the Veneto, where paintings were executed to a much lower standard of finish), and died out in the mid-sixteenth century when carved wooden chests became more popular. Such chests were usually decorated with abstract decorative motifs, but some have carved figurative reliefs, and there are several examples from the mid-sixteenth century (inspired by Roman sarcophagi) that feature the labours of Hercules. Wooden chests, and other furniture decorated with mythological reliefs, are also to be found in mid-sixteenth-century France, where the imagery can usually be traced to French or Italian print sources.

Although it did not last long, the contemporary importance of *cassone* painting should not be underestimated. A *cassone* painter, Apollonio di Giovanni, was celebrated as 'the Tuscan Apelles' whose depiction of the fall of Troy rivalled that of Homer and Virgil. Compared with that of some of the other artists working in Florence in the 1460s, Apollonio's work is Gothic and decorative, but in the quattrocento at least, the diffusion of classical subject-matter was not aligned with innovations in pictorial composition. Masaccio's paintings were of religious subjects; it was his old-fashioned younger brother, known as Lo Scheggia, a *cassone* painter, who depicted scenes from the *Aeneid* and Roman history (Plate II).

The subjects of *cassoni* passed over into related media. *Spalliere*, the rather larger wooden panels set above a chest or bed, depicted a similar

11. *Pyramus and Thisbe*, pastiglia box, early sixteenth century, Veneto

range, in some cases because rooms were being redecorated on the occasion of a marriage. Even *deschi da parto* (birth trays, often given to the bride at the time of the wedding), which predominantly showed religious subjects, picked up classical themes. But it was the white-lead pastiglia box that was closest to the *cassone* in both form and decoration. Presumably used for storing trinkets, pastiglia boxes were produced in the Veneto during the first three decades of the sixteenth century. Often no more than a foot long, these boxes were decorated with figures moulded in white lead and then glued to the surface. Narrative scenes were common and they were almost all classical, drawn either from Roman history (the hero Mucius Scaevola was a favourite) or mythology. Designs were sometimes taken from plaquettes or prints, but the overlap with *cassone* subject-matter is still considerable. The stories of the Judgement of Paris and of Diana and Actaeon were both popular, and so too was that of Pyramus and Thisbe, which was rarely seen on *cassoni* (Fig. 11).[2]

It is hard not to see in this clustering of mythological imagery around marriage chests, birth trays, and trinket boxes an early link between mythology and the female sphere. And the association continued. In seventeenth-century Antwerp, for example, table cabinets decorated with painted scenes from the *Metamorphoses* were often used by women to store their dowries. Now, however, it is much easier to trace the source of such paintings to illustrated editions of Ovid, or to compositions by such well-known artists as Rubens, or in Naples, where similar cabinets were also common, Luca

Giordano. Usually made out of ebony and ornamented with tortoiseshell or ivory, these cabinets were modelled on the Baroque architectural façade, and the paintings that decorated them executed on copper, wooden panels, or, in Naples, on painted glass.

Panels could also be created through the use of ivory relief or hardstone inlay, and the revival of the use of *pietra dura* in the Medici workshops resulted in such spectacular examples as the late seventeeth-century *stipo* in the Uffizi (Plate III). Here the smaller panels all depict scenes from Tempesta's Ovid, arranged around the death of Adonis according to a simple spatial logic that puts flying figures at the top, riders in the middle, and pedestrians at the bottom. (The logic was not obvious to everyone, however: there is an Antwerp cabinet with paintings of more or less the same subjects with Europa and Pegasus at the base.) It is just decoration, of course, but this one piece of furniture probably illustrates more mythological stories than would have been visible in an entire fifteenth-century palazzo.

Another way in which print imagery attained prominence was through its use in pottery. Maiolica, the Italian tin-glazed earthenware of the Renaissance, became increasingly popular for tableware during the sixteenth century. Less expensive than the gold and silver on which the wealthy dined in style, and more hygienic than the wooden and pewter plates favoured in northern Europe, maiolica also lent itself to display. In the fifteenth century it was usually decorated with the coat of arms of the patron, or other devices, but in the early sixteenth century narrative scenes became commonplace. To begin with they sometimes appeared around the rim of a plate with the coat of arms in the centre, but soon the entire surface was given over to the narrative. The vogue declined in the latter half of the century, when narrative scenes gave way to grotesque decoration, but for a period of over forty years *istoriato* pottery was produced in quantity at a variety of regional centres, among them Gubbio, Urbino, Deruta, and Faenza, which were not otherwise known for narrative painting.[3]

Subjects from classical mythology appear on plates, dishes, bowls, and vases, and are shown on at least half the number of surviving pieces, making *istoriato* maiolica, along with garden sculpture, one of the few forms in which mythological imagery predominates. This may have been by accident rather than design. Neither function nor patronage did much to determine the appropriate subject-matter for *istoriato* pottery; even unappetizing subjects like the flaying of Marsyas appear regularly. In consequence, the entire repertoire of Renaissance imagery – including the Old and New Testaments, the lives of the saints, Roman history, and scenes from vernacular literature

– appears in this context, often in the same service. Nevertheless, it is noticeable that there are proportionately fewer allegorical, historical, and epic subjects than in other media, while stories from Ovid, sometimes quite obscure, are more common. One reason for this is that the choice of subjects for maiolica seems to have been largely source-driven. Nobody was trying to use their dishes to make a point, and so the scenes depicted are determined chiefly by the cultural horizons of the painter and the availability of appropriate visual models. Of these, the most readily available were Venetian book illustrations and prints from major centres like Rome. But *istoriato* work is not all derivative, and in Urbino it became notably ambitious. Nicola da Urbino, the founder of the tradition, usually reworked prints from Italian editions of the *Metamorphoses*, but one of the other leading specialists, Francesco Xanto Avelli (Plate VIII), was a man whose literary interests rivalled those of painters in other media. The Fontana family were the leading producers of *istoriato* pottery in mid-century (see Figs. 78, p. 214; 88, p. 239; 109, p. 296), later succeeded by the Patanazzi, who specialized in grotesques but also painted narratives based on new print sources, like Salomon's Ovid (Fig. 98, p. 267).

In fact, mythological imagery became concentrated in maiolica to a greater degree than in the print culture from which it drew. One explanation for this might be that, left to themselves, artists gravitated towards a more light-hearted and erotic subject-matter – but this could equally well be provided by the Old Testament stories of Susanna and Bathsheba (neither of which is especially common in this medium). More significant, perhaps, was the perception (reflected too in the remoteness of the centres of production) that the use of *istoriato* ware was a rustic pleasure, to be indulged at a country villa rather than in town.

Throughout the Renaissance, and in every country in Europe, the most expensive and most prized form of decoration for domestic interiors was not painting of any kind, but tapestry. In Italian interiors, hangings of some sort usually covered the area between the frieze and the floor. These were not necessarily tapestries, and if they were, they were not always woven with figures, for figured tapestries were the most expensive of all. Nevertheless, until at least the seventeenth century, tapestries represent the main source of classical narrative imagery within a domestic setting. They were displayed at eye-level, and unlike frescoes of mythological subjects they were to be found in palaces just as often as in country villas, and in the principal rooms.[4]

Because tapestries were large, expensive, and took a long time to make,

their iconography had to be planned at the start. This was especially true if, as became increasingly common in the sixteenth century, a series of tapestries was commissioned for a single room. As early as 1448, the Medici agent in Antwerp was writing to his master about the relative merits of Samson and Narcissus as potential subjects for such a set. Although he suggested that the story of Samson might be a bit heavy, his opinion was unusual. The iconography of tapestry generally inclines towards the worthy and the conservative. Scenes from the Old Testament, ancient history, and the Trojan War are all more common than purely mythological subjects, and even then virtuous heroes, especially Hercules, are preferred to gods, nymphs and shepherds. Sets depicting episodes from the *Metamorphoses* do not appear before the mid-sixteenth century, and Bacchic themes are notable by their absence.

However, some patrons did acquire numerous sets of mythological tapestries. Mary of Hungary, sister of Charles V and regent of the Netherlands from 1530 to 1555, had sets illustrating the stories of Hercules (Fig. 45, p. 124), Venus, Cupid and Psyche, and Vertumnus and Pomona, as well as several series from Roman history, and allegories of the Seven Deadly Sins that included mythological figures. She obtained several of these from Joris Vezeleer, a goldsmith turned dealer in tapestries and jewellery, who also sold a 26-piece Story of Psyche to Henry II of France, and a set of Ovidian *poesie* to Philip II of Spain.

Even so, many of the most influential mythological series woven in Flanders were commissioned or designed elsewhere. The Psyche series followed the Master of the Die's prints after Raphael, and a mythological series featuring pagan gods surrounded by grotesque ornament was woven to the designs of Raphael's assistants, probably for Leo X. Like many other designs, the series was re-woven across the centuries: Henry VIII had a set made (Plate IX), and the Gobelins tapestry workshop produced its versions in the seventeenth century. Here, and in a separate series after Perino del Vaga for Andrea Doria in Genoa, grotesque ornament helped to infiltrate pagan subjects into a medium where they were not otherwise common. But Perino was also responsible for a lost series of the Loves of Jupiter for the Palazzo Andrea Doria, and possibly for a series of Apollo and the Seasons derived from the *Hypnerotomachia*.

When tapestry workshops were set up outside Flanders, mythologies became more common. The Medici in Florence, the Gonzaga in Mantua, and the Este in Ferrara all set up workshops employing Flemish specialists. But the designs came from the local court artists: in Florence, Bronzino was responsible for a set based on the *Metamorphoses*, and Allori designed series

featuring Latona, Niobe, and Paris; Dosso and Battista Dossi designed the Ferrarese Metamorphoses, and Giulio Romano the *Puttini* for Ercole Gonzaga. The workshop set up by Francis I at Fontainebleau produced the much imitated Diana series for the Château d'Anet (Fig. 100, p. 273), while in the seventeenth century the French royal factory became the source of many mythological series, beginning with Vouet's set of the Loves of the Gods.

The erotic themes common in French tapestry of the seventeenth and eighteenth centuries are not typical of earlier periods. The mythological figures selected for extended treatment are often those (like Phaethon and Niobe), whose lives teach obvious lessons. The chaste Diana features rather more prominently than Venus, and even Mary of Hungary's set devoted to Venus managed to present the goddess as a moral exemplar. Perino's Loves of Jupiter were a lot more respectable than the prints of the Loves of the Gods he had helped to design a few years before, and Jupiter's lovers sometimes even manage to keep their clothes on. Yet all this virtue may have been the product of necessity. Whatever the skill of the weaver, tapestry remains doggedly two-dimensional and its surface is never able to simulate the texture of human flesh. In tapestry, unlike painting and sculpture, the temptation to exploit the erotic potential of a subject is slight. On the contrary, the pull is in the other direction, towards the creation of a decorative effect. In both the Ferrara Metamorphoses and the Vertumnus and Pomona series woven in Brussels *circa* 1560, the horticultural setting is more memorable than the narrative, and in the mid-sixteenth-century Hercules series from Audenarde, the hero is almost lost in a forest of vegetation.

Of all forms of Renaissance culture, the one that had the most direct link with the visual arts was the festival, for artists were frequently employed in the design of scenery and costumes. Mythological imagery was commonly used in the entries of royal or noble persons into cities, and for wedding celebrations. Funeral ceremonies were sometimes almost as spectacular, but did not generally employ mythology; popular festivities, such as carnivals, relied more heavily on Christian and traditional folk imagery, but pagan elements were present as well. Entries and weddings were meticulously planned, and from the mid-sixteenth century written descriptions were circulated after such events. Although necessarily ephemeral, these festivals had a higher visibility than almost any other form of secular culture, and it was in this context that artists were most likely to work directly with leading poets and scholars.[5]

Weddings, and particularly the entry of a bride into a city, were the occasions on which the pagan gods most frequently put in an appearance. When in 1479 Eleonora of Aragon, the bride of Ercole d'Este, stopped in Rome on the way to Ferrara, the entertainment consisted not only of the traditional mystery plays but pantomimes featuring Orpheus and the animals, Perseus and Andromeda, Bacchus and Ariadne, Ceres, and the education of Achilles. For the wedding of Isabella of Aragon to his nephew, Ludovico Sforza employed Leonardo to design sets for a spectacle that involved the planetary deities, the Seven Virtues, and the Three Graces; the following year, Leonardo worked on the production of a comedy about Jupiter and Danaë for the marriage of Anna Sforza and Alfonso d'Este. In Venice, mythological pantomimes featured at patrician weddings, and classical elements played an increasingly important role in the carnival from the 1520s.

Mythological figures became more prominent in the Roman carnival from around the same period, although by the end of the century their importance had diminished. But they were never dominant in the *possesso* – the triumphal installation of a new pope – save in the case of Leo X in 1513. Leo was the first Medici pope and it was in Florence that such festivities grew most elaborate. The jousts of Giuliano de' Medici in 1475 had occasioned Poliziano's *Stanze*, and mythologies played a part in Medici festivals, particularly after the restoration of Medici rule by imperial forces in 1530. The first great occasion was the wedding of Duke Cosimo to Eleonora of Toledo in 1539, but the most sumptuous was that of Francesco de' Medici to Joanna of Austria in 1565. For the latter, Vincenzo Borghini and Giorgio Vasari co-operated on the programme which ended in a procession of the gods, who were supposed to be attending the wedding of Francesco and Joanna just as they had that of Peleus and Thetis. The procession comprised twenty-one chariots, each one a sort of 'This is Your Life' for a particular deity. The god was represented by a statue with appropriate attributes culled from the mythographers; painted reliefs showed key narrative episodes, and numerous attendants dressed as associated mythological characters or allegorical personifications either rode on the float, or followed on behind. It was perhaps the single most spectacular manifestation of mythological learning ever seen, and everyone was thoroughly confused.

Earlier in the festivities, Francesco d'Ambra's comedy *La Cofanaria* had been performed in the Salone dei Cinquecento of the Palazzo Vecchio. It was punctuated by six intermezzi, musical and theatrical interludes loosely based on the story of Cupid and Psyche. Intermezzi had been performed between the acts of both Latin and vernacular comedies since the late

12. *Apollo and Python*, intermezzo from a Medici wedding, 1589,
Agostino Carracci after Bernardo Buontalenti

fifteenth century. Primarily visual and musical, intermezzi often proved
rather more diverting to their audiences than the wordy comedies them-
selves, and because they were conceived as light entertainment their themes
were frequently mythological. In the second half of the sixteenth century
increasing attention was lavished on them, especially in Florence, where the
intermezzi performed at a Medici wedding of 1589, and recorded in a
series of engravings by Agostino Carracci and others, were a triumph of
scenography (Fig. 12). It was from spectacles such as these that opera
developed in sixteenth-century Florence. Several members of the Florentine
Camerata, who laid the theoretical foundations for opera, had worked on
the intermezzi of 1589. And in early Italian opera, from Jacopo Peri's *La
Dafne* of 1597 onwards, mythological themes predominate. In France, the
court ballet developed over the same period, initially under the patronage
of Catherine de' Medici, wife of Henry II. Partly inspired by the Italian
intermezzo, it too relied heavily on mythological themes, especially during
the reign of Louis XIII when the king and other members of the royal family
danced leading roles.

*

Although mythological imagery in princely weddings was common all over Europe, its use in other ceremonial events was more restricted, appeared later, and was associated with specific political developments. In the fifteenth century, visits by dignitaries were often the occasion for street pageants. These were usually on religious themes, although Beatrice d'Este, the Duchess of Milan, was entertained with mythologies on two diplomatic visits to Venice in the 1490s. But when associated with the Roman triumph, classical imagery, often decorating specially constructed triumphal arches, proliferated. Much of this was historical or allegorical, but mythological elements were prominent in the entries of the Holy Roman Emperor Charles V, and were taken up by other royal houses as well. As the heir to titles and lands across Europe, and to newly claimed territories in the Americas, Charles seemed to embody the Roman ideal of universal empire more plausibly than any of his predecessors. He was already the hereditary ruler of Naples and Sicily, but his defeat of the French at the battle of Pavia in 1525 ensured that there were no rivals to imperial hegemony.

The more universal the claims of the emperor, the more they came into conflict with those of the papacy, particularly after the Sack of Rome by imperial troops in 1527. The emperor might need the pope to perform his coronation, but he also required independent sources of symbolic legitimacy. When pope and emperor arrived in Bologna for the imperial coronation in 1530, the papal entry was celebrated with decorations on themes incorporating sacred subjects, while Charles V was greeted with triumphs of Neptune and of Bacchus (symbolizing his dominion over both sea and land), and with portraits and statues of Roman emperors and heroes. The mythologizing of Charles V continued in other Italian cities: in Naples, five pairs of colossal statues (Jupiter and Minerva; Atlas and Hercules; Mars and Fama; Janus and a bound Fury; Neptune and a wingless Fortuna) were erected in different parts of the city for his entry in 1535, and in the Piazza della Sellaria a mechanical spectacle was staged in which the rebellious Giants were struck down by a thunderbolt from Jupiter's imperial eagle.

As the festivities in Naples suggest, the subjects chosen for royal entries were ones associated with dominion and virtuous strength. Figures of Jupiter, Neptune, and Hercules were particularly common. In 1548, for example, Charles V's son, the future Philip II of Spain, entered Genoa to be greeted by paintings of Jupiter (Charles V) and Neptune (the Genoese Admiral Andrea Doria). But mythological themes served primarily to link the gods with the ruling house, not to identify individuals with the qualities of particular deities. In the Portico of the Emperors, designed by Rubens for the entry of Prince Ferdinand of Austria into Antwerp in 1635, statues of

twelve Habsburg emperors were interspersed with herms of twelve gods –
the *Dii consentes* whose statues were placed in the Roman forum. Here,
however, Charles V is Neptune; Rudolf II, Venus; and Ferdinand II, the
reigning emperor, Jupiter.

Initially associated with the Habsburgs, the classical entry spread to other
dynasties. Charles VIII was greeted with Herculean spectacles on his entry
into Vienna in 1490, and it was after Charles V's sister, Eleanor of Austria,
married Francis I of France that Francis was celebrated as the Gallic Hercules.
This was clearly an attempt to keep up with his in-laws, but the appellation
stuck. For French kings, Hercules always remained a primary identification;
on Henry IV's entry into Lyons in 1595 (Fig. 13), a statue of Hercules on a
pedestal holding his club (visible on the right) bore an inscription identifying
the king with the hero. However, such mythological roles were never exclu-
sive. The sheer profusion of decorative and theatrical imagery precluded the
creation of fixed interpretations. On the occasion of the entry of Charles IX
and Elizabeth of Austria into Paris in 1571, Catherine de' Medici, the queen
mother, appeared as Cybele, while Charles IX was Jupiter, and his siblings
Neptune, Pluto, and Juno. But François, duc d'Alençon, who was Pluto, did
not have to go through life as the god of the underworld.

Even more ephemeral than the festivals themselves were the firework
displays that sometimes accompanied them. Fireworks were associated with
religious as much as with secular festivals, but fire-breathing monsters were
an obvious speciality. In the spectacle staged outside the Louvre in 1628 to
celebrate the taking of La Rochelle from the Protestants, Andromeda was
chained to an artificial rock built in the Seine; when a monster arose spitting
fire, Perseus appeared just in time to save her. The allegorical intent is not
difficult to decipher – Catholicism saved at La Rochelle – but the mytho-
logical fireworks were unusually memorable. The Polish fireworks enthusi-
ast Casimir Siemienowicz was still talking about it in his *Grand art
d'artillerie* of 1651, a work that devotes several pages to the significance of
the gods and the best way to fill them with explosives (Fig. 14).

Fireworks were not the only sort of mythological ephemera; images of the
gods could also be made out of food, or even snow. Sugar sculpture was
popular for grand banquets like those depicted by Pierre-Paul Sevin in
mid-seventeenth-century Rome (Fig. 15). Here Apollo and the Muses can
be seen in the centre, with Mercury and Pegasus to the left and Diana on
the right, but in earlier decades Hercules appears to have been the most
popular table figure – Giambologna made one for the wedding of Marie de'
Medici and Henry IV. To the modern mind there is a big difference between

13. Henry IV's Triumphal Entry into Lyons, 1595

14. *Bacchus*, from Casimir Siemienowicz, *Grand art d'artillerie*, 1651

a figure made to be exploded or eaten and the masterpieces of Renaissance art, but at the time the distinction was less clear. No one expected interior decoration to last for very long, either. And a lot of it did not. Domestic frescoes were much less likely to endure than ecclesiastical ones because their owners were liable to redecorate, and few survive from before the second quarter of the sixteenth century.[6]

In the fifteenth century, fresco cycles devoted to classical mythology were virtually unknown. The preferred subjects were exotic or heraldic beasts, hunting and other courtly recreations, and, if there were narratives, scenes from history or chivalric romance. (In northern Italy, the knights of King Arthur still meant as much to aristocratic patrons as the heroes of antiquity.) The labours of Hercules are occasionally shown, but the context in which the gods were most likely to appear was in their role as planetary deities. In some decorative schemes, the astrological information presented was personal. In the vault of the garden loggia of the villa built *circa* 1506–20 for the banker Agostino Chigi in Rome, the position of the planets relative to the signs of the zodiac on the day of his birth is indicated in the hexagons of the ceiling, while the two central panels probably show the constellations that defined the meridian over Siena at the hour of his birth. The figures in the lunettes show the stars in mythological terms derived from Hyginus's *Poetica astronomica*, and may also be in some way connected with the

15. Table setting with mythological figures, Pierre-Paul Sevin

patron's horoscope. The frescoes at the Villa Farnesina (as Chigi's villa became known) marked a watershed in interior decoration: several entire rooms were frescoed with mythological subjects, including the entrance loggia, where the story of Psyche was illustrated by Raphael and his assistants (Fig. 16).

The Farnesina lacked two elements that were to become essential components of interior decoration over the next fifty years: grotesque ornament and stucco reliefs. Both were used to impressive effect by Raphael's assistant Giovanni da Udine in the garden loggia of the Villa Madama, and for the next century the themes and techniques developed by Raphael's workshop at the Farnesina and Villa Madama furnished a model for similar projects. Several of the artists who undertook them had gained their experience under Raphael, and one of them, Giulio Romano, later had the opportunity at the Palazzo Te in Mantua to rival the Farnesina with another version of the story of Psyche (Plates IV and V) and another astrological ceiling in the Sala dei Venti. The Palazzo Te in its turn inspired other projects. Ludwig X, duke of Bavaria-Landshut, was so impressed that in 1536 he commissioned an Italian wing for the Stadtresidenz in Landshut, the first German palace to be built in the classical style. The decoration included rooms featuring Arachne, Latona, Bacchus, Apollo, Diana, and Venus.

16. Loggia of Cupid and Psyche, Villa Farnesina, Rome, Raphael and assistants

One of Giulio's assistants, Francesco Primaticcio, worked with Rosso Fiorentino at Fontainebleau. Decorated throughout with mythological frescoes and stuccoes, the château brought a new style of decoration to France, and it created a distinctive iconography that gave a prominence to the female nude unprecedented not only in France but also in Italy (see Fig. 62, p. 177). The sheer quantity of mythological imagery was unusual, notably in the long Galerie François I, the Salle de Bal, and the Galerie d'Ulysse (now destroyed) which contained forty-eight scenes from the Odyssey along the walls and ninety-three mythological images in the vault. But despite the fact many of these designs were engraved, and some reused for tapestries and other forms of decorative art, no comparable interior is to be found in other French châteaux of this period. Even later in the century, most French painters worked out unambitious programmes derived from illustrated editions of Ovid.

In Italy, there was nothing quite like Fontainebleau, and in Rome itself the Sack of 1527 temporarily put a stop to frivolous patronage. Nevertheless another of Raphael's pupils, Perino del Vaga, supervised the use of mythological imagery throughout the Palazzo Andrea Doria in Genoa

(Plate X). This too had its imitators. Jean de Boussu, the imperial stable-master who visited the palace with Charles V, soon wanted something comparable for his château in Flanders. And it created a demand for mytho-logical decoration in the palaces of the nobility of Genoa that deployed the talents of local artists like Luca Cambiaso and G. B. Castello. The Genoese mythological interior (themed rooms with a defining narrative in the centre of the ceiling, subsidiary scenes on each side or in the corners, and individual figures in the spandrels) was later exported wholesale to El Viso del Marqués in Spain, the palace of Álvaro de Bazán, an admiral with strong Genoese connections.

If the first wave of mythological decoration flowed from the Villa Farnesina via Mantua and Genoa to France, Germany, and Spain, the second was focused on the villas of central Italy. Perino himself returned to Rome, where he supervised the mythological decorations of Paul III's apartments at the Castel Sant'Angelo (Fig. 119, p. 322). His example inspired Taddeo Zuccaro, another beneficiary of Farnese patronage, and the painter whose work was to revive mythological decoration in Rome. While in Fontana's workshop Zuccaro was responsible for mythological frescoes at the Villa Giulia, and a few years later, assisted by his brother and numerous others, he undertook the decoration of the Palazzo Farnese at Caprarola – although here the mythological content is constrained by counter-reformation morality, and mythologies predominate only on the ground floor where they appear in rooms decorated on the theme of the seasons. The tendency to organize mythological decoration in accordance with physical themes like the four elements or the four seasons was not new (both appear in Peruzzi's designs for frescoes at the Villa Madama), but in late sixteenth-century Rome it became the norm. Jacopo Zucchi decorated rooms of the seasons and the elements at the Palazzo Firenze and the Villa Medici in Rome. But in Zucchi's work things sometimes became more complicated. In the gallery of the Palazzo Rucellai in Rome, the gods are shown with so many obscure attributes that the artist wrote a handbook to explain them.

Another gallery, that of the Palazzo Farnese, is both the culminating achievement of Roman mythological decoration and a departure from it (Fig. 17). The gallery combined the architectural grandeur of the Sistine ceiling with the frivolous subjects of the Villa Farnesina. This was not unknown (it had often been attempted on the ceilings of Genoese palaces) but here the decoration was seemingly without any clear organizing prin-ciple, save a tendency to present images in pairs, and featured depictions of the Loves of the Gods that were more often found in easel paintings and

prints. Executed by Annibale Carracci and a number of assistants for Cardinal Odoardo Farnese, the gallery, which was begun in 1597, was designed to exhibit antique figures and busts in niches in the walls. The ceiling itself is also a showcase, because the subjects of the largest of the *quadri riportati* – Bacchus and Ariadne in the centre of the ceiling, and the stories of Polyphemus and of Perseus on the end walls – are all themes found in Philostratus's *Imagines*. And the implied comparison between painting and sculpture is made explicit in the scene on one of the end walls where Perseus, holding the Gorgon's head, turns his enemies to stone.

For several reasons, Venice stands outside this narrative. Because of their unstable foundations, Venetian buildings rarely had vaulted ceilings. And when you have the tangible reality of wooden beams above your head, there is less scope for frescoes opening up the heavens. At the same time, allegory assumed a particular importance because Venice's republican myth relied less on the glorification of the ruler as an individual than on the rather more abstract virtues of the state. In the decoration of the Doge's Palace, mythological figures (in so far as they appear at all) are always subordinated to the myth of Venice herself. In Tintoretto's *Venice Receiving the Tribute of the Sea* in the Sala del Senato, Venice sits like the Virgin in heaven surrounded by saints, except that her attendants are Aesculapius, Jupiter, Hercules, Saturn, Apollo, and Mercury. Even when the gods appear in their own narratives, as in Tintoretto's four mythologies for the Salotto Dorato (Fig. 91, p. 249), they illustrate texts carefully chosen for their allegorical potential. In the Sala del Consiglio dei Dieci, the centrepiece of the ceiling is, characteristically, not Jupiter defeating the Giants but an allegorized variant: Veronese's *Jupiter Expelling the Crimes and Vices*.

The Venetian willingness to incorporate personifications, historical and mythological figures in the same allegorical programme eventually spread beyond the republican tradition that had fostered it. In Baroque art, the unification of fictive space called for an equally seamless symbolic language. Ripa offered a vocabulary, but it was Venetian art, together with the example of Rubens, that provided the grammar. Pietro da Cortona is said to have interrupted the painting of the salone of the Palazzo Barberini in Rome to study the ceilings of the Doge's Palace. What effect the visit had is uncertain, but the ceiling, which celebrates the election of the Barberini pope Urban VIII, shows Divine Providence above Saturn and the Fates, with the Theological Virtues escorting the three bees (a Barberini symbol) as they fly towards the keys of St Peter and the papal tiara. Minerva defeats the Giants at one end of the room and Hercules drives away the Harpies at the other. To the right, allegorical figures rise above the temptations embodied by

17. Galleria Farnese, Palazzo Farnese, Rome, Annibale Carracci
and assistants

Venus and Silenus. As it stands, the ceiling is a mythological allegory, but it could easily have been allegorical mythology. Until Urban VIII objected, the figure of Divine Providence was going to be Jupiter, to indicate the majesty of the pope.

We can get a good idea of what the figure of Jupiter might have looked like from the Sala di Giove at the Palazzo Pitti, where Pietro da Cortona and his assistants later executed an ambitious decorative project across five rooms of the *piano nobile* following a programme prepared by Francesco Rondinelli. The iconography involves a series of rooms devoted to the planetary deities which together form a sequence (Venus, Apollo, Mars, Jupiter, Saturn) that depicts the education and destiny of a prince in allegorical terms. Here, unlike the Palazzo Vecchio where mythologies were in the private apartments, mythological allegories are used throughout a series of state rooms (Fig. 27, p. 90). The Sala di Giove, where the lunettes all depict mythological figures, functioned as the grand-ducal audience chamber. From these rooms, Le Brun learnt lessons that he took to Vaux-le-Vicomte and Versailles.

Of course, decoration was not confined to interiors. Far less well preserved, but of comparable importance in the history of mythological art, were the painted façades that adorned buildings in northern Italy and southern Germany during the sixteenth century. The constraints imposed by painting areas of wall between windows meant that façade paintings frequently consisted either of a vertical single figure within a fictive architectural setting, or else a horizontal frieze. In Venice, where artists including Giorgione and Tintoretto were responsible for mythological figures on the exterior walls of palaces, façade paintings were frequently polychrome, whereas in Florence and Rome sgraffito or grisaille paintings (like Polidoro da Caravaggio's lost Niobe cycle at the Palazzo Milesi) were more common. But it was perhaps in Genoa (where the Palazzo Andrea Doria was decorated with stories of Camillus on one elevation and of Jason on another), and in German cities like Augsburg and Nuremberg, that the painted façade assumed the greatest importance. In the sixteenth century, façade painting was primarily an urban, secular phenomenon linked to the competitive ostentation of local elites. In Italy, religious subjects were unusual, partly, no doubt, because the buildings painted were usually secular, but also because – as Lomazzo emphasized – the public highways were 'places of the Moon' where painters were at liberty to depict strange fantasies like the grotesque ornament in sgraffito decoration.[7] In Germany, the world turned upside down was a popular theme, but so too were religious, historical, and mythological scenes. These could all appear on the same façade. Paul Juvenal

the Elder's drawing for the Viatishaus in Nuremberg has the stories of Phaethon and Neptune at the top, the Old Testament battle of Betulia running across the middle, and the death of Actaeon and the Justice of Trajan at the lowest level.

Most fresco cycles were inside private buildings, and their impact on the history of art would have been limited without the existence of engravings. In the late fifteenth century, woodcuts depicting classical pastoral scenes began to appear in northern Italy, and Mantegna designed several mythological engravings, including a *Battle of the Sea-Gods*, scenes of Hercules, and of Bacchic revelry – subjects that remained an important part of the repertoire of printmakers for a century. But elsewhere, mythological subjects were often produced as a result of co-operation with a painter whose facility with mythology had been developed through work on a decorative scheme. Raphael's association with Marcantonio Raimondi supplied the printmaker with both original designs and spin-offs from his fresco cycles. After his death, Raphael's assistants continued to work with Raimondi and his school, and so gave Europe an enduring stock of mythological imagery derived from Roman sources. Thanks to print, even the most private images, like the *risqué* decorations in Cardinal Bibbiena's tiny *stufetta*, could become public property (Fig. 76, p. 210).

Mythological prints were not necessarily direct copies of frescoed decoration, but there was a clear connection between the decorators and mythological printmakers. Perino worked with Jacopo Caraglio and Giulio Bonasone; Giulio Romano with Giovanni Battista Scultori and others, Primaticcio with the engravers of Fontainebleau in the 1540s. One thing that all these projects had in common was an emphasis on the nude, and a determination to be sexy. This translated successfully into print. Because prints were relatively cheap, small-scale, and easily viewed in private, they were an ideal medium for pornography.[8] Giulio Romano had co-operated with Pietro Aretino and Raimondi on *I Modi*, a repertoire of sexual positions that landed Raimondi in gaol. But only a few years later, the publisher made another attempt to reach the same market. More cautious this time, the engravings of the *Loves of the Gods* by Caraglio after designs by Rosso and Perino showed twenty mythological couples in less explicit poses than in *I Modi* (Fig. 55, p. 156). Finding enough couples required some ingenuity: Cupid and Psyche, Venus and Mars, and the various loves of Jupiter were the standard erotic subjects, but this set also included obscure couplings derived from Ovid's list of the loves of the gods woven by Arachne. The series attracted censorship, and Bonasone's later series on the same theme

was a bit more reticent. So although print retained an elective affinity with erotic subject-matter, it was not until Agostino Carracci's *Le Lascivie* that anything comparable was attempted. The creation of a mythological series was, in any case, always rather ambitious. The Labours of Hercules made an obvious set, but Rosso and Caraglio's *Gods in Niches* (1526) and Bonasone's *Loves, Rages, and Jealousies of Juno* were unusual projects.

However, prints could also be educational. The so-called *Tarocchi*, designed by a Ferrarese engraver around 1470, was a collection of fifty cards in five groups which included sets of Apollo and the Muses and the Ten Firmaments (i.e. the planetary deities plus three). They may have been intended as some sort of educational game, but the sets were sold separately as well. A century later, when an Italian engraver, I. Paulini, was putting together a mythological alphabet, he had no need for the encyclopedic framework of medieval knowledge, and simply relied on Ovid. Each letter is formed from grotesque figures, and an appropriate mythological scene lies behind each letter: A is for Actaeon, B is for Bacchus, and so on. In contrast, the *Jeu de la Mythologie*, a set of cards made for the seven-year-old Louis XIV, has a clearer hierarchical structure: Jupiter, Saturn, Pluto, and Neptune are the kings; Juno, Venus, Diana, and Minerva the queens, and Mars, Apollo, Bacchus, and Mercury the knaves, while other mythological characters and incidents, each with an explanatory note, make up the rest of the suits.

Although mythological prints could be packaged in a variety of ways, they do not appear to have been in enormous demand. In 1572, for example, the Roman publisher Lafréry had only about forty mythological prints in a stocklist of over 600.[9] The same was true in northern Europe. Of the 300 prints or sets of prints published by Hieronymous Cock in Antwerp, only about twenty were mythological in theme. However, the artists with whom Cock worked were notably inventive in their choice of subjects: Cornelis Cort came up with a series of pastoral deities, and Philip Galle with a set of aquatic ones.

In Germany, too, classical themes were slow to spread. Famous as they are, Dürer's prints of mythological subjects are few in number, and rather literary in inspiration. What German printmakers lacked was the stimulus of a court devoted to the production of mythological imagery. In France, printmakers like Fantuzzi, Leon Davent (Fig. 62, p. 177), and Jean Mignon could simply copy or vary designs produced for the decoration of Fontainebleau, without direct recourse to humanist advisers or the literary texts that inspired them. Where, as in Antwerp or Nuremberg, humanists and printmakers lived alongside one another in the same city, you might get the

occasional collaboration and the illustration of some recondite subject. But it often needed a royal court to bring together the literary and visual elements of classical culture in a productive commercial relationship.

The best example of this is the shift in Goltzius's subject-matter in the mid-1580s. During the previous decade he had been supplying designs to Antwerp publishers, but it was only after van Mander introduced him to the work of Spranger, and he established links with the court in Prague, that mythological themes became common in the output of his workshop. In addition to his illustrations for the opening books of the *Metamorphoses* (perhaps meant for van Mander's commentary) Goltzius engraved some of Spranger's mythologies, and designed many of his own, a number of which were engraved by his followers Jacob Matham and Jan Saenredam.

Goltzius's influence on Dutch mythological art was considerable, yet no seventeenth-century Dutch printmaker rivalled his output of mythological subjects. The single most ambitious collection of prints of mythological subjects was that of the French connoisseur Michel de Marolles, under whose auspices the *Tableaux du Temple des Muses* appeared in 1655 with fifty-eight engravings after Abraham van Diepenbeeck, each consisting of a mythological scene and a brief quotation from a classical text in the original language. They are at their best in the depiction of scenes of punishment and torment.

Collections like these were works of art in their own right, but most prints were often of greater importance as sources for imagery in a variety of other media – not just frescoes and tapestries, but stained-glass windows and watch-covers in sixteenth-century France, painted tiles in Portugal, and ivory reliefs in seventeenth-century Germany. Almost the only two-dimensional medium that did not rely heavily on print was easel painting. But painting, in fact, was the medium in which mythological imagery was least common. There were just not enough commissions. Painters painted what was asked of them, and patrons usually wanted pictures for a purpose. Altarpieces and portraits were the standard products of most painters' workshops, and there was no mythological equivalent to the altarpiece in size or shape, let alone function. (Few mythological paintings were designed to sustain the sort of prolonged attention that an altarpiece might receive.) There were mythological portraits, of course, like the bizarre one of Francis I in which he is portrayed with the attributes of Minerva, Mars, Diana, Cupid, and Mercury (Fig. 18). But that was a manuscript painting, not a large-scale canvas. Despite the frequency with which princes were likened to gods in pageants, the mythological portrait is initially common only in France, from where

it spread to other parts of northern Europe in the seventeenth century. The primary function of portraiture was to fix a single enduring likeness; mythological identities were multiple, and often temporary.

For these reasons, mythology remained, until the seventeenth century, something of a novelty. Before then, the proportion of dated paintings devoted to mythological themes in any one year rarely rose above 2 per cent.[10] It was for the smallest and most private of interior spaces, the *studiolo*, that programmes of mythological imagery were first devised. The Muses, who presided over learning, poetry, and music, were a natural choice for the decoration, for the *studiolo* was the one room in a palazzo where patrons could relax and play with their intellectual toys. The paintings Isabella commissioned for her *studiolo* in Mantua had a double role. They formed part of the collection itself, and so included works by more than one artist, but at the same time they were also part of the decoration of the *studiolo* and so had to reflect the highbrow tastes embodied in the rest of the collection (Plate XV). The two objectives could conflict; Isabella liked to have the co-operation of a painter, and then send him written instructions (provided by a literary adviser) about the subject required. Giovanni Bellini did not like his instructions, and even though Isabella said he could come up with his own subject the painting did not materialize.

As the project went along, there was an increasing need for the new paintings to harmonize thematically with the ones that were already there. But a century later when these paintings were presented by the Duke of Mantua to Cardinal Richelieu and two paintings were commissioned from Poussin to hang alongside them at the Château de Richelieu, the new additions were quite different in both subject and mood: triumphs of Bacchus and Pan, later joined by a painting of Silenus. Ironically, the inspiration for Poussin's sequence of Bacchic subjects came from a group of paintings commissioned by Isabella's brother, Alfonso d'Este, for his *camerino* in Ferrara. Alfonso's recreations were less high-minded than those of his sister, and although he too sought a collection of painters brought together for their renown, the subjects chosen celebrated the pleasures of the body rather than the mind.

The erotic element in the paintings in Alfonso's *camerino* is clearer still in the four *Loves of Jupiter* painted around 1530 by Correggio for Alfonso's nephew, Isabella's son Federico Gonzaga (Fig. 60, p. 168). Federico gave them to Charles V, and these paintings may have stimulated the Habsburg appetite for groups of mythologies. Charles V's sister, Mary of Hungary, commissioned from Titian four mythological scenes of infernal torment for her palace at Binche in Flanders, while Charles's son, Philip II of Spain,

Francoys en guerre est vn Mars furieux
En paix Minerue & diane a la chasse
A bien parler Mercure copieux
A bien aymer vray Amour plein de grace
O france heureuse honore donc la face
De ton grand Roy qui surpasse Nature
Car lhonorant tu sers en mesme place
Minerue Mars Diane Amour Mercure

18. Mythological portrait of Francis I, possibly Nicholas Bellin

received Titian's *poesie*, a sequence of paired mythologies, beginning with a *Danaë* and a *Venus and Adonis* (Plate XII). Titian offered cut-price copies of the *poesie* to Philip's brother-in-law, the Emperor Maximilian II, and they may have helped to form the taste of his son, Rudolf II, who commissioned numerous mythologies (also referred to as *poesie*) from Bartholomeus Spranger, Joseph Heintz, Hans von Aachen and others for his court at Prague. Most of these works, even the allegories (Fig. 133, p. 356), were erotic, and Rudolf also went to some lengths to acquire the *Loves of Jupiter* that had been owned by his great-uncle (and maternal grandfather) Charles V.

This sequence of commissions produced a good number of the most famous mythological images. But although paintings were dispatched to locations as distant as Toledo and Prague, only two families were involved. The taste for mythologies and the artists who painted them was transmitted from one to the other, and then down the generations. Patrons wanted paintings like those belonging to their relatives (although the requirements of the two female patrons are rather more virtuous than those of their brothers), and the painters in their turn followed the example of their artistic predecessors.

Groups of paintings depicting mythological narratives were the exception rather than the norm. A large proportion of mythological paintings contain only one or two figures, usually a female nude, or a pair of lovers, often in a landscape setting or a domestic interior. The genre of erotic mythological pastoral had its origins in the circle of Giorgione in Venice at the start of the sixteenth century. Titian took up where Giorgione left off, quite literally in the case of the *Sleeping Venus* (Fig. 19) and the reclining female nude became a distinctive feature of Venetian painting, with notable examples by Palma Vecchio and Paris Bordone, among others. The degree to which such works were invested with mythological significance varied and was liable to shift over time. The Giorgione *Venus* is identified by the presence of Cupid (since painted over); the so-called *Venus of Urbino*, for which Titian used the same figure, has no obvious classical associations (although some imitators added them), while the Naples *Danaë*, commissioned from Titian by Cardinal Alessandro Farnese in imitation of the *Venus of Urbino*, was given a wholly new mythological identity.

The pleasure such paintings offered was primarily erotic, and for this reason they were more likely to be found in the patron's bedroom (where they might also aid the conception of children) than anywhere else. The same was probably true of the nudes of Lucas Cranach the Elder, the court painter of Wittenberg, whose workshop supplied numerous patrons with

19. *Sleeping Venus*, Giorgione

mythological erotica (Plate XIV). Cranach's compositions sometimes reflected developments in Venice, mediated perhaps by the Venetian Jacopo de' Barbari, who shared the patronage of the Elector of Saxony. But his pale, thin nudes, freezing in their almost invisible, fluttering drapery, share little else with their Venetian counterparts.

Jacopo de' Barbari was also one of the artists brought to the Netherlands by Philip of Burgundy, the humanist Admiral of Zeeland, to decorate his castle with mythological imagery, along with the sculptor Conrad Meit and the painter Jan Gossaert. Gossaert had accompanied Philip on an embassy to Rome in 1509, and he later produced several paintings of classical subjects (Plate X), perhaps the first mythological nudes in Netherlandish painting, beginning with his *Neptune and Amphitrite* of 1516. Philip's ambitions died with him and Gossaert had few immediate followers, but with artists like Frans Floris and Maarten de Vos working there, and the example of Fontainebleau not too far away, Antwerp established itself as the leading centre for mythological art in the Low Countries.

It was in Antwerp that Bartholomeus Spranger received his initial training prior to his departure for Italy, where he was briefly employed at Caprarola. He never returned to the Low Countries, but his example inspired the rapid growth of mythological art in Holland in the 1590s. In Haarlem, Hendrik Goltzius and Cornelis Cornelisz. produced work of comparable energy and drama, while in Utrecht Abraham Bloemaert and Joachim Wtewael

developed a range of mythological erotica. Works by these artists often include many figures, and subjects like *The Wedding of Peleus and Thetis* (Plate XVI) or battles of the Titans or Giants (Fig. 54, p. 150) were used to show off the artist's skill in handling multiple protagonists.

In the seventeenth century, too, the leading northern exponents of mythological painting – Rubens, Van Dyck, and Jordaens – were all trained in Antwerp. Mythological paintings probably account for about one-fifth of Rubens's enormous output. But a fair proportion of them were made for a single project – paintings for Philip IV's hunting lodge outside Madrid, the Torre de la Parada. In 1636, the king placed a bulk order for over sixty mythological scenes, designed by Rubens and mostly executed by his assistants, plus almost the same number of animal and hunting pictures. The mythological subjects were predominantly Ovidian, but there appears to have been no particular logic to their selection or display. Indeed, a low value seems to have been placed upon these works by all concerned: the price paid was comparatively low, and Rubens allowed individual assistants to sign their own names to the paintings; while in the Torre itself, none of the mythological scenes graced the main reception room.

The contrast with Rubens's earlier *Life of Marie de' Medici* is instructive. A life of the French queen narrated across twenty-one canvases commissioned by Marie herself for the gallery of the Palais de Luxembourg, the series was expensive, and very high profile. Although notionally historical in content, many of the paintings made extensive use of mythological allegory (Fig. 136, p. 368). But the gods who appear most prominently here – notably Jupiter, Juno, Minerva, and Mercury – are not those of the Torre de la Parada. The two commissions suggest a division between those of the gods who have been co-opted into the world of princely allegory, and those – like Diana, Bacchus, and their associates – whose natural habitat remains the more private landscape of the hunting lodge and the villa.

A similar division can be seen later in the century. The paintings for the Oranjezaal at Huis ten Bosch, where Amalia van Solms commemorated her late husband the stadholder Frederik Hendrik, include Apollo on the ceiling, with Minerva, Mercury, the Muses, and Mars in allegorical scenes below, and, at the lower level, two scenes from Vulcan's forge – the manufacturing base for the martial allegory above. In contrast, the decoration of Honselaarsdijk, the couple's other country house, had featured Venus, Flora, and Diana. Jordaens specialized in such rustic goddesses, but his immense *Triumph of Frederik Hendrik* at Huis ten Bosch finally excluded all mythological figures from the procession.

One reason why mythological allegory shies away from the rustic div-

inities of pastoral is that, in some cases, they are treated with a brutal naturalism. This type of mythological art, which was largely confined to easel painting and print, explored the territory of genre painting and literary burlesque. Some northern artists in Rome, the Bentveughels, actually acted out such scenes in their meetings, and the taste for mythological burlesque combined easily with the contemporary vogue for Caravaggesque naturalism. The results range from the sadistic theatre of Manfredi and Ribera (whose mythologies were, it is worth noting, mostly for Dutch and Flemish patrons) to the teasings of Velázquez, whose later paintings of *Venus* and *The Fable of Arachne* (*Las Hilanderas*) remain two of the most enigmatic mythologies of the seventeenth century.

The irreverent approach to mythology exhibited by some visitors to Italy may be indicative of a shift in the way antiquity was appreciated. Whereas sixteenth-century visitors from the North, like Maarten van Heemskerck, often treated the city as a compendium of visual sources, both sculptural and architectural, to be noted down and then rearranged at home (Fig. 94, p. 256), seventeenth-century artists began to experience the city more touristically, as a unified environment in which the landscape, the local population, and the light all contributed to the overall effect. While some exploited the tension between the ideals of antiquity and the squalor of contemporary Rome, others re-imagined their surroundings to suit their classical subjects. The result was a new genre of mythological landscape which continued long into the eighteenth century, its most notable exponent being Claude Lorrain. For him, mythology was a way of taking his paintings up-market, but for contemporaries like Cornelis van Poelenburgh, mythological subjects were just a pretext for nudity.

An important element in many mythological landscapes, often painted by a specialist, was the architecture – sometimes intact and sometimes falling picturesquely into ruins. Vitruvius had established some simple distinctions as the basis of architectural decorum. Temples of Minerva, Mars, and Hercules should be in the austere Doric order; those of Venus, Flora, Proserpina, the Nymphs and other 'delicate divinities' in the Corinthian, and temples of intermediate deities, like Juno, Diana, and Bacchus, in the Ionic.[11] This classification is faithfully repeated by Renaissance theorists, although Filarete suggested that there was another order which employed branches and other fantastic materials and was used for Pan, Faunus, and other woodland gods. The need for something more basic was also felt by the Strasbourg painter Wendel Dietterlin who, in his *Architectura* of 1593/4, made the Tuscan into an order suited to Bacchus, Cyclopes, and satyrs.

Although you can sometimes see Claude making an effort to get it right, practice did not always follow theory. Architects might have been more careful, but, of course, there was no demand for pagan temples as such. Theatres were a different matter, and Palladio was able to develop Vitruvius's ideas on theatre architecture for the Teatro Olimpico in Vicenza. The proscenium was decorated with stucco reliefs of the labours of Hercules, and would also have included allegorical statues had the academicians not preferred portraits of themselves. Few other theatres (which were usually made of wood) have survived from this period, but mythological decoration was probably not uncommon, and at Scamozzi's Teatro Ducale in Sabbioneta, stucco statues of the twelve gods still adorn the peristyle.

Mythological statues could also appear on the outside of public buildings, especially those – such as Sansovino's Libreria Marciana in Venice and Palladio's Basilica in Vicenza – that border a town's main square, the modern equivalent of a Roman forum. Set above the balustrade, these statues were usually made quite cheaply, for it was the overall effect that was important, not the individual figures. The evidence that the ancients had ornamented their buildings in this way was literary as much as archaeological. Palladio explained the huge number of statues in his reconstructions of ancient buildings by reminding his readers that half the population of Rome was said to have been made of stone. However, it was in Germany, where the Gothic tradition of architectural sculpture survived, that mythological figures were most fully integrated into buildings. The façade of Heidelberg castle, which included the seven planetary deities along with numerous other allegorical figures, was an exceptionally ambitious project. Elsewhere, mythology appeared in monumental doors and fireplaces. Dietterlin's *Architectura* is a compendium of plates showing architectural sculpture of this kind, some of it so fantastic that it is hard to imagine it being made. But it bore spectacular fruit in the doors created by Ebert and Jonas Wulff at the Schloss Bückeburg in 1604–6. The spectacular *Götterpforte* survives, with Mercury, Juno, and Ceres over the door, and Mars and (probably) Venus to either side (Plate VI), but there was also a *Wasserportal* with a relief of Diana and Actaeon, and a *Musikportal*.

In Italy, architectural sculpture was less common, and only when a façade was decorated with reliefs did mythological imagery find a prominent place. The best example is the Loggetta beneath the Campanile in Venice, decorated under Jacopo Sansovino's direction with four bronze statues and a number of marble reliefs in which there is a characteristically Venetian mix of mythological and allegorical subjects. But it was in stucco rather than stone that mythological subjects appeared most frequently. Stucco reliefs were an

important component of mythological decoration throughout the sixteenth century, and in the Casino of Pius IV in the Vatican gardens they were incorporated into the façade rather in the way that antique sarcophagus reliefs were built into the exterior walls of other Roman buildings.

The exterior of the Casino might have been decorated with mythologies, but the interior was not. There were limits to what was acceptable inside the Vatican, as there were in ecclesiastical contexts generally. Although Philip of Burgundy, now Bishop of Utrecht, could envisage incorporating the pagan gods into an altar screen, the implication of idolatry meant that mythological sculpture was never particularly welcome in churches. However, there were some notable exceptions. At the Tempio Malatestiano in Rimini, Agostino di Duccio and others carved marble reliefs of the planets, which – according to Pius II – made the church into a temple, not of Christ but of the pagan gods (Fig. 107, p. 293). Tomb sculpture was also largely closed to mythological imagery. Tullio Lombardo's tomb of Doge Andrea Vendramin in SS. Giovanni e Paolo in Venice was decorated with mythological reliefs, and it prompted one German visitor to complain that simple folk could end up venerating Hercules as Samson and Venus as the Magdalen. Elsewhere, sensitivity to criticism like this actually brought about the feared result. The tomb of Sannazaro in Santa Maria del Parto in Naples (by Montorsoli and Ammannati) has a mythological relief in the centre, and figures of Apollo and Minerva on either side, but Apollo and Minerva have been relabelled David and Judith.

The exceptional nature of these projects (and the protests they aroused) helps to confirm the general rule, and it was because of these limitations that mythological stone reliefs (other than for Herculean subjects) remained uncommon. Although sarcophagi provided a model, and motifs from them were rapidly assimilated into the repertoire of fifteenth-century Florentine sculptors, few mythological narratives were carved before Poliziano suggested to the young Michelangelo that he might try the *Battle of the Centaurs*. Even then there was no obvious use for it, and it is still in the Casa Buonarotti today. Antonio Lombardo's stone reliefs for Alfonso d'Este, several of which show mythological subjects, were an unusual commission, perhaps designed to recreate sculptures described by Pausanias.

The only form of art to develop directly from the imitation of the antique was the plaquette – a portable relief, usually in bronze and sometimes small enough to be held in the palm of the hand. In 1455, Pietro Barbo (the future Pope Paul II) established a foundry in Rome to reproduce antique gems in bronze relief. Over the next century, plaquettes like these became increasingly

popular in Italy and later in northern Europe, where Peter Flötner of Nuremberg produced numerous examples (Fig. 69, p. 191). There was much devotional imagery, but the connection with the antique was never lost and mythological and allegorical subjects appear on at least a quarter of surviving examples.[12] Plaquettes could be used to decorate household objects, such as inkstands, and they were also collected for their own sake, notably by humanists in centres like Rome, Mantua, and Padua. Perhaps because of their origins, Italian plaquettes remained close to their antique sources and so functioned as an important means of disseminating classical imagery before the spread of reproductive prints (for example, Fig. 40, p. 115). But the antique sources on which plaquettes drew were visual rather than literary and their iconography sometimes remained obscure. The epic heroes and heroines popular on contemporary *cassoni*, and the scenes of metamorphosis to be found on early sixteenth-century maiolica are notable by their relative scarcity. In Germany, where plaquettes attained their greatest refinement, subjects more often overlap with those of contemporary prints and paintings, and the same is true of seventeenth-century German ivory reliefs, which routinely draw on earlier print sources. Such reliefs were carved as artworks in their own right, though ivory mythologies could also be used for functional objects like tankards or tobacco graters.

Similar to plaquettes, but developed independently in the courts of fifteenth-century Italy, medals were based on coins rather than gems. Circular and double-sided, they usually had a portrait head on one side and an associated device, allegory, or narrative on the reverse. Mythological figures appear infrequently, some of the most notable being on medals of young women. For the marriage of Giovanna degli Albizzi Tornabuoni in Florence in 1486, medals were cast with the reverse showing the three Graces and an armed Venus; and for the sixteen-year-old Ippolita Gonzaga, Leone Leoni produced a medal featuring the goddess Diana (Fig. 106, p. 292). Leoni's medals have more mythological themes on the reverse than most, particularly those he produced for the Habsburg court.[13]

Medallists were sometimes also gem-engravers, and because classical gems often depicted mythological scenes Renaissance engravers (whose work was often indistinguishable from its antique prototypes) needed to show mythological subjects as well. For this purpose drawings by well-known artists were sometimes used. Valerio Belli asked Michelangelo for a sacrificial scene, and Giovanni Bernardi turned Michelangelo's presentation drawings for his young friend Cavalieri into rock-crystal intaglios. These in turn were destined for incorporation into a casket for the Farnese family, which would have been rather like the Cassetta Farnese, also with intaglios

by Bernardi but after drawings by Perino del Vaga, now in Naples. Rock-crystal engraving later became the speciality of the Saracchi workshop in Milan, whose work was prized in Spain (Fig. 125, p. 337) and southern Germany. Intaglios were usually destined for the collector's cabinet, whereas cameos, which required less scrutiny, were more adaptable. Some engravers, such as Belli, depicted mythologies, but cameos were also more diverse in their iconography (antique heads were a speciality) and could be used to embellish objects of all sorts.[14]

One potential use for a cameo was as a badge. The hat badge, or *enseigne*, had been introduced to Italy by the French invasion of 1494. A descendant of the pilgrim's badge, it remained fashionable for men in both countries for about half a century. Artists as renowned as Cellini made *enseignes* in precious metals. The designs could be religious or emblematic (as Alciati had intended) but classical subjects became common as well, notably in France. Gems not only functioned as badges in themselves, but sometimes also formed part of a more complex design called a *commesso*. For example, one *commesso*, of a type acquired by Francis I as an *enseigne*, has a figure of Mars in gold against a lapis background and holding a shield inset with a cameo of Venus and Cupid (Plate VII).[15]

Around the middle of the sixteenth century, the pendant replaced the hat badge as the most fashionable form of figurative jewellery. As a result, *enseignes* were often turned into pendants, but the new fashion was otherwise very different. More often worn by women, pendants were frequently formed from grotesque strapwork, and produced, for instance, in Germany, Spain, and the Netherlands where hat badges had been less common – Antwerp and Augsburg were notable centres. Subjects were various: there was a new vogue for female figures like Diana; amorous mythological couples; and, in Spain and the Netherlands, the rape of Europa.

Goldsmiths who designed mythological pendants, for instance Erasmus Hornick of Augsburg, were also responsible for ornamental metalwork of many other kinds, ranging from sword hilts to salt cellars. Mythological or non-specific *all'antica* figures were, of course, popular for the decoration of gold and silver tableware from the first quarter of the sixteenth century onwards. Giulio Romano designed many such items for the Gonzaga court, as did Cellini at Fontainebleau, where his salt cellar with Neptune and Tellus (Earth) was produced for Francis I (Plate VII). The vessels best suited to the illustration of narrative scenes in relief were the tazza (a basin raised on a central stem), where concentric circles of frieze-like decoration were sometimes employed, the vase, and the ewer. Ewers and basins could form an iconographically unified ensemble, as in the set made by Paul van Vianen

in 1613 which shows two scenes from the story of Diana and Callisto on the ewer, and reliefs of Diana and Actaeon on the basin – both themes linked to water. An alternative means of decorating tableware was offered by the process of enamelling, which achieved its most refined form in Limoges in France in the third quarter of the sixteenth century, and was used to decorate plates, candlesticks, and caskets with mythological imagery. But mythological subjects were rather less common in enamel than in the relief work of south German goldsmiths in the same period, and largely dependent on other sources, notably Italian prints.[16]

In addition to the narrative scenes, the pagan gods also appeared as finials on caskets, drinking-cups, and the like. Tiny mythological figures carved out of ivory sometimes stood guard beside inkpots (which had long been a focus for mythological imagery in other media (Fig. 128, p. 346)), but standing figures were most commonly cast in bronze. The bronze statuette was a type of domestic ornament that had been prized in Roman times, and was collected again in the Renaissance. The form re-emerged in Florence, where the few mythological sculptures of the quattrocento were predominantly in this medium. Many statuettes were directly copied from antique statues, and the Mantuan sculptor known as Antico specialized in the production of very highly finished works of this kind for Isabella d'Este and other members of the Gonzaga family. A taste for statuettes also developed in Padua where sculptors like Bellano and his pupil Andrea Riccio met the local demand, and in Venice, where followers of Sansovino continued to make small bronzes throughout the sixteenth century. In southern Germany, bronze statuettes were also increasingly common, but there, unlike Italy, statuettes were often used in small domestic fountains. Few of these are now intact – the Actaeon table-fountain made in Augsburg in the 1550s is an exception (Fig. 20) – but mythological figures, like the planetary deities from an Augsburg table-fountain of *circa* 1530, and Wenzel Jamnitzer's gods of the seasons from an ambitious house-fountain made for Maximilian II in the early 1570s, sometimes survive separated from their original context.

Statuettes were not very complicated iconographically; they usually consisted of one, or at most two, nude figures whose identifying attributes are of little relevance. However, they could form part of more ambitious programmes, such as Francesco de' Medici's *studiolo* in the Palazzo Vecchio. The eight bronze statuettes commissioned for the room were part of an elaborate iconographical programme designed by Vincenzo Borghini that illustrated the arrangement of the collection in terms of the four elements, with one element (and two statuettes) for each wall. The only sculptor to

20. *Actaeon*, table-fountain, mid sixteenth century, Augsburg

contribute two statuettes to the project was Giambologna, but although his workshop went on to mass-produce statuettes of all kinds, about 40 per cent of them mythological, the only others to form a (mythological) group are the twelve *Labours of Hercules* commissioned for the Tribuna of the Uffizi. One reason for this was that statuettes were not expected to stay in the same place for very long. Small and relatively inexpensive, they were frequently given as gifts, and by the seventeenth century were being bought and sold all over Europe. In consequence, certain classical poses and body-types became more widely disseminated in this form than in any other.

Almost all these objects were products of goldsmiths' workshops. Sixteenth-century goldsmiths were accustomed to working with mythological imagery in a way that other craftsmen were not, which is why portraits sometimes show them holding a small mythological figure to signify their trade. Few had the opportunity to produce such figures on a larger scale, but one who did was Benvenuto Cellini. While Cellini was working at Fontainebleau he was commissioned to make twelve life-size figures of gods and goddesses for use as candleholders around the royal table. Only one was ever completed, and when he returned to Florence he reused a couple of his designs for the bronze statuettes at the base of his monumental figure of Perseus in the Piazza della Signoria.

The circumstances that led to the commission were exceptional. Despite the obvious ancient precedents, the use of monumental mythological figures in public sculpture was uncommon. In the early years of the sixteenth century, during the republican interlude, Michelangelo's *David* stood outside the Palazzo della Signoria, with Donatello's *Judith and Holofernes* in the Loggia dei Lanzi. By the end of the century, the *David* was still in place, but now accompanied by Bandinelli's *Hercules and Cacus*. Ammannati's Fountain of Neptune stood on the corner, while under the Loggia dei Lanzi, Cellini's *Perseus*, which had been commissioned to balance the *Judith*, stood with Giambologna's *Rape of the Sabines* which had replaced it (Fig. 21).

The takeover of the square by classical gods and heroes can be explained by the fact that sculpture in Florence developed a distinct political dimension. The *David* and the *Judith* were in civic space because the republican government had placed them there. To accompany the figure of David, another depiction of a giant-slayer was planned: a statue of Hercules and Cacus, all the more appropriate as Hercules appeared on the great seal of Florence. But the marble was not delivered, and after the Medici had regained control of the city the commission was given, not to Michelangelo (as had originally been intended), but to his rival Bandinelli. When the

21. Piazza della Signoria, Florence, with Michelangelo's *David*,
Bandinelli's *Hercules and Cacus*, and Cellini's *Perseus*

Medici were briefly expelled once more, the unfinished block was given
back to Michelangelo who proposed making it into a sculpture of Samson
and the Philistine. This plan came to nothing, for the Medici returned and
gave the marble back to Bandinelli, who completed his *Hercules and Cacus*
(Fig. 26, p. 89). By this stage, however, Hercules had come to signify the
ruling dynasty rather than the republic, and it was with some anxiety about
the public reaction that the statue was finally placed in its intended position
in 1534. Later, Cellini's *Perseus with the Head of Medusa* was commissioned
to stand opposite the *Hercules* – a juxtaposition with Hercules that echoed
Alessandro de' Medici's seal, which had shown Hercules on one side and
Perseus on the other.

It is a confusing narrative, but one with a pattern. Sixteenth-century
Medici patrons eschewed the Old Testament subjects of their forebears
which had been appropriated by the republic, and helped themselves to
the Florentine symbol of Hercules. In consequence, mythological imagery
became associated with Medici patronage, and instead of statues of Israelite
heroes like Judith, David, and Samson, Medici rule was celebrated through
statues of Hercules, Perseus, and Neptune. Nevertheless, it is precisely

because the civic space was contested, and the Medici forced to develop a new iconography, that public sculpture became so important. Elsewhere there is nothing comparable; Sansovino's giant statues of Mars and Neptune, commissioned in 1554 for the Doge's Palace, were uncontroversial representations of the perennial Venetian concern with warfare and the sea.

The one form of public sculpture in which mythological figures came to predominate was the fountain. It was possible to think of events from sacred history that might adorn a fountain (Moses striking the rock, for example), but religious imagery never took hold. It was hard to take fountains seriously; the sensual, playful possibilities of water had already been celebrated in the late medieval 'fountain of love', and even though the fountain gradually lost some of its erotic associations it was never sacralized. Some classical sculptures had originally been used as fountains, while others lent themselves to adaptation. In Rome, antique statues of nymphs, satyrs, and putti were used for fountains throughout the sixteenth century. In Florence, however, new fountain figures had to be commissioned. Most of these presupposed a garden setting, and the relative informality of the iconography reflected this. For civic spaces something more impressive was required. The Fountain of Neptune in the Piazza della Signoria, first mentioned by Bandinelli in 1550 but completed many years later by Ammannati and others, became the model for fountains of this type, with a heroic male nude at the centre and attendant figures around the basin. The precedents for this design were then very recent – Cellini's projected Fountain of Mars at Fontainebleau, and Montorsoli's two fountains, one of Orion and one of Neptune, in Messina – and, like the Florentine project, designed to celebrate the military prowess of the ruler. Neptune was the god of lakes and springs as well as the sea, but he often owed his position in civic imagery to the growing importance of naval power.

Unsuccessful in the competition for the Florentine fountain, Giambologna was able to execute a Fountain of Neptune in Bologna, and his followers, Hubert Gerhard and Adriaen de Vries (who later became the court sculptor to Rudolf II), carried on his approach in the municipal fountains of Augsburg. In central Europe, mythological fountain imagery was nothing new. There had been fountains with mythological figures in the palaces of Matthias Corvinus of Hungary in the fifteenth century. But German fountains were traditionally less reliant on a monumental single figure at the centre and were often built in tiers, with a corresponding increase in the complexity of the iconography. The Neptune fountain, which Georg Labenwolf of Nuremberg cast from models by Lienhard Schact for the courtyard of the Danish king's castle at Kronborg, had thirty-six figures, with Neptune

at the top, tiers of putti and sirens, and six goddesses below. In Italy, complex fountains, like Ammannati's six-figure allegorical Juno fountain, were not unknown, but the German tendency to use narrative scenes, like Diana and Actaeon, or the Judgement of Paris, was distinctive.

The association of mythological imagery with fountains is part of a wider pattern. During its formative period, Christianity was an urban religion. Its myths dealt with history rather than nature, and it offered its adherents little imaginative purchase on natural phenomena. Springs, rivers, winds, trees, the cycle of the seasons, all were largely irrelevant to the Christian story. So when, in the fourteenth and fifteenth centuries, people started to take a more conscious pleasure in nature, they looked to classical sources to help them appreciate it. Machiavelli cannot have been the only person to take Ovid or Tibullus on his walks and sit reading by a spring, and the poets soon started to populate woods and streams with the gods, nymphs, and satyrs of their classical predecessors. These were the exotic fauna that people hoped to draw out of the forests and into their gardens. Diana, Pan, and the Dryads used to come to rest by the pond at an Este villa near Ferrara, so the poets claimed.

Alongside this tendency to see contemporary gardens in terms derived from pastoral, in Rome there was another, more practical link between horticulture and the world of antiquity. When classical statues were ex-humed, they too usually ended up in someone's garden. In a city where antiquities were common, it was the obvious place in which to put large, valuable, but usually broken objects. These figures were not necessarily the sylvan deities of pastoral, and when attention was eventually given to their display, their relationship with their surroundings had to be considered. From the fifteenth century onwards garden walls had sometimes been decorated with paintings of mythological subjects, and where the garden contained antique statues they occasionally served as models for the painted figures. Alternatively, the statues themselves could be naturalized by being turned into fountains or placed in grottoes. The reclining antique figure of Cleopatra (now identified as Ariadne) which had been acquired by Julius II in 1512, by the 1530s was inhabiting a grotto and functioning as a fountain with water flowing into an antique sarcophagus below. More ambitious was the display of the Niobe group at the Villa Medici in Rome. By adding a number of wholly unrelated antique statues (including a rearing horse) for additional effect, the whole drama was restaged in the garden against an architectural backdrop.

In Rome there were enough ancient statues to populate a garden, but

elsewhere they were less easy to come by. At the Villa Medici at Castello in Tuscany, and in the Boboli gardens behind the Palazzo Pitti in Florence, the sculpture was mostly commissioned, much of it to designs by Niccolò Tribolo (Fig. 22). Both gardens eventually included highly finished figures for the principal fountains by Giambologna, Ammannati and others, as well as rustic grottoes (Fig. 71, p. 200). However, the iconography of Tuscan villas is less reliant on mythology than the antique-filled gardens of Rome; there are also personifications of natural phenomena, like Giambologna's Appenino at the Villa Medici at Pratolino, and the Boboli gardens contain a number of rustic genre figures.[17]

Other than the Medici villas, the most important late sixteenth-century gardens are to be found in the villas outside Rome to which cardinals retreated from the intrigues of the papal court, notably the Villa d'Este at Tivoli; the Palazzo Farnese at Caprarola; the Villa Lante at Bagnaia, and the Villa Aldobrandini at Frascati. Here, too, there is a distinction between those gardens that contain antique sculpture and those that do not. The iconography of the garden at the Villa d'Este, for which a large number of antiquities were collected, was particularly complex. It had numerous fountains, grottoes of Venus and of Diana, and reliefs from the *Metamorphoses* along the Alley of a Hundred Fountains. In contrast, at the Villa Lante, where there are no antiquities, the iconography of the garden is far less involved, and often borrowed directly from the Villa d'Este.

There were several themes to which Roman garden iconography repeatedly referred. One was the idea of the garden as a place of intellectual inspiration, a Parnassus where Apollo and the Muses might dwell, and where fountains recalled the Hippocrene stream that had sprung from the hoof of Pegasus. Another was the garden of the Hesperides where Hercules slew the serpent that guarded the tree with the golden apples. A third, less focused than the others, was that of the garden as pastoral, populated by satyrs, nymphs, and the gods and goddesses of nature.[18]

In some cases, the iconographical centre of the garden was the nymphaeum. Originally a cave sacred to the nymphs, it had already become a formal architectural feature in ancient Roman times. The word found its way into the vernacular in the *Hypnerotomachia Poliphili*, but the formal type of nymphaeum, often a hemicycle decorated with statues, was not adopted until the mid-sixteenth century. At the Villa Giulia, built for Pope Julius III in 1551–4, a sunken nymphaeum is the focus of a sequence of courtyards behind the villa. Passing through a court filled with antique mythological figures and stucco reliefs, the visitor looks down on the nymphaeum from an entrance loggia two levels above. The four female caryatids

22. *Hercules and Antaeus*, Villa Medici, Castello, Niccolò Tribolo
with bronze figures by Bartolomeo Ammannati

23. Nymphaeum, Villa Barbaro, Maser, Andrea Palladio and
MarcAntonio Barbaro

survive, but here there were also originally a sleeping Venus, and ten putti
spouting water. Below the loggia, a grotto, frescoed with mythological
allegories of the seasons by Taddeo Zuccaro, housed Mercury, Hercules,
and other ancient statues of the gods.

The nymphaeum at the Villa Barbaro in the Veneto, constructed shortly
afterwards and perhaps influenced by it, provides an instructive comparison
(Fig. 23). The villa may have been designed by Palladio and frescoed by
Veronese, but the nymphaeum, positioned directly behind the villa and an
integral part of the design, is the work of a DIY enthusiast. Rather than
antiques, the statues in the niches of the hemicycle are stucco figures (includ-
ing several with pastoral associations, such as Pan, a female satyr, Bacchus,
Diana, and Actaeon) probably made by one of the patrons, MarcAntonio
Barbaro. Below each one is an Italian rhyming couplet making a moral
point on behalf of the figure above. The distance between Rome and Venice,
between antiquarian fantasy and pastoral allegory, is clear. And although
the Teatro dell'Acqua at the Villa Aldobrandini at Frascati later reinterprets
the Villa Barbaro's juxtaposition of villa and nymphaeum on a monumental
scale, it too is antiquarian in inspiration.

Some of the best-known sculptures of the Renaissance, which modern
viewers are accustomed to seeing in the clinical surroundings of a museum,
started out as garden ornaments. Both Michelangelo's and Sansovino's
marble figures of Bacchus began life this way (Fig. 3, p. 9). As the appre-

ciation of contemporary sculpture grew, much-admired statues were brought indoors. In Duke Cosimo's private apartments in the Palazzo Vecchio, Sansovino's *Bacchus* was displayed alongside Michelangelo's unfinished *Apollo* and Bandinelli's *Bacchus*. Bernini's *Apollo and Daphne* (Fig. 122, p. 330) would, a century earlier, have gone straight outside, but Scipione Borghese commissioned it for display alongside his collection of modern paintings and antique statues on the ground floor of the Villa Borghese.

Cardinal Maffeo Barberini supplied both the *Apollo and Daphne* and Bernini's *Rape of Proserpina* with moral epigrams which were inscribed on the base of each group. Such inscriptions were unusual additions to sculpture, but the practice of providing written interpretations of mythological artworks after they had been completed was becoming increasingly common. At the most basic level, prints had long appeared with a few lines of explanatory verse beneath the image. Verses were usually written after the image had been completed, and occasionally without reference to it. The purpose was sometimes, as with Cardinal Barberini's epigrams, to display wit or bring out the moral of the story, but often the verses did little more than explain what was going on.

The potential incomprehensibility of mythological imagery was obviously an issue, and little handbooks, like Zucchi's guide to his frescoes in the Palazzo Rucellai and Roschino's pamphlet on Pietro da Cortona's *Divina Providenza* at the Palazzo Barberini, could be written to explain a complex programme. In the seventeenth century, paintings and sculpture also inspired more self-consciously literary works, ranging from the sonnets in Marino's *La Galeria* (almost seventy of which are mythologies) to the much longer poems about Reni's *Rape of Helen* and *Bacchus and Ariadne*. The relation of such literary interpretations to the iconography of the work varies, and they are distinct from the kind of programme that would have been provided by iconographical advisers. Evidence for the involvement of advisers is, in any case, largely confined to decorative programmes of some complexity, whether festivals, gardens, tapestries, or frescoes. The kind of men who gave advice – Cosimo Bartoli and Vincenzo Borghini in Florence; Pirro Ligorio and Annibale Caro in Rome; Daniele Barbaro in Venice; Pontus de Tyard in France – were usually antiquarians or poets or both. They specified the subjects to be treated, but do not seem to have been overly concerned about the way in which they were interpreted by the artist. In the production of individual mythologies, complex allegories like those Isabelle d'Este sought for her *studiolo* needed written instructions, but most

mythological artworks, especially in the decorative arts, would have been produced without consultation with an adviser.

One reason why the involvement of advisers was usually unnecessary was that the various modes through which classical mythology was transmitted to the Renaissance had an impact on different areas of visual culture. Ovid's *Metamorphoses* is the most widely illustrated text, but for all its popularity in print and maiolica, subjects from Ovid are less dominant in other, more prestigious media. In major decorative cycles, Ovidian subjects are often relegated to the frieze rather than appearing on the walls or ceiling, and their importance in tapestries is a late development. Apuleius's story of Cupid and Psyche, which lent itself more easily to sequential illustration, enjoys greater prominence in these contexts, while ekphrastic subjects from Lucian and Philostratus rival Ovidian ones in easel painting. Where a decorative programme of some complexity was required, as was the case with ceiling frescoes, the organizing principle was frequently astrological rather than literary. Ceilings were ill-suited to linear narrative, and the ancient association of the ceiling with the sky ensured that the planetary deities presided overhead in many of the most ambitious decorative projects.

There was, in addition, a broad consensus about what subjects belonged in which locations. In his work on architecture, Alberti distinguished clearly between the graver subjects appropriate for a town house and those for a country property 'where all the gayest and most licentious embellishments are allowable', and also between the representation of the deeds of great men, suitable for public and princely buildings, and those of rustics, suitable for pleasure houses and gardens. Alberti himself seems to have considered 'pictures of such fictions of the poets as tend to the promotion of good manners' to be equally acceptable in public contexts, and in *De pictura* his examples of *istorie* are usually mythological in that they are derived from examples of antique art.[19] But he was writing before classical subjects had become common, and there was more resistance to mythology than he had imagined. Even a century later, mythological imagery had not achieved the centrality he envisaged. In the writings of theorists like Armenini and Lomazzo, whose observations were based on actual practice, the place of mythological subject-matter is more clearly circumscribed. Armenini recommends edifying *istorie* for friezes (for which, he notes, patrons rarely proposed subjects), citing the example of an uncouth Genoese patron whose manners improved as a result, but it is clear that he was thinking primarily of history rather than mythology. In country houses, where location is more significant than status and the purpose of decoration is to provide diversion rather than edification, more allowance is made for whimsy. In loggias,

gardens, and fountains there is even scope for fauns, satyrs, centaurs, sea-monsters and the like.[20] Lomazzo reserves the state rooms for historical subjects, but allows for mythologies in the private apartments, and encourages their use in fountains and gardens. In bathrooms, too, aquatic subjects are appropriate.[21]

Many of the arguments used by these theorists can be traced back to Vitruvius. His distinction between stage scenery that was tragic (showing columns and statues suitable for kings), comic (ordinary dwellings), and satyric (trees, caverns, and mountains) is reflected in the Renaissance theory of decorum.[22] Although Vitruvius seems to have considered mythologies and figures of the gods to be compatible with the grand style, Renaissance writers are more comfortable with mythology in the comic and satyric modes. It was from Vitruvius, too, that the mid-sixteenth-century attack on grotesque decoration took its lead. He had complained that 'such things do not exist and cannot exist and never have existed', and many Renaissance commentators agreed with him, notably Daniele Barbaro – there are no grotesques at Maser – and Gilio da Fabriano. Cardinal Paleotti went a stage further and argued that the style had actually been invented as an aid to subterranean devil worship.[23]

The concern expressed about grotesque ornament is an indication of its rapid spread. It grew round images like ivy. Transmitted via prints, grotesques were used as internal and external decoration, in private and public rooms, in palaces and churches, around the borders of tapestries, on maiolica, and in metalwork, furniture, and jewellery. Not quite mythologies, but populated with the satyrs, sphinxes, sirens, and who knows what else, grotesque ornament was the place where fantasies grew into myth and ornament teetered on the brink of narrative (Fig. 24). According to Doni, grotesques were derived from chance images like those seen in stains and clouds. For Ligorio, they were replete with moral significance. The distance between nonsense and allegory contracted to almost nothing: before you knew it, the stain on the wall was teaching you a lesson.

Grotesques, for all their ubiquity, always remained marginal – quite literally in the many cases where they constitute the frame or the boundary of the work itself. They tend to fill those spaces least likely to generate meaning. In this respect, their distribution parallels that of mythological art itself. Mythological imagery is often found where you might otherwise have had non- or semi-figurative decoration. But while grotesque decoration remained ornamental and eventually went out of fashion, mythology gradually migrates from the margin to the centre: from the frieze to the ceiling,

24. *Grotesques, with Apollo and Daphne*, Sala di Apollo, Castel S. Angelo, Rome, Domenico Zaga

the epigram to the epic, the intermezzo to the opera, and from small private spaces to large public ones.

This was often a move from outside to inside. One of the clearest patterns in the distribution of mythological subjects is the association between mythology and open environments. Mythological decoration is more often found in rural or suburban villas rather than urban palaces, and in towns it is more common on exterior façades than as interior decoration. Mythological frescoes are most often found on a ceiling which the viewer can imagine being open to the heavens where the gods dwell, or in a loggia, half-open to the garden. In every sense, mythologies belong at the edges of any decorative scheme, at the points where the viewer is not only distanced from normal social life, but actually gazing out beyond its horizons. Gardens are the only context in which mythology is overwhelmingly dominant, and landscape is the genre of painting in which mythological figures become most common. However, mythology's association with the open spaces does not mean that it is found predominantly in public ones. Mythology entertained the populace in festivals and in the craziness of painted façades, but villas and gardens were private places where patrons relaxed from the burdens of their public duties, and the interior rooms in which mythologies were initially

found were private as well – the study, the bathroom, and the bedroom.

There was over time an overall increase in both the quantity and the prestige of mythological art. And by the mid-seventeenth century paintings, tapestries, prints, and statuettes depicting classical themes were available on the art market in every major European country. Nevertheless, for most of this period mythologies are found in locations and media that were considered to be of secondary significance. For this reason they constitute only a tiny fraction of the output of virtually every major artist in this period. Donatello, Michelangelo, and Bernini were between them responsible for only a handful of mythological sculptures. The famous mythologies of Botticelli, Correggio, Titian, and Velázquez are unrepresentative of their production as a whole. The artists who are most heavily concerned with mythology are slightly less well known: Cellini and the sculptors of late sixteenth-century Florence; decorators such as Giulio Romano, Rosso, and Primaticcio at Fontainebleau; Perino del Vaga, and Jacopo Zucchi; the painters of *cassoni* and the designers of tapestries; goldsmiths like Valerio Belli, Leone Leoni, Erasmus Hornick, and Wenzel Jamnitzer; specialists in *istoriato* pottery like Xanto Avelli and Nicola da Urbino; Giulio Bonasone and the enterprising printmakers of the Raimondi school. In the North, Spranger and his followers in Haarlem and Utrecht are the most prolific exponents of mythological art. In the case of Joachim Wtewael, mythologies account for a third of his output. There are few other painters in the whole of this period of whom this is true, and Poussin is perhaps the first painter working in Italy (other than an interior decorator or a genre specialist) whose output is equally divided between the secular and the religious.

The taste for mythological imagery was even more specific. Individual patrons had an enormous influence. Every Catholic church needed several altarpieces; only the most ostentatiously acquisitive people needed a lot of mythological art. A small number of ambitious patrons such as Philip of Burgundy, Francis I, Duke Cosimo de' Medici, and Rudolf II tried to develop court styles in which mythological imagery was used across a variety of media. As a result, mythologies tend to cluster around particular centres. But individual patronage of mythological art, often fuelled by a partiality for the erotic as much as anything else, could only effect so much. Monarchs like Rudolf II or Philip II of Spain could bring in artists or paintings from elsewhere, yet it was only in the case of Francis I, whose successors continued his patronage, that the local culture was permanently transformed.

In geographical terms, therefore, the spread of mythological art is uneven. Although its sources are not always Italian, it appears first in Italy. In Florence, it was initially only on *cassoni* that mythologies were commonplace,

and it was in the northern courts of Ferrara and Mantua that the taste for mythology developed first. The moment at which mythological imagery first takes on its characteristic form was in Rome between the accession of Leo X in 1513 and the sack of the city in 1527. With its strong links to antiquity, Rome remained an enduring source of inspiration for mythologies, yet it was chiefly in places newly allied to the empire – Genoa, Mantua, Florence – that mythological decoration flourished after 1530. The extension of imperial power happened to coincide with the arrival of the minimum kit for mythological art, and the effect was immediate. For the sheer abundance of mythological decoration nowhere can match Genoa, and in the Florence of Duke Cosimo and his successors mythological imagery was disseminated in festivals, sculpture, and the Medici tapestry workshops. If requested, Venetian artists could produce delightful *poesie*, but they were not often asked – the great mythological paintings of Venice were often destined for Habsburg patrons. In Naples and Sicily, under Spanish rule from the early sixteenth century, mythological imagery was used to celebrate imperial triumphs (for example, the Montorsoli fountains in Messina), but despite the humanist literary culture of late fifteenth-century Naples it never took root.

In the North, the cities of Augsburg and Nuremberg were the places where mythology was most fully integrated into local production, especially in painted façades and goldsmiths' work. But in the Prague of Rudolf II an explosion of mythological imagery was produced that had not been seen since Fontainebleau. And from Gossaert to Jordaens, Antwerp was the most consistent source of mythological art in the Low Countries. Nevertheless, the taste for it only spread to the Northern Provinces when transmitted via Prague.

These are patterns produced by constant movement rather than organic growth. Most artworks were executed by local artists for local patrons, but this is much less true of mythologies. Northern artists working in Italy and Italians working in the North were both more likely to produce mythologies than their compatriots back home. You had to travel in order to assimilate or to disseminate the benefits of the study of antiquity. Yet not all paths led to or from Rome. It is a good bet that an Antwerp goldsmith working in Augsburg or a Nuremberg master working in Prague was more likely to be producing mythological ornament than the local craftsmen. And it was not just the artists who travelled. In Spain, mythologies were imported from Venice, Flanders, and Naples, though religious imagery was produced in Spain itself. Mythology often travelled further than other types of art because demand was intermittent, and concentrated in a few lavish courts and wealthy cities.

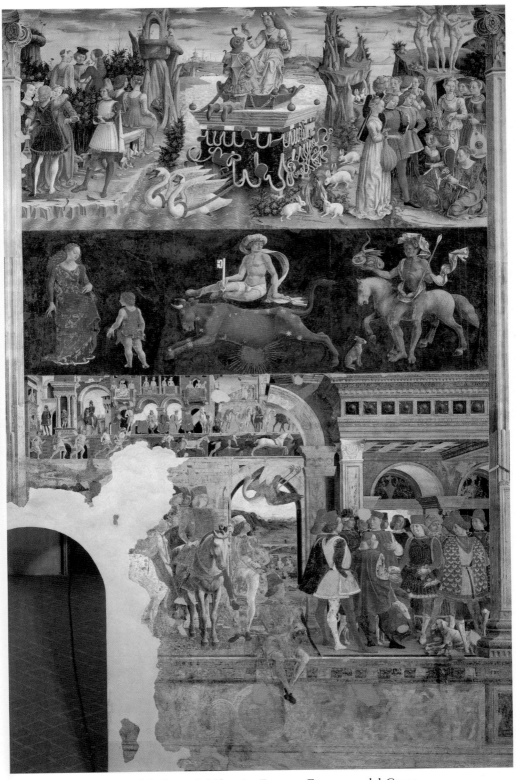

I *April*, Palazzo Schifanoia, Ferrara, Francesco del Cossa

II *Cassone* with scenes from Roman history, Lo Scheggia

III *Stipo* with stories from Ovid after Tempesta, seventeenth century, Florence

(*From left to right*)
Top: Ganymede; Perseus riding Pegasus
Middle: Europa; death of Adonis; Nessus and Deianira
Bottom: Pyramus and Thisbe; Atalanta and Hippomenes; Narcissus

IV&V Sala di Psiche, Palazzo Te, Mantua, Giulio Romano and assistants

VI Door with figures of the gods, Schloss Bückeburg, Ebert and Jonas Wulff

VIIa *Mars, commesso* with cameo of *Venus Chastising Cupid*, mid sixteenth century, French

VIIb *Neptune and Tellus*, salt cellar, Cellini

VIIIa *Perseus and Andromeda*, from *La Bible des poetes*, 1493

VIIIb *Leda and the Swan*, plate, Francesco Xanto Avelli

There is also a strong connection between subject and medium. Mytho-
logical imagery is often concentrated in media that are temporally and
geographically specific: *cassone* painting in Tuscany; pastiglia boxes in the
Veneto; *istoriato* maiolica in central and northern Italy; domestic fountains
and ivories in southern Germany. This makes it hard to see any single
relationship between the distribution of imagery and the media through
which it is transmitted. But there are perhaps two discernible clusterings.
One grouping, comprising *cassoni*, pastiglia boxes, illustrated editions of
Ovid, and maiolica, has a strong narrative content, and is slow to assimilate
classical models. These are often forms with roots in the fifteenth century,
whose significance diminished sharply by the 1560s. Production was
localized, and (with the exception of illustrated Ovids) had a relatively
limited impact on other media. In contrast, there are various forms, many
of which first come to prominence around 1530, in which narrative is less
important than their significance as symbol, ornament, or spectacle. These
include the classical entry, grotesque decoration, the emblem, the fountain,
the pendant, and the statuette. More receptive to antiquity, they also feed off
one another, and each becomes a pan-European phenomenon, collectively
producing a type of art that has since been termed mannerist.

Taken together, these two clusters are not exactly central to what we have
come to think of as the history of art, let alone to wider intellectual history.
But it is a useful reminder that the diffusion of classical mythology came
about through an accumulation of expensive yet seemingly trivial exchanges:
the distribution of pornography and wedding presents, and the acquisition
of things such as picnic dishes and jewellery, and garden ornaments for
people's holiday homes. It may not sound like a cultural revolution, but
that is what it turned out to be.

3

Hercules

There is not a lot of snow in Florence, but in the winter of 1406 there was enough to build snowmen. One of the figures made on this occasion was a gigantic Hercules almost twenty feet high, armed with a stout shield and a heavy club, and accompanied by a fierce lion.[1] The Florentines knew who Hercules was because he had been on a seal of the city since 1281. And if they looked carefully they would have seen his exploits carved in the right jamb of the Porta della Mandorla of the cathedral, completed the previous year. Some of the masons from the cathedral may have helped. It was not just children who made snowmen. In 1494, Michelangelo was commissioned to build a snowman in the courtyard of the Medici palace. Perhaps this was a Hercules too, for the artist's biographers both mention it in connection with a marble Hercules he had made a couple of years earlier. Then, grieving at the death of Lorenzo de' Medici, Michelangelo had spontaneously started work on a spare block of marble and carved a stone giant to take the place of his dead patron. It has since disappeared, lost at Fontainebleau. Like the snowmen, it seems to have been made without thought of the future, just for the sake of making something out of materials that were ready to hand.

In the fifteenth century, Hercules often appears like this – unexpectedly, made out of whatever material was locally available. Yet spontaneous actions are often the most heavily determined. The Florentines usually made snow lions rather than snowmen (in 1406 there had been a whole pride of them roaming the streets), but that was not an accident either, for the lion, the *marzocco*, was also a symbol of the Republic. Even so, it is hard to tell if the snow-Hercules of 1406 was, strictly speaking, a civic sculpture. That same year the Chancellor of Florence, Coluccio Salutati, died, leaving behind the manuscript of *De laboribus Herculis*. He had been prompted to write not by local concerns but by a friend who had asked how Hercules could kill his own family in one of Seneca's plays and then go to Olympus as a god in the next. It is a fair question, and Salutati spent a long time trying to answer it before moving on to an allegory of the hero's many labours. His

immense treatise (which remained unpublished until 1951) was read by later Florentine scholars like Cristoforo Landino, but it probably did not influence the building of snowmen or much else. And yet it is still significant. It shows that Hercules was on people's minds.

No other mythological figure received this sort of attention at the start of the fifteenth century, and the fact that Hercules did is an indication that he was thought of not as one of the pagan gods but as a virtuous hero of antiquity. Boethius had enumerated the labours of Hercules and enjoined people to follow his example. Petrarch had originally put Hercules at the head of his list of famous men, and the hero also appeared regularly in series of *uomini famosi* in fourteenth- and early fifteenth-century fresco decoration. Long before any of the other gods received a room of their own, there were chambers of Hercules at palaces in Padua and Ferrara.

It is in this context that Antonio Pollaiuolo's three large canvases for the great hall of the Palazzo Medici should be understood. Painted around 1460, they showed the same three labours as the Porta della Mandorla – Antaeus, the Nemean lion, and the Hydra. All are lost, but the compositions are preserved in the artist's two small panels of *Hercules and Antaeus* and *Hercules and the Hydra* (Fig. 25), and on early sixteenth-century maiolica from Gubbio. Some scholars date the Renaissance from the day Hercules resumed his athletic breadth of shoulder, his club, and his lion's skin. In Pollaiuolo's canvases for the Palazzo Medici that day has arrived. But although his Hercules has all the right attributes, he has not regained his place among the gods, for the rest of the gods have not yet returned to join him. Apart from a small panel of *Apollo and Daphne*, there are no mythologies among Pollaiuolo's paintings. He produced several bronze statuettes of Hercules, but not of other gods.

For Florentines at least, Hercules still belonged with the heroes of the Old Testament. Dante had compared Hercules' victory over the giant Antaeus to that of David over Goliath.[2] So when in 1508 a large block of marble was ordered for Michelangelo to carve a statue as a pendant (companion-piece) to his *David* for the Piazza della Signoria, Hercules was the obvious subject. Yet by the time Bandinelli brought the project to completion in 1534, the significance of Hercules had undergone a shift. When his *Hercules and Cacus* was finally unveiled, it provoked so much hostility that over a hundred satirical poems were attached to its base (Fig. 26). One of the few to survive suggests that this Hercules was perceived rather differently. The statue complains to the crowd: 'Don't you know who I am, all you riff-raff? I am the image of the son of Jupiter – I am Hercules, who because of my arduous trials deserves to be venerated as a god.'[3]

25. *Hercules and the Hydra*, Antonio Pollaiuolo

Would a similar response have greeted Vincenzo de' Rossi's Hercules fountain of 1561–84? Rossi's drawing shows that it would have had eight fighting groups on the octagonal balustrade; three further groups were to preside over the upper basin, surmounted by a statue of Hercules supporting the heavenly sphere. Had it been finished it would have been the most spectacular Herculean monument of the Renaissance. It was never completed, and six of the fighting figures ended up in the Sala dei Cinquecento in the Palazzo Vecchio. There, at least, Hercules' pretensions were taken seriously. In the Sala d'Ercole in the private apartments of Duke Cosimo, Hercules is clearly one of the gods – his room part of a suite which also includes rooms or loggias devoted to Saturn, Jupiter, Juno, and others. In the *Ragionamenti*, Vasari explained that he wanted his Hercules to be understood as a model for princes, and that the labours were to be interpreted in terms of the qualities and achievements of his Medici patrons.[4]

A century later, at the Palazzo Pitti, Hercules does not need a room to himself because he appears in all Cortona's planetary rooms as the prince's

26. *Hercules and Cacus*, Baccio Bandinelli

constant companion, first receiving the youth from the arms of Venus and eventually presenting him to Jupiter. The labours are nowhere to be seen. This Hercules does not have to fight his way through a succession of wild animals; he is already quite at home in the heavens, gliding down with unaccustomed grace to greet the youthful prince as Minerva (Pallas) pulls him away from the bed of Venus (Fig. 27). Unlike Vasari's frescoes, this is not mythology glossed as allegory, it is allegory dressed up as myth.

The continuing importance of Hercules in Florence disguises underlying shifts: between the historical, the mythological, and the allegorical Hercules; the Republican hero and the Medicean god. It is easier to see what is unusual about the career of Hercules in Florence if we look at what happened elsewhere. Hercules can be found all over Europe in the fifteenth century: in Hungary and Spain; in Flanders and Florence and Ferrara. Soon after Salutati, other authors started to write about Hercules as well. Quite independently, Enrique de Villena produced an allegory in Catalan, *Los doze trabajos de Hércules*, completed in 1417, and Pietro Andrea de' Bassi wrote *Le fatiche d'Ercole* in Ferrara in the 1420s.

Hercules is everywhere because he is almost always a local hero. Unlike

27. Sala di Venere, Palazzo Pitti, Florence, Cortona

most of the other gods, he had gone west. In order to steal the cattle of the
three-headed giant Geryon, Hercules had sailed to Iberia, and while there
had set up the Pillars of Hercules at the Straits of Gibraltar. The legend
furnished clear evidence that Hercules had been to Spain, and suggested
that he might have stopped off at all sorts of other places in western Europe
as well. According to Annius of Viterbo, whose forged history was published
in 1498, Hercules had come from Spain to rule Italy, where he had built up
parts of Florence, and given names to many places in the region: Arno
originally meant lion; Livorno came from Libarno, the Libyan lion, and so
on.[5] The springboard for many of Annius's fantasies was Diodorus Siculus,
who has a long section on Hercules in his *Library*. And, as the Burgundian
court historian Olivier de la Marche noted, Diodorus also provided evidence
that Hercules had travelled throughout the Celtic regions and might have
stopped in Burgundy long enough to found a dynasty there.[6] So stories of
Hercules, who is clothed in medieval armour, appeared in Flemish tapestries
from the mid-fifteenth century, and the labours of Hercules were the subject
of a performance at the wedding of Charles the Bold in 1468.[7] The literary
source for these scenes was the first two books of Le Fèvre's *Recueil des
hystoires de Troyes*, written at the court of Philip the Good, Duke of
Burgundy from 1419 to 1467. Largely derived from Boccaccio but freely
elaborated in line with the chivalric tastes of the Burgundian court, Le

Fèvre's narrative was copiously illustrated in both manuscript and printed editions. Translated into English by Caxton, it had appeared in Irish before the end of the century.

Tapestries based on Le Fèvre were exported from Flanders to Ferrara, where (to judge from Decembrio's dialogue) they may have come in for some criticism for their lack of classical accuracy. However, the Este court was already generating Herculean imagery of its own. De' Bassi's *Le fatiche d'Ercole* was written at the request of Niccolò d'Este sometime in the 1420s and at least one manuscript was illustrated with miniatures. The identification of the house of Este with the hero was celebrated in the name of Niccolò's son, Ercole, who ruled from 1471 to 1505, and it was in his time that Herculean iconography proliferated.[8] De' Bassi's work was published in a lavish edition; there was a Hercules fountain in the courtyard of the Castel Vecchio; and the labours of Hercules appeared in paintings and wall-hangings, and also on three big pastries which greeted Ercole's bride, Eleonora of Aragon, when she stopped in Rome on her way to Ferrara in 1473.[9] The ruling house claimed descent from Hercules, but here, as nowhere else, Hercules lived on through his name. It was in the Ferrara of Ercole II (1534–59) that Giraldi's *Vita Herculis* of 1514 was finally published in 1539; that G. B. Giraldi Cintio wrote *Dell'Ercole*, an epic poem in twenty-six cantos (1557); and that Dosso and Battista Dossi produced strange allegorical paintings and tapestries on Herculean themes. Ercole even planned to rename the town of Brescello, recently regained from the Spanish, Erculea, and a giant statue of Hercules by Sansovino was placed there in anticipation. Through marriage, the Herculean pretensions of the Este passed to the Gonzaga as well: Isabella d'Este's son Federico II appears as Hercules in the centre of an astrological ceiling in Mantua, and his younger brother was another Ercole, celebrated as such in the frontispiece of a commentary on Vitruvius.

At the Burgundian court, as in Ferrara, the classical and the chivalric traditions overlapped. The Order of the Golden Fleece, founded in 1430, is one example of the fusion, and it was at the eighteenth chapter of the Order that the *impresa* of its new Master, the young Charles V, was first displayed.[10] It consisted of two columns standing on rocks in the sea. They were joined together by a crown, and (in later versions) accompanied by the motto PLUS ULTRA (Fig. 28). The columns symbolized the two pillars of Hercules and the motto was an inversion of the note said by Le Fèvre to have been pinned to one of them by Hercules. Rather than a warning not to pass the pillars because there was nothing more beyond, Charles V's motto asserts a determination to go 'further still'. The device was doubtless originally meant to be

28. Portrait of Charles V, sixteenth century, Dutch

understood within the context of the Order of the Golden Fleece, but it also identified Charles V with Hercules and was later seen as an indication of his ambition to surpass the hero not just in geographical terms but in virtue, valour, and fame. Wherever Charles went, Hercules went too. The triumphal entries that were staged for him as he moved throughout his vast empire usually included the *impresa*, and sometimes more direct references to the emperor's Herculean achievements.[11] Parmigianino's portrait of Charles V, painted while he was in Bologna for his coronation, showed the infant Hercules offering him the globe as a symbol of the emperor's universal dominion. And when Charles V came to Florence in 1536, shortly after the marriage of his illegitimate daughter Margaret to his protégé Alessandro de' Medici, Tribolo's *Hercules and the Hydra* was erected with an inscription celebrating the emperor as the bringer of peace. Even at his funeral, the pillars of Hercules bore an inscription commemorating Charles as the conqueror of the monsters of that time.

However, Charles's travels rarely took him to places Hercules had not already visited. His paternal grandfather, Maximilian I (whom he succeeded as emperor), had also been seen as Hercules at least from the time of his wedding to the daughter of Charles the Bold. In Germany, they were not solely reliant on the Burgundian tradition. They had another classical source to go on, for Tacitus had claimed that Hercules had visited Germany, and that German warriors sang his praises before battles.[12] Annius had identified

a Hercules Alemannus distinct from the Greek and the Libyan Hercules, and the hero was incorporated into Habsburg genealogy. All the same, when Maximilian is portrayed as Hercules Germanicus in a woodcut of *circa* 1500, he looks awkward in his new guise: the lion-skin clings to his chest like a baby monkey, and he has to hold the club and bow as far away from his body as possible. Luther, who takes on the same identity in a woodcut that shows him giving the scholastics a good thrashing, looks much more at home in the role.

The dukes of Bavaria traced their ancestry to Hercules as well, and the labours of Hercules are shown in Thomas Hering's stone relief roundels in the Italian hall at Landshut (Fig. 50, p. 137). Unlike the smaller rooms with their mythological paintings, the Italian hall has famous men on the ceiling, and the planetary deities over the fireplace. It is not clear whether Hercules belongs with the former or the latter. On the façade of Heidelberg castle, he appears alongside statues of Joshua, Samson, and David on the first floor, separated from the planetary deities above by the Virtues on the second.

Hercules was also to be found further east. Matthias Corvinus's castle at Visegrad in Hungary had a Hercules fountain in the centre of the courtyard. In Poland, too, rulers were compared with Hercules from the fifteenth century onwards, although Herculean iconography only proliferated in the seventeenth, during the reign of Sigismund III.[13] The Vasa kings of Sweden were slower to take on the role, but there are references to Gustavus Adolphus as Hercules, and the major Swedish poem of the seventeenth century is Georg Stjernhjelm's epic, *Hercules*. According to Diodorus, Hercules did not make it to Britain, but others were not so sure – after all, had he not fought someone called Albion? Henry VII's achievements were compared with the labours of Hercules in a poem *Les douze triomphes de Henry VII* (1497), and in the reign of Henry VIII there were many Herculean tapestries in the royal collection.

So in the end Hercules went almost everywhere, even to places he had not managed to visit on his earlier travels. But the country in which he became most influential was Spain. Spanish chronicles like the thirteenth-century *Toledano* suggested that Geryon was the ruler of three provinces on the Iberian peninsula, and even in the late fifteenth century many Spanish writers still considered Hercules to have been an outsider who robbed Geryon of his herds.[14] Representations of the hero often appear as the result of some external stimulus. The triumphal entry of Charles V into Seville in 1526, which included a 'Hercules carrying the columns', may have helped to remind locals that Hercules was said to have been the discoverer, and Julius Caesar the founder, of their city. In the town hall, which was begun the

29. *Hercules Separating Calpe and Abyla*, Zurbarán

following year, the two figures appear prominently on the façade. During the sixteenth century Hercules appeared on the façades of other Spanish town halls, nowhere more spectacularly than at Tarazona, another Herculean foundation.

The sources of this imagery were often foreign. A series of plaquettes of the labours of Hercules by the Veronese gem-engraver Moderno (Fig. 40, p. 115) was repeatedly used in the most diverse of contexts, notably in the sculptural decoration of the house of Gabriel Zaporta, the imperial banker, in Saragossa.[15] At El Viso del Marqués, Genoese artists frescoed the main staircase with the labours of Hercules. Only at the start of the seventeenth century do depictions of Herculean themes become common in Spanish painting, beginning with Francesco Pacheco's *Apotheosis of Hercules* at the Casa de Pilatos in Seville, and culminating in Zurbarán's extraordinary group of ten of the labours for the salon of the Buen Retiro. Placed above the windows, and alternating with far larger paintings of Philip IV's victories, Zurbarán's paintings have a dark intensity (Fig. 29). Hercules' naked body, seen in a carefully rehearsed sequence of action poses, is sometimes all that emerges from the gloom. It is as though he is the practitioner of some occult martial art whose moves are re-enacted as manoeuvres in the teeming battle scenes beside them. There are no obvious correspondences, but intercut with the battles like an Eisenstein montage the intended effect is unmistakable.

However, the Spanish identification with Hercules could be turned against itself. If you thought about it, it was the three-headed monster Geryon who

was really Spanish. That, at any rate, is how the enemies of Spain saw it. Geryon features as Spain in both the iconography of Henry IV of France, and in Protestant propaganda after the Dutch Revolt. In the 1580s, the Protestant successors to the Spanish were also greeted as Hercules, and it is possible that Goltzius's oversized print of Hercules from 1589 reflects the sense that provinces have reclaimed their sovereignty, and with it, the Spaniard's Herculean identity, The grotesquely overdeveloped figure, holding the club in one hand and the horn of Achelous in the other, is accompanied by an inscription that refers to the hero's victory over many monsters, including, rather pointedly, 'you three-bodied Geryon'.[16]

Hercules arrived late in France, but when he got there he was quite at home, because he had been a Frenchman all along. Picking up a suggestion of Diodorus, Annius's history, published in France by the royal printer Geoffroy Tory in 1510, suggested that Hercules had come from Libya to Gaul, married a local girl, and founded a line of French kings.[17] Tory may have had this in mind when, at the start of a book about typography, his *Champ Fleury* of 1529, he quoted Lucian's description of a Gallic Hercules originally published in 1496, translated into Latin by Erasmus in 1506, and now made available in French for the first time.[18]

Lucian describes seeing a picture of Hercules as he was portrayed by the Celts. In it, Hercules has a pierced tongue from which chains lead to the ears of his companions. But it is not about fashion. Hercules is old and balding, and the chains represent the eloquence with which he keeps his listeners enthralled. So in the illustration that accompanied Tory's text, the French Hercules is shown leading his followers by the ears (Fig. 30). It is a weird image – too weird, in fact, to have much appeal to anyone other than a Frenchman or an emblematist. Yet it helped Tory make the point that the French are the most eloquent of peoples (according to Juvenal, they taught the British to speak properly) and that the vernacular language has the same powers of persuasion as Latin or Greek. Tory's motivation was linguistic rather than political, but the Gallic Hercules was just what Francis I needed to become a Hercules in his own right and on his own terms. The Gallic Hercules appeared in royal entries into towns from 1532 onwards, and when Charles V came to France, Francis I could be hailed as the Gallic Hercules alongside Charles's Libyan one. When the emperor was not around, however, French kings could be said to unite the combative qualities of the Libyan Hercules with the civilizing influence of the Gallic one.[19]

Literary references to the King as a Hercules Gallicus leading people by the ears continued to appear in verse, but the visual identification of French

30. *Hercules Gallicus*, from Geoffroy Tory, *Champ Fleury*, 1529

monarchs with Hercules was decreasingly reliant on this image. The military exploits of Henry IV lent themselves more easily to traditional Herculean iconography, and seventeenth-century French kings continued to employ Herculean imagery with little reference to the story that had spawned it.[20] Identification with Hercules was not confined to royalty, however. Great nobles were also sometimes compared to Hercules, and Louis XIII's chief minister Cardinal Richelieu was extravagantly celebrated as Hercules in verse and in the decoration of the Château de Richelieu, which included an *Apotheosis of Hercules* and a picture of Hercules and the Hydra accompanied by anagrams identifying the Cardinal with the hero.[21]

Despite its potential value as a means of portraying royal eloquence, the Hercules Gallicus did not enter the repertoire of other royal houses. There is a German Protestant print of Gustavus Adolphus as a Hercules Gallicus, but that is about it.[22] By that time, the Hercules Gallicus had been established by the emblematists not as a symbol of France but, as Lucian had intended, a type of eloquence. Alciati was the first to make an emblem out of Hercules Gallicus; others followed, and in Bonasone's print in Achille Bocchi's *Symbolicarum quaestionum libri*, he is given his own cart and the punning injunction from the gospels: 'Let him understand, he who has ears.' Valeriano took a different approach and made the pierced tongue the symbol of eloquence.[23]

Although Hercules Gallicus had gone straight into French royal iconography and into the emblem tradition, it was a while before he was picked up by the mythographers. This, of course, merely reflects the fact that Hercules Gallicus is not, strictly speaking, a figure from classical mythology at all.

Mercury was the god associated with eloquence in antiquity, and as a result the attributes of Hercules Gallicus and Mercury easily became mixed up. Dürer's drawing of an allegory of eloquence has Mercury dragging his followers along with chains from his mouth.

An image like the Hercules Gallicus, which is based on a single, slightly marginal, classical source and had no antique models, needed the emblem tradition to survive. The same was true of the story of the 'Choice of Hercules', or 'Hercules at the Crossroads'. The tale derives from the Greek sophist Prodicus which was known to the Renaissance through a variety of routes.[24] According to Prodicus, when Hercules was young and pondering his future two women appeared to him, one called Virtue, and the other Happiness, nicknamed Vice (Cicero says Pleasure). Both described the benefits of living their way – one path is a short and easy road to pleasure, the other a more arduous but ultimately more rewarding route to wealth and renown.

A variant of the story appeared in Silius Italicus's *Punica*, where the choice was given to the young Roman soldier Scipio as he sat under a beech tree, and it is this scene that was depicted by the young Raphael in his painting of the subject. However, many elements of Silius's narrative also found their way back into the representation of Hercules, and so the choice he made could be imagined with widely varying degrees of anecdotal elaboration. At its simplest it is a single letter, Y. According to Pythagoras (whose views were recorded by an obscure Latin poet believed in the Renaissance to be Virgil himself), human life was like a Y: at some point the path divides and one branch leads to Pleasure and the other to Virtue. Tory depicted it beautifully in *Champ Fleury*: the path of Pleasure has steps and a handrail, and a precipitous drop at the end; that of Virtue is less comfortable but not potentially fatal.[25] Cicero (who is quoting Xenophon quoting Prodicus) is marginally more forthcoming. He does not mention the two women and places the hero at the crossroads without much guidance – a scenario that appears only in Pierre Coustau's emblem book of 1555.[26] Xenophon, who gives the fullest account of Prodicus's story, includes the two women – one showing off her body, the other modestly dressed in white – but gives little indication of the setting. Silius Italicus introduces the tree and has Virtue describing her home set on a hill and reached by a steep rocky track.

Most descriptions of the scene reflect more than one source, and many make Hercules the protagonist in the drama described by Silius. Although there are passing references to the story in Petrarch and Boccaccio and it was discussed at length by Salutati, the subject first became popular in

Germany. The appearance of the tale in Sebastian Brant's *Narrenschiff* brought the tale into popular literary culture, and it remained a common subject for emblematists, artists, and writers. Unlike the Hercules Gallicus (and most of the other Herculean subjects found in emblem books), the 'choice of Hercules' was used by painters as well as printmakers. This may well have had something to do with the fact that Hercules often appears to be choosing between two women rather than two paths. The women could be identified as Venus and Minerva, which made the Choice of Hercules rather like the Judgement of Paris – a subject with which it is occasionally conflated in sixteenth-century German art.

What exactly was the hero choosing between? If one woman is naked and the other clothed or armoured, the choice is almost self-explanatory. When, as was often the case in later northern representations of the subject, both women are clothed, artists seem to have thought the options needed a certain amount of elaboration. The attractions of a nude Voluptas might be obvious, but a clothed Voluptas is often surrounded by a litter of vanities – jewellery, moneybags, musical instruments, wine goblets, even sports equipment – all metaphors for the female body. (But was not the female nude meant to be a metaphor for these things in the first place?) In Georg Stjernhjelm's Swedish epic the attractions of pleasure are indicated allegorically by the presence of Bacchus and Cupid. On the other hand, the benefits of Virtue, being intangible, are often less graphically illustrated. Military triumphs were one option, particularly if Minerva appeared armoured, as in the painting executed after Rubens's designs for the entry of Ferdinand of Austria into Antwerp in 1635. And explicitly Christian imagery eventually became more common, especially in Protestant countries. Indeed the subject itself could be conceived in religious terms, as it is in Thomas Bradshaw's *The Shepherds Starre* (1591), where the choice is aligned with that between Protestantism and Catholicism.

The version of the scene that proved most influential was, however, rather more secular in tone. The choice offered in Annibale Carracci's painting for the Camerino Farnese is not between sin and salvation but (as in the classical sources) between self-indulgence and renown (Fig. 31). The hero sits under a palm tree (a symbol of victory) rather than a bay. On one side, Pleasure indicates the trivial pursuits with which the hero might while away his time, while on the other Virtue points to a path where Pegasus stands on a plateau, waiting to take the hero higher still. The patron, Odoardo Farnese, had been likened to a new Hercules in his youth, so it is natural to assume that (as so often) the choice of Hercules has been transferred to the ruling prince or patron. Odoardo's father, Alessandro Farnese, had also been

31. *Choice of Hercules*, Annibale Carracci

presented with the choice, so here as elsewhere a new generation of princes was able to re-enact the choice of their predecessors. In many cases, of course, Hercules was himself the ancestor of the ruler, and so whether the decision was given to Maximilian I, Francis I, or Philip III, they always chose Virtue. The popes, who should not have had any trouble in deciding, were slow to catch on. But the future Urban VIII wrote a poem on the subject in which snakes infest the path of Pleasure.[27] Poussin put a snake on the path of Virtue instead.

As an account of Hercules' coming of age, the 'choice' displaced Le Fèvre's story that the hero, when thirteen, had gone to Mount Olympus and challenged all comers to outdo him in wrestling, running, shooting, stone-throwing, and feats of arms. It was the first ever Olympic games; needless to say, Hercules won all the medals. Depictions of the event appeared in editions of Le Fèvre, including the Dutch translation (Fig. 32). But the iconography did not establish itself in Italy, and although it was on account of his association with the Olympic Games that Hercules was the patron of the Accademia Olimpica in Vicenza, the internal decoration of Palladio's Teatro Olimpico included stucco reliefs not of his sporting victories, but of the twelve labours.

32. *Hercules at the Olympic Games*, from Raoul Le Fèvre,
Vergaderinge der historien van Troyen, 1485

In most contexts, Hercules' achievement was characterized by his completion of these labours. According to many classical sources he undertook them on the orders of his cousin, a weakling named Eurystheus. The canonical number of the labours given by late antique authors like Apollodorus and Hyginus was twelve: the Nemean Lion, the Lernean Hydra, the Erymanthian Boar, the Ceryneian Hind, the Stymphalian Birds, the Augean Stables, the Cretan Bull, the Mares of Diomedes, the Girdle of Hippolyta, Queen of the Amazons, the Cattle of Geryon, the Apples of the Hesperides, and Cerberus.[28] These twelve frequently appeared together in classical art, and at least one sarcophagus relief showing the sequence was known to artists in Rome from the early sixteenth century. Its influence can be seen in the central colonnade of the *Triumph of Hercules* tapestry for Leo X (Plate IX), and on carved *cassoni* later in the century. Some lines of verse, believed at the time to be by Virgil, were frequently quoted in celebration of the twelve canonical labours, and these twelve also feature in the epigram to Alciati's emblem of Hercules.[29] However, they almost never appear together elsewhere in the Renaissance.

For example, only four of the labours in the pageant at the wedding of Charles the Bold overlapped with the canonical twelve. In this case, all were drawn from Le Fèvre, but even when ancient sources were used, the canonical labours did not have priority. The main reason for this was that

Boethius had listed a different twelve that included Achelous, Antaeus, Cacus, the Centaurs, and Hercules supporting the Globe (though not Geryon, the Stables, the Amazons, the Bull, or the Hind). Boethius's *Consolatio* had attracted numerous commentators, translators, and illustrators (Fig. 33 – the figures on the far right are unrelated: the Cyclops Polyphemus with Agamemnon below). His sequence of the labours is to be found in Chaucer, in Villena, and, with one change (Geryon for the Birds), in the *Libellus*. Even in the sixteenth century, this grouping was far more influential than the canonical one. Boethius was the basis for Peruzzi's frieze of the labours at the Villa Farnesina, and the *Libellus* the inspiration for Frans Floris's group of ten paintings executed for the Antwerp merchant Niclaes Jongelinck. However, there are modifications in both cases, and it is unusual to be able to trace the selection of labours to a single literary source. Classical authors had described many other exploits as well, and any comprehensive tally was much higher. Salutati followed Boccaccio in listing thirty-one; de' Bassi described twenty-three; Agrippa d'Aubigné knew of thirty-four, and the seventeenth-century alchemist Michael Maier managed to come up with thirty-six, although all these writers included events from the hero's life that were not strictly labours at all.

With so many to choose from, it was not easy to fit them all in. *Le dodici fatiche di Hercole*, an illustrated late fifteenth-century poem, got round the problem by selecting twelve feats from Diodorus, and then dealing with Hercules' love-life and death in a second part. In the visual arts, artists and their advisers just picked and mixed their Herculean subjects depending on the number of slots available. Here the total is often ten or less. Few rooms could accommodate twelve tapestries, while in painting, the labours were often a way of filling friezes, lunettes, or other small recurring spaces in larger schemes. Other than in print, only the most ambitious projects – for instance, tapestries for Mary of Hungary and for the Duke of Bavaria, Rossi's fountain, Wenzel Jamnitzer's casket, and Zurbarán's paintings for the Buen Retiro – showed the clear (if sometimes unrealized) intention of bringing the number up to twelve.

Depictions of Herculean subjects were not especially common on painted *cassoni*, and, in Italy at least, easel paintings of the labours were rare. Herculean imagery proliferated in other media, especially in those (such as print or small relief sculpture) that lent themselves to serial treatment. Early examples include a series of plaquettes derived from the Hercules sarcophagus (now lost, but known from nielli), and Moderno's plaquettes – which may have inspired both Antico's medallions of the labours, and the prints of Herculean subjects after Mantegna. However, series of prints

33. *Labours of Hercules*, from Boethius, *De consolatione philosophiae*, 1501

devoted to the labours did not became common until the early sixteenth century. Drawings by Raphael suggest that he may have been working on a set, but it was Caraglio's six prints after Rosso that were finally published by Baviera.

Several of Caraglio's prints were used by maiolica painters in the 1530s, but for all their drama they had nothing like the impact of a set of woodcuts by Giovanni Andrea Valvassori produced in Venice at the beginning of the century.[30] It comprises twelve subjects from Boccaccio beginning with Hercules' birth (and the strangling of the serpents) and ending with his death, and is distinguished by the fact that Hercules carries a mace rather than a rough wooden club (he also carried a mace in earlier marginal drawings to a manuscript of the *Libellus*). The series, some of which are known only from much later French copies (Fig. 42, p. 118), was used as the basis for a wooden frieze at the castle of Vélez Blanco in Spain, and also had a lasting influence in southern Germany. When artists in Dürer's studio were working on drawings for a set of twelve medallions of the labours, they took over Valvassori's selection of subjects and many of his designs as

well. Thirty years later, the appeal of Valvassori's prints was undimmed. They were the model for the majority of Thomas Hering's roundels in the Italian Hall at Landshut (Fig. 50, p. 137) and, in 1550, for Heinrich Aldegraver's series of engravings. All of Valvassori's imitators appear to have worked independently of each other, and although each substitutes alternative designs for some of the labours, there are few variations in the selection of subjects. This degree of conservatism in an area where inconsistency was the norm suggests that artists were choosing their own subjects rather than using other sources of iconographical information. It was not until the 1540s that Hans Sebald Beham's series offered an entirely independent range of subjects and images.

Taken together, all these prints and plaquettes provided a portable repertoire of Herculean imagery for craftsmen working in other media. The designs from Dürer's studio were used by the Nuremberg goldsmith Ludwig Krug for the shell cameos he carved to ornament a covered cup. Aldegraver's prints after Valvassori were in their turn faithfully reproduced by Pieter Maas on a set of parcel-gilt plates made by Thomas Bampton of London in 1567. Motifs from Valvassori, Caraglio, and possibly Moderno reappear in the stone reliefs of the labours on the rood-screen in the cathedral at Limoges. And the screen, which was carved in the 1530s, may itself have provided inspiration for local craftsmen working in enamel. Around the mid-sixteenth century the labours are depicted on numerous caskets and salt-cellars produced in Limoges. The designs draw freely on earlier sources. There are Hercules caskets based on Valvassori and a candleholder in which Aldegraver's series is reproduced round the base.

Herculean subjects rarely appear among the surviving white-lead pastiglia boxes of the Veneto. However, many-sided objects like caskets potentially provided a good way to display the labours. The gilt jewel casket made by Wenzel Jamnitzer, probably for the Duke of Bavaria, depicts the labours using formulae loosely derived from Aldegraver and others. But the designs used to decorate precious objects like this were not necessarily derivative. Influence could travel in the opposite direction as well. Annibale Fontana's rock-crystal intaglios for a now dismantled casket from the ducal collection in Mantua were reproduced as plaquettes in ivory; many years later, they were used by Algardi as the basis for his stucco reliefs of the labours on the ceiling of the Galleria di Ercole at the Villa Doria Pamphili.

To a greater degree than other mythological subjects, representations of the labours retained the character of their sources: intaglios became stuccoes; bronze reliefs were reworked as stone reliefs, and so on. Even where no specific source is evident, it is not unusual to find the labours represented

as a series of grisaille paintings, or (at Landshut and the Alhambra) as medallions set in a wall. One consequence is that many of Hercules' super-human feats appear on quite a small scale and in monochrome.

All the same, the labours chosen were not a random selection. Some are essential to the hero's identity, others merely curiosities. If there is a defining moment in the life of Hercules, it has to be his struggle with the Nemean lion. It was his first job. The lion had an invulnerable pelt, and Eurystheus, at whose command Hercules undertook all the canonical labours, told him to go and fetch it. Arrows just bounced off the lion's fur, so Hercules had to tackle the beast with his bare hands. It was easier said than done, and Renaissance artists imagined the scene every way they could. Many followed Moderno in using the antique model of a head-to-head wrestling match. The hero would surely have come off worse in this – only Floris's Hercules had the sense to wedge his club between the lion's jaws. Some sensibly show him approaching the lion from behind. In the classical sources Hercules strangles the lion, yet in the Renaissance he is often shown straddling the beast and ripping its jaws apart. Strictly speaking this was Samson's technique, but it was used in works from the circle of Mantegna, and was widely disseminated through Valvassori's prints. Antico's relief shows why it was popular (Fig. 34). Whereas the excitement of a head-to-head confron-tation easily gets lost in a tangle of manes, Samson's technique allows the viewer to see the lion's fangs and claws.

Hercules removed the lion's skin, and thereafter wore it himself. It goes without saying that he did not wear it during the fight with the lion, and most artists remembered to leave it off. All except Michelangelo, who in a red chalk drawing of three of the labours shows Hercules wearing it. He knew he had made a mistake, and tried to cover himself with a note saying that this was actually the second of the lions killed by Hercules. You can believe him if you want to, for Hercules did kill other lions as well, and in illustrations to Le Fèvre he takes on three at once. Taking shelter in trees behind him are Molorcus, a shepherd the lions had forced up a tree, and Hercules' man, Philotes.[31] They are still stranded up there in Cort's print after Floris and in sixteenth-century Flemish tapestries based on other literary sources.

Attired in the lion-skin, Hercules became more than a little leonine himself. In Pollaiuolo's *Hercules and the Hydra*, the violence comes less from Hercules' taut, classical pose than the lion-skin that billows out behind him and transforms his entire upper body into one voracious pair of jaws. Here it looks as though the Hydra is going to be clubbed to death. But that was never

34. *Hercules and the Nemean Lion*, Antico

going to happen because every time it loses one head two more grow in its place. In fact, Hercules only manages to kill the monster with the help of his nephew Iolaus, who prevents this proliferation by cauterizing the stump of each severed head with a burning faggot. In Zurbarán's version you can see the lad, torch at the ready, peering nervously into the Hydra's cave.

The Hydra obviously needs help and so Juno sends a crab. In Cort's print after Floris, a whole army of reinforcements is arriving. But Hercules kills the crab; Juno sets it among the stars, where it becomes the constellation Cancer. The story is in Hyginus's *Poetica astronomica*, and so Hercules and the Hydra appear in one of the hexagons of the Sala di Galatea at the Villa Farnesina. In Floris's painting the Hydra has ten heads, though the usual number (given by Seneca and Boccaccio) is seven.

The other struggle depicted by Pollaiuolo is with Antaeus, a Libyan giant

35. *Hercules and Antaeus*, from Enrique de Villena,
Libro de los trabajos de Hércules, 1483

who was in the habit of challenging passing strangers to a wrestling match – a challenge that was not entirely fair, because his mother was the earth and he was invincible when in contact with her. Hercules knew what to do. He held him in the air so that no part of his body was in contact with the ground, and squeezed the life out of him while he was separated from his mother. You do not often get to see the mother, but in Floris's painting Hercules is treading down the hag with his left foot as he hoists her son into the air. A psychoanalyst might have something useful to say about this, and indeed about many other representations of the subject, for there is often something weirdly sexual about the confrontation. In the 1483 edition of Villena, for example, Hercules is lying on the ground holding the giant on top of him. Antaeus's tongue sticks out provocatively (Fig. 35). If it looks like the mating ritual of two ungainly insects, it is not wholly inappropriate: from Fulgentius onwards, Antaeus was regularly identified with lust.[32]

In Floris's painting, the front-to-back pose of the wrestlers is derived from a famous antique statue known in Rome from at least the early sixteenth century. Although something like this position was also implied by the descriptions of the struggle in Lucan's *Pharsalia* and Philostratus,[33] the moral tradition pointed in another direction. According to Fulgentius, Antaeus's name came from the Greek *antaios*, meaning facing or contrary, and less antiquarian artists often preferred the psychological intensity of a head-to-head confrontation. You can see the dramatic benefit in Pollaiuolo's

statuette where Antaeus rises above Hercules, and desperately tries to push Hercules' head away with his arm.

The upward momentum of Antaeus's body is accentuated further in Tribolo's reworking of Pollaiuolo's group, later cast by Ammannati for a fountain at Castello (Fig. 22, p. 77). Looking at the figures soaring above, you are reminded of Landino's interpretation of the struggle. Whereas Salutati had thought that lifting Antaeus from the earth just meant depriving him of his nourishment – rather like Terence's '*Sine Cerere et Baccho friget Venus*' ('Without Ceres and Bacchus, Venus grows cold') – Landino believed Antaeus was the irrational part of the soul being raised 'on high towards divine things'.[34] Neither the fountain nor Pollaiuolo's composition was based on Landino's text. However, Landino would have seen Pollaiuolo's painting in the Palazzo Medici and it is hard to imagine how he could have thought in these terms had his mental picture of the struggle been the classical one, let alone that shown in Villena.

If Antaeus was a well-matched adversary with whom a struggle could be interpreted by Dante in terms of a medieval trial of strength,[35] Hercules' victory over another giant, Cacus, is distinctly punitive. Cacus had for centuries been identified with *kakos*, the Greek for evil, and Hercules shows him no mercy. He is often holding the giant down, or stamping on his genitals. Notwithstanding the appeal of the Greek etymology, the story is not part of the Greek cycle of stories about Hercules, and its literary sources are predominantly Roman – notably the *Aeneid*, Livy, and Ovid's *Fasti*. Bringing the cattle of Geryon back from Spain, Hercules stopped in Rome, where the fire-breathing giant stole some of them, concealing his traces by dragging them backwards to his cave.

In Caraglio's print after Rosso, Hercules catches him in the act (Fig. 36). The figure of Hercules, which comes from Rosso's *Moses and the Daughters of Jethro*, works better here than in the painting. With one movement Hercules seems simultaneously to overtake, apprehend, and strike the thief. The economy and drama of the action made this print a model for other artists. It is reproduced in this form on a plate decorated by Avelli, but on the Limoges cathedral relief only the pose of the hero is retained and Cacus is shown lying on the ground. Indeed, the pose became so characteristic of the hero that it is also used in other contexts, such as Hans von Aachen's allegorical *Hercules Overcoming the Vices* for Rudolf II.

The literary sources actually describe the encounter between Hercules and Cacus taking place in the gloom of the giant's cave – a sinister place decorated with the heads of his victims. A print by Goltzius shows the struggle in all its sepulchral horror, but, for obvious reasons, most artists

36. *Hercules and Cacus*, Jacopo Caraglio after Rosso Fiorentino

preferred to locate it in the open. Cacus had lived on the Aventine hill, so in the early seventeenth century, when the countryside around Rome was first explored by artists, the subject found its way into landscapes. Domenichino painted a pair showing *Hercules and Cacus* and *Hercules and Achelous* for the Villa Ludovisi in Rome, and Poussin later produced a strange *Landscape with Hercules and Cacus* in which the action, seen in the far distance, is tonally merged with the mountainside on which it is set.

108

The *Libellus* said that Cacus was a centaur, but he is rarely shown as such, not least because Hercules had so many other centaurs to deal with. He fought most of his adversaries only once, but he had encounters with centaurs on several occasions. The centaurs were the descendants of Ixion and a cloud shaped in the form of Juno. They were a rough lot, and they could not go anywhere without causing trouble. When the Lapith king, Pirithous, invited Eurytus and some other centaurs to his wedding with Hippodamia, they got drunk and tried to make off with his bride and the other Lapith women. A fierce battle between the Lapiths and centaurs ensued, which Theseus helped the Lapiths to win. However, Boccaccio said that it was Hercules who came to their assistance, and he cited Ovid as a source, although – as Salutati noted – Ovid makes no mention of his involvement in the fray.[36]

Nevertheless, the subject became a common one, popularized by Valvassori's woodcut. It is usually a mêlée, and sometimes (as in Aldegraver's version) Hercules rescues a woman from the clutches of a lustful centaur. Representations of the story of Pholus, a hospitable centaur who opened a jar of wine for Hercules but then left him to fight off the gatecrashers, are rare by comparison, though the tale appears in *Le dodici fatiche*.[37] When Hercules is fighting centaurs alone (without the presence of a tell-tale jar, or of women and other combatants) there is litle reason to suppose that the battle is anything other than generic. And the same is obviously true of Giambologna's *Hercules and the Centaur* in the Loggia dei Lanzi in Florence. Here, however, Hercules has subdued his opponent and is about to finish him off with his club. The Medici now wanted images of domination rather than struggle.

Although Hercules killed a couple of centaurs with arrows (one was Chiron, perhaps the subject of Beham's print of Hercules shooting a centaur, the other Nessus – but that is another story), he generally fought them with the aid of his club. He can also often be seen swinging his club at Cerberus. However, that is misleading, for this was not a search-and-destroy mission: the three-headed dog who guarded the entrance to Hades had to be brought up from the underworld, simply shown to Eurystheus, and then returned to his post. The only problem was that Cerberus did not want to go, and so he growled and dug in his heels as Hercules tugged on his chain. In some versions of the subject – Rosso's print and (following him) Floris's painting and the works derived from it – Hercules tackles Cerberus while stepping over the body of a man. This is probably Pirithous, who had been killed by Cerberus when he and Theseus tried to snatch Proserpina from Hades.[38] However, the commentary of pseudo-St Thomas on Boethius conflates the

FATA PHERÆCIADÆ MISÉRANS VXORE REDEMÉTA ABSTVLEF ALCESTEN CERBÉRE SÆVE TIBI

37. *Hercules and Cerberus*, Cornelis Cort after Frans Floris

two stories and has Hercules join Theseus and Pirithous's venture. This version of events is reflected in Le Fèvre (where woodcuts show Pirithous lying in just this position, and Hercules actually brings Proserpina back to Ceres), Valvassori, and probably also the *Triumph of Hercules* tapestry (Plate IX).[39] According to most sources (except Diodorus) Pirithous never returned from the expedition, though Theseus remained alive in Hades. Hercules eventually freed him, as he also did Alcestis, who had saved her husband Admetus from death by dying in his place. She can be seen emerging from the underworld in Cort's print after Floris (Fig. 37).

These stories (only three of which belong to the canonical twelve, and one of which is not even Greek) form the core of any Hercules cycle in the Renaissance. When, as was often the case, only a few of the labours are depicted (for instance, in Mantegna's Camera Picta in Mantua) they tend to be drawn from this group, and when a larger number are shown these are the ones least likely to be omitted. Yet over time there is a discernible shift in emphasis. In the fifteenth century the model tends to be the manly struggle with Antaeus – a duel in which the combatants almost mirror one

another – but by the seventeenth century it is the battle with the Hydra, the suppression of the monstrous feminine, that is the most frequently represented of the labours.

Given the concentration of mythologies on *istoriato* pottery, you might expect it to be a rich source of Herculean subjects. It is not. Imagery used on maiolica was often Ovidian, and although Hercules' exploits are reviewed in Book 9 of the *Metamorphoses*, most involve no transformation of any kind and are passed over quite quickly. Translators routinely filled out these brief allusions by extending Hercules' lament, but the original text focused on Hercules' birth and death rather than his achievements; for this reason Ovid is not generally a major source for the depiction of the labours. The labours would have made good subjects for a service, yet when Francesco Xanto Avelli (who tackled more Herculean subjects than most) painted one for a family whose device of Hercules and the Nemean lion appeared on every plate, no attempt was made to find matching subjects. In fact, only one of the surviving eight has a Herculean theme – a Hercules and Cacus in which Hercules has the giant bending over for beating like a naughty schoolboy.

The one medium in which a broader range of the labours appears is tapestry, for sets of Herculean tapestries remained popular from the mid-fifteenth to the mid-sixteenth century. Fifteenth-century Flemish tapestries based on Le Fèvre include many unusual subjects, though these were no longer present in the set of Hercules tapestries woven in Brussels for Mary of Hungary in the mid-sixteenth century. The subjects are chosen from Boethius, but even then tapestry design remained at one remove from the *all'antica* designs that were disseminated through prints and plaquettes: Cerberus and Achelous are shown with human bodies, just as they were in fifteenth-century illustrations to Ovid. In contrast, Floris's contemporary paintings of the labours in Antwerp utilized Roman prints. About ten years later, Cort's engravings after Floris provided the basis for a set of tapestries of the *Labours of Hercules* woven in Antwerp for Duke Albrecht of Bavaria's castle at Dachau.

Here, as so often, *all'antica* designs found their way into tapestry via other media. Of the additional tapestries added for Duke Albrecht's series, one was based on a print by Agostino Veneziano after Giulio Romano, depicting the infant Hercules strangling two serpents. Boccaccio had made this precocious feat the first of the labours, and (although there was no classical basis for this) many others, including Valvassori, followed suit. Vasari's painting of the subject in the Palazzo Vecchio shows Hercules

strangling the serpents in front of his parents, Jupiter and Alcmena. By this time, however, Jupiter was long gone. He stayed only one night in Alcmena's bed (although he did enjoy himself so much that he delayed the dawn, and some said he was actually there for three nights), having deceived her by taking the form of her husband Amphitryon while he was away at the wars. According to Plautus, whose version is reflected on a mid-fifteenth-century Sienese *cassone*, Amphitryon came home while Jupiter was still there and Mercury had to keep him talking outside.[40] But in the end it was Juno, not Amphitryon, who caused trouble. Ovid said she kept Alcmena in labour for seven agonizing days by having Lucina, goddess of childbirth, sit outside the door with her legs crossed and her hands clasped. (The scene often appears in illustrated editions of the *Metamorphoses*.) Eventually, one of Alcmena's servants surprised Lucina into opening her arms; Hercules was born, and Lucina spitefully changed the servant into a weasel.

That was only the beginning. One night Juno sent two enormous serpents to kill the child. Hercules, sleeping with his twin brother Iphicles (fathered by Amphitryon on his return), woke up and strangled them with his bare hands. The scene, from which Iphicles is usually omitted, is illustrated in Le Fèvre, and is also fairly common in Italian art. It shows the infant in his cradle with Alcmena and various nursemaids recoiling in horror. Theocritus plays up the domestic drama, and it is this we see in Agostino Veneziano's print (Fig. 38).[41] Alcmena wakes her husband, who lights a lamp to see what is going on. The sight that greets their eyes is extraordinary. Silhouetted against the wall, one arm raised like an infant Laocoön, the child wrestles with the serpents gripped in his pudgy fists.

People obviously felt the lack of a proper beginning to Hercules' labours, and so Agostino's print was also co-opted for a series of Herculean frescoes at Soragna, based on Caraglio's prints after Rosso. Among the other scenes in the series is the hero's struggle with the river-god Achelous – a rival for the hand of Deianira – who battled with Hercules first in human form, then as a serpent, and finally as a bull. Achelous survived to tell his own story in the *Metamorphoses*, where Hercules' struggle with the river-god in each of the three forms is frequently shown in a single woodcut. The earlier phases of the struggle therefore look very like the battles with Antaeus and the Hydra, and so it is no surprise to find Franco transforming them into these labours in his illustration to Book 9 of Anguillara's translation.

Hercules subdued the bull and pulled off one of his horns, which was given to the nymph Abundance and became a horn of plenty. In Rosso's influential version, Hercules is as agile as a cowboy wrestling a steer, but in Colard Mansion's Ovid, and in some later tapestries, the scene is more

38. Hercules Strangling the Serpents, Agostino Veneziano after Giulio Romano

contrived. Achelous appears as an armoured warrior with a bull's head, a sort of minotaur, while Hercules, attired in Mansion's version in what looks suspiciously like a space-suit, stands over him in triumph (Fig. 39). Thankfully, this semi-human Achelous was long forgotten by the time the butchers of Antwerp featured the struggle in the centre of their beef-themed arch for the entry of Ferdinand of Austria in 1635.

Unlike the river-god Achelous, the Cretan bull actually was a bull, perhaps even the one who had abducted Europa and fathered the Minotaur. Hercules went to Crete, subdued the beast, and brought it back to Eurystheus. Although the subject had been popular in antiquity, in the Renaissance it was largely supplanted by the story of Achelous (which had the authority of Boethius and Ovid). One bullfight looks much like another, and unless Hercules is actually pulling off one of the horns (or the nymphs to whom it is given are present in the background) it is difficult to distinguish between the two struggles.

However, you can see Hercules with the bull over his shoulder on the *Triumph of Hercules* tapestry (Plate IX). And in the late fifteenth-century frieze at Castel Bracciano, he takes the bull back by boat. Here, it is the

39. *Hercules and Achelous*, from Ovid, *Metamorphoses*, 1484

Erymanthian boar who gets a piggyback home. Hercules had captured the boar by chasing it until it was exhausted (although the *Libellus* states that he struck it with his club, as he does on Jamnitzer's casket). The boar was still alive, and at Bracciano there is a glint in his eye. When Eurystheus saw the monster he was so frightened he hid in a jar; the scene is not included at Bracciano, but the boar seems to remember it.

Hercules' encounter with Geryon is one of those labours for which no one ever seems to have found a satisfactory formula. It was a tricky operation. Hercules first had to dispatch Geryon's two-headed dog, then the three-headed giant himself, and finally bring his herd of cattle all the way back

40. *Hercules and the Cattle of Geryon*, plaquette, Moderno

from Spain to Greece. Moderno's dramatic representation of Hercules simultaneously taking two bulls by the horns (perhaps inspired by antique representations of him restraining two of the horses of Diomedes) worked well in sixteenth-century Spain, where it was often reproduced (Fig. 40), but it was usually the fighting rather than the fetching that people wanted to see. This was awkward, because although multiple heads could look surprisingly good on a dog, placed on a man's shoulders they tended to confuse the viewer. Elsewhere, Geryon sometimes makes do with only one head, although not because a three-headed man was thought impossible. Sandys notes that a Geryon was quite conceivable since he had it on good authority that a pair of Siamese twins joined at the waist had recently lived to the age of twenty-eight, both excelling in music, speaking several languages, and arguing with one another, until one torso died and the other 'pined away with the stench thereof'.

It was in the far west, too, that Hercules picked the apples of the Hesperides. The apples had been the Earth's wedding present to Juno when she married Jupiter. They grew on a tree on an island where they were guarded by the dragon Ladon, and tended by the Hesperides, nymphs of the evening. It was Hercules' job to go and fetch them. He killed the dragon, and picked the fruit. For the entry of Cardinal-Infante Ferdinand into Antwerp in 1635, Rubens placed the story on the summit of the Arch of the Mint. Seen from the back, the scene represents the mining of precious metals in the Spanish dominions of the New World. For Hispania, who plucks the fruit, money

grows on trees. But she can only do so because Hercules has defeated the dragon, a labour that now becomes an allegory of the processes of production visible below – the backbreaking work of the miners (many doubtless slaves) and the craftsmanship of Vulcan who transforms the raw materials into the wealth so effortlessly harvested above.[42]

The role of Antwerp in the world economy had cetainly grown since the fifteenth century. In one of the woodcuts to the Dutch translation of Le Fèvre, a herd of sheep is grazing on a plateau, and Hercules is climbing up to take on their heavily armed shepherd. It would be hard to guess which of the labours is illustrated here were it not for the fact that the Greek word for sheep, *mēlon*, is the same as that for apple. Palaephatus and Diodorus had suggested that the quest for the apples of the Hesperides might actually have been sheep-rustling, and Le Fèvre went along with the suggestion, making the giant Atlas the guardian of the herd and Theseus Hercules' companion in arms.[43] This version of the story is in keeping with Le Fèvre's general preference for rationalized versions of myth, but in the mid-fifteenth century, when wool was still gold, it also made economic sense in a way that it would not have done a century later.

In the villas around Rome, there is no hint that Hercules might have been trading in anything. The garden of the Hesperides was just that, and so could be recreated at will. The most ambitious project, never fully realized, was at the Villa Este at Tivoli, where a statue of Hercules holding the apples stood above the Fountain of the Dragons. Celebratory verses imagined Hercules presenting the apples to the patron, Cardinal Ippolito d'Este, who reciprocates by dedicating the garden to Hercules (who had associations with both the Este family and the ancient Roman town of Tivoli).[44] Somewhat less polite, though far more entertaining, were the complicated automata pictured in Giambattista Aleotti's translation of Hero of Alexandria's treatise on pneumatics, *Gli artifitiosi et curiosi moti spiritali* (1589): as Hercules brings his club down on the dragon's head, the monster responds by spitting water directly into his face (Fig. 41).

For earlier generations of commentators, however, the story belonged not in the garden, or the Americas, but in the sky. According to Hyginus, Juno set the defeated dragon among the stars, where he could be seen between the two bears.[45] Now the battle continues in the heavens, for Hercules is there too, his left foot on the dragon's head. This is the scene towards which the astrologer gestures in the French print after Valvassori's depiction of the Hesperides (Fig. 42). But there is a double significance here, for the figure holding the globe is Hercules himself, and the astrologer none other than Atlas, whom Hercules has relieved of his burden.

41. *Hercules and the dragon of the Hesperides*, from Hero of
Alexandria, *Gli artifitiosi et curiosi moti spiritali*, 1589

The idea that Atlas was actually an astrologer was found in Diodorus. He
took the picture of Atlas bearing the celestial globe upon his shoulders to
mean that he had discovered the spherical nature of the heavens, and the
tale of Hercules relieving him of his burden as an indication that this
knowledge had been passed on to the hero. Le Fèvre made this transfer the
subject of his version of the story, and in one of the woodcuts to the 1494
edition Atlas can be seen carrying a couple of heavy books on his shoulders.
Whatever Atlas taught Hercules, it does not yet seem to have been the
spherical nature of the heavens: fifteenth-century representations of the
subject often show them as an amorphous cloud.

According to some accounts, Hercules had to enlist the help of Atlas to
obtain the fruit, and held the heavenly sphere while he did so.[46] In others
Hercules simply takes over when the giant is exhausted by his burden. It
was on this basis that the image became a symbol of the transfer of power.
The subject was used to illustrate the abdication of Charles V and the
succession of Philip II in Philip's entries to Milan in 1548 and Antwerp in
1549. Charles, who had spent his life as Hercules, now took on the role of
Atlas and passed the burdens of state to his son, the new Hercules. But
these responsibilities were not just passed down the Spanish branch of the
Habsburg line: Hercules holding the globe also appears on Rudolf II's
armour in a relief by Adriaen de Vries.

Apres auoir occis, l'insommeille serpent,
Les pommes d'or ie cueille au Iardin d'Hesperie,
Porte le faix du Ciel, qui dessus tout s'espend,
En soulageant d'Athlas, la force deperie.

42. *Hercules and Atlas with the Garden of the Hesperides,*
after Giovanni Andrea Valvassori

The motif was used in a similar way at the Villa Aldobrandini at Tivoli, where a statue of Hercules receiving the heavens from Atlas was at the centre of the Teatro dell'Acqua. The poets celebrated Cardinal Aldobrandini as a Hercules taking the globe upon his shoulders, just as later they celebrated Cardinal Camillo Pamphili, for whose villa Algardi produced a stucco on the theme. Despite its popularity with papal families, this imagery does not appear to have been used in the *possesso* (the procession of a new pope) where it would obviously have been relevant, even though an earlier pope, Leo X, had also been likened to Hercules shouldering the burden of the universe.[47]

Representations of Hercules carrying the pillars of Gades were unknown in antiquity, and it was Boccaccio who made the subject into one of the labours. The travels of Charles V did much to disseminate the subject, though Valvassori's woodcut (which was wholly innocent of Habsburg propaganda) did more to determine its appearance. In earlier imagery, the hero often transports the columns by boat, but in Valvassori's print the hero is trudging along with one column over each shoulder, and the sea and the upright pillars guarding the straits in the background. Hans Sebald Beham's print of the subject does without sea altogether, and has Hercules carrying the pillars through a townscape (Fig. 43). The image was quickly recycled in Poland as part of the decoration of the town hall in Poznań.

It was generally assumed that the Straits of Gibraltar were already in existence, and that Hercules had, if anything, narrowed them with a pair of classical columns. But as Diodorus acknowledged, there was another tradition in which the Mediterranean had originally been an inland lake cut off from the Atlantic by a range of mountains until Hercules created a passage between them by pushing apart the mountains Calpe and Abyla. This version appears in Zurbarán's series, where the hero is almost bent double with the strain of forcing the mountains apart (Fig. 29). It carried a different implication. Whereas placing the columns at the straits was essentially defensive (according to Diodorus, an attempt to keep out the sea-monsters), opening up the Mediterranean meant that Hercules was the one who had cleared the way for the Spanish exploration of the Atlantic.

It was very often these rather than the canonical labours that made up the numbers when the hero's exploits were illustrated as a series. Of the canonical twelve, six were to varying degrees marginalized in the Renaissance – the Cretan Bull, the Hind, the Birds, the Mares, the Amazons, and the Stables. This can partly be explained by the omission of most of these labours from the listing found in Boethius and the *Libellus*. But that is not

43. *Hercules Carrying the Pillars*, H. S. Beham

the whole story. With the exception of the Amazons and the Cretan bull, these subjects were also the ones least commonly represented in ancient art. Given that people in the Renaissance were unaware of the frequency with which subjects appeared in antiquity, it suggests that there was something about the labours themselves that failed to catch the imagination. Although no one seems to have spelt it out, you cannot help feeling that these tasks may have been thought to be beneath the hero's dignity: one of the labours is pest control, and the last is a contract cleaning job.

In several cases Hercules' adversaries are female. The Ceryneian hind had golden horns and hoofs that allowed her to outrun everything until the indefatigable Hercules grazed her with an arrow and carried her back. The idea that a female deer made an unsuitable quarry is confirmed by the tendency for artists to prefer the version of the story in which the beast is male, the Arcadian stag. However, there was no way to turn the Amazons into men, or to give a more heroic gloss to the story of how Hercules went to fetch the girdle of Hippolyta, Queen of the Amazons. And although the battle with the Amazons was illustrated in the Italian Ovid of 1497, the subject did not catch on.

Another problem with these labours was that several involved retrieving something of value, rather than suppressing something undesirable. Her-

cules' allegorical identity focused on his role as a destroyer of monsters, not as a collector of rarities. The Stymphalian birds were not exactly monsters, but they lived in huge numbers deep in the woods of Arcadia and had started to plague the surrounding area; so Hercules frightened them into the air with a rattle and then shot them down with arrows. It is one of the canonical labours, and is also in Boethius's twelve, but it rarely appears in this form. The Stymphalian birds never found their Hitchcock because the story became conflated with another. Phineus also had a bird problem. He was blind and the Harpies used to swoop down onto his table, stealing some of the food and fouling the rest. According to the *Aeneid*, these Harpies were found on the Strophades, islands in the Ionian sea. Servius was clear about the difference between the Strophades and the Stymphalides, but Hyginus already had them muddled, and in subsequent mythographies they became fused.[48] The confusion spread through translations, commentaries, and illustrations to Boethius. Boccaccio also affirmed that the Stymphalian birds were Harpies, and although Salutati was aware of the difficulties and made them into separate labours, no one else cared.[49] In Villena, the story of King Phineus is substituted for the Stymphalian labour, and the formula employed in the woodcut for the 1483 edition is also that used at Bracciano (Fig. 44) and the Villa Farnesina – all perhaps derived from Boethius.[50] Even without Phineus, the Harpies are often substituted for the birds, and Hercules shoots Harpies in Dürer's painting of the Stymphalian birds and in the tapestries derived from it. So when Hercules whacks a Harpy with his club on Cortona's Barberini ceiling, he has not quite left the realm of mythology for that of allegory.

Other stories were probably marginalized on grounds of taste as much as anything else. Diomedes, King of Thrace, was in the habit of feeding his four mares on human flesh, and when Hercules killed him he too was eaten. This moment is the one usually shown in representations of the subject, as it is in the tapestry for Mary of Hungary, where the mares lower their heads to eat with the tentative grace of the natural herbivore (Fig. 45). Le Brun's more dramatic version, painted for Cardinal Richelieu, draws on the description and illustration to Vigenère's Philostratus in which, rather than killing Diomedes and leading the sated horses away, Hercules has to subdue the writhing animals with his club.[51] If the sight of horses eating a man was not all that appealing, the thought of mucking out the Augean stables was truly repulsive – not just to patrons of the arts but to Hercules as well. Diodorus says it was because Hercules thought the task unworthy of him that he diverted the waters of the river Alpheus through the stables to do the job for him. This is what is happening in Zurbarán's painting of the subject.

44. *Hercules with Phineus, the Cretan Bull, and a Centaur*, Sala di Ercole, Castel Bracciano

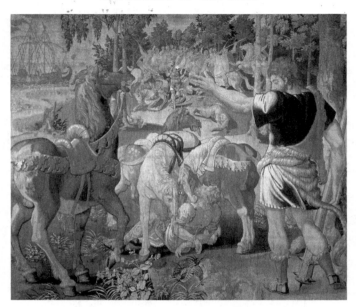

45. *The Horses of Diomedes*, tapestry, workshop of Willem Dermoyen

There is no manure in sight. The hero stands like a Victorian lock-keeper surveying his work. Not everyone knew the story, though: Virgil Solis has Hercules clearing away the dung with a pitchfork.

Of course, Hercules did much else as well – heroic deeds that rarely made it into cycles of labours either in antiquity or the Renaissance. Augeias did not pay for the cleaning of his stables, and when Hercules gathered together an army to collect the debt, Augeias appointed as generals the Molionides, who were two men joined as one. Hercules ambushed and killed them.[52] In Dürer's print, he is preparing to deliver the final blow. Gabriel Salmon clearly knew the image, but he may have taken it to be Hercules and Cacus, for he fused it with Rosso's version of Cacus in his series of the labours.

Single images of obscure subjects were very rare, but in large decorative cycles some of the less familiar labours found their way into the scheme. Among the lunettes painted by the Cavaliere d'Arpino in the Loggia Orsini at the Palazzo del Sodalizio dei Piceni in Rome is one showing Hercules rescuing Hesione by dropping a large stone on the head of a sea-monster. At Castel Bracciano, Hercules releases Prometheus from his torment (perhaps an indication that the subjects illustrated are derived from Salutati), and kills King Busiris, who had got into the habit of sacrificing his visitors. In the Sala di Ercole at Caprarola, Albion and Bergion try to steal the cattle

Hercules is bringing back from Spain. And the scene also appears in Poussin's project for the long gallery of the Louvre, where there are many unusual Herculean subjects derived from Baudouin's extended version of Conti.

The labours almost all came with allegories of one kind or another. Some remained more or less fixed, from Fulgentius onwards: Cacus was evil; the battle with Antaeus is the struggle with lust. Other sins were distributed accordingly: the birds sometimes represent avarice, the Hydra envy, the lion anger or pride. But the allegories were not always moral. There were also good historical explanations for some of these fables. People had believed in centaurs because the first riders were taken to be men and horses joined together; the Hydra (Greek for water) was a swamp drained by Hercules; Achelous was a river whose waters he had channelled to render the surrounding region fertile.

The lion and the boar may have been just what people said they were, and there was really nothing to add. Some of the hero's other opponents obviously needed further interpretation. According to Giovanni del Virgilio, Cerberus signified the earth, 'which is the mouth of hell', and his three heads the three continents; or perhaps the three heads represented Seneca's three forms of anger. According to the *Libellus*, it was the three types of gluttony (too much, too fancy, and too often). As for Geryon, Boccaccio suggested that his two-headed dog signified military and naval power and his three heads the three islands over which he ruled; or perhaps that he was really three brothers acting together. The Hydra's seven heads were less clearly differentiated. Boccaccio said that Plato had identified the Hydra as a sophist, and so Le Fèvre has her setting Hercules seven riddles to solve before the combat starts.

What all these examples have in common is the fact that Hercules is single and his opponent multiple. No one seems to have made much of this, although Bacon came close to it when he made the struggle with Achelous into an allegory of battle. Hercules, who does not change his form, is the invader intent on a single purpose; the protean Achelous, the defender, must deploy diverse strategies.[53] In retrospect, it is possible to see that this singleness was potentially a limitation. Although Hercules had strength, he lacked guile – rather like Samson, another strong man easily deceived by women. The quality with which Hercules was associated was *fortitudo*, a virtue far more physical than the English 'fortitude'. It was on this account that the infant Hercules strangling the serpents was shown with Judith (a biblical exemplar of *fortitudo*) in an early sixteenth-century Flemish painting (by the Master of the Mansi Magdalen).

Hercules did not get much respect from the church fathers, but beginning in the tenth century the parallel between Hercules and Samson was exploited, first in literary and later in visual form. However, Hercules' reputation as a killer of lions and giants also facilitated his identification with David. The two were linked in Florentine republican iconography, and in a series of tapestries woven in Audenarde in the mid-sixteenth century each of the labours is accompanied by one of the feats of David in a medallion below. The lions made an obvious pair, but it is not otherwise easy to see connections between the events in David's and Hercules' lives, let alone their joint relationship to the figures of the Liberal Arts who occupy the medallions above.

Hercules' resolute way with dragons and serpents also had a potential Christological significance. Pietro Testa's print of the infant Jesus stepping on a serpent with a classical relief of Hercules and the Hydra in the background makes the analogy explicit. For Ronsard, who worked out the parallels between Hercules and Christ in great detail in his long poem *Hercule chrestien*, the serpents were Herod's soldiers sent to massacre the innocents. The most obvious of Ronsard's parallels was between Christ's harrowing of hell and Hercules' descent into Hades, where he liberated Theseus and Alcestis. Allusions to it had already been made by Dante, and for Boccaccio, Salutati, and Le Fèvre, Hercules' adventures in the underworld constituted a significant part of his story. But the emphasis is not maintained, and in the visual arts this aspect of the legend is almost wholly neglected. This sort of subject was covered by Christian iconography, and it was superfluous to Hercules' role as an exemplar of virtue. Liberating souls from hell was not something most people were expected to do, even princes.

Other parallels with Christ had a more local significance. After defeating Cacus, Hercules offered a sacrifice to Jupiter, and this became the site of the Ara Maxima, a famous altar in ancient Rome. It is one of the major subjects in Grimaldi's frescoes for the Galleria di Ercole at the Villa Doria Pamphili near Rome. Here, however, local interest has become fused with allegory. Annibale Caro once devised an *impresa* showing the Ara Maxima and likening Hercules' defeat of Cacus to Christ's victory over evil, and the foundation of the Ara Maxima to the establishment of the Roman church. A similar equation between the Ara Maxima and the church underlies Grimaldi's painting, for there Jupiter is seen receiving the sacrifice in the heavens between Leo and Virgo, signs under which the Pamphili Pope Innocent X was elected.

Given that the papal throne, believed to be that of St Peter himself, was

decorated with Carolingian ivories of the twelve labours, you might expect numerous parallels between papal power and Herculean strength. But the iconography of the *cathedra petri* never received much attention, and the popes were not routinely celebrated as Hercules in art. When they are, it is usually on account of the family rather than the job. The Herculean imagery associated with Leo X owed as much to Florentine traditions as Roman ones – notably the idea that Hercules had been the first Tuscan to wear the *insignia leonis*.[54] In the case of Paul III (Farnese) it may have been the result of his recent alliance with Charles V. In 1538, the pope brokered a truce between the emperor and Francis I, and Ottavio Farnese, his grandson, married Charles V's daughter Margaret of Austria (the widow of Alessandro de' Medici). So the following year the Roman carnival was led by wagons celebrating first Charles V, and then the Farnese, while the fifth cart identified Hercules as the sun, and thus as the pope, with the lion representing the power of heresy and the Hydra's many heads 'the impious doctrines refuted by the Councils'. An *impresa* showed the infant Hercules strangling the serpents, which was taken to signify that it was not just the pope but also the 'little Hercoletti' of the church who were expected to stifle heresy.[55]

Sixteenth-century Catholicism felt itself to be threatened on all sides, and Hercules' role as the victor over evil-doers took on an increasingly polemical edge. Annius of Viterbo likened the expulsion of the Moors from Spain to Hercules' defeat of Geryon.[56] But Geryon would not go away, and Hercules can be seen battling with a Turkish Geryon armed with a scimitar in the allegory of Sigismund III of Poland over a century later. In the meantime the Hydra, which had the advantage of looking like one of the beasts of the Apocalypse, had become the most common symbol of the foe. In the frontispiece to Fonseca's *Justa expulsion de los moriscos de Espana* (1612) Hercules is shown bashing away at the Hydra with his club. And at the end of the century, the spectacularly positioned wooden figures of Hercules and the Hydra on the buffet of the organ loft at the Bernardine church at Leżajsk in Poland is probably there to fight off the Turks.[57]

References to the Hydra of heresy were also commonplace, and a medal struck in 1572 to commemorate the St Bartholemew's Day Massacre showed Hercules and the Hydra on the reverse.[58] Yet this did not stop Protestants from claiming Hercules as one of their own. Zwingli, who was himself celebrated as a Hercules Helveticus, had numbered the hero among the ancients whom Francis I (the Hercules Gallicus) could expect to meet in heaven.[59] And in *L'Hercule chrestien* (*c.* 1630) the Huguenot poet Agrippa d'Aubigné selected twelve of the labours as examples of the way the Christian should overcome difficulty and temptation: the Erymanthian boar shows

that 'it is necessary to overcome the swinishness in ourselves', and so on.[60] Here, Hercules becomes the model for the Protestant believer journeying through the inner landscape of sin. The analogy also worked in another context. In Bunyan's *Pilgrim's Progress*, Christian, in his battle with Apollyon, is said to have defended himself as stoutly as Hercules would have done.[61]

However, the labours of Hercules did not signify great feats of strength, Erasmus argued, so much as projects that bring great benefits to other people and none for the man who undertakes them. Erasmus knew what he was talking about. If any work deserved to be called 'Herculean', it was the unending labour of classical scholarship. You could devote your whole life to it, neglecting your finances, appearance, and health, only to be rewarded with the indifference of the uneducated, the mockery of the half-educated, and the spiteful quibbles of the learned.[62] No wonder he had his portrait painted by Holbein with his hand resting on a volume on which is inscribed in Greek capitals, the Labours of Hercules. In the *Adages*, Erasmus had elaborated this Herculean identity with a nice mix of self-pity, boasting, and irony, and it is natural to take the portrait in the same spirit. Unlike the panegyrics to Herculean princes, it is an identity forged from the inside out. Seated in his study, Erasmus lacks the obvious attributes of the hero. But by identifying with the feelings of Hercules as he trudges on from one thankless task to the next, he also lays claim to the hero's achievements, and perhaps his immortality as well.

Like Erasmus, Hercules was an illegitimate child who had to work for everything he got. But following a great victory he sometimes allowed himself a rest. After he had defeated the giant Antaeus he fell asleep on the sand. While he dozed, a whole army of pygmies crept up on him. According to Philostratus they were related to Antaeus, but so small that Hercules was like a fortified city to them.[63] In the painting by Dosso Dossi after Philostratus's description they are carrying ladders to storm the sleeping citadel of their enemy (Fig. 46). It was futile, of course. Hercules awoke and gathered up his little adversaries in the lion-skin to take back to Eurystheus. The figure of Hercules is reminiscent of the antique statue of Nile surrounded by putti that had been found in Rome some years before, and for Vigenère the story brought back pleasant memories of a party held by Cardinal Vitelli in Rome where the guests had been attended by thirty-four deformed dwarfs.[64] In Alciati the story became a warning to those tempted to overreach themselves;[65] but in the Ferrara of Ercole II the moral probably did not need to be spelt out.[66]

46. *Hercules and the Pygmies*, Dosso Dossi

As the years went by, Hercules began to take more time off. He may have been a self-made god, but he ends up a slacker like the others. From the mid-sixteenth century onwards reference to the labours becomes less frequent, and depictions of the hero resting begin to appear. G. F. Grimaldi's frescoes for the Galleria di Ercole at the Villa Doria Pamphili include two showing the hero having a rest after defeating the opponents whose bodies lie beside him. In the Camerino Farnese, which was used as a bedroom, Hercules reclines among the trophies of his labours opposite a Sphinx whose pedestal bears the inscription, 'Toil is the bringer of beautiful rest.' In the emblem books the Sphinx symbolized ignorance, so even the labours from which Hercules now rests may have been mental rather than physical, in line with the increasing identification of the hero with genius or the power of the intellect.

Paul III's rapprochement with Charles V had given the Farnese an incentive to develop a Herculean iconography, but it was the Farnese Hercules, a giant antique statue exhibited in the courtyard of the Palazzo Farnese from about 1550, that set the tone. The hero leans gloomily on his club, a deep thinker rather than an action hero. Farnese imagery consistently places

more emphasis on the 'Choice' than the labours, and even these are inter-preted in rather intellectual terms. In the Camerino, *Hercules Supporting the Globe*, which is paired with *Hercules Resting* on either side of the *Choice*, is given a philosophical gloss by the inclusion of two astronomers.

Out of town, Hercules was more relaxed. At the Villa Farnese at Caprarola, the most impressive room in the entire palace, a vast loggia overlooking the town and surrounding countryside, was also decorated with Herculean subjects by Federico Zuccaro and Jacopo Bertoja. The central scene, which dominates the four traditional labours that surround it, shows Hercules swimming in a lake. According to Servius, the nearby Lago di Vico had been formed when Hercules, asked for a demonstration of his strength by the local people, thrust his club deep into the ground. When they were unable to pull it out, Hercules did so himself, and water gushed out. As Hercules swam in the newly created lake, the stupefied locals retreated to higher ground. They eventually built a temple in his honour.[67]

The significance of the whole story is easy to fathom. The top of Hercules' club, just visible above the water in the central painting, is topped with a Farnese lily. The Farnese had carried out engineering work on the lake, and there was an indoor fountain at one end of the room into which a river seemed to flow. It is as though the water that Hercules discovered is flowing directly into the room to cool the air – not strictly true of course, but a pleasing fancy nevertheless.

Another Herculean subject that appears more or less for the first time at Caprarola is the story (found in Julius Pollux's *Onomasticon*, but taken, like other subjects in the Sala dei Lanefici, from Polydore Vergil's chapter on textiles) of the hero's discovery of Tyrian purple.[68] The freedom of Taddeo Zuccaro's preparatory drawing conveys the holiday atmosphere better than the painting (Fig. 47). Hercules and his girlfriend are walking on the beach when the dog bites into one of the shells brought in by the tide and reveals the famous purple dye. The girl makes Hercules give her a dress in the new colour, and in another painting he can be seen presenting it to her.

Swimming and going for strolls along the seashore is not the kind of thing that Hercules had time for in the fifteenth century, and with nothing to do he fell into bad company. Rubens's *Drunken Hercules* shows the consequences. The subject is classical and the figure is derived from the Farnese Hercules, but instead of leaning on his trusty club this Hercules has to rely on satyrs for support. In antiquity Hercules had been a legendary drinker, and there were illustrations to prove it. But the Renaissance, with its insistence that Hercules was the man who chose Virtue over Pleasure, was slow to exploit the story. Hercules is more often coupled with Bacchus as a conqueror of

47. *Discovery of Tyrian Purple*, Taddeo Zuccaro

distant lands than as a drinking companion. Yet the evidence was there: Cartari noted that Hercules was reputed to be a serious drinker, and Conti quotes a Greek poem about the hero staggering along drunk after a feast. Rubens, who was quite health-conscious, paired the subject with a painting of *The Hero Crowned by Victory*. It is a humiliation for Hercules: in many representations he had been the model for the Christian knight who receives the laurels; now he can barely stand.

There was one subject, however, from which artists shied away: the madness of Hercules. According to the ancient sources, Hercules was originally married to a woman named Megara with whom he had children. Afflicted with madness by Juno, he killed the children, and, according to some, Megara as well. The story is the subject of Seneca's *Hercules furens*, and it is described in graphic detail by Philostratus.[69] According to many ancient sources, the twelve labours were an act of expiation (although Diodorus said it was the thought of undertaking them that had depressed him in the first place), but the precipitating crime is never shown in any series. Le Fèvre develops the romance between Hercules and Megara in some detail, but suggests that Hercules was tricked into killing her. These horrifying events appear to have worried people in the Renaissance far more than comparable tales of other gods and heroes. Even the engraving to

Vigenère's edition of Philostratus does not do justice to it. Only Alessandro Turchi's painting confronts the tragedy.

Unlike Achilles, Hercules did not have a weak point physically; his heel was his heart. As Ovid noted, it was Venus rather than Juno who was the real bane of his life.[70] Of course, there were lots of women – the fifty daughters of Thespius, for starters. Some said he slept with them on fifty successive nights, always believing he was with the same woman; others that he had them all in one night. St Gregory Nazianzenus thought that was enough for anyone, and counted it an extra labour.[71] But Hercules appears only once in prints of the *Loves of the Gods*. There was nothing heroic about his achievements in this department. On the contrary, much play was made of the way the unconquered hero was ignominiously defeated by love.

One image says it all. Hercules pulls a thread from the spindle held by a woman while another uses the same gesture to adjust the wimple on his head. Hercules looks up vacantly, completely absorbed. As the inscription explains, he has been subdued by love and has submitted to domination by the Lydian girls who keep him occupied with little jobs (Fig. 48). That gesture with thumb and forefinger is a measure of the hero's shame: the girls can tease him the way he teases the thread from the spindle. Pictures like this were popular, and Cranach painted several of them. The moral of the story was meant to be taken seriously, and pictures of Hercules spinning appear in emblem books from the mid-sixteenth century.

The story of how Omphale, Queen of Lydia, had enslaved Hercules and made him wear women's clothes while she appropriated his club and lion-skin for herself was well known. However, Omphale, who had purchased the hero when he was sold into slavery to atone for a murder, was not necessarily Hercules' lover in the classical sources, and although Fulgentius had made their story into one of his brief sequence of Herculean myths, for other mythographers – whether classical, medieval or Renaissance – it was of marginal interest. Apart from anything else, it was inconsistent with Hercules' role as the moral hero. Salutati, who worried about these things, reminded readers of the serpent which Hercules had killed on Omphale's land, and for which (according to Hyginus) he had been placed among the stars as the serpent-holder.[72] But there was no way to change the subject. The story was too funny for anyone to forget it. In the Middle Ages, it formed part of the litany of great men dominated by women, and it was recounted several times by Boccaccio, both in the *Genealogia deorum* and in his collections on famous men and women.

One curious thing is that Boccaccio refers to Omphale as Iole. Hercules

48. *Hercules and Omphale*, Cranach

had won Iole in an archery contest, and she was the girl who later inspired the fatal jealousy of Hercules' wife Deianira. Her confusion with Omphale may have originated with Servius, and since the primary classical source for the tale, Ovid's *Heroides*, did not mention Omphale by name, it persisted. In Tasso's *Gerusalemme liberata*, it is still Iole who wears the lion-skin, and a Cupid is added to gloat over Hercules' downfall. You can see him grinning behind the couple in the Farnese gallery, where Hercules occupies himself not by spinning yarn but by playing a tambourine (as he also does in Statius).[73] It was to Iole, too, that Ovid's story of Hercules kicking Faunus out of bed was routinely transferred. The tale, which comes from the *Fasti* but also slipped into the *Ovide moralisé* under Iole's name, describes how Hercules and Omphale had gone to their separate beds still wearing one another's clothes, when Faunus, who had taken a fancy to Omphale earlier in the day, tried to get into bed with her.[74] Feeling the lion-skin in the dark he quickly turned his attention to the other sleeper; reassured by the soft fabric he climbed in. Hercules woke up, Omphale called for some lights, and in the confusion Faunus slipped away. Bloemaert depicted the scene with great panache, and it made an obvious companion for depictions of Hercules and Omphale, though they are only paired like this by Primaticcio at Fontainebleau and by Tintoretto as part of a larger group of Herculean subjects painted for Rudolf II.

The appetite for such subjects in these particular courts is a good indication that their moral implications had been subsumed in the erotic. Spranger's Herculean paintings for Rudolf were particularly saucy. His *Hercules, Deianira, and Nessus* is already based on Caraglio's print from *Loves of the Gods*, but he spices it up with still more intimate caresses. In his *Hercules and Omphale* she is a dominatrix, and he is a masochist enjoying the humiliation. Tintoretto probably did not realize how far he could have gone. His four paintings for Rudolf II are hard to reconstruct with complete confidence, but the group appears to have consisted of *The Origin of the Milky Way, Hercules and Omphale, Hercules Kicking Faunus Out of Bed*, and, most probably, *Hercules with the Muses playing Musical Instruments*.

The story of the origin of the Milky Way is strange. Being born of a mortal, Hercules did not automatically have immortality, so Jupiter brought him to suckle at the breast of his wife Juno while she slept. The milk spilt and the Milky Way was formed. The story appears, naturally enough, in the *Poetica astronomica*, although Hyginus allows that it might have been Mercury rather than Hercules who was involved, and, in his treatise on Hercules, Giraldi notes that some said Minerva had to take over from Juno when she found the greedy child too much for her.[75] Giulio Romano and Bonasone both pick up on this aspect of the story, while Alciati (whose emblem made Hercules the model for other illegitimate children) and Tintoretto both follow Hyginus. However, Tintoretto's painting originally had another dimension. It has been cropped at the bottom, and once showed a lily springing up where Juno's milk fell to earth.[76]

The *Origin of the Milky Way* also appears among Rubens's workshop paintings for the Torre de la Parada where it is one of several Herculean subjects in a series of mythologies whose primary source is Ovid's *Metamorphoses*. This development is in itself worth noting, for not only were Herculean themes relatively unimportant in the tradition of Ovidian illustration, they often appeared in contexts where scenes from the *Metamorphoses* might have been considered out of place. Yet by the beginning of the seventeenth century, the distinction between Herculean seriousness and Ovidian whimsy is beginning to break down. Reni's series of four paintings for Ferdinando Gonzaga, Duke of Mantua, depicting the *Hydra, Achelous, Nessus and Deianira*, and the *Death of Hercules*, is unusual both in its reliance on the *Metamorphoses* and in the purposeful cohesiveness of the subjects. *Nessus and Deianira* provide the key to the group as a whole (Fig. 49). When Hercules and his wife Deianira came to a flooded river, the

49. *Nessus and Deianira*, Guido Reni

centaur Nessus offered to help them across. Deianira went first, riding on the centaur's back. But when they got to the other side, the centaur tried to rape her. Hercules, trapped on the opposite bank, could only do one thing. He drew his bow and shot the centaur dead.

The arrow was dipped in the Hydra's poison, and as Nessus lay dying the poison mingled with the centaur's blood flowing onto his shirt. Seemingly repentant, Nessus told Deianira to take his shirt and use it if she ever needed to win back her husband's love. She must have been surprised because centaurs do not often wear shirts (in Reni's painting this can only be the crimson drapery with which he has secured his prize), and it was years before she followed his suggestion. Hercules was besotted with Iole, and Deianira decided that the time had come. She gave the shirt to Lichas to take to Hercules. When Hercules put it on he felt not the warmth of love, but the heat of the Hydra's poison burning his flesh. Realizing that the shirt was the cause of his pain, Hercules picked up the man who had given it to him and threw him into the sea. To no avail: the agony was unbearable. There was no alternative: Hercules constructed a funeral pyre for himself on Mount Oeta, persuaded Philoctetes to light it in exchange for his bow and arrows, and steadfastly awaited the end. Through his death, not only Nessus but also the Hydra and Achelous had their revenge.

In illustrations and tapestries derived from Le Fèvre, Hercules is left smouldering on the pyre: 'The most valiant knight in the world ended his days in this miserable way', reads the inscription on the tapestry at Hampton Court. Seneca had said onlookers were so impressed by his endurance in the flames that they wondered if fire should be added to the list of enemies overcome in his labours. Yet it is only in sequences of the labours derived from Valvassori that the death of the hero is routinely depicted. Here the emphasis shifts from Hercules' death to his deification. Whereas Valvassori shows Hercules' tomb in the background, Hering's roundel at Landshut has him ascending to heaven in a chariot: Hercules could overcome the consuming flames just as he had everything else (Fig. 50).

Although Hercules' apotheosis is attested by Seneca, Boccaccio, and Ovid, it does not become a common subject until the second half of the sixteenth century. It enters the repertoire of illustrations to the *Metamorphoses* with Salomon, and thereafter Hercules is often being taken up to heaven in this way. Francesco Pacheco's tempera panel for the presence chamber of the Casa de Pilatos in Seville was the first of many ceiling paintings to adopt the subject. In the late seventeenth and eighteenth centuries, the apotheosis of Hercules became a favoured subject for large-scale ceiling paintings: by

50. *Death and Apotheosis of Hercules*, Thomas Hering

Le Brun at Vaux-le-Vicomte, Giordano at the Casa del Buen Retiro, François Le Moyne at Versailles, Tiepolo at the Palazzo Canossa in Verona.

His end reminds us that Hercules is not quite like the other gods. For a start, he is the only one of the Olympians who really knows what death is like. (Bacchus was dismembered when he was a child, but that is not quite the same.) And it is the knowledge of his own mortality that makes him moral in a way that immortals never can be. Achille Bocchi invented a Herculean emblem with the motto, 'Death is the best guide to life.'[77] Hercules made the right choice, and so can everyone else. Dolce said that the death and apotheosis of Hercules showed that 'a man could, by means of his labour and virtue, attain immortality'. And Boethius's concluding reflection on the labours of Hercules was inscribed on a sixteenth-century tombstone in

Chipping Norton: 'When you overcome the earth, the stars will be yours.' The Olympians did not usually offer much comfort in the hour of death, though when Rudolf II died and went to heaven, Hercules was there waiting to meet him.[78]

The bad thing about becoming a god is that by definition you were not one to begin with. Compared with the beatitude enjoyed by the other Olympians, the life of Hercules is a bit grim. It is not just that he has to work to fight off oblivion, he is also very isolated. The other gods all have friends, or at least servants. Jupiter has Ganymede and the other Olympians; Venus, Cupid and the Graces; Apollo, the Hours and the Muses; Diana, the nymphs; and Bacchus, a whole army of maenads and satyrs. Le Fèvre created a side-kick for Hercules named Philotes, and the tapestries for Mary of Hungary show an attendant in every scene, but in reality Hercules was a loner. It is part of his moral destiny, of course, and his emotional life is a disaster anyway. Whereas his labours are exemplary, his loves are warnings, more comic than erotic. His passion is his work, and there is often more energy in the depictions of Antaeus or Cacus than there is in pictures of Hercules with Deianira or Omphale.

It is perhaps on account of his ordinariness as much as his virtue that Hercules never became a demon. There is nothing uncanny about him. Many pagan deities were compared to Christ; only Hercules is consistently likened to a Christian, and from the early Middle Ages Hercules is at home in Christendom in a way that the other classical gods are not. And so the process through which Herculean imagery spreads is also rather different. The early literary sources for Herculean subjects tend to be heavily mediated. Boccaccio, Le Fèvre, Boethius, and the *Libellus* are the key texts. Diodorus Siculus and Seneca feed into the historical and moral traditions respectively, but Ovid is not initially all that important and neither, despite having a range of Herculean subjects to offer, is Philostratus.

Medieval mythographers gave more attention to Hercules than did their sixteenth-century counterparts, and the new sources of Herculean imagery were not classical authors so much as emblematists and local historians. Although not entirely distinct, mythography, historiography, and the emblem tradition were relatively independent. The chroniclers were not primarily concerned with the hero's role as a moral example, and the emblematists often relied on stories such as 'Hercules at the Crossroads', or the Hercules Gallicus, which were absent from early mythographies. Because the Renaissance Hercules relies on these sources rather than directly on classical literature, the iconography of the hero has many novel features. Herculean imagery proliferates when two or more of these traditions are

brought into alignment. Over time, they start to intermingle. Herculean genealogies are reaffirmed through the imagery of 'Hercules at the Cross-roads'; emblematic subjects slowly find their way into representations of the labours, and stories (like that of Cacus) which the mythographers had made into moral allegories are exploited for their local interest.

One effect of this fusion is that the centrality of the labours diminishes. Indeed, save in Spain the labours are not especially prominent in seventeenth-century art. Tempesta produced a set of prints of the labours, but they had nothing like the impact of his *Metamorphoses*. Even when the labours are shown, they are marginalized. If you compare the Herculean imagery at Castel Bracciano with that of the Palazzo Farnese, you can immediately sense the difference. At Bracciano, Hercules works his way round the room through a seemingly endless sequence of tasks, each as demanding as its predecessor; in the Camerino, the labours appear only as small grisaille paintings on a ceiling dominated by a fresco of the Choice. The shift in emphasis from labour to choice fits into the wider pattern in which activity gives way to rest, and a stoic death to a heavenly apotheosis. And yet throughout, Hercules remains an exemplar of sovereignty and virtue. What changes is the way in which sovereignty and virtue are understood.

These shifts cannot be documented with any precision, but in geographical terms there are two more or less simultaneous movements in the diffusion of Herculean imagery. One, flowing from north-east Italy to southern Germany, France, and Spain, involves the dissemination of visual formulae for the labours – notably those invented by Valvassori and Moderno. The other comes from Burgundy and moves down to France, northern Italy, Spain, and the empire. The two rarely connect, and of the two it is the latter that ultimately proves the more influential. The range and longevity of the formulae derived from Valvassori are impressive, but they peter out on plates and candlesticks without ever having undergone significant development. But even though Le Fèvre's imagery did not catch on, it helped to foster the association of Hercules with the imperial ideal. You could not really say what this Hercules looked like, but the idea he embodied prompted the invention or appropriation of images which then spawned others in their turn.

Within this process, Charles V played a significant role. It would be misleading to think of Hercules as the logo of the imperial franchise, but Herculean imagery enjoyed a particular vogue during his reign, and the Herculean princes of the second half of the century were frequently following Charles's example. Philip II was his son and heir; the Medici and Farnese had been his vassals, both linked by marriage to his daughter Margaret, and

the French royal Hercules was developed as a rival to the Habsburg Hercules after the marriage of Francis I to Charles V's sister. The significance of the Habsburg connection is confirmed by the fact that the two places where Hercules is conspicuous by his absence are Venice and the United Provinces – both states whose republican identity was articulated against Habsburg pretensions to universal dominion. The *impresa* of Andrea Gritti, the Doge who had led Venice's army against Maximilian I, has Atlas, not Hercules, holding the heavenly sphere.[79] However, it is difficult to quantify the Habsburg effect. Was Ferrante Gonzaga memorialized by Leoni's *Hercules and the Hydra* on account of his career as Charles V's general or the Herculean identity he shared with his brothers Cardinal Ercole Gonzaga and Federico II? The answer is probably both, for very often Charles's example may have done no more than allow the fusion of local traditions with the imperial model.

4

Jupiter

Jupiter is the father of the gods; although, unlike the Christian God, he too had a father, as did his father before him. So let's begin at the beginning, if we can find it. Boccaccio was obsessed with this sort of thing (his *Genealogia deorum* lives up to its title) but artists and patrons do not seem to have shared the interest. Save in mid-sixteenth-century Florence, mythological art rarely follows any sort of genealogical progression. The great wedding pageant of 1565, *La Mascherata della genealogia degl'iddei dei Gentili*, traced the gods back as far as they would go, all the way back to the first of all the gods, Demogorgon (a spelling mistake). In a speech in Statius's *Thebaid*, Tiresias mysteriously refers to the 'high lord of the triple world', an otherwise unknown entity identified by ancient commentators with Plato's creator, the demiurge. This *demiourgos* somehow became the rather more sonorous Demogorgon, and so at the very end of the parade came an old man in a cave, pulled along by dragons. Few could have recognized him, but it was Boccaccio's Demogorgon, accompanied by Chaos and Eternity, with Darkness and Night lurking in the shadows.[1]

Preceding Demogorgon in the procession was Uranus, and then Saturn. To see how Saturn came to power you would have to go inside the Palazzo Vecchio. There, in the centre of the Sala degli Elementi, Saturn, surrounded by other heavenly powers, is castrating Uranus with a scythe. Vasari had originally planned to turn the hand of Michelangelo's God from the Sistine ceiling into that of Saturn reaching across to grab his father's genitals. But viewers were spared the sight by Boccaccio's suggestion that Saturn had performed the operation more clinically.[2] On the wall behind is the birth of Venus, engendered from Uranus's genitals as they were thrown into the sea.

The fact that the story is portrayed in this way is a good indication of the influence of Boccaccio on Florentine iconography, for according to Fulgentius it was not Uranus but Saturn himself who was castrated – by Jupiter, others added. The idea found its way into the *Ovidius moralizatus* and the *Libellus*, and it was on this basis that Saturn was sometimes shown

51. *Castration of Saturn*, from Ovid, *Metamorphoses*, 1484

in the awkward position of having to be castrated and eat his children at the same time, as he is even in the French translation of Boccaccio which reused the illustration that had appeared in the Colard Mansion edition of the *Ovide moralisé* and *La Bible des poetes* (Fig. 51). At the Palazzo Vecchio, however, the eating of the children is saved for the centre of the adjacent Loggia di Saturno. Warned that one of them would usurp him, Saturn started to devour them as fast as he could, but his wife Ops saved Jupiter by offering Saturn a stone in the child's place. Ops herself has a room of her own in the same suite, as do Jupiter and his wife Juno, and Jupiter's son Hercules.

The pivotal role of Saturn as the link between the Sala degli Elementi and

this genealogical sequence was not completely accidental. According to the *Aeneid*, Saturn had come to central Italy after being deposed by Jupiter, and had established the golden age of peace and natural prosperity whose return had been promised in Virgil's fourth *Eclogue*.[3] Saturn had been greeted on his arrival in Italy by Janus, the King of Etruria. The scene appears in the Loggia di Saturno and in Polidoro's earlier fresco at the Villa Lante in Rome, but they are in effect looking at the meeting from different angles. Janus had ruled from the Janiculum hill, the site of the Villa Lante, and was for this reason often compared to the popes, while Saturn had (according to Ovid's *Fasti*) sailed up the Tuscan river, and was linked with the return of the golden age under Medici rule.[4]

Saturn's golden age was succeeded by the silver age of Jupiter. Having been saved from his father's jaws, the infant Jupiter was spirited away to be nursed by the nymphs Amalthea and Melissa, who fed the child on goat's milk and honey. However, Amalthea was often taken to be the name of the nanny-goat herself. She did not get much thanks for her help. Her horn was ripped off to become the horn of plenty, and her skin was presented to Jupiter as an aegis. The entire story can be seen in Taddeo Zuccaro's frescoes at Caprarola, where the Sala d'Amalthea owes its prominence to the *capra* (goat) in Caprarola.

The goat was more frequently linked to the sign of Capricorn, not least in the Sala di Giove in the Palazzo Vecchio, painted for Cosimo I who, in emulation of the Emperor Augustus (and of the Emperor Charles V), had chosen Capricorn as his *impresa*. Amalthea also illustrated the sign of Capricorn in Jacob Jordaens's zodiacal decorations for his own house. There the similarities end, for Jordaens had already made the subject of the nurture of Jupiter his own. Here, the goat has no imperial pretensions. The inscription attached to the engraving after Jordaens makes the point quite well: having been brought up on goat's milk, is it any wonder that Jupiter turned out to be as randy as a satyr?[5]

In seventeenth-century Dutch painting the nurture of Jupiter is often assimilated in pastoral – nowhere more so than in Berchem's painting in which there is barely a hint of the child's momentous destiny – but the single most influential depiction of the subject was that of Giulio Romano, who painted the subject with the goat's hind legs lifted off the ground by the greedy infant suckling underneath, as part of a series depicting the early life of Jupiter for his Gonzaga patrons. The other pictures show Jupiter guarded by the Corybantes (who made a commotion to conceal the infant's screams from the predatory Saturn), Jupiter enthroned, and the unusual subject of Jupiter and Juno ascending to Olympus to take possession of their kingdom.

(Jupiter had divided the world with his brothers – Neptune had the ocean, Pluto the underworld.) This family history of the gods shares with the later series at the Palazzo Vecchio several of the same subjects, and a notable interest in scenes of infancy, but whereas Jupiter is the central figure in Giulio's series, in Vasari's he serves chiefly as the link between Saturn and Hercules.

Once he took charge of Olympus, Jupiter, like any new ruler, set out to make an example of those who offended him. His punishments were inventive. Prometheus, the most famous of his victims, was chained to a mountain in the Caucasus and had his liver eaten daily by Jupiter's eagle. Other criminals were tortured in the underworld. Visitors to Hades were greeted with extraordinary sights: Tantalus unable either to drink the water in which he is immersed or to eat of the fruit that hangs over his head; Sisyphus fruitlessly pushing a rock up a hill; Ixion bound to a fiery revolving wheel; the Danaides, forever filling a leaking receptacle with water, and the giant Tityus stretched out waiting for his liver to be eaten by an eagle or a snake. Their crimes were various. Some had trespassed on Jupiter's love-life: Ixion had wanted to seduce Juno; Tityus had tried to rape Latona; and Sisyphus was a trickster who told Aegina's father that it was Jupiter who had abducted her. The others were guilty of domestic offences: Tantalus was a poor host who, not having much food in the house when the gods came over for dinner, chopped up his son and popped him in the stew; the Danaides were forty-nine sisters who, on their wedding night, murdered the forty-nine brothers they had married.

Mentioned only briefly in the Latin text of the *Metamorphoses*, all these subjects are elaborated (with some variation) in early Italian editions where they are accompanied by a woodcut showing Ixion, Tityus, Sisyphus (carrying rather than pushing the stone, in line with the Italian translation), and the Danaides. But the Danaides never became a popular subject, so when in the 1630s Ribera painted four of the condemned for a Dutch patron, the group comprised Tityus, Tantalus, Ixion, and Sisyphus. It was an inspired commission, for Ribera had already begun to specialize in scenes of martyrdom, and knew better than anyone how to convey the agonies of torture. But he did his job too well. The paintings traumatized the patron's wife, and were returned after she gave birth to a deformed son whose hand was contorted with Ixion's pain.

Ribera's set was presumably modelled on Titian's paintings of the same subjects, yet there had been no adverse reactions to Titian's work when it decorated the great hall of Mary of Hungary's palace at Binche. The difference is doubtless partly attributable to the temperament of the two painters, but there is also a sense in which these subjects are the stuff of public rather

than private art. Titian's paintings were displayed opposite a set of tapestries of the seven deadly sins, which culminated (on the wall adjacent to Titian's paintings and immediately behind the throne) in one representing Pride, which showed the fall of Phaethon; in the galleries at either end of the hall there were paintings of Apollo and Marsyas. Viewers of Titian's paintings probably were not expected to internalize the pain, merely to note that those who offended the gods always received their just reward.

That at least is the implication of the first Habsburg commission in which these subjects appear. *Los Honores* is a nine-piece set of tapestries commissioned before 1520, possibly by the Emperor Maximilian and his wife, but pawned to the Fuggers and paid for by Charles V.[6] In the *Iustitia* tapestry, the fall of Phaethon and the Condemned (who here include the Danaides and Phineus, as in Seneca's *Hercules furens* – but not Tantalus) appear on either side of the throne of Justice, under an inscription stating that the Thunderer rewards piety (Fig. 52). Along the base is an array of mostly biblical characters who are the beneficiaries of justice. From either side of the throne, Jupiter emerges to wield his thunderbolts against Phaethon and Ixion; they too must receive their just reward. It is hard to believe that the decision to commission paintings of the Four Condemned was not inspired by this arrangement.

Divine punishments became common in sixteenth-century art. Cornelis Cornelisz. van Haarlem designed four tondi (engraved by Goltzius) in which Ixion and Tantalus tumbling headlong into the underworld are paired with Phaethon and Icarus falling from the sky. In northern Italy, related subjects were used to create themed ceilings. Luca Cambiaso's Sala delle Punizioni in the Palazzo G. B. and A. Spinola in Genoa has the fall of Phaethon in the centre with subsidiary panels showing the punishments of Icarus, Marsyas, Arachne, and the Giants, while in the Sala dei Giganti at San Secondo the battle with the Giants is at the centre with the punishments of Icarus, Phaethon, Prometheus, and Niobe as subsidiary scenes. The interpretations given to Goltzius's prints were generally applicable: striving for fame, goods, knowledge, or honour only tempts you to overreach yourself: be content with your lot.

The most spectacular of these subjects was the fall of Phaethon. Ovid tells the story of how Phaethon borrowed the chariot of the Sun and, like a teenager driving his father's car, was soon careering out of control. Jupiter had to do something to prevent him burning up the earth, so he struck him down with his thunderbolt. The story comes at the end of the Apollonian sequence in Books 1 and 2 of the *Metamorphoses*, and in early illustrated editions of Ovid the fall of Phaethon usually appeared in the background

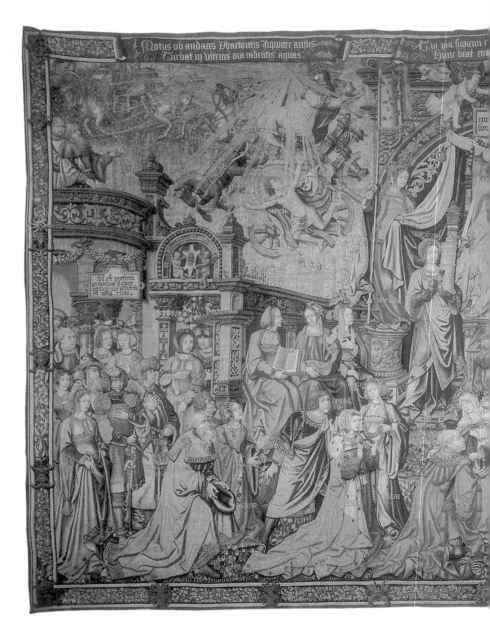

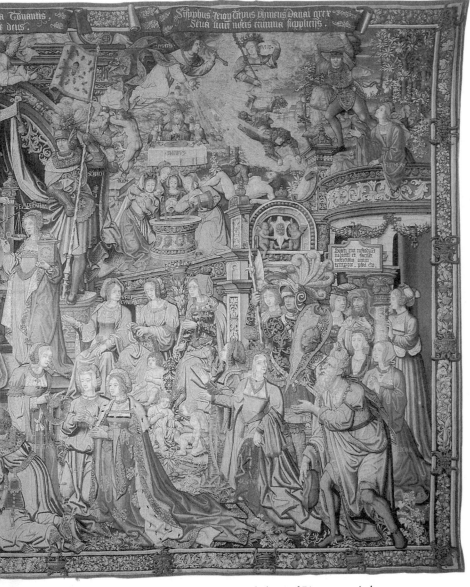

52. *Iustitia*, tapestry, workshop of Pieter van Aelst

of the scene in which Phaethon asks his father Apollo for the chariot. But in the sixteenth century the fall of Phaethon often appeared separated from its narrative context as the central panel in a decorated ceiling. Giulio Romano started the fashion in the Palazzo Te, where (perhaps for the entertainment of his horse-loving patron) he included several horse-drawn chariots viewed from below. The fall of Phaethon is, appropriately enough, in the Sala delle Aquile – a reminder of the potency of that Gonzaga eagle.

Georg Pencz may have picked up the idea from Mantua and taken it to Nuremberg, where both he and Paul Juvenal decorated ceilings with the fall of Phaethon. In all these cases, the horses are scattered in all directions, as though they barely feel the pull of gravity. It could not last. Probably influenced by a Roman sarcophagus relief, Michelangelo depicted Phaethon falling headlong in his first drawing of the subject for Cavalieri. In his other versions, the horses too are falling (Fig. 53). The design was reproduced in plaquettes and in rock crystal, and directly influenced the illustration in Dolce's *Trasformationi* and Giacomo Franco's engraving for Anguillara. But only when the scene is painted almost life-size (as it was by G. B. Castello in a loggia of the Villa di Tobia Pallavicino in Genoa) does the viewer sense the full drama of the spectacle.

It is appropriate that the figure of Jupiter in Michelangelo's Venice drawing turned out to be a prototype for the figure of Christ in the Sistine *Last Judgement*, for the fall of Phaethon had long been understood as a moral, if not theological, condemnation. As Dolce noted, Phaethon's fate was a warning to all overreachers. Horace had applied it to lovers, but by the late Middle Ages it had become a warning to those in authority – first ecclesiastical, then secular – about the abuse of their power. Medieval interpretations potentially critical of the powerful were often subsequently modified; this one stuck. For Sandys, too, Phaethon was 'a rash and inexperienced Prince, inflamed with desire of glory and dominion'.

Phaethon represented those who could not handle power, the Giants those who sought to usurp it. They were the offspring of Gaia, born from the blood of Uranus when he was castrated by Saturn. Her second family, they took the place of the Titans who had been defeated when Jupiter and the Olympians took control of the world. Some said they had been formed from the blood of the Titans themselves. To rouse their anger for a new struggle, Gaia only had to remind them of what had happened to Prometheus, Tityus, and the Titans. This time they were going to win. Piling mountains one on top of another, the Giants stormed heaven.

Dramatic representations of the battle are to be found in works after

53. *Fall of Phaethon*, Michelangelo

Goltzius. The Giants brandish clubs, while in the background their comrades can be seen carrying huge boulders up the mountain. The Olympians respond with more sophisticated weaponry: Jupiter with his thunderbolts, and Minerva with her spear. Goltzius was illustrating Ovid's *Metamorphoses* which names none of the protagonists, but the inscription by Franco Estius reveals that foremost among these heroic figures are the ancient hundred-handed monsters Briareus and Typheus, identified as Titans by Boccaccio and often drafted into the struggle on the Giants' side (Fig. 54). Given that Goltzius knew no Latin and the inscription postdated the drawing from which the engraving was made, it suggests that Estius is responding to the image, not the other way round. From the very first word, the inscription exploits the dramatic pose of the central figure: '*Stat Briareus celum affectans*' ('Briareus stands threatening heaven'). In fact, these words are merely a reworking of Statius's '*Briareus stetit aethera contra*' which opens

54. *Battle of Gods and Giants*, after Goltzius

a passage in which Briareus, a Bruce Lee with extra hands, simultaneously
defends himself against all the Olympians.[7] Goltzius knew nothing of this,
but that commanding figure at the centre of the composition may have
brought Statius's words to mind – the pose itself the bridge between two
otherwise unrelated classical texts.

Although the distinction between the Titans and the Giants was usually
maintained by the mythographers, it was blurred by poets, even in antiquity.
In the Renaissance, there is almost no attempt to depict the hundred-handed
with their extra limbs, or the Giants with their distinctive serpent feet. All
you needed to know was that the Giants were very big. Nobody doubted that
gigantic humans had existed (and might still exist), and in the mythographies
there was an ongoing debate about the archaeological evidence. The story
of the revolt of the giants was therefore easily integrated into biblical history.
For some, the reference to the Giants trying to storm heaven by piling
mountains on top of one another recalled the Tower of Babel, while others
preferred to think of the Giants as the rebel angels cast out of heaven –
which is how they are depicted in *La Bible des poetes*. This explanation
actually fitted the Titans better than the Giants, but the distinction between
the two was so hazy that it hardly mattered.

The revolt of the Giants and the Tower of Babel were shown together in an Antwerp pageant of 1561, but in general contemporary rather than historical references were more significant. Erasmus followed Horace in making the rebellion of the Giants an example of force without wisdom,[8] but for most authors the Giants were characterized by their pride (which is why Briareus is shown on the cornice of pride in the *Purgatorio*). In medieval commentary the Giants were identified with overweening princes and tyrants, yet by the time of Sandys they had become 'the tumultuary vulgar; rebelling against their Princes, called Gods'. This shift was in large measure the result of the appropriation of the myth by Charles V. When he visited Genoa in 1533 and 1536 he stayed in the Palazzo Andrea Doria, where he appears to have conducted official business from the Sala di Giove on the *piano nobile*, underneath Perino's fresco of the defeat of the Giants. The ceiling is divided in two by a bank of low clouds above which sit the Olympians, with Jupiter in the centre wielding his thunderbolts against the Giants (Plate X). The Giants have clearly got the worst of it. Although the fighting continues in the background, this is a struggle – unlike the later battles of gods and giants produced in Haarlem – whose conclusion is not in doubt. The contrast between the serenity of the Olympians and the contorted poses of the defeated Giants, several of whom wear turbans, is striking.

Perino's ceiling was to become the most influential depiction of the subject, but Giulio Romano's Sala dei Giganti in the Palazzo Te at Mantua was the most spectacular. Produced at about the same time (1532–4), it too depicts the defeat of the Giants, but follows a different text – Agostini's version of Ovid in which the Giants are metamorphosed into monkeys – and also incorporates the story of Typheus from Book 5 of the *Metamorphoses*, inventively showing the Giant crushed beneath Mount Etna, with his shoulder making the shape of the island of Sicily and his fiery breath erupting from the volcano. Never before had anyone conceived of mythological art as a total, all-encompassing experience. The inscription (from Statius) that goes around the room reminds the viewer that if this is what happened to the Giants, there is not much hope for rebellious humans. But the room was meant to exhilarate rather than terrify. It led to the tennis-court, not the dungeon.

The idea that the imperial conquest of Italy was somehow akin to the defeat of the Giants had a curious pedigree. According to Diodorus Siculus, Osiris had conquered the whole world. This feat was usually credited to Bacchus/Osiris, although Diodorus noted that Osiris could also be identified with Jupiter, and said that the rebellion of the Giants had been against both Osiris and Jupiter. Annius picked up on the idea that Osiris had visited

western Europe and gave a full account of how Osiris, 'called Jupiter the Just', had reigned over Europe.[9] Jean Lemaire, who used Annius extensively, rehearsed all this in his *Illustrations de Gaule*, written for the edification of the young Charles V. The battle with the Giants is located in Italy, for the Italian people were being pitilessly oppressed by 'the great giants named Titans', and so while the emperor Osiris/Jupiter was being fêted in Germany, 'they sent their ambassadors to plead with him to deliver them from servitude as he had other provinces'. Their request was granted, and after three great battles in which Hercules fought alongside Osiris/Jupiter, the Giants were defeated, and Italy enjoyed a decade of peace and prosperity. The script had, in effect, been written before the event.[10]

Pordenone's painted façade for the Palazzo Tinghi in Udine (which commemorated Charles V's ally Pompeo Colonna) also depicted the fall of the Giants, and it was the theme of a mechanical spectacle staged for Charles's entry into Naples in 1535. So it is no surprise to find Aretino exploiting the analogy when he wrote to the emperor a couple of years later. Whereas the Giants sinned only against nature, Charles's enemies sinned against both nature and God. It is a riff on Cicero's observation that the revolt of the Giants signified the refusal to follow nature combined with a recognition that Charles's enemies are distinguished by differences in religion as well.[11] Aretino was thinking primarily of the Turks, but later references to the theme often cast the Protestants in the role of the Giants. After the battle of Mühlberg, where Charles V defeated the Protestant elector of Saxony in 1547, Leone Leoni created a medal of the emperor showing the fall of the Giants on the reverse, accompanied by the inscription DISCITE IUSTITIAM MONITI. In 1549, the arch of the Genoese in Antwerp, erected for Charles and Philip's triumphal entry, depicted the defeat of the Giants alongside the inscription NE TEMNITE DIVOS. In fact, they are two halves of the same sentence '*discite iustitiam moniti et non temnere divos*' ('Be warned, learn righteousness and never despise the gods') from the *Aeneid*, where the account of the punishments suffered by those in the underworld includes this warning from Phlegias, king of the Lapiths.[12] Almost hidden from view in the tapestry of Pride in the Great Hall at Binche is a depiction of the man who utters the words. It all fits together like a jigsaw, and suggests that the decorations at Binche reflect the same moment of punitive euphoria.

The concentration of this imagery in the 1530s in Italy and post-1547 in northern Europe directly reflects the emperor's two major military successes: his Italian victories of the late 1520s, and his temporary ascendancy over Protestant forces after Mühlberg. By the time of Dolce's *Trasformationi*, the parallel between the Giants and the emperor's enemies was so well

established that it could be cited in the dedication of the book. Dolce's was also the first Italian version of Ovid to contain an illustration of the fall of the Giants, for the subject circulated as imperial propaganda long before it entered the repertoire of Ovidian imagery. Colard Mansion's Ovid had turned it into the fall of the rebel angels, and it was only with Salomon's illustrations of 1557 that it became a common Ovidian subject.

On Charles V's abdication, Philip II of Spain was thought to have inherited his father's role as Jupiter. But it was not only the Habsburgs who were celebrated in this way. As Callimachus's *Hymn to Zeus* had made clear, Jupiter was the king of the gods and so the god of kings.[13] The fall of the Giants featured in Francis I's entry into Rouen in 1549, and it subsequently enjoyed some popularity in French verse. Ronsard celebrated Henry II's triumphs over his enemies in these terms, and the Giants were frequently identified with the Huguenots.[14]

Given the identification of the revolt of the Giants with Protestantism, it would have been natural for the pope to be cast in the role of Jupiter. Paul III (Farnese) adopted the winged thunderbolt as an *impresa* after he had joined Charles V in his struggle against the Protestants in Germany in the late 1540s.[15] And when Erasmus was in Rome during the pontificate of Julius II, he had complained of a Good Friday service at which the preacher had celebrated the warrior pope as a Jupiter threatening the world with his thunderbolt.[16] He may have been exaggerating, for there is little visual evidence of a papal Jupiter in this period. A century later, when Pietro da Cortona was going to paint one at the centre of the ceiling in the Palazzo Barberini, he was quickly dissuaded, although the fall of the Giants remained the subject at one end of the ceiling, where Minerva cruises over the battle-field surveying the carnage.

The Barberini ceiling, like almost all the other versions of the subject in Catholic Europe, shows the defeat of the Giants. Since Lucan, the battle of gods and giants had been taken as a model of civil war, and it is no accident that the subject was most commonly represented in places like northern Italy, mid-sixteenth-century France, or the late sixteenth-century Netherlands, where sovereignty was contested. The winner usually cast himself in the role of Jupiter, yet in the works of Goltzius and Wtewael the Giants are given heroic roles. There is no formal identification of the Dutch Revolt with the Giants' rebellion, but it is not hard to see these valiant monsters as the forerunners of Milton's Satan.

When Orpheus sang, he switched effortlessly from the Giants to Ganymede,[17] for Jupiter is both an irresistible gravity and an unbearable lightness.

Which you experience depends on whether you are his enemy or his ally. In illustrations derived from Bersuire, the Giants lie defeated at Jupiter's feet, while through the window the eagle can often be seen taking Ganymede up to Olympus. At the Casa de Arguijo in Seville, Ganymede is paired with the fall of Phaethon. On the *piano nobile* of the Palazzo G. B. and A. Spinola, the Sala delle Punizioni is balanced by a Sala degli Amori di Giove. In the same way, Titian's *Four Condemned* can be seen as the counterpart of Correggio's *Loves of Jupiter*. The patronage of Mary of Hungary and Charles V was complementary, not contradictory, and the impact of Charles V is just as evident in representations of the loves of Jupiter as it is in the fall of the Giants; but whereas the fall of the Giants is a subject for large-scale frescoes, the loves of Jupiter feature in cabinet paintings, prints, and, in some cases, the decorative arts.

Unlike the labours of Hercules, the loves of Jupiter had no canonical number. In Book 6 of the *Metamorphoses*, a partial enumeration of Jupiter's many conquests begins the sequence of Arachne's tapestries on the loves of the gods, woven in her contest with Minerva. In early Italian translations, however, several of the god's more obscure lovers are omitted, and Ganymede is added at the end. Some of Jupiter's other intrigues receive fuller treatment elsewhere in the *Metamorphoses*, and by putting together a selection Boccaccio had been able to come up with ten female conquests for *L'Amorosa visione*.[18] Boccaccio's list is a sort of triumphal procession, like the triumphs of Cupid described in ancient sources and in Petrarch's contemporary *Trionfo d'amore*. Petrarch himself does not mention Jupiter's lovers individually, but Bernardo Lapini da Montalcino's commentary (which appeared in many printed editions from 1475 onwards) contained a list which in its turn provided the basis for Leone Ebreo's account in his *Dialoghi d'amore*, published in 1535.[19] *L'Amorosa visione*, which may have influenced the *Hypnerotomachia Poliphili*'s series of triumphs involving Europa, Leda, Danaë, and Semele, was also printed several times in the first half of the sixteenth century, so there were in effect two traditions – one derived directly from Ovid, the other from the poetry of Petrarch, and from Boccaccio.

Despite this, until the 1530s there was no precedent for showing the loves together as a group, and only the rapes of Europa and Callisto are illustrated in early editions of the *Metamorphoses*. The rape of Europa also appears quite frequently on *cassoni* and on pastiglia boxes. But, since the loves of Jupiter were, strictly speaking, extra-marital affairs, they were not an obvious theme for wedding presents. An antique gem showing Leda and the swan ensured that this subject was represented on plaquettes, and later

in jewellery as well. The appearance of these subjects often seems to be source-driven. In Peruzzi's work at the Villa Farnesina, for example, three are shown in the hexagons of the Sala di Galatea as part of the astronomical programme derived from Hyginus's *Poetica astronomica*, while three others appear in the largely Ovidian frieze of the Sala del Fregio (with Europa appearing in both). In the early sixteenth century, nobody seems to have thought of putting them all together. What changed this was the rise of printed pornography.

I Modi, Marcantonio Raimondi's explicit series of prints after Giulio Romano, featured anonymous couples in a variety of sexual positions.[20] Its sequel, Caraglio's *Loves of the Gods*, recast the lovers as mythological figures, many of them taken from the Latin text of Book 6 of the *Metamorphoses*. Four showed loves of Jupiter – Io, Semele, Mnemosyne, and Antiope – subjects chosen because Jupiter makes love in human or semi-human form rather than in metamorphosis, so preserving the idea of including couples in every print (Fig. 55 – though here the figures are Jupiter and Juno). By fleshing out the list in the *Metamorphoses*, Caraglio helped to give Ovid's series a new importance, later evidenced by the Sala di Aracne at the Palazzo Andrea Doria at Genoa, Herman Posthumus's paintings in the Arachne room at Landshut, and Spenser's description of the tapestries of 'Cupid's warres' in *The Faerie Queene*. And the *Loves of the Gods* were also influential in their own right. The genealogy is not difficult to trace. Caraglio's set not only inspired Bonasone's *Loves of the Gods* (which included Leda, Semele, Io, and Danaë) but Michael Coxcie's only slightly less *risqué* drawings of the *Loves of Jupiter*, which were also destined for engraving by the Raimondi school. Perino del Vaga, one of the artists who provided the drawings for Caraglio's engravings, was later responsible for the series of tapestries of the *Loves of Jupiter* woven for the Palazzo Andrea Doria in Genoa.

Meanwhile Giulio Romano, the designer of *I Modi*, had left Rome for Mantua where he became the court artist of Federico Gonzaga, and was responsible for a series on the infancy of Jupiter, and the design for the *Jupiter and Olympias* in the Sala di Psiche at the Palazzo Te (Fig. 56). Although there is no evidence that they were destined for the Palazzo Te, Correggio's four paintings of the *Loves of Jupiter* for Federico clearly reflect the taste for mythological erotica that Giulio brought with him. And so it goes on. One of Giulio's assistants, Primaticcio, joined Rosso, the other of Caraglio's designers, in Fontainebleau to create the pairing of *Danaë* and *Semele* at the centre of the Galerie François I. And it was the print after Primaticcio's fresco that, along with Correggio's *Danaë*, provided the model for Titian's two paintings of Danaë, the second of which became the first of

55. *Io*, Jacopo Caraglio after Perino del Vaga

his *poesie* for Philip II. Even Michelangelo's *Leda* and *Ganymede* were grafted onto the family tree. The *Ganymede* found its way into Coxcie's series of the *Loves*, while the *Leda* was copied by Rosso and went on to influence Primaticcio's and Titian's paintings of Danaë.

But other than *The Rape of Europa*, Titian's *Danaë* is the only one of the loves of Jupiter to feature in his paintings for Philip II. Somewhere along the route from porn to *poesie*, the loves of Jupiter had lost their centrality. In fact, the vogue for depictions of the loves of Jupiter was short-lived. All the thirty-odd images mentioned above were produced between Caraglio's *Loves* of *circa* 1526 and the end of the 1530s. During this period there were two main audiences for depictions of the loves of Jupiter: anonymous consumers of pornography, and the Holy Roman Emperor. Correggio's *Loves* were given to Charles V by Federico Gonzaga; Perino's tapestries were woven for his visit to Genoa, and the gallery of Francis I was hurriedly completed for Charles's visit in 1539. To a remarkable degree the audience for all these visions of lust was one man.

There are two interlocking stories here: the diffusion of mythological erotica from Rome, and the celebration of the emperor as Jupiter. It is the

56. *Jupiter and Olympias*, Sala di Psiche, Palazzo Te, Mantua,
Giulio Romano and assistants

eagle that connects the two. Determined that the *Loves of the Gods* should
not be taken for mere pornography like *I Modi*, the publisher made sure
that the identifying attributes of the protagonists were clearly displayed
in every print. Jupiter is therefore always accompanied by his eagle and
thunderbolts – the poor bird sometimes almost squashed beneath the heav-
ing bodies of the lovers. It was by no means standard practice to include a
large bird of prey in erotic scenes. (At the Farnesina, for example, the eagle
features only in the abduction of Ganymede.) But for a couple of decades
thereafter the eagle has an uncanny way of turning up in sexual encounters,
notably in the tapestries at the Palazzo Andrea Doria, and in the *Jupiter
and Olympias* at the Palazzo Te. Michelangelo's aquilophilic drawings for
Cavalieri are part of a wider phenomenon.

The eagle was of course also the heraldic device of the Holy Roman
Emperor, and of the Gonzaga in Mantua, and as such central to their
identification with Jupiter. But when is the eagle just an attribute of Jupiter
and when is it an imperial or Gonzaga emblem? It depends on the context.
Unlike the other scenes on the same wall (a *Polyphemus* and a *Pasiphae* –
both from Philostratus) which share the theme of illicit desire, the story of
Jupiter and Olympias is a very unusual one. Found in Plutarch's *Life of
Alexander*, it tells how Jupiter Ammon lay with Olympias in the form of a

snake while her husband Philip of Macedon looked on through the chink in the door. Philip was blinded in the offending eye (you can see the flames of the thunderbolt doing the damage), and Olympias gave birth to Alexander the Great.[21] Federico himself had a son named Alessandro by the wife of another man, and at one stage sought to make Alessandro his legitimate heir. Given the parallels, and the prominence of the eagle and thunderbolt, it is easy to see that here the overt eroticism of Caraglio's *Loves* has become overlaid with a covert dynastic reference.

Later in the century, the identification of the eagle with Charles V is sometimes quite unambiguous. Battista Franco's *Allegory of the Battle of Montemurlo* shows Michelangelo's *Abduction of Ganymede* in the sky above a depiction of the battle of 1537 in which Cosimo I defeated his enemies with the aid of Charles V (Fig. 57). Here, as in Vasari's depiction of Ganymede in the Sala di Giove in the Palazzo Vecchio, Ganymede is identified with Cosimo raised up by imperial power. (In the Palazzo Vecchio, Vasari interprets the scene as Cosimo's elevation to a dukedom by Charles V.)[22]

In this regard, it is worth noting the inclusion of the abduction of Ganymede in Correggio's other loves of Jupiter. Although Ganymede is appended to the other loves of the gods in early Italian vernacular translations of the *Metamorphoses*, he is absent from both Caraglio's and Bonasone's series, and does not appear among Perino's loves of Jupiter either. The long allegory (derived from Lactantius via Fulgentius) that Ganymede receives in Agostini's translation may well be relevant here. It explains that Jupiter actually won Ganymede under the sign of the eagle which he had put on his standards after an eagle had appeared as an auspicious omen during his struggle against Saturn and the Titan. This association of the eagle with victory helps to explain the presence of Ganymede in Franco's *Allegory*. And since Correggio's series was commissioned by a man whose symbol was the eagle and given to another whose symbol was also the eagle, it is easy to see its potential relevance. Federico was also elevated to a dukedom in 1530, and the emperor had earlier given Federico permission to use the device of Mount Olympus. What better image of being taken up to Olympus by the emperor who had triumphed under the sign of the eagle than the abduction of Ganymede?

Uncertainty about the precise date and purpose of the commission for Correggio's *Loves of Jupiter* makes it difficult to be sure of its significance, but it is still possible to offer a plausible account of the painting's genesis. When Charles V came to Mantua in 1530 he particularly appreciated the Sala di Psiche, where he would doubtless have remarked on the *Jupiter and Olympias*, if only because it may well have been the rudest thing he had

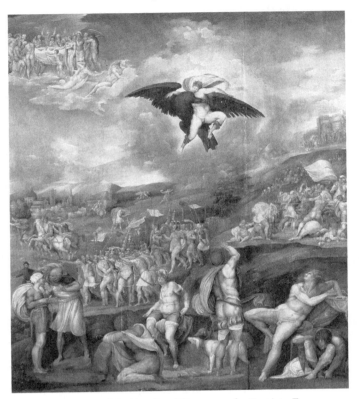

57. *Allegory of the Battle of Montemurlo*, Battista Franco

ever seen. The fact that Federico presented Charles with an only slightly less explicit series of images sometime later suggests real confidence that Charles would appreciate them. The *Abduction of Ganymede* may refer to Federico's elevation by the victorious emperor, while the other canvases exploit the general theme without having any specific political reference (rather in the way that the *Jupiter and Olympias* is itself accompanied by thematically related images of no dynastic import), the painter secure in the knowledge that if Charles liked the *Jupiter and Olympias* he would enjoy these as well.

This hypothesis, like its alternatives, can only be speculative, but it is given added weight by its parallels in Genoa, where in the early 1530s a set of tapestries showing the loves of Jupiter, known as the *Furti di Giove*, were displayed in the Sala di Giove. Designed by Perino del Vaga and woven in Flanders, the series comprised six tapestries – Alcmena, Callisto, Danaë, Semele, Io, Juno. Whereas Correggio's *Loves* were as steamy as they could

be without depicting human couples, Perino rendered the couples suitable for tapestry by reducing the nudity and eliminating provocative poses.

In all this naughtiness Europa is notable by her absence. Although the rape of Europa is the most frequently illustrated of the loves of Jupiter, and heads the list of the loves of the gods woven by Arachne, it appears in none of the more *risqué* series save Coxcie's inclusive *Loves of Jupiter*. Europa did not make a good subject for pornography because the crucial scene is an abduction rather than a rape, and Jupiter is stuck in his beguiling but slightly ridiculous bovine form. Still, painters of maiolica tried to exploit the subject's erotic potential. There is a plate from Urbino where Jupiter gets his hoof over Europa's leg, and one from the workshop of Virgiliotto Calamelli in which Europa and a human Jupiter do not wait to get to Crete to consummate their union.

The popularity of Europa as a subject for maiolica is due in part to the fact that it almost invariably featured in illustrated editions of Ovid. There were numerous other evocative descriptions of her abduction in classical literature,[23] but the essentials of the story are always more or less the same. Europa is out playing with her friends by the sea in Sidon when Jupiter catches sight of her. Turning himself into a white bull, he wins her trust by his gentleness. He allows her to pet him, and adorn him with flowers, and then induces her to sit on his back. As soon as she does so he starts edging towards the water. Suddenly he charges in and they're off, the bull speeding through the waves with Europa hanging on for dear life. Eventually they get to Crete, where (as Erasmus tersely remarked) Jupiter ceases to be a bull and Europa a virgin.[24] Their child was called Minos.

There are, however, one or two differences between the sources that sometimes make it possible to identify the literary tradition behind the image. In the *Metamorphoses* Ovid describes how Jupiter persuades Mercury to drive a herd of cattle down to the shore so that he can mingle with them and approach Europa undetected. Erasmus imagined the scene in one of his poems, and it is portrayed in very similar terms by Peruzzi in the Sala del Fregio at the Farnesina.[25] Lucian gives more detail about the journey across the sea and has Europa accompanied by Neptune, Venus, and cupids with lighted torches.[26] It is most unusual to see anything like this, but Jordaens painted the subject in precisely this way around 1615.

Identifying the literary source by Europa's position on the bull is altogether more tricky. In Book 2 of the *Metamorphoses* Ovid presents her holding on to a horn with her right hand and resting the other on the bull's back. Illustrators of Ovid usually follow this description (although the prints

often show this in reverse), but Lucian and Achilles Tatius both have Europa holding the horn with her left hand, and using the other either to keep hold of her drapery (Lucian) or, less plausibly, to turn it into a makeshift sail (Achilles).[27] Titian's *Europa* uses Lucian's technique, but it is hard to make a positive identification of the source because artists often did not bother about which hand did what. In the *Hypnerotomachia Poliphili*, which in turn influenced Giorgione's lost painting of the subject, Europa is waving to her companions on the shore with her free hand. Some artists, including Tempesta, have her using both hands to steer the bull like a jet-ski, and even the 'Look, no hands!' approach can be found in early seventeenth-century statuettes by followers of Giambologna.

Other than a drawing by Peter Vischer the Younger which shows Europa coming ashore in Crete bedraggled and tearful, there are few representations of her arrival. But you can follow the whole story, including the arrival in Crete, from right to left on a single *cassone* panel (Fig. 58) by Liberale da Verona: no abrupt transitions here, merely a rite of passage – appropriate enough in the context, although hardly a reflection of the literary sources, which give little attention to Crete and exploit the contrast between the bull's gentle seduction of the guileless Europa and the exhilarating ride across the waves. The scenes were very different in mood, and each required a distinct sensibility, so most artists preferred to concentrate on one or the other.

For once, Jupiter had not waited for the girl to be alone. He seduced her when she was with her friends and he was part of a herd of cattle. Their meeting is a social occasion of sorts, and Jordaens, in his 1643 version of the subject, conveys (perhaps more clearly than he intended) something of its awkwardness. Jupiter has curled himself into a seat for Europa, and she and her equally robust friends threaten to crush him between them. Other members of both herds look on bewildered. Cupid is going to have to work hard to unite this couple. But in Veronese's painting the artist has done it for him (Fig. 59). Europa is already locked into position by a chain of interwoven arms that forms three circles to match those of the garlands and horns of the bull. It is a ritual performed, as rituals should be, spontaneously and uncomprehendingly, and Jupiter licks her foot in appreciation. Poliziano had described Jupiter licking Europa's feet as he swam across the sea, but this caress is part of a cycle of reciprocal gestures: she responds with the light pressure of her right foot on his rear leg. In northern art, where Veronese's painting was influential, the sense of ritual is lost, although the festive atmosphere is retained, nowhere more vividly than in Hendrik van Balen's many representations of the scene.

Claude, who specialized in both pastoral and marine landscapes, turned to the rape of Europa not only because it enabled him to show off his skills, but because it combined them in the kind of classical theme he used to raise his paintings above the level of genre. His first version, painted in 1634, was both one of his earliest mythologies and one of his largest paintings to date. It was obviously a success, and may have helped to secure the support of one of his most important patrons. In consequence, he kept returning to the theme and eventually painted it at least five times. It is one of the few erotic subjects he could have treated without having to confront what were, for him, the unwelcome possibilities of nudity and sex. Even so, his rape of Europa does not contain so much as a hint of seduction. It is more like a donkey ride on the sands – a scene he had, in fact, painted in one of his coastal landscapes.

Claude's Europa rides side-saddle, as she does in the majority of paintings from the sixteenth century onwards. In contrast, fifteenth-century Italian representations of Europa, including those in the 1497 edition of Ovid and the *Hypnerotomachia*, frequently show her sitting astride the bull, or even lying on top of him. The change may reflect a growing concern with decorum, but it also helped to keep Europa's feet dry. In Book 6 of the *Metamorphoses* Ovid emphasizes that Europa drew up her feet so as not to get them wet. This would have been difficult if she was astride the bull, and Dürer could solve the problem only by having her kneel on the bull's back.

58. *Europa*, Liberale da Verona

Riding side-saddle, it was much easier to manage, although perhaps only Coxcie's Europa would have arrived in Crete with her feet perfectly dry.

It is a long way from Sidon to Crete, yet some representations of the subject make it look as though Europa is merely fording a river on the back of an ox. To appreciate the story of Europa, you really had to have seen the sea – to understand how vast and alien and treacherous it was, and how improbable the sight of a bull surging through the waves. In the sixteenth century, there must have been many artists who had never done so. Representations of the subject on maiolica, in particular, rarely suggest an awareness of what was involved. But Titian conveys all these things in a way that few other painters manage to do. Both Europa and the bull are way out of their depth. Only someone accustomed to travelling across the water could have painted the scene in this way.

The subject was fashionable in Venice as in most maritime centres, except – curiously enough – Genoa. Titian's painting was influential, but the print in Salomon's Ovid had, through its numerous variants, the wider impact. The subject was popular in the decorative arts and was used in pendants in the later sixteenth century in the Netherlands and Spain, while in Portugal the abduction was illustrated on *azulejos* (painted tiles) from the mid-sixteenth century onwards. Portugal was, in a sense, the Sidon of western Europe from where Europa's westward voyage could have continued all the way to the Americas, though nobody seems to have thought of this.

59. *Europa*, Veronese

In fact, the use of Europa to represent the continent was initially more common at its centre than its edges. The rape of Europa had never established itself as a narrative subject in central Europe. But if being in the middle of Europe made it difficult to imagine what it might be like to be carried across the sea to unknown lands, it also gave a precarious tangibility to the idea of Europe itself. In the imperial room of Bučovice castle, a painted stucco relief of Europa on the bull stands to the left of one showing Charles V riding down a Turk. Charles was long dead by this time, yet the implied connection between the emperor and the idea of Europe lived on after him.

The identification of Europa with Europe is an ancient one. Horace had claimed that Europa had given her name to half the world, and Ovid said a third. By the time Europa was routinely used to symbolize Europe in the visual arts, her dominion had shrunk to a quarter. The theme of the continents, or parts of the world (as they were then called), developed primarily as a response to the discovery of the Americas.[28] People became more conscious of the continents as distinct areas, and bringing the number up to four gave them a nice symmetry. All the same, it was not until the final quarter of the sixteenth century that personifications of the four continents, seated like Europa on representative animals, began to appear in Antwerp and elsewhere. Before this, the use of Europa and the bull as a symbol for

Europe itself was uncommon in the visual arts. The most notable exception is a print by Conrad Schnitt, which shows Europa being carried across the water to be molested by an assortment of ecclesiastics. The accompanying inscription (conceivably by Erasmus) likens Jupiter, who ravishes Europa as a bull, to the monks who defile Europe in the guise of innocent lambs.

Allegorical readings of the story of Europa are relatively rare, for the most frequently repeated interpretation of the myth of Europa is the euhemerist one which suggests that her voyage across the sea was actually accomplished in a ship with a white bull as its sign. It was illustrated in the 1539 edition of Boccaccio's *De claris mulieribus* because that is how he tells the story, but it has no influence on illustrations to Italian editions of Ovid, even though it always features in the allegories. In the case of Europa, the narrative is more robust than its interpretations.

According to Moschus, Europa was carrying a basket depicting the story of Io when she went down to the shore that day.[29] She should have looked at it more closely, for Io's fate is the mirror of her own. Whereas Jupiter became a bull, Io was turned into a heifer. (As Martial said, the two metamorphoses ought to have been better co-ordinated.)[30] In the sky, Io and Europa offered competing explanations of how the bull came to be set among the stars, but on earth they went in opposite directions: Europa to Crete, Io to Egypt. Between them they founded two civilizations.

The story of Io is told in the first book of the *Metamorphoses*. Like a teen movie, it swings from horror to comedy and back, and always has a sequel. Jupiter asks Io if she fancies a walk in some dark woods. She runs for her life, and gets a long way before she is caught in a thick cloud. Then something reaches out of the fog and takes hold of her; it is Jupiter. The unnatural cloud arouses Juno's suspicions. So, just before Juno arrives, Jupiter changes Io into a heifer. Juno is not fooled, but she plays dumb: 'Whose is this pretty little thing? Where did she come from?' Jupiter is dumb: 'Oh, you know, she just sprang from the earth.' 'If she does not belong to anyone, why not give her to me?' his wife replies. Stuck for an answer, Jupiter does as he is asked, and Juno gives Io into the charge of a giant called Argus. He has a hundred eyes, and keeps ninety-eight of them open at any one time. But Jupiter does not give up. He sends Mercury, disguised as a shepherd with a reed pipe. Mercury wins Argus's trust and then lulls him to sleep with the story of Pan and Syrinx. When the last of the hundred eyes has finally closed, Mercury hacks off Argus's head with a sword (Fig. 9, p. 25).

Argus's hundred eyes were recycled in the tail of Juno's peacock, but Io stayed a heifer. Driven mad (Virgil, not Ovid, says she was tormented by a

gadfly), she wandered the world until she came to Egypt. There, her human form restored, she was worshipped as the goddess Isis. Plutarch and Diodorus take up the story when, as Isis, Io gave the Egyptians the law, and married Osiris.[31] He was killed and chopped into many pieces, but Isis collected them all and buried them in a pyramid from which emerged the bull-god Apis.

In the 1490s, Pinturicchio and his assistants painted pretty much the whole story in the upper levels of the Room of the Saints in the Borgia apartments in the Vatican. The Borgia symbol was the bull, and for the patron – Pope Alexander VI, known as 'the ox' – the point of the story was its ending, the veneration of a bull-god so like himself. The rape of Io is not directly shown in Pinturicchio's cycle, nor in early illustrated editions of Ovid, where the standard scenes always show Jupiter and Juno discussing the heifer. There are a couple of versions in Caraglio's *Loves of the Gods* – one shows the conversation (Fig. 55, p. 156) while the other has Juno almost falling over the coupling bodies of Jupiter and Io. (In both, following Boccaccio's identification of Juno with Luna, the goddess is shown with a crescent moon in her hair.)[32] Here, as in other representations of the subject, the purpose of the cloud is to conceal the lovers from Juno, and there is no suggestion that Jupiter has been metamorphosed. Even so, it is hard to believe that without Caraglio's example anyone would have suggested the story of Io as a subject for an erotic painting.

In Correggio's painting of the subject, Io seems to be making love to the cloud itself (Fig. 60). But is she? The answer will depend on whether Correggio's *Loves* are viewed in the context of the Ovidian tradition or the triumphal one. The origin of the idea is hard to trace with any certainty, although Bernardo's commentary on Petrarch states that Jupiter covered Io in the form of a cloud,[33] and Leone Ebreo and the later Italian translation of Boccaccio contain the same implication.[34] Yet why, if Jupiter has transformed himself into the cloud, are his face and hand still visible within it? The closest literary equivalent to Correggio's painting is Agostini's translation of Ovid, which emphasizes that Jupiter and Io made love within the cloud, and highlights precisely the same features as Correggio – the kiss, Jupiter's grip, and the mutuality of the lovers' pleasure. The animal drinking from the pool in the foreground confirms that Ovid lies behind this iconography, for she is not (as art historians claim) a deer, but (as any farmer could tell you) a heifer. As she bends down to drink from a pool (like her predecessor in Caraglio's print), her crescent-shaped horns (doubtless prompted by Juno's crescent moon) portend her transformation into the Egyptian goddess Isis, whose appearance is described in just these terms

later in the *Metamorphoses*.[35] Here, with wonderful concision, are two metamorphoses in one.

Correggio had imitators, but his interpretation had no lasting impact on the representation of the subject. Subsequent depictions usually revert to showing Jupiter and the heifer separated from Juno by the cloud. Even the engraving after Goltzius, which has Jupiter lunging at the naked Io, uses the cloud to form a cave through the entrance of which Jupiter and Io can be seen again, innocently going out to greet the approaching Juno as man and heifer. In order to bring out the nuances of this relationship you really had to be familiar with the physiognomy of cattle. Most Italians did not bother with much more than big eyes and long lashes to convey Io's charms; in Holland, where there was a tradition of cattle-painting, there was more emphasis on Io's personality. Ovid describes at some length the plight of Io when, as a heifer, she goes back to her father's home and tries to talk to her family, yet the scene is almost never depicted save in a painting by Daniel Vertangen.

Although the story of Mercury and Argus became one of the staple subjects of landscape painting both in the North and in Rome, it was only the involvement of farmyard animals that took the loves of Jupiter into the realm of pastoral. They are not a common source of garden imagery and appear only occasionally in fountains. Indeed, they are not at all common in sculpture, except in miniature. For one thing, they are mostly too horizontal in line to make good statues, although Europa sitting on the bull was a popular subject for statuettes. The exceptions are the stories of Leda and Ganymede. In both cases, Jupiter is a bird.

Unlike Europa and Io, Leda is hardly mentioned in the Latin text of the *Metamorphoses*. There is more about her in the Italian editions of Ovid, but no illustrations. Other classical sources do not say much about her either, and it is from Fulgentius that Albricus and Boccaccio take their information. In Correggio's painting the cupids playing musical instruments on the right may reflect Boccaccio's account in which the swan enchants Leda with his song,[36] but representations of Leda rarely follow a text. Apart from anything else, there is not much to know, except that Jupiter mounted Leda in the form of a swan. A Roman sarcophagus relief and an antique cameo once in the collection of Lorenzo de' Medici give the picture: Leda leans back, the swan between her thighs unfurling his neck for a kiss.

An antique standing Leda was also known and reproduced on plaquettes, but the reclining Leda became the most common formula for the representation of the story. It is just about the only explicit representation of the sexual act routinely found in Renaissance art, and printmakers often show

60. *Io*, Correggio

Leda making the most of it. Giulio Campagnola's woodcut depicts her with her head thrown back in pleasure; the print by G. B. Palumba (the Monogrammatist I.B. with a bird) has her with one hand round the swan's tail pushing him in. Had Leda's lover been a man rather than a swan, such images would have attracted censorship. And in later centuries they did. More than the other loves of Jupiter, pictures of Leda were subject to attack – Michelangelo's painting was reportedly destroyed on the orders of Anne of Austria; Correggio's was savaged by a member of the French royal family in the eighteenth century. And it is hardly surprising. The sight of a woman having sexual intercourse with a large swan ought to prompt some sort of reaction.

Nevertheless, the subject does not appear in Caraglio's *Loves*, and in Bonasone's series it is actually treated more reticently than usual. In the Renaissance, Leda seems to have had an ambiguous position within the erotic imaginary. She appears on the back of a portrait medal of the noted courtesan Faustina of Rome, yet an image of her intercourse with the swan could also be used by a respectable married woman, or worn as an *enseigne* by a man. At some level many people seem to have accepted that Leda's lover was neither a man nor a swan, and hence that images of their conjunction did not really depict copulation (either human or bestial). Indeed, the erotic focus of the subject lies elsewhere. It is often displaced to the swan's outstretched neck. Ronsard imagined the beak going into Leda's mouth, and he cannot have been the only person to do so.

The painting that Ronsard had in mind when writing *La Défloration de Lède* may have been Michelangelo's, then in the possession of Francis I. Painted around 1530, it was meant for Alfonso d'Este – another erotic subject for the patron of Titian's *Bacchanals*. Although the design closely follows that of the antique cameo in Lorenzo's collection, even down to the gentle caress of the swan's tail feathers, one of Alfonso's courtiers criticized the painting, and Michelangelo gave it away to an assistant who took it to France. Neither this nor any of the other antiquities known to the Renaissance shows the outcome of the unlikely coupling, but as the literary sources make clear, the union produced children born from eggs. There was much disagreement about which child came from which egg, and unless, as in Xanto's plate in Bologna (Plate VIII), the eggs are helpfully stamped with the names of their occupants, it is not always possible to tell who is hatching where. But Michelangelo, with his sculptor's X-ray eyes, saw the living form enclosed within the shell, and Bos's engraving (presumably after Michelangelo's cartoon) has Castor and Pollux emerging from one egg, and Helen visible through the shell of the other.

In this respect, Michelangelo differed from Leonardo, whose *Leda* had four children sorted by sex, as in vernacular Ovids.[37] Between the two of them, they established Leda as an important subject for later Florentine artists, including sculptors. Ammannati produced a marble group based on Michelangelo's version – a great lump of stone feathers between Leda's legs – but most people realized that Leonardo's idea of having Leda and the swan standing side by side was going to work better in three dimensions. Leonardo had created an extraordinary dynamic between the two in which the complementarity of their curves appears to be a function of each figure's independent rotation. His followers could see the mechanism but could not reproduce the effect. Bandinelli thought about having the swan's neck winding round Leda's arm like a snake; Vincenzo Danti had a better idea: he drew the spiralling motion of the figures upwards by having Leda raise one arm to pull up her hair.

Common in sixteenth-century Italian painting, print, and maiolica, representations of Leda are less frequently found elsewhere. Perhaps because of the paucity of literary sources, the subject did not become common in northern Europe, and is almost unrepresented in seventeenth-century Dutch art. Only the presence of Michelangelo's painting ensured its popularity in France. In this case, it was the prestige of Michelangelo's name, rather than the originality of his composition, that accounted for his design's success. With his *Ganymede* of 1532 it was different.

Representations of Ganymede, abducted by an eagle and taken up to Olympus to become Jupiter's cup-bearer, were already common. But once Michelangelo's composition became known, people seemed content to imagine the scene as he had done (Fig. 57, p. 159). Variants found their way into the emblem books (including later editions of Alciati, where Ganymede signifies rejoicing in God); and Sebastiano del Piombo jokingly suggested that, if supplied with a halo and turned into the vision of St John the Divine, the design might be used for the cupola of the Medici chapel in Florence. It may have been the ambiguity of the design that made it so adaptable. The Ganymede who writhes languorously in the eagle's outstretched wings is also shackled by the cruel talons around his legs. Imitators occasionally felt obliged to resolve the tension. The second of Bocchi's emblems illustrates Pliny's description of a statue of Ganymede in which the eagle is careful not to hurt the boy with his claws for fear of disturbing his 'peaceful sensations', but modifies Michelangelo's design to loosen the eagle's grip.[38] Bonasone clearly thought those talons would have disrupted Ganymede's tranquillity. Would Michelangelo have agreed?

That Michelangelo turned to Ganymede so soon after the Leda was no

coincidence. Ganymede and Leda were often paired: they appear side by side on a sarcophagus relief known in sixteenth-century Rome, and at the top and bottom of a fifteenth-century manuscript of Petrarch. In Michelangelo's case, the Ganymede drawing was accompanied by one of Tityus in which the condemned man is attacked not by a vulture but an eagle very like that in the Ganymede. The pairing is widely assumed to be antithetical – the raptures of divine love contrasted with the torments of profane love. Yet the eagle's beak makes no incision in Tityus's flesh, and the movement of its head across his chest is no more threatening than that of the eagle in the Ganymede drawing. In fact, Tityus's pose – on his back, left arm behind his head, left knee raised – is curiously reminiscent of the depiction of Leda on a stucco roundel in the Vatican *Logge* in which the swan sits on top of Leda, as though he has just landed on her stomach. If, as this suggests, rapture and torment are fused in the artist's imagination, it may help to explain why he added the drawing of the fall of Phaethon to the group the following year. The sequence – Leda, Ganymede, Tityus, Phaethon – reveals that Michelangelo was thinking about the loves and punishments of Jupiter. With a difference. These were usually themes of a public art in which love and punishment were contrasting aspects of Jupiter's sovereignty, but in Michelangelo's case they were private works destined for Tommaso de' Cavalieri, a young nobleman he had only recently met and with whom he was passionately, if chastely, in love. The choice of such grandiose themes may suggest a certain awkwardness in the visual language of intimacy; yet there can be little doubt that for the self-styled 'prisoner of an armed Cavaliere', love and punishment were one.

The homoerotic import of the story of Ganymede was universally acknowledged, but with widely varying degrees of acceptance.[39] There is some evidence to suggest that the story became the focus of homoerotic feelings and their suppression, though the fact that Ganymede had a job to do helped to distract attention from the erotic aspects of the story, and official disapproval restricted the way it could be depicted. Once he had arrived in Olympus, Ganymede displaced Hebe as Jupiter's cup-bearer, a blatant bit of sexual discrimination that appears in the work of Rubens and other seventeenth-century artists. But Rembrandt's Ganymede is clearly far too young to work. Bawling, weeing, fending off his tormentor with one pudgy hand, and defiantly clutching his cherries in the other, Rembrandt's Ganymede is a problem child about to be put to bed. And what awaits him there? If you look at the way the eagle spreads his wings across the entirety of the canvas, you cannot help experiencing some of the horror that Ganymede must have felt. Rembrandt thought about what mythical events would have

been like if they happened to you, rather than being something you did. With other people it was different. Most preferred to cast themselves in the active role. Petrarch imagined himself the eagle that carried Ganymede through the air.

Egidio da Viterbo, the Prior General of the Augustinian Order, considered Jupiter's affairs an indication of God's love for humanity. He had a point, for Jupiter's capacity for love seemed unlimited. Some of his affairs, like that with Alcmena, the mother of Hercules, or Diana's nymph Callisto, involved the impersonation of another individual, but most required a metamorphosis. Latin editions of Ovid state that Jupiter ravished Aegina as a flame, Asteria as an eagle, Persephone as a snake, Mnemosyne, the mother of the Muses, as a shepherd. Most of these subjects are rarely illustrated or discussed, although Leone Ebreo fitted some of them into an astrological scheme whereby Jupiter's loves represented the conjunction of his planet with one of the others. Aegina is a hot, fiery affair generated by the conjunction of Jupiter and Mars, and so on.[40]

The only occasion on which Jupiter's love seems to have been tainted by the form of his metamorphosis is when he ravished Antiope as a satyr. According to Leone, this signified a love that was, like the satyr itself, half virtuous and half bestial. Perino seems to have thought the same, for although the subject appears among his designs for Caraglio's *Loves*, it is absent from the *Furti di Giove* tapestries. Indeed, there are fewer examples in sixteenth-century Italian art than was once supposed, for the subject has often been confused with that of Venus spied upon by a satyr. Representations of Jupiter and Antiope only became common in the early seventeenth century in northern art, beginning with Goltzius's *Jupiter and Antiope*, itself derived from a Carracci print, *Venus and a Satyr*. Van Dyck's version was to become the most successful. Here, like the beast he has become, Jupiter approaches from behind, and unveils the girl as she sleeps.

Jupiter usually got what he wanted. But even the king of the gods sometimes missed out. Jupiter and Neptune were both courting Thetis until they learned that her son would one day outdo his father, so they both backed down and married her off to Peleus. All the gods came to the wedding. Sexual desire was not always so easily sublimated. A nymph called Juturna was proving frustratingly elusive, so Jupiter tried to persuade the other nymphs to catch her for him. One of them, Lara, warned Juturna, and also told Juno. Jupiter wrenched out her tongue in revenge. The story is found in Ovid's *Fasti*.[41] You can see it happening in Cornelis van Haarlem's painting. Like a pair of cut-throats in an alley, Jupiter and Mercury work

as a team. One restrains Lara, while the other pulls out her tongue with a pair of pliers. As an additional punishment, Lara was forced to relocate to the underworld. Mercury escorted her down, the god of eloquence accompanying a terrified mute. He raped her on the way.

Of course, Jupiter also had a wife, Juno. Easily identified by her peacock, she often appears alongside her husband at formal occasions like banquets or councils of the gods. Despite her jealousy over Jupiter's constant philandering, Juno and her husband were occasionally at peace: in Goltzius's *Metamorphoses* they can be seen after a boozy supper, bantering about sex. Juno claimed that men find greater pleasure in intercourse, but Tiresias (who was called in to adjudicate because he had been both man and woman) did not back her up, and so she blinded him.[42] If what Tiresias said was true, Juno was missing out, for Jupiter tended to neglect the marriage bed. She even had to borrow the girdle of Venus in order to get her husband to perform his conjugal duties, but it worked a treat, and in Annibale's fresco in the Farnese Gallery you can see the results.

It had been different once. Before they were married Jupiter had taken Juno's virginity while disguised as a cuckoo. Cartari reports the tale, and Bonasone illustrated it as an example of the way great things can come from small causes. Bacon argued that the story showed that to get anywhere with someone as stuck-up and nasty as Juno you had to make yourself as wretched as a cuckoo.[43] But Juno did not get a bad press everywhere. When rulers were identified as Jupiter, their wives were sometimes given the attributes of Juno, as was the case with Henry IV and Marie de' Medici. And in Venice, the goddess's identification with wealth ensured her a prominent place in the allegories of the republic, most notably in Veronese's *Juno Showering Venice with Riches* in the Palazzo Ducale. This, like Ammannati's Juno fountain, is a state allegory. Rubens is the only artist who really appears to have appreciated Juno as a woman. In his *Juno and Argus* (Fig. 61) she looks magnificent as she arrives to supervise the delicate operations needed to transfer Argus's eyes to the peacock's tail. She is every inch a queen, yet Rubens also sensed that she was more than that. In his late *Judgement of Paris* it is Juno who stands at the centre of the painting. She pulls a fur cloak into a triangle across her body. The action was made famous a couple of years later by the artist's second wife, Helena Fourment. Her pose may remind the viewer of a *Venus pudica*, but the gesture is Juno's.

The one serious attempt to take Juno centre stage was Bonasone's ambitious series of twenty-one prints of *The Loves, Rages, and Jealousies of Juno*. Dating from the 1560s, Bonasone tried to do for Juno what had already been done for her husband, by bringing together stories of love and

61. *Juno and Argus*, Rubens

of punishment. Since Juno had visited the underworld to enlist the help of the Furies, it was natural to show her looking in on the tortures of Tantalus and Tityus. But she had also endured her own punishment. Once, angered by her persecution of Hercules, Jupiter suspended his wife in the air (so making her the symbol of air), her hands tied with golden chains and her feet weighed down with anvils. As for love, other than Jupiter, Juno's most famous suitor was Ixion, who had to make do with a cloud. The fact is, her relations with Venus had been soured by losing to her in the Judgement of Paris.

Despite its title, Bonasone's series does not show many of Juno's other jealousies; they are, though, a recurrent theme in Ovid, where Juno's anger is responsible for many of the metamorphoses. Her vengeance on her rivals is never more effective than in the case of Semele. Jupiter had already made her pregnant when Juno discovered what was going on. So she disguised herself as Semele's old nurse Beroë and struck up a conversation with her. Juno eventually brought the talk round to Semele's good fortune in bearing Jupiter's child, but added a note of caution: people are always going round seducing girls by claiming to be gods; Semele needs proof that Jupiter really is who he claims to be.

Next time Jupiter came round, Semele requested a favour. He swore that she could have whatever she wanted. So when she asked to see him in all his majesty as Juno herself did when they made love, he could not refuse. As Leon Davent's print after Primaticcio's lost painting for the Galerie François I reveals, Semele got more than she bargained for (Fig. 62). Engulfed in winds and storms, and struck by Jupiter's thunderbolt, Semele's body could not withstand it. She died in the act of love. Jupiter and Semele feature in several of the more *risqué* series of loves, and the pose of the lovers indicates that Primaticcio's painting may owe something to Caraglio's print of the same subject. So it is easy to forget that what you are looking at is the death of a pregnant woman. Miraculously, the child survived. He was Bacchus. In the *Hypnerotomachia*, you can see him being picked out of the sludge that had once been Semele, although, according to the classical sources, the foetus had not come to term, and Jupiter had to sew it into his thigh.

This conjunction of sex, death, and unorthodox obstetrics obviously did not appeal to everyone. Scenes of Semele's death and Bacchus's reimplantation tend not to exploit the subject's erotic potential, while erotic treatments of the theme downplay the fatal consequences of the lovemaking. In Bonasone's series of the *Loves*, for example, there are two prints: the first shows Semele naked in bed with Jupiter's thunderbolt above; the second, the birth

62. *Semele*, Leon Davent after Primaticcio

of Bacchus from Jupiter's thigh (Fig. 63). Here, two trees can be seen behind Jupiter, one with full foliage, the other blasted and bare. According to Nonnos, Semele had dreamt of a tree with unripe fruit that was struck by lightning, but from which the fruit was saved unharmed.[44] The motif of the blasted tree appears behind the lovers in the erotic print after Marco Dente, and also in Giulio Romano's painting – a discreet reminder that all this fooling around is going to end in tragedy.

In the Galerie François I, the significance of the story of Semele was also its association with the consuming power of fire. Primaticcio's painting was located over a fireplace, and ornamented by a small tondo with a classical scene depicting the burning of books. In general, the story was treated as a natural allegory: Semele is the vine, ripened by heat, that brings forth the grape of Bacchus. But this, like the other allegories of the loves of Jupiter, had little obvious bearing on the way the story was represented. The exception was the fable of Danaë, where the allegory was so central to the story that it became fused with it.

The story of Danaë is a sealed-room mystery.[45] Informed by an oracle that the child of his daughter Danaë would kill him, Acrisius locked her up in a tower. It was a bad idea, for as Ovid and later Montaigne noted, locking up your daughters only makes them more desirable. (You can't win:

Gioue si posi in corpo quel bambino
Di seme morta per troppo uedere
Et fu chiamato poi Bacco diuino

63. *Birth of Bacchus*, Bonasone

Boccaccio said that Europa was abducted because she was allowed to hang
out at the beach.)[46] Anyway, there was a hole in the roof. Jupiter worked
his way through and then fell into Danaë's lap in a shower of gold. In the
course of time, she gave birth to Perseus. When Acrisius discovered what
had happened he put them both in a chest and pushed them out to sea. Of
course, Perseus killed him in the end – a freak accident with a discus – but,
unlike the Oedipus legend, it is the beginning of the story that holds your
attention. It is a reminder that, however hard you try, you cannot keep
anything sealed up for ever. There is always going to be a crack somewhere,
and someone or something will find a way through.

Even in antiquity, people knew what that thing was. As Horace noted, it
is gold that slips past sentries and breaks down walls. Very early on, the
interpretation of the myth is incorporated into the narrative. It was not a
rain of gold that fell into Danaë's lap but a shower of golden coins. Augustine
said that the fable showed how a woman's chastity might be corrupted by

gold, and Boccaccio followed suit, quoting Theodontius's conjecture that Danaë might actually have done a deal with Jupiter to get out of her prison. It was a small step from this to the idea that Danaë was simply selling her body for money. In Terence's comedy *The Eunuch*, a courtesan has a painting of Danaë hanging in her house.

Terence was popular, and in the sixteenth century the reference is frequently exploited.[47] In Du Bellay's *La Vieille Courtisanne* the heroine has a picture of Danaë above her door, and a similar painting hangs on the wall in the brothel scene in Frans Francken II's *Prodigal Son*. It is hard to know whether such references reflect the decoration of contemporary brothels, although it is not impossible, for the link between Danaë and prostitution was a commonplace, and pictures of Danaë were as notorious as Danaë herself. In *The Eunuch*, a young man is left alone with a virgin in the room where the painting of Danaë is located. Excited by the picture, he thinks: Why cannot I do what Jupiter is doing? – and so he does. Augustine used the story as an example of the evil effects of pagan mythology, and in the sixteenth century it became a standard example of the potentially harmful power of images. But the logic worked the other way as well. If you wanted an arousing image, Danaë was an obvious subject to choose.

This is what appears to have happened when Titian was painting his *Danaë* for Alessandro Farnese. Originally intended simply as an erotic nude, she was first supplied with the features of an identifiable courtesan (presumably the cardinal's favourite) and then turned into Danaë. The cardinal clearly expected something that would turn him on, and so when the papal nuncio writes to the artist from Venice about the progress of the work, Titian reassures him that the *Venus of Urbino* will look like a nun beside her. What made her less like a nun was having her legs apart. Medieval images of Danaë show her fully clothed while catching the golden rain in her apron. Correggio cleverly used Danaë's legs to spread the drapery across her lap, but Primaticcio, influenced by Michelangelo's *Leda*, opened her legs wide enough to accommodate a swan. Aretino had thought that any man would be happy to take the bird's place in Michelangelo's painting, and in Titian's *Danaë* anyone can. But Danaë does not open her legs just to accommodate voyeurs. The story itself is about openness and closure. If Bonasone's pornographic print exploits the analogy between room and womb more graphically than most, it only makes explicit a meaning already implicit in the narrative.

Compared with these paintings, Perino's tapestry in Genoa was a fairly decorous rendering of the subject in which Jupiter sits on the bed behind Danaë as the golden shower lands in the drapery around her lap. This was

in line with Perino's general policy of showing Jupiter in human form in every scene, and as some translations of Ovid had Jupiter turning back into his own shape once he had got through the hole in the roof, such depictions were not unusual. However, there was no textual precedent for the idea that Jupiter appeared in a cloud and dropped handfuls of coins into Danaë's lap – which is how the Semino workshop portrayed the scene for Genoese bankers. The patrons knew that money passes from hand to hand and never falls through the roof, and one of them, Ambrogio di Negro, must have liked the story enough to allow the decoration of an entire room to be devoted to it.

The first owner of Goltzius's *Danaë* was another banker, Bartholomeus Ferreris. It is an extraordinary, not to say repulsive composition, in which cupids fly through the air carrying money bags in the shape of testicles. Only a banker could really have enjoyed the spectacle, yet it is not travesty. The story of Danaë is little elaborated in classical sources, so Goltzius makes visible all that tradition had added to it – Jupiter's eagle, an old nurse, and Mercury. In Le Fèvre, Jupiter had courted 'Danes' through an old woman who acts as an intermediary, and in an illustration he can be seen approaching her tower holding an open box of jewels with which he bribes his way in.[48] By the seventeenth century, the inclusion of an old woman had become standard practice. Mercury, too, had long been hovering in the wings. Leone Ebreo had assigned Danaë to the conjunction of Jupiter and Mercury,[49] for Mercury, as well as being a messenger, is the bringer of wealth.

Although the story of Danaë often seems completely dominated by its allegory, it had another dimension. Van Mander tells of a peasant who, catching sight of a picture of Danaë in a painter's house, identified the subject as the Annunciation to the Virgin Mary. He was not being totally stupid. The parallels between the Danaë and the Virgin had been explored by the fourteenth-century moralizers of Ovid, and at a more literal level in Franciscus de Retza's *Defensorium inviolatae virginitatis Mariae*, which asked why, if Danaë had become pregnant by a golden shower, the Virgin should not have conceived by the Holy Spirit. In the 1490 edition of the text, there was a woodcut showing Danaë in her tower looking up towards the rays of the sun in chaste expectancy.

The difference between this image and the type of Danaë who was (as van Mander noted) shown with her legs apart should have been obvious to anyone, even a peasant. But there are certain images of Danaë where the seemingly unbridgeable dichotomy between the Annunciation and common prostitution becomes strangely blurred. In the *Hypnerotomachia*, for example, the description of the triumph of Danaë is no different in kind

64. *Danaë*, Rembrandt

from those of Europa or Leda, although her carriage is drawn by unicorns, symbolizing virginity, and she wears the deep blue associated with the Virgin Mary. In Gossaert's *Danaë*, too, the drapery is blue; the girl is seated and her upward gaze is reminiscent of that in the *Defensorium* (Plate X). Yet she is no more innocent than Gossaert's other nudes. When Erasmus complained of collectors who preferred pictures of Danaë to those of the Annunciation, he acknowledged the parallel without allowing for the possibility that a viewer might see the significance of the latter in the image of the former.[50] If Gossaert's *Danaë* reminded contemporary viewers of the Virgin, it was surely with a frisson of sacrilege.

With Rembrandt's *Danaë* (Fig. 64), the recognition that there is another potential level of meaning points in the other direction. In Otto van Veen's collection of Horatian emblems money bursts through the walls and past the sentries while Danaë receives the shower of gold in the background. The print contains two versions of the gesture with the outstretched arm. In one, Danaë pulls at the bed curtain; in the other, one of the soldiers spreads his arms in wonder. The movement of Rembrandt's Danaë is closer to the latter, which suggests that the allegory here overrides the narrative. And yet the shower of coins has dematerialized. We are left with a meta-allegory: the shower of gold was only money; money is just a message.

5

Venus

Although Venus was the goddess of love, no one remembers her wedding to Vulcan, just the gossip that followed it. As Mercury said to Apollo in Lucian's *Dialogues of the Gods*, what was a stunning girl like Venus doing with a crippled blacksmith for a husband? He was probably all sweaty and covered in soot from the forge.[1] It was easy to see his point. From the Farnesina onwards, the workshop of Vulcan was often depicted over fireplaces, and you could sense the heat and the smoke as you approached. Venus is not always there, partly because she did not appear in the ancient relief that influenced the school of Raphael, but also because almost the only time she went to see her husband was when she seduced him into manufacturing arms for Aeneas (her son by another man). The story is found in Virgil and the scene is popular in sixteenth-century northern art, beginning with Maarten van Heemskerck's painting of 1536.[2] Vulcan's team of Cyclopes were making Jupiter's thunderbolts when they were interrupted by Venus's order. But that was not all they produced. Cornelis van Haarlem's *Venus and Vulcan* of 1590 displays the range of Vulcan's output, and the proto-industrial scale of his operation (Fig. 65). It is a clever painting, composed to look like a fireplace. Inside the hearth the group with raised hammers is from a print after Heemskerck – the motif relegated to the back of the shop like any superseded design.

Here, Venus is doing her bit on the sales front, directing the viewer towards one of the more expensive items – Minerva's shield, decorated with the head of Medusa. It is unusual to find her in this role. You were much more likely to see Venus with other men rather than with her husband. There was not really too much reason to be jealous of Vulcan. According to Ovid's *Ars amatoria*, Venus used to imitate his limp when she was alone with her lover Mars[3] – a lovely, leggy girl pretending to be a working-class cripple. But she got what she was asking for. Venus and Mars thought no one knew of their affair, but Apollo found out because the sun sees everything. He was so scandalized that he went to tell Vulcan. The blacksmith

65. *Venus and Vulcan at the Forge*, Cornelis Cornelisz. van Haarlem

was stunned. He devised a metal net so fine that it was almost invisible, and placed it around the bed. Mars and Venus were in for a shock. The next time they went to bed, they were caught in the trap.

There are two versions of the story, one in the *Odyssey*, the other in the *Metamorphoses*. Both relate that the gods came to see the spectacle of Venus and Mars caught in a net, but the version of the story found in Homer is more detailed. The gods all found the plight of the lovers hilarious. Mercury said that even though Mars was the butt of the joke, he would still change places with him. That made them all laugh even more, except for Neptune, who wanted to put a stop to the whole thing and offered to stand surety for Mars if Vulcan would release him. And that is how it ended, although nobody forgot about what had happened. Ovid says the gods could not stop talking about it for ages.

The scene is one of those subjects that are almost always included in illustrated editions of the *Metamorphoses*. In the 1497 edition Venus and Mars are lying on top of the bed with the net tucked in around them. How

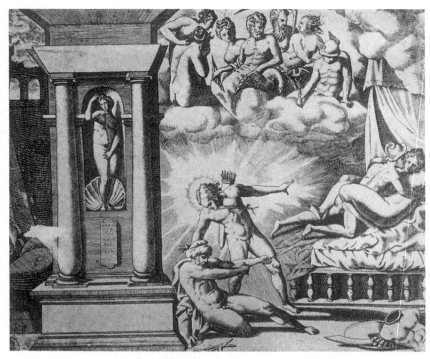

66. *Venus and Mars*, Jacopo Caraglio

they got into that position was anyone's guess. No one was sure how Vulcan's trick actually worked. A mid-sixteenth-century Flemish tapestry shows Vulcan laying the net flat on the bed before Mars and Venus arrive. And Caraglio's print has Vulcan pulling the net tight around them (Fig. 66). But quite often Vulcan just takes a run at the lovers and throws the net over them. That is what happens in illustrated editions of Ovid from Salomon onwards. Tempesta's version, where the mesh of the net interrupts the lines formed by the rays of the open heaven, is particularly striking. It suggests direct observation of fishermen casting their nets against the sun.

Homer's account is less commonly illustrated than Ovid's, even though parts of Homer's version (for example the role of Neptune) crept into Italian translations of the *Metamorphoses*. One crucial difference is that according to Homer the goddesses did not come to see the spectacle. Sixteenth-century artists rarely excluded them, but occasionally the virgin goddesses make an effort to preserve their modesty by looking away. That is true of the drawing after Parmigianino where the scene is rendered with an unusual degree of realism. Vulcan leads the bashful Diana and a gaggle of other gods (including

Hercules and Minerva) to peek round the door. It could be happening in any palazzo where the courtiers were adept at catching one another out. In contrast, Caraglio's print has the gods looking down from the sky, which is where they are also usually to be found in northern art. The subject was popular from Floris and Heemskerck onwards, not least because it gave artists the opportunity to try their hand at one of those Olympian crowd scenes so prized in the late sixteenth century. These compositions, of which Wtewael's is the most elaborate example, tend to become quite confusing, even though they are almost all based on Ovid rather than Homer.

Complete renditions of Homer's story are rare save in the much copied series of tapestries first woven in Flanders in the mid-sixteenth century, and still being produced in the Mortlake workshop a century later. The tapestries present the story of Vulcan rather than that of the lovers themselves, and (as was usually the case with tapestries) the erotic potential of the narrative is not exploited. Indeed, in the surviving pieces Venus and Mars hardly appear at all, and all the action takes place around them. So in the scene in which Neptune intercedes for the lovers, Neptune is joined by the three Graces and Cupid in his request to Jupiter, while Venus, Mars, and Vulcan are glimpsed only in the background to the left. But there is a subtle shift of emphasis. Whereas in Homer Neptune appears more concerned with preserving Mars' dignity than anything else, here he is working with Venus's allies (the inscription states that Neptune speaks on behalf of the Graces). The implication of this is quite different. Homer's Mars is at fault for allowing himself to get caught in such a ridiculous position; the tapestry suggests that it is Venus who requires forgiveness for having ensnared Mars in the first place.

Needless to say, the tapestries (all of which have a moral woven in) do not play for laughs. Yet the story was always meant to be funny, and artists sometimes exploit the humour of the situation. Tintoretto modified the story considerably. In his version, the god of war hides under a table, still wearing his helmet, while Vulcan has to resort to some forensic gynaecology to find out what his wife has been up to. Few other Venetian artists risked this sort of thing, though in one of Veronese's paintings of Mars and Venus Mars' horse gets impatient and peers round the corner. And no wonder, for Mars had stayed a lot longer than he intended. According to Lucian's dialogue *The Dream, or the Cock*, Mars took along his friend Alectryon to keep a lookout, but he fell asleep, and Apollo caught the lovers.[4] In revenge, Mars turned Alectryon into a cock – which is what his name means in Greek. This version of the story was slow to filter through to the mythographers, and Enea Vico's print after Parmigianino follows Lucian's original text. The

pose of Venus and Mars is derived from Giulio's *Two Lovers*, but little Alectryon, silhouetted against the rays of the rising sun, has the crest on his head which Lucian says came from the crest of the helmet he was still wearing when the metamorphosis overtook him.

Mars wears a similar crested helmet, and in Vico's other print of the subject he keeps it on even when he is in bed with Venus (as he also does in Caraglio and Wtewael). But generally speaking, people thought that Mars got undressed first. The scene is depicted in the tapestry series, and it is why Mars looks so awkward in Rosso's drawing – Cupid is helping him out of his undershirt. In many cases, however, you just see Mars' arms and armour lying around on the floor. The idea that Mars had to lay aside the weapons of war to experience the pleasures of love was, of course, central to the allegorical significance of the story, but it also elided the contrast between the bodies of the lovers. The juxtaposition of Venus's warm and naked flesh with the cold hard armour of Mars potentially transformed allegory into texture. You hardly needed to know the story; you could feel it.

Veronese and Paris Bordone both used the juxtaposition of flesh and armour to good effect, but the artist who exploited it most frequently was probably Rubens. He used it in all sorts of contexts, though never more dramatically than in his *Allegory of War* where Venus tries to restrain Mars as he pulls away from her towards the Fury Alecto. Minerva, rather than Venus, is usually shown restraining Mars, or even – as in an earlier sketch – fighting him. And it is her gesture there that is now given to Venus. But by transforming Minerva's lunge into a last embrace, Rubens changes its meaning and gives the allegory the weight of personal tragedy. In Titian's *Venus and Adonis*, Venus had tried to prevent the departure of Adonis when he left for the hunt; now she is going to lose Mars as well.

The idea that Mars would not submit to Venus was a novel one. It was usually the other way round, for as Sandys wrote (paraphrasing Plato), 'audacity is the page unto love; not love to audacity'.[5] And since everyone identified Venus with love and Mars with war, most people followed Plato in thinking that their affair showed how the power of love could defeat the god of war; or, as Leone Ebreo put it, how the benign aspect of the planet Venus tempered the warlike Mars.[6] Other interpretations of their union ranged from Aristotle's view (quoted by Equicola and Cartari) that their story demonstrated that soldiers inclined to lust, to Plutarch's opinion that Venus and Mars represented the union of love and discord, whose offspring was harmony.[7]

Nevertheless, there was no escaping the fact that this was a rather sordid

tale. Plato had singled it out as one of those stories people did not need to hear from the poets, and his sentiment was echoed by many others.[8] Fulgentius said that the fable just showed how valour was corrupted by lust,[9] and this was the type of interpretation that featured in commentaries to Italian translations of Ovid. In early editions Mars represents the flesh, Venus lust, and Apollo the light of truth that reveals their sin. Van Mander made a similar point. The story of Venus and Mars not only shows how lust leads to shame, it is a reminder that you cannot hide wrongdoing from God, or protect yourself from divine retribution. The inscriptions on the tapestries of the story of Vulcan are replete with warnings against pleasure and in favour of steadfast married love.

These moral interpretations were not clever enough to satisfy most commentators, and many also offered physical allegories. Heraclitus had said that Mars trapped in a net represented the victory of fire (Vulcan) over iron (Mars), while Servius had pointed out that the marriage of Venus and Vulcan showed that generation needed heat.[10] Later commentators floated all sorts of theories, and by Sandys's time things had become really complicated: Mars is hot and Venus is moist, from which comes generation; but Neptune releases them from Vulcan because water extinguishes fire. Funnily enough, many contemporary viewers do not seem to have thought about depictions of Venus and Mars in these sort of terms at all. Ronsard, who would have known Rosso's version from Fontainebleau, merely notes that anyone who has seen Mars and Venus together will be able to imagine what he gets up to with his girlfriend.[11]

Whatever else they were, Venus and Mars were in love, and Lucretius has an evocative description of Mars lying besotted in Venus's lap, looking up, hanging on her every soothing word.[12] His account could have influenced Botticelli's painting of the couple, which places the pair end-to-end like the male and female reclining figures inside *cassoni*. However, despite Savonarola's claims to the contrary, Venus and Mars were not actually all that common in this context. There is a striking figure of Venus and Cupid playing with her girdle from inside a Florentine *cassone* painted by Paolo Schiavo. But it is not altogether clear how married couples felt about being likened to a pair of adulterers once they were married. Some people may have thought that Mars was actually Venus's husband, but it is noticeable that ruling couples do not often identify with the pair. When the Mantuan poet Battista Fieri identified the figures of Mars and Venus in Mantegna's *Parnassus* with Isabella d'Este and her husband, he ended up apologizing for his mistake.[13] And when Henry IV of France was portrayed as Mars, his

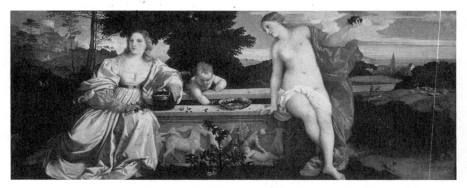

67. *Venus with the Bride* ('Sacred and Profane Love'), Titian

wife, Marie de' Medici, generally took the role of Minerva or Diana rather than Venus.

Although Venus was not a very good model for a wife, she was strongly associated with the process of becoming one. The link between Venus and weddings was an ancient one, for it was her girdle, the *ceston*, that legitimized marriages (as opposed to the 'incestuous' marriages that were not so sanctified). Venus therefore frequently features in wedding imagery. Paris Bordone's *Venus and Mars Crowned by a Victory* is too full of wedding symbolism to be anything other than a nuptial allegory (though only Mars looks like a portrait). And Titian's so-called 'Sacred and Profane Love' shows a prospective bride waiting patiently beside the goddess of love (Fig. 67). The painting was commissioned for the marriage of Nicolò Aurelio to a young widow, Laura Bagarotto, and its pensive mood may reflect these sombre circumstances, for epithalamic paintings were not always so serious. According to Boccaccio, Hymen, the god of weddings, was the son of Venus and Bacchus because marriages were made for two reasons: sex and a good party.[14] It is this kind of attitude that helps to explain how Lotto's *Venus and Cupid*, in which the child cheerfully urinates through a myrtle-wreath into his mother's naked lap, might also have been an acceptable allegory of marriage.

However, Lotto's painting is also a reminder that allegories often needed to be shocking if they were going to get the message across. For example, Bronzino's *Venus, Cupid, and Jealousy* and his *Allegory of Love* may well be allegories of much the same thing, but the latter is unforgettable in a way that the former is not (Plate XI). And this time it is all because of Cupid's bottom. It is one of the most obscene sights in the whole of Renaissance art. And Bronzino must have known it, for he wrote a poem about bottoms (well, frying-pans actually, but *padella* had a double meaning in Tuscan

slang)[15] and added this one after the painting had been finished. Cupid was originally seated behind his mother (which helps to explain the awkward position of his head) but that was not good enough for Bronzino. He wanted Cupid's bottom to stick out into the viewer's space. In *Venus, Cupid, and Jealousy* Venus holds Cupid's arrow so that it is directed between her own legs. Here it points down towards Cupid's buttocks.

The figure to the left of Cupid with his head in his hands shows some of the symptomatology of the syphilitic. Yet the science that gives this allegory its nightmarish power is theology, not medicine. There is something almost satanic about the perversity of the composition, for it was evidently inspired by Michelangelo's Doni tondo *The Holy Family*, where the Virgin turns to embrace the Christ-child who is clambering into the space between her head and her right arm (which is bent back to steady her son, just as X-rays show the original composition in Bronzino's *Allegory*). Meanwhile the bald and bearded figure overlooking the pair has been transformed from Joseph into Time, and Michelangelo's puckish curly-headed John the Baptist has metamorphosed into a second Cupid spreading flowers. The Holy Family has become possessed by the devil, who has taken the form of one of the prim little girls Bronzino painted for the Medici court. She proffers a honeycomb, yet cannot conceal the reptilian tail beneath her dress. The apple Venus holds in her left hand may be the golden apple of the Hesperides, but the tongue that glistens between her lips and disappears in Cupid's mouth is the tongue of the serpent.

Bronzino can hardly have been conscious of this theological substratum within his composition. It emerges unbidden from the conjunction of the religious imagery with which he habitually worked as a painter, and the burlesque humour so evident in his verse. The two were never intended to meet, and the result is almost surreal. The painting is a complex allegory, the precise details of which are still contested, concerning the unhappy consequences that follow the initial sweetness of sexual love. And yet it is also a reminder that allegory, which claims to tell us something of the meaning of the world, often relinquishes painting's claim to tell us about the world itself.

The consequences of love might be unfortunate, but unlike the other gods Venus did not go around killing people. In a pantheon of deities terrifying in their indifference and brutality, she was the kindly one (*alma Venus*, as the Latin poets called her), a mother whose indulgent tenderness towards her wilful child can be seen in almost every representation of the pair. Even if she had wanted to, Venus could not have harmed anyone. She did not

68. *Triumph of Cupid*, from *Hypnerotomachia Poliphili*, 1499

have any weapons. Jupiter has his thunderbolts, and Hercules a club; Apollo and Diana are lethal archers, Minerva has a spear, and even Bacchus has a thyrsus and an army of berserkers. Venus generally has nothing, though she tries using her torch as a sort of flamethrower in Perugino's *Battle of Love and Chastity*, and the image of the armed Venus enjoyed a brief currency among the Florentine humanists.

Of course, Venus did not really need weapons. There was no need to fight off men when she could enslave them with desire. And to do that all she needed was the help of her little boy and one of his arrows. Few could resist, and the list of Cupid's conquests in Petrarch's *Triumphus Cupidinis* was long and distinguished. The poem describes Cupid riding enthroned on a cart pulled by four white horses, followed by some of the many figures from classical history and mythology who had succumbed to his power. The image may well be derived from Latin verses known to Lactantius, but Petrarch's account superseded it, and became the basis for numerous learned commentaries.[16] On the other hand, the iconography of the *Trionfi* quickly acquired a degree of independence from the text. In the *Hypnerotomachia*, where Poliphilo and Polia are roped into the procession, the triumphal car is drawn by dragons preceded by a most unusual array of symbols: a vase in the form of a breast spouting milk, the three-headed symbol of Serapis, and two satyrs carrying three-headed ithyphallic herms (Fig. 68).

Cupid sees none of this because he is wearing a blindfold. It was a habit he had picked up long after the end of antiquity, following the advice of medieval mythographers.[17] The blindfold nicely conveyed the arbitrary nature of his attacks on unsuspecting gods and mortals, but he usually took it off to fight Pan. He defeated him, of course, because Love conquers all (Greek, *pan*). The phrase *omnia vincit amor* came from Virgil's tenth

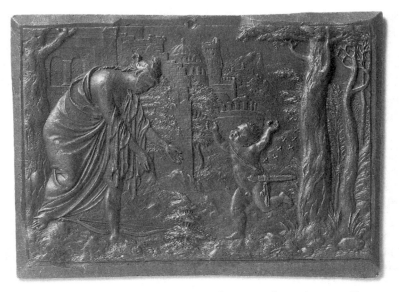

69. *Venus with Cupid Stung by a Bee (The Sense of Touch)*, Peter Flötner

eclogue, and the story of Cupid's struggle with Pan was described by Boccaccio.[18] Although it features in the *Hypnerotomachia* and early sixteenth-century prints, the subject became a popular one for painters only in seventeenth-century Italy. It was a far more economical way of illustrating the triumph of Cupid than enumerating all his conquests by name, but the old Petrarchan model lingered long into the sixteenth century.

The presence of Cupid alongside abstractions like Chastity and Fame inevitably raised the question of whether Cupid was really a god or just a personification. In *Octavia*, Seneca tells Nero that it is human error that makes Love into a god.[19] Love is really a state of mind, fostered by youth and leisure: without the right conditions it just withers away. The sentiment is frequently echoed by Renaissance authors, and there is quite a lot of imagery in which Cupid's role is essentially allegorical. For example, one of the *Idylls* traditionally attributed to Theocritus tells how Cupid was stung by a bee when stealing some honey.[20] When he showed his hurt to his mother she could not help reminding him that he too was a little creature who could cause great pain. The story appears in a drawing by Dürer, paintings by the Cranach workshop, and in a lead plaquette by Peter Flötner (Fig. 69). Outside Germany, the theme was unusual, and it is virtually unrepresented in Italian art.

In Italy, Cupid learns by instruction rather than experience. Correggio's

famous *School of Love* has Venus shepherding Cupid to learn his letters at Mercury's knee. And Mercury must have been a gentle teacher, for in the *Hypnerotomachia* he saves Cupid from his mother's anger after the exposure of her adultery with Mars.[21] But education and punishment were concepts rather less distinct in the sixteenth century than they are today. And there were all sorts of ways to punish Cupid when he was naughty, which he always was: you could hold his bow tantalizingly out of his reach; clip his wings so that he did not fly; give him a good beating; tie him up; or, if you wanted to do the job properly, crucify him. This was the idea of a late Roman Christian poet called Ausonius. And his poem was not as obscure as you might think: Cartari reproduced it in full,[22] and it is illustrated in a sequence of drawings by Giulio Romano.

Cupid is sometimes the victim of the girls he has been tormenting, but he got into trouble with everyone. An early seventeenth-century Flemish tapestry series, *The Sufferings of Cupid*, after Anthonis Sallaert, shows him being persecuted by a whole sequence of allegorical figures, both virtuous and vicious (Justice, Envy, Temperance, Sadness, Chastity, Avarice). And as the inscription around Gossaert's *Venus and Cupid* points out, he did not even spare his own mother. That is one reason why she is often the one giving him a beating, though she sometimes hands him over to Mars. The violence of this form of chastisement is always shocking to modern eyes – Cupid never gets away with a rap on the knuckles – but Manfredi's painting, in which Mars belts the blindfolded boy with a knotted rope, was surely designed to give even his contemporaries a bit of a jolt.

Incidentally, the fact that it is often Mars who thrashes Cupid may be an indication that the artist concerned took him to be Cupid's father. There were all sorts of theories about whose son Cupid really was, and how many Cupids there were. Almost everyone agreed that Venus was his mother, but was he the son of Vulcan, Mars, Mercury, or Jupiter? Perhaps he was not Venus's child at all. Hesiod had said he was the offspring of Chaos; Cicero had mentioned that one Cupid was thought to be the son of Mercury and Diana, and Boccaccio picked up both this and his suggestion that Cupid might be the offspring of Darkness and Night.[23] But within the visual arts it hardly mattered. After all, the birth of Cupid is rarely a subject in itself (though it appears in Le Sueur's cycle in the Cabinet de l'Amour at the Hôtel Lambert), and no one showed Cupid with anyone other than Venus in the role of his mother. But which Venus was she?

From antiquity onwards the mythographers had posited multiple deities of the same name as a way of rationalizing the conflicting traditions concerning

the gods. Few of these have any resonance outside the mythographers' manuals, except when it comes to Venus and Cupid. In this case, it was not ancient texts that needed sorting out, but the contradictions of the human heart. There are three pairings: the heavenly and the earthly Venus, Eros and Anteros, and Sacred and Profane Love. However, they are not precisely aligned, and apart from the first they are largely Renaissance inventions rather than classical traditions.[24]

The first exposition of the difference between the heavenly and the earthly Venus is found in Plato's *Symposium*, and it became an established theme in Neoplatonic thought. The heavenly one was born from the genitals of Uranus, while the earthly one was the child of Jupiter and Dione (an otherwise obscure Titaness). But interpretations varied. Cicero had identified four Venuses, and this confused the issue. Remigius made the chaste Venus the wife of Vulcan, and the goddess of lust the daughter of Uranus and the mother of Hermaphroditus. On the latter point he was followed by the medieval mythographers, including Boccaccio.[25] In any case, since nobody knew anything of Venus's birth from Dione's union with Jupiter (or any other parents), the focus was invariably on the birth at sea. The degree to which the two Venuses were thought to represent opposing qualities varied as well. Remigius placed them in opposition. One represented honest and lawful loves, the other pleasure and lust. Boccaccio had more difficulty keeping them apart, and Ficino, in his influential commentary on the *Symposium*, emphasized that the earthly Venus led the way to the celestial one.

It is, in general, hard to know how much weight should be given to the development of this allegorical tradition when looking at mythological art. The only occasion on which there is any need to distinguish one Venus from another is when both are shown in the same image, in which case the convention was that the celestial Venus was nude and the terrestrial one clothed. However, this is exceedingly rare. The two Venuses appear together in Lorenzo Costa's allegory *Comus* for Isabella d'Este, but Titian's so-called 'Sacred and Profane Love' is no such thing.

Whereas the earthly and heavenly Venuses were always arranged on a vertical axis, Eros and Anteros were on the same plane. Pausanias had seen a relief of Eros and Anteros struggling for a palm, but their relationship was originally one of complementarity rather than conflict. Eros was love, and Anteros was love reciprocated (or sometimes love avenged). Themistius explained that it was the birth of Anteros that enabled Eros to grow (and vice versa). However, the heavenly and the earthly Venuses also had their own Cupids – at least one born to each. These were originally distinct from

ΑΝΤΕΡΩΣ AMOR VIRTV
tis alium cupidinem fuperans.

Aligerum aligeroq; inimicum pinxit amori
 Arcu arcum atq; ignes igne domans Nemefis
Vt quæ alijs fecit patiatur,at hic puer olim,
 Intrepidús geſtans tela mifer lachrymat.
Ter ſpuit inq; ſinus imos (res mira)crematur,
 Igne ignis furias odit amoris amor.

70. *Anteros and Eros*, after
Jörg Breu, from Alciati,
Emblematum liber, 1531

Eros and Anteros, but there was a later tradition derived from Servius and first fully expressed in the Renaissance by Petrus Haedus in which Anteros was actually the antithesis of Eros – a representative of divine love who extinguished human love. This was the conception of Eros and Anteros that was picked up by Alciati, who, in his emblem 'Anteros, the Love of virtue overpowering the other Cupid', has Anteros breaking Eros's bow and letting him feel the flames with which he makes others burn (Fig. 70), or, in later editions, tying him to a post and burning his weapons. The motif was transmitted to other emblematists, even though the classical conception of Anteros as love returned continued to be expounded by the mythographers. Eventually divine love and profane love became the subject of two separate emblem books by Otto van Veen, where they are distinguished by the use of a blindfold to cover the eyes of profane love. In early seventeenth-century Italy, divine love overcoming profane love also became a subject for painters like Reni and Castiglione.

Cupid was not usually the focus of desire himself, except in the story of Cupid and Psyche. The tale is not a classical myth, but an allegorical fiction which the second-century Latin writer Apuleius included as a digression

in his novel *The Golden Ass*. However, the story was included in the mythographies of Fulgentius and Boccaccio, and (although the Renaissance mythographers pass over it quite quickly) there was little sense of its being a intruder among the stories of the gods.[26] Indeed, Boccaccio fitted it into his genealogy by explaining that Psyche was the fifteenth daughter of Apollo, a view derived from Martianus. The painter of one early Florentine *cassone* seems to have followed this interpretation, but otherwise there is little evidence that artists used anything other than the text of Apuleius and its numerous vernacular variants.[27]

Psyche was so lovely that even Venus was jealous of her. She sent Cupid to make her fall in love with some no-good, but he fell for her himself and had Zephyr transport her to his palace. There, Cupid came to Psyche only at night and would never let her look at him. Warned by her jealous sisters that her lover was a monster, she took a lamp to look at Cupid while he slept. Awakened by a droplet of oil falling from the lamp, he abandoned her. Psyche wandered the earth searching for her lover, trying to accomplish tasks that Venus had set for her. Some of these involved going to the underworld (Plates IV & V), where Psyche had to obtain water from the River Styx (central lunette) and retrieve a box from Proserpina (left lunette). When Psyche opened it, she fell into a deep sleep (right lunette). At last, Cupid relented, and begged Jupiter to approve their union. He did so, and Mercury carried Psyche up to Olympus, where the marriage of Cupid and Psyche was celebrated by the gods. When Psyche bore a child, her name was Voluptas (Pleasure). You can see her sharing her parents' bed in the Sala di Psiche at the Palazzo Te (Plate IV).

It was impossible to miss the allegory, for Psyche was the Greek word for the soul. All the commentators had to work around that, but otherwise they differed radically. According to Fulgentius (who chose to ignore the story's happy ending), Venus (Lust) tempts Psyche (the Soul) with Cupid (Desire) and punishes her when she succumbs. Equicola repeats the theory with the proviso that Psyche's sisters might be better identified as anger and greed, rather than flesh and free will.[28] In contrast, Boccaccio, whose comments were sometimes reprinted in Renaissance editions of Apuleius, saw that everything turned out right by making Cupid into honest love (i.e. God), and Voluptas into eternal joy.

You can see the serpent biting its tail – a symbol of eternity – as it circles the tip of the pillow on Cupid and Psyche's bed in the Palazzo Te. So perhaps Boccaccio's allegory had not been entirely forgotten. But the rest of the painting suggests that viewers were not expected to focus on it. The spectacle is rather low in narrative content. The story has already been told in the

octagons of the ceiling and across the lunettes below, and has culminated in *The Marriage of Cupid and Psyche* in the centre of the ceiling. With the story out of the way, the fun can start. Raphael had ensured that all the gods turned up for the feast, but Giulio Romano included only those who would really enjoy it. Starting from the left, there is the drunken old woman to whom Apuleius likens the teller of the tale, and Vulcan, with his hammer in his belt. According to Apuleius, he cooked the meal, but here he's probably giving orders to the woman who will ensure that the fresh game arriving behind him is properly prepared. To the right, Apollo sits in a pose taken from an antique gem, opposite Bacchus and Silenus on the other side of his table. Bacchus has come all the way from India, bringing with him tigers, elephants, and camels. To the right, Cupid and Psyche are sprawling on a day-bed, waited on by Ceres and Juno themselves. Behind them satyrs sacrifice a goat before a statue of Bacchus. In the very centre of the painting is a dazzling display of crystal, gold, and silver.

The scene, which continues round the corner of the room to include an assortment of rustic deities preparing the table, must count as one of the most ambitious pieces of mythological art in the entire Renaissance, and its priorities appear to be (in descending order): the ostentatious display of wealth, the pleasures of male and female nudity, the inclusion of exotic animals and the occasional reference to the antique. The much reprinted allegory of the tale of Cupid and Psyche by Filippo Beroaldo ends by saying that the philosophers use Pleasure to calibrate the highest good – a reference to the Epicurean view also reflected in Ficino's positive estimation of the quality.[29] But as Equicola followed Aristotle in pointing out, pleasures are of various sorts: some necessary and natural (like drinking when you are thirsty), others natural but unnecessary (like enjoying gourmet food); some pleasures are cruel, some pure, and some in between.[30] So which type of pleasure is depicted here? The answer is surely that no one knew and no one cared, for this is not primarily an allegory of pleasure but a depiction of it the viewer can share when enjoying the 'honourable leisure after work' to which the inscription refers.

The prominence of the fable of Psyche at the Palazzo Te was the result of a fortuitous conjunction. The first translation of the story had been dedicated to Federico Gonzaga's mother, Isabella d'Este, and Giulio Romano had been one of Raphael's assistants at the Villa Farnesina. So everyone involved must have known the story already. This is just as well, for both here and at the Farnesina the sequence of images is difficult to follow. Raphael had devoted the centre of the ceiling to paintings of the Council of the Gods and the Feast of the Gods, and left the narrative to unfold across the spandrels.

Perhaps this was one reason why the Master of the Die produced a series of thirty-two prints, loosely inspired by Raphael's example but based on designs by Michael Coxcie, that took you through the story step by step.

It was this version of the story that Perino took with him to Genoa, and which he later reused in the Castel Sant'Angelo in Rome. But although the story spread quickly around Italy, it had more difficulty in establishing itself elsewhere. The tale remained popular in Genoa, but it was not among the subjects that Genoese artists took to the Palazzo di Álvaro de Bazán in Spain. Similarly, the decoration of Landshut, although inspired by the Palazzo Te in Mantua, included no imitation of Giulio's cycle. The only place to which the story was successfully exported was France, where Henry II purchased the Flemish Cupid and Psyche tapestries made after prints for the Master of the Die, and Niccolò dell'Abate was commissioned to decorate the king's bedroom at Fontainebleau with the subject. However, the most important surviving work from the period is the stained glass at the Château d'Ecouen, where the story is narrated across forty-four windows with verse inscriptions below. Once again, the cycle comes from the Master of the Die, whose prints even reached England where they inspired wall paintings at Hill Hall in Essex.

The fact that this print series was needed to disseminate the iconography of Cupid and Psyche is revealing. Although vernacular translations of the story were available in French, Spanish, and German from the early sixteenth century, they did not generate imagery of their own. The subject became a major theme in Spanish literature, but the first surviving paintings date from the second half of the seventeenth century. In Germany artists did not pick up the subject until the time of Rudolf II, and in the Low Countries it barely features before the seventeenth century. Perhaps Cupid and Psyche were victims of their own literary success. One reason why visual imagery was slow to spread was that the story retained its narrative integrity in a way that other tales did not. People wanted the whole story or nothing at all. So although well suited to fresco cycles, other media were problematic: a tapestry series was prohibitively expensive, but the story had too many episodes to fit on a casket or a cup. This made it difficult to find a suitable form, and the stained glass at Ecouen was an inspired solution.

When individual episodes eventually started to appear independently, the dramatic moment when Psyche sees Cupid for the first time, and the final episode in which the gods gather to celebrate the wedding feast, were the most popular subjects. However, they were not combined with other tales about Cupid to create a series of the 'life and loves' of the precocious child. The author of the *Hypnerotomachia* had imagined seeing a ceiling decorated

with Cupid's deeds, but there does not actually seem to have been one before Le Sueur's sequence at the Hôtel Lambert, and even that did not include any reference to Psyche.

Venus, for once the enemy rather than the friend of the lovers, plays an unusual role in Apuleius's story, and it is unclear whether rooms decorated with illustrations of the tale were thought of as Venusian spaces. Egidio Gallo's poem on the Farnesina envisages Venus leaving Cyprus to take up residence at the villa, but it predates the decoration of the Loggia of Cupid and Psyche.[31] At the Palazzo Te, the north wall of the room contains two scenes inspired by the *Hypnerotomachia* – *The Bath of Venus and Mars*, and *Venus, Mars, and Adonis* – but such fillers were unusual. In contrast to the many rooms decorated with the story of Cupid and Psyche, rooms entirely devoted to Venusian subjects are comparatively rare. This is curious in a way, for in late medieval poetry, and, indeed, in Poliziano's *Stanze*, the mythological material often appears in a description of the decoration of the house of Venus. But since she was generally portrayed naked, Venus was always liable to incite lust. Sometimes, as at the residence of Philip of Burgundy, paintings of her were covered with a curtain, but you could not cover the decoration of a whole room with curtains, so Venusian spaces tended to be those where erotic thoughts were desirable or acceptable. The cottage where Philip used to entertain the ladies, for example; or else the bedrooms or bathroom of the patron.[32] The *stufetta* of Cardinal Bibbiena certainly did nothing to dispel the idea that a space filled with images of Venus might lead to inappropriate thoughts. (The sequence goes from Venus's birth from the genitals of Saturn hitting the water, to Ericthonius's birth from Vulcan's semen landing on the ground when he tried to rape Minerva.) Nevertheless, similar decoration appeared in other bathrooms and bedrooms elsewhere, and so it is no surprise that the inscription in the Venus Room at Landshut tries to pre-empt criticism of the iconography: 'Baths, wine, and Venus corrupt our bodies; they also restore the body.'

Bathrooms, and bedroom ceilings (like that at Landshut), were one thing, but to find a sequence of Venusian subjects fit to hang as tapestries you had to be quite inventive. The surviving pieces from the mid-sixteenth-century Venus cycle woven for Mary of Hungary in Brussels include scenes of flowers being offered to a statue of Venus (the only time she is depicted nude); Venus passing judgement on Psyche; gathering flowers with Cupid (a contest she won with the help of a nymph called Peristera); saving Aeneas from Diomedes, and telling Diomedes of his wife's adultery. The literary sources

for this series are unusually eclectic: Ovid describes flowers being presented to a statue of Venus in the *Fasti*; Peristera is in Boccaccio and Pictor; the Psyche episode is from Apuleius, and the story of the fight with Diomedes and its consequences for his marriage is from the *Iliad*.[33]

On a smaller scale, too, the presentation of Venusian subject-matter presented difficulties. Although *cassone* painting was unambiguously focused on the pleasures and trials of love, it is not the loves of Venus that are on display, and Venusian subjects are pretty much absent from pastiglia boxes as well. Venusian imagery was also little used in portrait medals and royal entries, for she was meant to be the object, not the subject, of desire. But if she was rarely allowed to define a space or a person, she was always ready and waiting to be admired. Venus regularly appears on plaquettes and on small ornamental objects of every kind. Statuettes are common, especially in the late sixteenth century, and Venusian jewellery was also popular.

In some of these media, the influence of antiquities was particularly strong and there were a lot of antiquities to choose from. More than any of the other Olympians, Venus lived in and through her statues, which often exercised a disturbing power over those who saw them. Pliny described how a young man had tried to make love to one, and even in the twelfth century an English visitor to Rome related how he felt drawn to go back to look at an antique statue of the goddess several times.[34] By the sixteenth century, Roman statues of Venus were more numerous, but they still attracted a great deal of attention – not all of it positive. Giovanni Francesco Pico della Mirandola saw the Venus and Cupid in the Belvedere sculpture garden and wrote a poem, *De Venere et Cupidine expellendis*, in which he envisaged a sort of mental cleansing that would allow him to dwell on higher things.[35] Elsewhere, water often helped to wash away sinful desires and in other gardens statues of Venus were displayed in fountains or grottoes. An antique seated Venus belonging to Ippolito d'Este was supplied with figures of Eros and Anteros and used as the centrepiece for a Fountain of the Woods at the Villa d'Este in Rome, and at the Villa Giulia a sleeping Venus was the focal point of the nymphaeum. At the Boboli gardens in Florence, they used modern sculpture, and a Venus by Giambologna became the centrepiece of the fountain in the third room of the Grotto Grande. Four fauns look up at her, spitting with lust (Fig. 71).

The association of Venus with fountains and gardens goes back to antiquity. Claudian had written of a garden sacred to Venus where Cupid dipped his arrows in one of two fountains (the water was honeyed in one, poisoned in the other), and Philostratus had described a painting in which cupids were gathering apples in an orchard dedicated to Venus.[36] Titian's

71. *Venus*, Boboli Gardens, Florence, Giambologna

Worship of Venus for the *camerino* of Alfonso d'Este illustrated Philostratus fairly literally, save that he supplied a statue of Venus to make her presence, which Philostratus had indicated only by tokens, more apparent. By this time, however, the garden of Venus had become overlaid with a wealth of other associations, many derived from the traditions of courtly love. Scenes of lovers in an enclosed garden were common in the late Middle Ages, though they rarely included the goddess herself. The *desco* in which an extra-terrestrial Venus visits earth to beam sex-rays into the heroes Achilles, Tristram, Lancelot, Samson, Paris, and Troilus is unusual, but it is a reminder of how fully her power was acknowledged.[37] Compared with an image like this, which draws on Christian rather than classical iconography, the antiquarian eroticism of the *Hypnerotomachia* seems rather coy. The whole book is, in effect, a wander through the gardens of Venus, but it culminates in Poliphilo's arrival at Cithera, the island of Venus. The goddess was associated with one island already, and it is as the queen of Cyprus that she features in Boccaccio's book on famous women. Venus came from Cyprus to you; Cithera is where you went to her.

Where do Botticelli's images of Venus fit into all of this? Since the early twentieth century his mythological paintings have come to epitomize the Renaissance rediscovery of paganism, and of Venus in particular. In fact, they are rather isolated works. They had little influence on the development of later iconography, and they draw on none of the literary sources that artists customarily used. Botticelli's mythological imagery cannot usually be traced directly to the *Metamorphoses*, the *Libellus*, or even Boccaccio's *Genealogia deorum*. He seems to have got his instructions straight from Poliziano, or one of the other learned men in Florence, and so skipped all the usual mediating texts.

On the far right of the *Primavera* (Fig. 72), the wind-god Zephyr is pursuing the nymph Chloris, who became Flora, the goddess of flowers, after the wind-god had married her. In Ovid's *Fasti*, Flora exhales roses as she speaks, but in Botticelli's painting it is Chloris who breathes out the flowers that form Flora's dress. The device links all three figures, for the power of Zephyr's breath forces the flowers from the corner of Chloris's mouth towards Flora. There is no getting away from the redundancy here: Chloris and Flora are the same person shown twice. Is this a confusion? Probably not, for the painting is based on some lines from *De rerum natura* (rehearsed by Poliziano in his *Sylvae*) where Lucretius had referred to the coming of spring as a procession consisting of Venus, Flora and her husband Zephyr, accompanied by the dancing Graces. So Flora is one of the

72. *Primavera*, Botticelli

principals, and the story of Chloris is just a flashback which explains how she became the queen of flowers.[38]

Venus stands in the centre of the painting, with the Graces and then Mercury to the left. The Graces are there primarily because they are mentioned in the narrative, though their appearance closely follows Seneca's description of them dancing in a ring clothed in transparent gowns. According to him the Graces represented the giving, receiving, and returning of benefits, which passed from hand to hand between them. The eldest sister,

Aglaia, has the honour of bestowing the gift, which she passes to Euphro-
syne, and then to the youngest, Thalia. Botticelli illustrates this sequence
very precisely, placing Aglaia, the oldest of the Graces, on the right
and indicating the direction of flow through the height at which the hands
are joined – from the original bestowal high above the heads of Aglaia
and Euphrosyne, anti-clockwise to their return on the right, where
Aglaia retrieves her gift from the upturned hand of Thalia. As for Mercury,
Seneca says he is depicted with the Graces because painters include him,

and that is perhaps the primary reason he is in Botticelli's painting as well.

Alberti had recommended Seneca's account to painters in *De pictura*, without reference to the antique statue group of the Graces already known in Rome.[39] The marble group, which was originally in the Colonna family collection, was transferred to Siena at the end of the fifteenth century. It showed the three Graces standing naked in a row, their hands resting lightly on one another's shoulders. The central figure has her back to the viewer, while the others face forwards. This had become the accepted visual formula in late antiquity, and more than one version of it was known in the Renaissance. Servius explained it by saying that one Grace is seen from the back and two from the front because for every benefit bestowed two are returned – a view frequently repeated in medieval mythography.[40] Here, however, the arrangement and significance of the Graces was far more ambiguous. According to Bersuire they might be thought of as Faith, Hope, and Charity, but they could also represent Avarice, Lust, and Infidelity. In which case it is Infidelity who turns her back on us, just like a woman who turns her back on a man because he is poor, mocking him like those who had 'turned their backs and not their faces' to the prophet Jeremiah.[41]

Although the rediscovery of the antique visual formula more or less coincided with a renewed awareness of the interpretation found in Seneca, the two did not fit together very well. These girls are all of the same age, and there is no sense in which they are exchanging anything among themselves. However, in Raphael's painting, perhaps based on the group after its transfer to Siena, each holds a golden ball, a reference to the golden apples of the Hesperides (Fig. 73). Venus could be depicted holding all three golden balls or apples (Fig. 9, p. 25), and the Graces were sometimes shown playing with them among themselves. As there were three, it provided a good opportunity to demonstrate the simple two-for-one exchange described by Servius, and you can see the juggling act in representations of the so-called Saxon Venus, described in the *Cronecken der Sassen* of 1492, as well as in Raphael.[42]

A poem attached to the base of the group when it was in the Colonna collection identifies the figure with her back to the viewer as Thalia, with Euphrosyne to her right and Aglaia to her left. There was, though, some disagreement about these names. In a tradition that passes from Lactantius Placidus's commentary on Statius through the medieval mythographies to Boccaccio, the first of the Graces was Pasitea (a name given to one of the Graces in Homer).[43] In the interpretation that went with this sequence, Pasitea was *attrahens* (attracting); Aglaia, *demulcens* (enticing); Euphrosyne, *retinens* (restraining/retaining), for attraction to something comes to

73. *Three Graces*, Raphael

nothing unless you can also draw it to you and hold on to it. Boccaccio took this to mean that Euphrosyne is the Grace who faces the other two in order to restrain them. However, the ancient visual formula could also be read in a more linear fashion, as it is on the reverse of the medals of Pico della Mirandola and Giovanna degli Albizzi.[44] Both show the same classical group, but whereas Pico's inscription reads 'Beauty – Love – Pleasure' (inspired by Ficino's dictum that Love comes from Beauty and ends in Pleasure), Giovanna's is 'Chastity – Beauty – Love', which probably implies that Beauty comes from Chastity and ends in Love.

Although the Graces are essentially a visual formula with allegories attached, they did have parents. Lactantius Placidus had identified them as Jupiter and Autonoë (though others said Eurynome), and Boccaccio followed Albricus in thinking they might well be Bacchus and Venus. But the Graces were not exclusively associated with Venus. There was also a tradition that linked them with Apollo, and Cartari shows Mercury as their leader and (following Pausanias) gives them a rose, a die, and a myrtle branch to hold.[45] Tintoretto's *Mercury and the Three Graces* follows this tradition.

The Graces proved to be more popular in Italy than anywhere else, but they appear less frequently as time goes on. It might be tempting to suppose that they suffered from their association with a particular symmetrical visual formula, and so proved unsuited to the baroque sensibility, were it not for the fact that they appear repeatedly in the works of Rubens. Here, they are not associated with Venus so much as with other gods. Conti had emphasized that the Graces represented the fertility of the fields,[46] and Rubens has them doing such things as holding up a basket of flowers, or attending a statue of the goddess Natura.

In the tradition of illustration derived from Bersuire, the Graces routinely appear in depictions of Venus. The goddess herself stands naked in the sea, with the Graces either in the water beside her or on the bank, while an adolescent Cupid flaps around, blindfold, overhead. The reason Venus stands in the sea is that she was born there. The anatomical peculiarities of that birth from the severed genitalia of her father are often shown with disturbing fidelity in late medieval illustration. And this may be why Poliziano, in a passage in the *Giostra* otherwise based on one of the Homeric Hymns, devotes half a stanza to a description of that 'severed stem' bobbing in the foam-flecked waves beneath the swirling sky.[47] Botticelli, who followed Poliziano's account in the *Birth of Venus*, must have made a conscious decision to leave this bit out. It was surely the right choice, but it had a curious effect (Plate XI). This is a painting in which everyone's genitals are covered twice, which only draws attention to them.

Is it this that agitates the painting? The sight of Venus gliding towards the shore to be greeted by one of the Horae could have been portrayed more peacefully. The full force of Zephyr's breath, which makes Venus hold down her hair to preserve her modesty, goes straight to the Hora flattening the drapery against her groin. It is all text-book stuff. Alberti had said that it was a good idea to show wind-blown drapery revealing the shape of the body on one side and billowing out on the other.[48] But he said nothing about which bits of the body should be so exposed. In Botticelli's painting it is the air, not the sea, that is full of seed.

It is almost as though the castration of Saturn had never happened. According to Boccaccio (who was following Macrobius), before time began things had been propagated by seeds falling from the heavens to earth, and it was only after the birth of Venus that generation came about through the intercourse of the sexes.[49] This theory was relayed by Leone Ebreo to Cartari, but this was only one of many possible interpretations. Medieval interpreters had devoted much thought to the story. For some, it was sexual pleasure

that had been cast into the sea of repentance (for had not it been said in Lamentations, 'great is the sea of your repentance'?), to emerge as sanctified joy. For others, it was the taste of the sea that lingered in the saltiness of semen and sweat.[50]

Beautiful as she was, there was something rather grotesque about the circumstances of Venus's birth, and the story was increasingly marginalized. Its place in Venusian iconography was eventually filled by the Marine Triumph and the Venus Anadyomene. Apuleius describes Venus crossing the sea in the company of tritons and nereids, and Claudian has a dramatic account of Venus riding to a wedding on the back of a triton.[51] Claudian's description was closely followed in Peruzzi's fresco in the Sala della Prospettiva in the Farnesina, but Raphael's *Galatea* downstairs provided the more enduring model. In Vasari's Sala degli Elementi at the Palazzo Vecchio, the Marine Triumph (representing the element of water) acts as the sequel to the castration scene above. Here, Venus stands on a shell propelled by wind power alone, though some artists followed Raphael in attaching a water-wheel. But Venus could also dispense with her usual shell-chariot, and ride a dolphin instead. Dürer's drawing of Venus riding a harnessed dolphin and holding a cornucopia topped with a blind Cupid is only the strangest of these images (Fig. 74). Whether it reflects Nonnos's claim that after Venus emerged from the foam a dolphin carried her to Cyprus is uncertain.[52] Venus had been associated with dolphins since antiquity (she is accompanied by one in the ancient statue known as the Medici Venus), and Venus and the dolphin eventually became a popular theme for jewelled pendants, although here she usually rides side-saddle.

When she finally reached the shore, Venus stood there for a moment, dripping with water and wringing her hair. Pliny had described Apelles' painting of Venus emerging from the sea, and several artists, including Titian, attempted to rival his work.[53] It is no coincidence that many of the most famous representations of Venus Anadyomene are Venetian, for had not Venice risen from the sea, as alluring as the goddess herself? A high-relief marble by Antonio Lombardo conveys the moment most effectively (Fig. 75). Both wet and windswept, his Venus has a naturalness that many of the others lack – dramatic proof that even if the painters could rival the ancients, the sculptors could still outdo them.

Apelles' model for the painting had been Phryne, the most famous courtesan of her day, and there could be something self-consciously steamy about this subject. The *stufetta* of Cardinal Bibbiena is one example (Fig. 76). According to Ovid's *Fasti*, Venus had been spied upon by satyrs when she

74. *Venus on a Dolphin,*
Dürer

emerged naked from the sea. Pontano had elaborated the scene and imagined
a satyr rudely staring at her while she was combing her hair and doing her
make-up.[54] Venus, thoroughly embarrassed, headed for the safety of a rose
garden. But she was blushing so much that the flowers ended up blushing
too, and that, Pontano suggests, is the reason why roses changed their colour
from white to red. No one seems to have followed him on this, though
Pictor quotes the poem in full.[55] However, in the *stufetta* the scene showing
Venus drying her hair while spied upon by a satyr is followed by one in
which Venus pricks her foot on the thorn of the rose – the reason given for
the change of colour in the *Hypnerotomachia*. It is not the same explanation,
but the continuity is suggestive nevertheless, and it makes you wonder
whether Cardinal Bibbiena had Pontano's *Eridanus* and the *Hypnerotoma-
chia* in the back of his mind when choosing the subjects for the room; the
sequence of images, which goes from Venus's birth at sea to her love for
Adonis, is unusual, and includes themes touched on in both texts.

Elsewhere paintings of Venus being spied upon by satyrs generally place the
scene in the woods. There is no specific literary source, and so no indication
of what happens next. The sleeping nymph spied upon by a satyr in the
Hypnerotomachia was an obvious inspiration, for Colonna had compared
it to Praxiteles' statue of Venus.[56] And since Venetian painters, thanks to
Giorgione, all thought Venus was in the habit of sleeping in the open air,

75. *Venus Anadyomene*, Antonio Lombardo

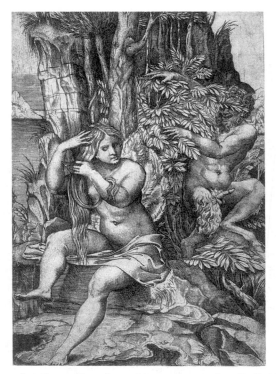

76. *Venus Spied upon by a Satyr*, Marco Dente after Giulio Romano

the satyr was a natural addition. It is not altogether clear where Giorgione got this idea from, but thereafter the reclining female nude, either asleep or propped up on one elbow, became a common motif in Venetian painting. The subject quickly travelled north to become a theme in the art of Cranach and others.

It is pointless to ask what Venus was doing, sleeping naked in the landscape, for it was the cultural neutrality of the landscape background that allowed the fantasy to take flight. Indoors, Venus was more likely to be taken for a courtesan. But is a landscape background enough to indicate that a reclining nude is the goddess? One answer might be that a nude woman is the goddess Venus when accompanied by Cupid. Whereas Cupid does not need Venus to identify him, Venus herself is frequently only saved from anonymity by the presence of her little boy. But Cupid comes and goes. The Cupid in Giorgione's *Sleeping Venus* was painted out; Titian's *Venus of Urbino* is the same figure moved indoors without a Cupid, but some imitators put one in for good measure. In the various versions of

Titian's paintings of Venus with a musician, Cupid is sometimes there and sometimes not. In later inventories the terms 'naked woman' and 'Venus' are almost interchangeable. The obvious conclusion is not that all these women are the goddess, but rather that being Venus is a matter of degree, or perhaps of perspective.

If a naked woman is not Venus she is often a courtesan. But the two roles were not mutually exclusive, for the connection between the goddess and prostitution went back a long way. According to Lactantius, she had established the profession in Cyprus because she did not want to be the only woman who was going around chasing men. The slur never went away, although Polydore Vergil pointed out that even if Venus had led a shameful life (and there was not much doubt about that), she probably was not the first to take up the profession because prostitution is mentioned in the first book of the Old Testament.[57] In any case, the accusation although morally damning was also an erotic endorsement, for prostitutes were a primary focus of male desire. And classical goddesses like Venus and Flora were useful in that they elevated that desire into culture.

The association between Venus and prostitution made it easier for people to see that she was naked. Almost all the gods are naked or semi-naked in Renaissance art, but Venus and her companions are the only ones whose nudity is routinely discussed. Their nudity is part of their identity, not just a reflection of the classical models. There were various accounts of what it signified. Boccaccio said that the Graces were naked because in friendship there must be nothing feigned, nothing false, nothing covered up; Brant, that Cupid was naked because love cannot be disguised; Fulgentius (also Boccaccio and Cartari), that Venus was naked either because that is how people tend to be when they have sex, or because lust deprives people of everything else they possess, or else because the crime of lust is never hidden.[58]

Although Venus might not have had to bother too much about her clothes, she still took a lot of trouble over her appearance, and for this she needed a mirror.[59] Pictures of courtesans looking at themselves in a mirror became a theme in sixteenth-century Venetian art, and eventually they take on the identity of Venus. But it was only in the second half of the sixteenth century that Venus's entire beauty routine became an established pictorial subject. In Italian painting, she is often to be seen looking in a mirror while the three Graces fuss over her hair. This motif was prompted by Cartari's quotation of Claudian's description of Venus's preparations for the marriage of Honorius and Maria.[60] Annibale Carracci was perhaps the first to follow this account in detail, and Albani went on to paint the subject repeatedly, though only

in his final version did he include the great palace which Claudian said Vulcan had constructed for Venus.

Velázquez's *Venus*, lying alone on a bed, is unrelated to these celebrations of primping (Plate XII). In fact, she is one of those women who can be identified with the goddess only by the presence of Cupid who here holds up the mirror in which, we are meant to surmise, she sees not herself but the viewer behind her back. Who is she looking for? The *Roman de la Rose* pointed out that if Venus and Mars had had a mirror they might have seen Vulcan coming.[61] Velázquez probably is not thinking of that, but to judge by the role of the mirror in *Las Meninas*, and his obvious interest in the story of Venus, Mars, and Vulcan (he had already painted the other protagonists), his concerns are broadly similar. This is a painting about illicit love suspended at a moment of uncertainty. Perhaps Venus does not know whether the man behind her is her husband or her lover. Perhaps the viewer does not know that the figure of Venus is modelled on the antique statue of Hermaphrodite. One person who might have appreciated the ambiguities was the purchaser of the painting, Gaspar de Haro, a connoisseur of paintings and prostitutes.

So who was the love of her life? Not her husband, obviously. There were plenty of others to choose from – in addition to Mars, there was the Trojan hero Anchises, the father of Aeneas, and Mercury, with whom she conceived Hermaphroditus (who, incidentally, did not become Hermaphrodite until his union with the nymph Salmacis), and Bacchus, whose son was the monstrous Priapus, to name a few. But the love of her life was not one of the gods, and he was barely more than a boy. Ovid tells the story. Adonis was descended from a work of art – his grandmother was Pygmalion's statue – and you could not help noticing how beautiful he was. In fact, he looked rather like Cupid, and when Cupid's arrow accidentally grazed his mother's breast (her finger in the *stufetta* of Cardinal Bibbiena) she fell for his lookalike. The courtship was conducted out of doors. They used to lie on the grass together, Venus resting her head in his lap while she told him the story of how Atalanta and Hippomenes were changed into lions. But Adonis had the restlessness of youth, and he loved hunting. Venus managed to take an interest too, but she was frightened for him: some animals knew how to stick up for themselves. Her fears were justified. While they were apart Adonis was gored by a boar. She heard his groans, and swooped down to revive him. Too late. All she could do was ensure that a flower grew from his blood. It was the anemone, although the Greek poet Bion said that roses grew from Venus's tears as well.

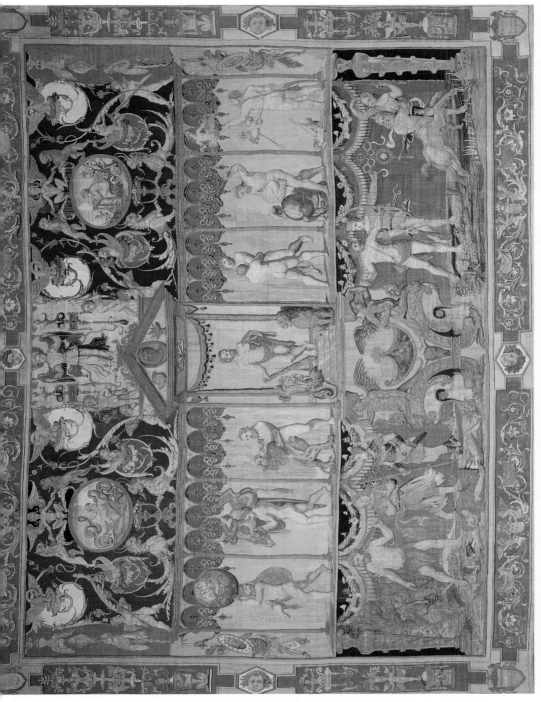

IX *The Triumph of Hercules*, after Giovanni Francesco Penni and Giovanni da Udine

Xa *Jupiter Defeating the Giants*, Palazzo Doria, Genoa, Perino del Vaga

Xb *Danaë*,
Gossaert

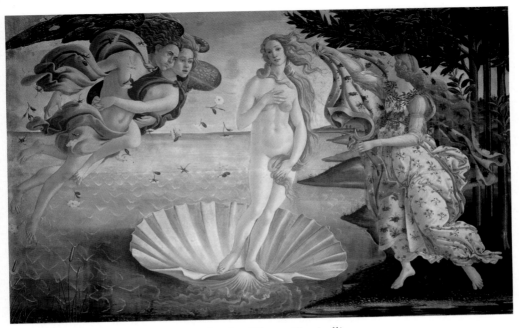

XIa *Birth of Venus*, Botticelli

XIb *Allegory of Love*,
Bronzino

XIIa *Venus and Adonis*, Titian

XIIb *Venus*, Velázquez

XIIIa *Bacchus and Ariadne*, Titian

XIIIb *Drunken Silenus*, Rubens

XIVa *Diana and Endymion*, Poussin

XIVb *Diana and Actaeon*, Cranach

XVa *Parnassus*, Mantegna

XVb *Death of Coronis*, Elsheimer

XVI *The Wedding of Peleus and Thetis,* Wtewael

77. *Venus and Adonis*, Van Dyck

The unhappy ending did not stop aristocratic couples of the seventeenth
century having themselves painted in the guise of Venus and Adonis. Hont-
horst's painting of Adonis leaving Venus (1641) brings out the vulnerability
of the lovers, but Van Dyck's double portrait of the future Duke of Bucking-
ham and Katherine Manners is the most startling example (Fig. 77). Just as
Shakespeare's 'Rose-cheeked Adonis hied him to the chase', so George
Villiers (then just a marquis) seems to be setting out on the first confident
morning of their love. His bride does not try to detain him (as Venus does
in another version of the composition) because she is far too busy posing
for the artist who appears to have painted the head (though not, of course,
the body) from life.

This is how love ought to be, open and unashamed. Not like the love of
Adonis's parents. Myrrha had conceived an insane passion for her own
father. The only way to put a stop to it was to kill herself. Foiled in the
attempt, she eventually tricked her father into sleeping with her when he
was drunk. In Ovid, the story is told from her perspective, but (like the story
of Lot's daughters in the Bible) it is very much a patriarch's view of how

78. *Birth of Adonis*, plate,
Fontana workshop

such things happen. The virtuous father, enraged at her deception, then tried to kill her and she was forced to flee. She wandered for nine months until she could go no further. Then, as the labour pains began, she begged the gods for metamorphosis. Her wish was granted, and she gave birth as a myrrh tree. Lucina acted as the midwife, assisted by naiads. The story is told at length in the *Metamorphoses* and it was routinely illustrated in vernacular editions, but it never established itself as a subject for painters. A plate from the Fontana workshop shows why. It looks like a crucifixion scene in a pre-Christian matriarchal cult. Myrrha has become a totem, and her drapery a giant snake. Lucina holds her, like Mary Magdalene at the foot of the cross, though here the wound secretes, not water and blood, but the infant Adonis, bathed in myrrh (Fig. 78).

Unlike the story of Myrrha, that of Venus and Adonis was uncommon in maiolica and other forms of decorative art. The primary reason for this is that Ovid had divided the narrative into two parts and used it as the frame for the much longer tale of Atalanta and Hippomenes. It was not illustrated in any Italian edition of Ovid before Tempesta, and its initial vogue in painting owed more to the *Hypnerotomachia* than to the *Metamorphoses*. Colonna had picked up a variant of the story in which Venus is grazed by a rose thorn when trying to save Adonis from a thrashing by the jealous Mars.[62] For this reason (according to the *Hypnerotomachia*) white roses turned red on the anniversary of Adonis's death. The scene

was illustrated, and it inspired the representation in the Sala di Psiche at the Palazzo Te and (more directly still) a print by Giorgio Ghisi. The *Hypnerotomachia* may also have introduced the theme to Rome. The description of the death of Adonis (in which Venus is attended by Cupid and three nymphs) is followed in Sebastiano's *Death of Adonis*, and the composition was reused by Peruzzi in the frieze at the Farnesina. A year or two later the *stufetta* of Cardinal Bibbiena, with its depictions of *Cupid Wounding Venus*, *Venus Extracting a Thorn*, and *Venus and Adonis*, continued the trend.

Only in the second half of the sixteenth century did the story of Venus and Adonis become a common subject. It is possible to point to several, apparently independent, events that helped to bring about the change. One was the inclusion of two woodcuts of the story in Salomon's Ovid of 1557. The designs themselves were much modified, but illustrations showing Venus and Adonis appeared in most subsequent editions of the *Metamorphoses*. Their tragic love affair was no longer just a framing device, but an Ovidian subject in its own right. In poetry, a similar shift had already occurred. One of the earliest treatments of the theme was Diego Hurtado de Mendoza's *Fábula de Adonis, Hipomenes y Atalanta* which appeared in a pirated edition in Venice in 1553, the first of many treatments of the subject in Spanish literature. Diego Hurtado de Mendoza had been the Spanish ambassador in Venice and Titian had painted his portrait, so it is tempting to see a connection between the publication of his poem in Venice and Titian's *Venus and Adonis* for Philip II which was completed the following year (Plate XII). But Titian is far more likely to have been familiar with Lodovico Dolce's *Favola di Adone* of 1545, and Dolce seems to have remembered his own description of Adonis as a '*leggiadro fanciul*' when looking at one of Titian's paintings of the subject, for he uses the same words to describe Titian's graceful youth.[63]

Dolce's poem helped to erode the significance of the story of Hippomenes and Atalanta by elaborating that of Adonis. But it did not imply, as Titian's painting does, that Venus physically tried to prevent her lover from leaving for the hunt, or that Adonis had to pull himself away from Venus's embrace. It was the painting that transformed the representation of the myth, yet as so often with Titian the composition seems to have come from nowhere. The idea of transferring Venus's sense of loss at Adonis's death to his departure appears in a poem in Pontano's *Eridanus*, where Adonis comes to Venus in a dream and then disappears, leaving her in tears as she calls after him bewailing her abandonment.[64] It is unlikely that Pontano's lines lie behind Titian's painting, but it shows that the idea of bringing the two

halves of the story together in a single moment of love and loss occurred to other people as well. And Titian's antique source, the famous relief known as the *Bed of Polyclitus*, may have helped to seal the join. In the relief, the woman, whose pose Titian used for Venus, is accompanied by a sleeping man whose left arm hangs down by his side. Titian had drawn the male figure, and other artists used it as a model for the dead Christ. In the painting it is only the dangling arm that remains – now hanging on to the leashes of the dogs – but it is a portent of the death that awaits him: just like the dogs themselves (big, serious, hunting dogs, so different from the greyhound that accompanies Adonis in later representations of the subject), whose awkward juxtaposition makes them ominously reminiscent of three-headed Cerberus, guardian of the underworld.

The painting is affecting as well. It is Venus's unseen arm that gives the game away. There's no pictorial necessity involved. Her left arm circles round behind him simply because she cannot let go. The gesture is unknown in antiquity – the closest thing to a hug any mythological figure ever receives – and you sense that Venus may inadvertently have become part of a new economy of emotion that she does not understand. Dolce misses it; all he can think about is what a turn-on she is even when seen from the back, but Shakespeare read the moment the same way: 'With this he breaketh from the sweet embrace/Of those fair armes which bound him to her breast.'[65] He probably never saw the painting, but he could feel the bodies tearing apart.

Titian's example, mediated through prints, eventually helped to make the subject popular in the North, though the four prints of the story of Adonis by Philip Galle after Anthonis Blocklandt are more closely related to the style of Fontainebleau – notably in the death scene, where the figure of Adonis simultaneously recalls Rosso's *Death of Adonis* and his *Dead Christ*. Rosso's drawing of the *Death of Adonis* (the basis for Primaticcio's painting at Fontainebleau) probably reflects Bion's lament, which describes how Venus tries to extract one last kiss from the dying Adonis's lips, and how his body is tended by cupids and mourned by the Graces.[66] Rubens obviously knew the poem, for his painting of the scene illustrates it still more precisely, with the cupids breaking their weapons in grief.

Bion's lament was one of several by Greek poets. Moschus described the capture of the offending boar by cupids, and the boar's attempt to excuse his behaviour to Venus.[67] 'He looked so pretty, I could not resist giving him a kiss on his thigh,' the beast explained. Venus knew how he felt and let him go. The scene appeared, paired with the death of Procris, in Giulio Romano's

set of designs for a series of mythological hunting accidents (perhaps destined to be woven as tapestries) for the Gonzaga. This pairing was not unique. Veronese's *Venus and Adonis*, in which Venus fans Adonis while he reclines in her lap, is also matched with a *Cephalus and Procris*. The trend continued. Domenichino's *Death of Adonis* at the Palazzo Farnese was paired with *Apollo and Hyacinthus*; Velázquez's *Venus and Adonis* for the Alcázar, with a *Cupid and Psyche*. Given that Titian's painting had been paired with a Danaë, it looks as though the frame of reference has shifted from desire to loss.

The taste for tragic love scenes fostered by Tasso's account of Tancred and Erminia in *Gerusalemme liberata* may have been a factor in this. And in the seventeenth century, the story of Adonis became more popular than ever before. Marino's epic *Adone* may have been a general source of inspiration for artists working in Italy, but it is uncertain whether Albani's painting (part of a cycle of roundels on Venusian themes for Scipione Borghese) which attributes the death of Adonis to Mars' intervention reveals Marino's influence or not, for in Anguillara's Ovid Mars had actually turned himself into the boar. In Holland, where Titian's model was particularly influential, the focus is often on the moment when Adonis leaves his mistress, and Adonis is compared with those who ignore divine counsel at their peril, an interpretation that may owe as much to Titian as to any textual source. However, scenes of his death are unusual before mid-century, whereas in Flemish painting they are relatively common and often interpreted in terms that recall the death of Christ and the mourning of the Virgin. Poussin's numerous treatments of the theme are, by contrast, decidedly secular.

Curiously, in view of Poussin's later obsession with the cycle of the seasons, his paintings of the subject contain no hint that the story might be read as a natural allegory. However, Macrobius's account of the story as an Assyrian fertility myth in which Adonis is the sun and his death the coming of winter was repeated by Boccaccio, Equicola, and many others.[68] According to this interpretation, Venus ruled the upper hemisphere and Proserpina the lower, and so Venus's six months of mourning signified the amount of time the sun spent away in the other hemisphere. In Vouet's *Four Seasons*, Venus signifies spring, and Adonis winter (Fig. 130, p. 349).

It is hard to avoid comparisons between the stories of Mars and Adonis. The fable of Venus and Mars is a comic tale of illicit lust played out in a domestic setting between two adults who are polar opposites; that of Venus and Adonis is a story of love and loss set in a timeless landscape. In the

latter, the difference between the lovers is not one of temperament but of age. (Adonis is not much older than Cupid, so he never beats him.) Venus had to balance Mars: when Mars is not on top of her, they are often standing or sitting side-by-side. With Adonis she could afford to relax, and the pair are usually shown canoodling under a tree. This made them a very horizontal couple (which must be one reason why, unlike Venus and Mars, they appear so infrequently in sculpture) and for that reason they were ideally suited to the landscape format of cabinet painting. Indeed, their story almost became a landscape subject in its own right – nowhere more effectively than in Swanevelt's series of etchings, where the lovers are almost hidden by towering trees.

Adonis is a latecomer to the ranks of mythological lovers. He does not appear in the lists found in Petrarch's *Triumphus Cupidinis* or in Boccaccio's *L'amorosa visione*, and in Brant's *Narrenschiff* it is the love of Myrrha for her (and Adonis's) father that makes it into the litany.[69] Nevertheless, as representations of Venus and Mars became fewer, those of Venus and Adonis proliferated. Did the story of Mars and Venus become a stale old joke, or was its narrative appeal lost to allegory? Does the displacement of Mars reflect changing ideals of masculinity, a more romantic conception of love, the pressure of Christian morality?

According to some Greek sources, Venus covered the body of Adonis with lettuce leaves. The scene appears in an emblem in Alciati to illustrate the point that lettuce is such an effective bromide that even an aphrodisiac like colewort cannot reverse its effects.[70] It is one of the few times Venus features in Alciati, for there are fewer Venusian emblems than you might expect. It was much easier to let Cupid illustrate the moral of a story than his mother, who was always trying to distract you with her good looks. But there was one subject that owed its existence to the emblem books: *Sine Cerere et Baccho friget Venus* ('Without Ceres and Bacchus, Venus grows cold'). It is just a line from Terence, but there was enough truth in it to keep the subject going independent of its context. The phrase is repeated by the mythographers from Fulgentius onwards, and in the Middle Ages it was interpreted in the context of the birth of Venus: crops (Ceres) are cut down with the scythe (castration of Saturn), delivered to the gastric juices (Bacchus), and lust is produced, just like the birth of Venus from the sea.[71] The phrase was illustrated only when divorced from this improbable double allegory. It first appears in Barthélémy Aneau's *Picta poesis* of 1552, where Venus stands on an altar between the other gods. Later, in the emblem book of Haechtanus, Venus is left shivering in front of a makeshift fire while

Bacchus and Ceres wander away.[72] The two forms of the subject persisted. One showed Venus deprived of food and wine, the necessities of love, whereas in the other she is enjoying their benefits.

Spranger produced paintings depicting both possibilities. In one, the three form a triangle, while in the other Bacchus and Ceres go off together and leave Venus in the cold, camped under a little awning where she does her best to keep warm. The theme was heavily developed in the circle of Goltzius, who was responsible for a dazzling drawing of the three gods enjoying the fire (Fig. 79). Saenredam engraved a series of prints after Goltzius showing the respective cults of Venus (lovers), Ceres (peasants), and Bacchus (drinkers). Rubens picked up the theme with his usual panache, showing Venus and Cupid huddled under a piece of gauzy material while a satyr laden with fruit looks on. But Italian artists did not take to it. This was partly, no doubt, because it derived from the northern emblem tradition. Though you cannot help wondering whether anyone bathed in the Mediterranean sunshine really thought Venus would get cold without Ceres and Bacchus, or that love needed to feed off anything so material as bread and wine.

For the modern viewer, Venus is born in Botticelli's painting, but she is perhaps the member of the classical pantheon whose presence is most constant in western culture. At the *possesso* of Leo X there was a statue of Venus with the inscription: 'Mars was; Minerva is, and I, Venus, always will be.'[73] And that is probably true, because if she had never been born she would have had to be invented. Venus appears frequently in medieval literature, most notably the *Roman de la Rose* where she is a central figure in the allegory, and she is also involved in the stories of Mars, Adonis, and Pygmalion. As the *Roman de la Rose* was recycled in all sorts of ways, Venus (unlike the other gods) was probably just as central to literary culture in 1400 as she was one or two centuries later.

The Renaissance did make some distinctive contributions to her cult. Not only did visual representations of the goddess proliferate to an unprecedented degree, but certain new themes emerged, notably those associated with the revival of the fable of Cupid and Psyche, the creation of an iconography for Bacchus, Ceres, and Venus, and the elaboration of the Neoplatonic philosophy of love. However, Neoplatonism is not central to the understanding of Venusian imagery in the period, for the Renaissance Venus was created in Venice, not Florence. Though they later spread throughout Europe, the reclining nude in a landscape, the toilet of Venus, and the iconography of Venus and Adonis were all initially Venetian

79. *Bacchus, Venus, and Ceres*, Goltzius

products. None has any obvious links to Neoplatonism. The first two have only a limited textual foundation in any case, and the story of Venus and Adonis plays no significant role in the works of Ficino or Leone Ebreo.

There are at least three interconnected factors in the Venetian production of Venusian imagery: the sea, prostitution, and trade. The last two are of direct importance. Though she was a marine deity, with a name so close to that of the city that the poets could ask whether the goddess had given her name to the city, or the city to the goddess,[74] Venus owes her prominence in Venetian iconography to the city's legendary courtesans. They themselves identified with the goddess, and, over time, images of them became increasingly indistinguishable from those of their patroness. The relationship worked at the level of supply as well as demand. It was not just that prostitutes were dressed up as Venus. Even if you wanted to paint a Venus rather than a courtesan, you would still need a courtesan to pose for you. And Venice was one of the few places where female models were easy to find. Elsewhere, things were different. When Titian went to Ferrara to work on the *Bacchanals* for Alfonso d'Este he complained that the lack of prostitutes meant he was unable to find a model.

The importance of oil painting and the absence of a court meant that Venice was the first place in Italy where paintings were collected by large numbers of private citizens. This was important, because Venusian imagery spread largely without state support. Queens were Juno, Minerva, or Diana, and no prince wanted to be seen encouraging prostitution. Save at the time of marriage, Venus (and her imagery) belonged in the private sphere – hidden away in the bedroom, the bathroom, the garden grotto, and the jewellery box. So whereas the iconography of some gods developed through multiple images produced for a single patron, Venusian imagery spread through single images for multiple patrons.

That is doubtless one reason why the most important relationship in a painting of Venus is often that between the goddess and the viewer. The gods almost invariably appear with other protagonists, but Venus is frequently alone, accompanied only by her child. No woman except the Virgin received this kind of individual attention, and in Venus's case it was not even mediated by the structures of religion. Sheer lust is what men were expected to feel, and also what they were expected not to feel – for however seductive she might appear, a painted Venus was a household ornament, not a woman. Guercino's *Venus, Mars, and Cupid* makes the point with alarming frankness (Fig. 80). Venus, Mars, and Cupid are assembled in an almost familial setting, and Venus is teaching Cupid how to use his bow and arrows. So he draws his bow and aims at the figure to which his mother

80. *Venus, Mars, and Cupid*, Guercino

points – the viewer. It is a cheap trick in a way, like the pointing finger in 'Your King and Country Need You.' But it is more truthful than that, for if the painting wants you, you probably want the painting.

6

Bacchus

He has always been drinking, and he arrives when you least expect him, often with a posse in tow – a fat old man stupefied with wine, several women trance-dancing, a bearded fellow blowing relentlessly on some pipes, and a band of helpers who are half-man and half-goat. In antiquity, no one wants him in their house because given the opportunity he will drive them mad. His crowd are not people who went out for a good time and got carried away, they are people who have lost themselves entirely, crazies, snake-handlers, the sort who mutilate animals with their bare hands.

You can try to keep him out, of course. But that is not the answer. As Pentheus, the king of Thebes, discovered, Bacchus does not have to lay siege to a city. The people spontaneously stream out to greet him – men and women, old and young, rich and poor, all indiscriminately mixed up together. What is needed is not defence but containment. Yet containment is impossible. When Pentheus throws Bacchus's companion Acoetes in prison, the chains fall from his arms, and the doors fly open of their own accord. There is nothing Pentheus can do except leave the city and try to confront Bacchus and his followers in person. It is a courageous action, requiring more than mere physical bravery. Defending Thebes against a besieging army would be honourable, even if he were defeated; fighting a boy whose weapons are long hair, flowers, and embroidered drapery is shameful in itself. So when Pentheus stands alone confronting the army of Bacchantes and their blubbery, infantile leader, as he does in a woodcut to a Latin edition of Ovid published in 1582 (Fig. 81), there is an unexpected pathos in the image. One man against the mob, a solitary voice of reason protesting vainly against the collective madness. What arouses sympathy is the realization that he is sacrificing his pride only to sacrifice his life as well. Humiliation first, then death.

In the classical sources, the structure of Pentheus's encounter with Bacchus is clear enough: tradition against innovation, Greece against the Orient. In the *Ovide moralisé* this confrontation had been brought closer to home:

81. *Pentheus Confronts the Bacchantes*, from Ovid, *Metamorphoses*, 1582

Pentheus is every 'pious man of good habits, and a chaste and honest life', while the Bacchantes are the Jews who put Christ to death. The city of Thebes may have become the city of God, but the dynamics of the encounter are the same: inside and outside, civilization and its barbaric alternative, and the terrible, degrading process by which the one is drawn inexorably, and for the Christian, sinfully, to the other.

The engraving of the story of Pentheus in the 1614 edition of Vigenère's *Philostratus* (Fig. 82) illustrates the end of the story – the consequence of Pentheus's later attempt to spy on the Bacchantes. The print (engraved by Leonard Gaultier after Antoine Caron) is divided vertically so that the city of Thebes is visible in the distance on the left, while on the right the Bacchantes dance in a mountain grove. The upturned tree is the one in which Pentheus hid to spy on the Bacchic rites; a few paces ahead the Bacchantes take their terrible revenge. One holds Pentheus's severed head in her outstretched arm so that it is positioned on the boundary between the city and the mountain, its blank gaze half-turned to the dancing figures above. But if the horizontal plane describes a transition from culture to nature, the vertical axis relates a family tragedy. In the foreground are the grandparents, Cadmus, the founder of Thebes, and Harmony, his wife; not, as Philostratus describes them, reaching with tender desperation for their last embrace in human form, but already transformed. Cadmus conquered

224

Thebes by sowing dragon's teeth that became soldiers; now it is his fate to become a dragon himself, as the metamorphosis works in reverse. One of the monsters turns, sensing the tumult above. The Bacchantes are their children, Agave and her sisters, and the man they are murdering is the grandson of Cadmus and Harmony, Agave's child. They think he is a lion (a wild boar, in Ovid) and by the time Agave realizes it is her son it is already too late. The elaborate funeral shown in the distance can do nothing to bring him back.

The head of Pentheus, held aloft by his mother at the crossing of the two axes, is a reminder that the boundary between culture and nature is also a boundary between life and death, and that every generation that tries to cross it does so at its peril. According to Vigenère, the moral is not just that religion should keep its distance from irreligion but that even the pious should not pry into the mysteries of the supernatural. Curiosity should be kept in check. Borrowing Tiresias's words from Euripides' *Bacchae*, Vigenère makes the story of Pentheus stand for the need for unquestioning acceptance of inherited tradition and the desirability of remaining in communion with the Catholic church.[1] Like the heads of criminals that were regularly displayed on city walls all over Europe, the head of Pentheus is a warning to anyone tempted to look beyond the limits of the established order.

Despite being treated at length in Philostratus and Ovid, the story of Pentheus did not become an established artistic subject and is rarely seen outside illustrated editions of the *Metamorphoses*. The rather similar tale of Lycurgus, the king of Thrace who drove Bacchus into the sea only to be driven mad in return, was almost never represented. Such subjects can be found in decorative cycles – the death of Pentheus in Daniele da Volterra's frieze at the Palazzo Farnese in Rome, the madness of Lycurgus by Jean Boulanger in the Galleria di Bacco at the Palazzo Estense at Sassuolo – but they are otherwise absent from the repertoire of Bacchic themes. It is easy to see why. In Philostratus, the story of Pentheus showed that it was madness to resist madness, that confrontation was the wrong response. For Plutarch, Lycurgus's attempt to eradicate the Bacchic cult by chopping down all the vines in his kingdom (the action shown in the background of Boulanger's fresco) is an example of the futility of using reason to suppress rather than channel irrational emotion.[2] But for the increasingly authoritarian and disciplined societies of the late sixteenth and early seventeenth centuries these myths may have had unwelcome implications. In both cases the forces of disorder triumph and a monarch is cruelly and savagely killed. It is not merely, as the French edition of Conti notes, that it was 'very difficult for

82. *The Bacchantes*, Leonard Gaultier after Antoine Caron,
from Philostratus, *Les images*, 1614

princes and kings instantly to eradicate an established pattern of dissi-
pation'.[3] The death of a monarch suggested that the forces he opposed were
stronger than he was, and that the civil and religious order he represented
was fragile and vulnerable.

Whereas in the classical world the Bacchic cult had usually been tolerated,

226

to the early modern observer Bacchic rites could be redolent of the primitive savagery of the Brazilian Indians;[4] and the destructive frenzy of the Bacchantes seemed quite unlike anything that might recognizably be a legitimate form of religious expression. Critics of Bacchanalia, such as the Protestant scholars who authored a series of anti-Bacchic tracts in the early seventeenth century, reaffirm the traditional Christian view that all the pagan deities are really demons, and object to the deformation of the image of God involved in the mingling of human and animal that characterizes Bacchus's retinue.[5] Taking the opportunity to score a few points against early Renaissance humanism, and the popes in particular, these authors sometimes also point to the idolatrous nature of Bacchic worship,[6] and, although it embarrasses them even to mention it, the nudity of the participants and the appalling licentiousness of the orgies.[7]

Not all these concerns were universally shared, but the representation of the Bacchanal in early modern Europe nevertheless differs significantly from that in antiquity. The most obvious change is that the maenad, the frenzied female Bacchante who features so prominently in the ancient sources and who reappears in nineteenth-century painting as a simpering chorus girl, now almost disappears from view. Maenads appear among Bacchus's train, but their central role in Bacchic worship is forgotten, and few artists seek to capture their ferocity. The best attempt is probably Boulanger's fresco of the death of Orpheus in the Palazzo Estense at Sassuolo (Fig. 83). According to the *Metamorphoses*, Orpheus was torn apart by maenads, and Bacchus, who for once regretted their actions, turned the offenders into trees (a scene charmingly painted on a plate from Gubbio). Boulanger is careful to show all the weapons Ovid described – branches, stones, thyrsi – yet by placing the action on a stormy sea-shore with the maenads' hair streaming behind them and the trees bending in the wind, he also gives the scene a wild, almost romantic lyricism. But the Sassuolo cycle is once again the exception. Despite its appearance in illustrated editions of Ovid, the death of Orpheus had difficulty in establishing itself as an artistic subject in other contexts. It was even suppressed in Monteverdi's *Orfeo*. The original version of the opera ends with Orpheus torn apart by the Bacchantes, but a new ending was substituted in which Apollo appears and takes Orpheus up to heaven.

The tendency to shy away from the representation of madness and maenadism meant that depictions of Bacchus were distinctly one-sided. In antiquity, women were said to worship Bacchus by dancing in the mountains, men by drinking wine in symposia.[8] In the Renaissance, Bacchus's strong association with feminine spirituality and power almost disappeared. In consequence,

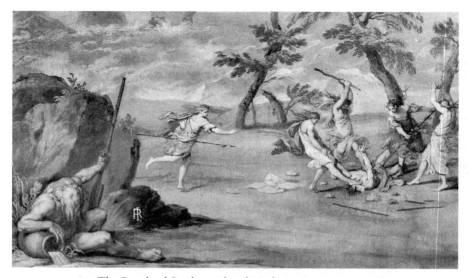

83. *The Death of Orpheus* (detail), Palazzo Estense, Sassuolo,
Jean Boulanger

the idea that the destructive and creative powers of the god were indissolubly linked was also lost, or at least transposed into a rather different context. It is possible to trace this subtle but decisive shift in a single work, Michelangelo's *Bacchus* (Fig. 84). In antiquity, the most famous statue of Dionysus had been that of Praxiteles, and for Callistratus its most admirable quality was its capacity to express the madness of the god: 'The eye was gleaming with fire, in appearance the eye of a man in a frenzy; for the bronze exhibited the Bacchic madness and seemed to be divinely inspired, just as, I think, Praxiteles had the power to infuse into the statue also the Bacchic ecstasy.'[9] Compare this with Condivi's account of the most famous Renaissance statue of the same god, 'his face, merry; the eyes, squinting and lascivious, as is usual in those excessively given to the love of wine'.[10] Condivi's description may not be altogether accurate but it marks an unmistakable shift in the perception of what the figure of Bacchus should convey: madness has become merriment; the eye that gleamed with fire now squints in drunken lust.

Although Praxiteles' statue was lost, it is unlikely that the young Michelangelo, with his ardent desire to rival and surpass the sculptors of antiquity, was unaware of his example, and the way he chose to follow it is revealing. Condivi makes the unusual claim that it conforms in every way with the intentions of ancient writers.[11] According to Pliny, Praxiteles made a bronze

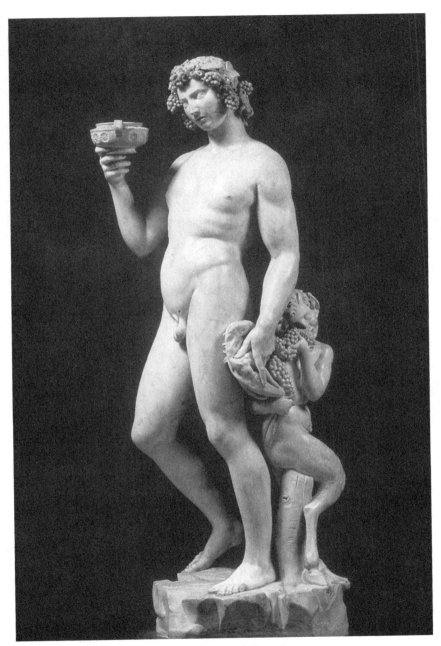

84. *Bacchus*, Michelangelo

Bacchus, Drunkenness and a satyr.[12] Whether, as some readings suggest,[13] this meant a drunken Bacchus with a satyr, rather than three figures, is uncertain, but the idea that Praxiteles' Bacchus was connected with the portrayal of drunkenness is clear enough. And Callistratus's description of the statue of an Indian offered a model of how this state might be represented in stone: 'Drunkenness was overcoming him, and yet the colour of the marble did not betray his drunkenness . . . but this condition was indicated by the attitude; for he stood reeling and jovial, not able to plant his feet steadily, but tremulous and tending to sag to the ground.'[14]

Whatever the sources, there can be no doubt that Michelangelo managed to convey the drunkenness of Bacchus sufficiently clearly for his biographer to claim, as Alciati had done of Praxiteles' work,[15] that the statue was a simple moral allegory about the harmful effects of drink. However, in its original context the drunkenness of the figure may not have been understood quite so negatively. Ficino, a friend and correspondent of both Riario, who commissioned the statue, and Galli, who subsequently purchased it, claimed that the drunkenness of Bacchus could be equated with one of Plato's four forms of divine madness, and as such was an intoxication that might elucidate divine mysteries.[16] Whether anyone ever thought about the figure in these elevated terms when they came across it standing neglected in the garden of the Casa Galli is another question (Fig. 3, p. 9), but at the end of the fifteenth century the conceptual possibility was at least open in a way that it does not seem to have been for Condivi and later viewers.

Michelangelo's statue holds in tension two aspects of Bacchic intoxication that subsequently develop distinct iconographies. Although it was easier to assimilate a deity whose ambivalence was expressed in inebriation rather than frenzied destruction, the negative aspects of drunkenness were still sufficiently troubling for them to be represented separately from the positive portrayal of inebriation as a form of inspiration. What may have made Michelangelo's *Bacchus* almost unreadable to subsequent generations was its assimilation of divine intoxication to a portrayal of literal stumbling drunkenness. The elevation of the spirit and the sagging of the body are difficult to convey simultaneously in a single figure; they lead, quite literally, in different directions. So rather than trying to portray both at once, the negative effects of drink are frequently transferred to another member of Bacchus's entourage, Silenus, leaving Bacchus free of any obvious incapacity as the idealized god of drinkers.

In order to make explicit the specifically elevating effects of drink a new image develops: the winged Bacchus. Pausanias described how the Amyclaeans gave Bacchus the title *Psila*, meaning wings. Repeated by

Rabelais, this passage became the source for an emblem showing a winged Bacchus, or a Bacchus and Pegasus. In the version that appears in Haechtanus's *Mikrokosmos*, a tubby little Bacchus sits astride his barrel as he does in so many late medieval representations, but his head is sprouting wings and by his side the winged horse Pegasus rears up heavenwards. In a note, Haechtanus explains that Bacchus is winged and has the swift horse Pegasus with him because he bears minds aloft.[17] Although learned, such enthusiasm for Bacchus was not necessarily all that serious. The cult of Bacchus lent a pseudo-antiquarian respectability to many a student drinking bout. Participants could literally dress up their activities in classical garb. Members of the Bent, the association of northern artists in seventeenth-century Rome, staged pageants in Bacchus's honour,[18] and representations of a model or even the artist himself with the attributes of Bacchus became common in northern art. Caravaggio's portrayals of Bacchus provided the prototype for many of these, and also for the figure of Bacchus in Velázquez's *Los Borrachos*, where Bacchus, surrounded by grinning peasants, initiates a new devotee to his cult.

If Bacchus and Pegasus bearing men aloft came to stand for the benefits of wine, Silenus falling from his ass illustrated its more mundane consequences. In Greek mythology, sileni are simply satyrs of advancing years, and the few references to Silenus as an individual are barely enough to form a distinct identity. But in Renaissance and Baroque art, Silenus regularly appears as almost fully human, Bacchus's indispensable companion and an instantly recognizable character in his own right. He is invariably depicted incapacitated by wine, sinking inexorably to the ground, being led or carried by others. Falling is his trademark. The chief literary source for the creation of what is almost a new mythological figure was Ovid. In the *Fasti*, Ovid describes how Bacchus discovered honey when the bees, drawn to his band by the sound of the cymbals, were shut up in the hollow of a tree. Silenus and the satyrs were delighted and went in search of more. But when Silenus tried to stand on the back of his ass to reach inside another tree he was stung and fell off. This is the central scene in the second of two panels that Piero di Cosimo devoted to the story (Fig. 85). Silenus, here bald but clean-shaven, snaps off a branch of the tree as he unsuccessfully tries to prevent himself from falling, while his ass jubilantly kicks out at him as he tumbles. To the right, he is unceremoniously levered up again, and on the left Bacchus and his companions smear mud onto Silenus's painful stings.

Piero's unusual subject was chosen in order to exploit the similarity between *vespae*, wasps that might sting like the hornets in Ovid's tale, and

85. *The Misfortunes of Silenus*, Piero di Cosimo

the name of the patron, Giovanni Vespucci, whose crest featured wasps. The more customary context for a depiction of Silenus falling from his mount was a Bacchanalian triumph or revel. For this, there were both literary and visual sources in the classical tradition. Sarcophagus reliefs known in the Renaissance showed Silenus being propped upright on his ass by satyrs or other figures at his side, and Ovid's *Ars amatoria* described how, when Bacchus and his followers found Ariadne, Silenus clung lopsidedly to the mane of his ass and fell off head first when he tried to urge his mount forwards with a rod.[19]

Falling is one measure of Silenus's incapacity; his vulnerability to capture is another. In the sixth of Virgil's *Eclogues*, illustrated with a woodcut by Goltzius in Karel van Mander's translation, Silenus is sleeping when he is surprised by two lads who tie him up, and allow the naiad Aegle to paint his face with mulberries.[20] The event is also the subject of rough drawings by Rubens and Poussin, but it was another account of capture that inspired both painters. In Ovid's *Metamorphoses*, Silenus is captured by Phrygian peasants and brought to their king, Midas, who is himself a devotee of Bacchus, and welcomes his aged guest before returning him to his leader. Bacchus then grants Midas's wish that all he touches will be turned to gold, with the disastrous result that even food and wine become metal when handled. Pleading with Bacchus for relief from his gift, Midas is told to wash away the stain at the source of the river Pactolus.

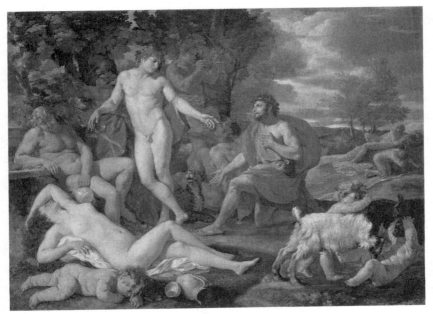

86. *Midas before Bacchus*, Poussin

In illustrated editions of Ovid, the episode in which Silenus is brought to Midas by the peasants is usually the central subject, and other aspects of the story – Midas's plea to Bacchus, Midas washing in the Pactolus – are, if shown at all, indicated only in an abbreviated fashion in the background. For Poussin and Rubens, however, the story became the pretext for the development of two very different pictures. Poussin ignores the story of Silenus's capture altogether, and shows Midas at the Pactolus, and, in a larger and more unusual composition, Midas addressing Bacchus (Fig. 86). The result is that Silenus is marginalized, shown asleep in the background of the *Midas before Bacchus*, but otherwise absent.

Rubens picks up the image of Silenus stumbling along with the peasants to meet Midas, and makes it the basis for a remarkable image of the drunken Silenus in which the purpose of the journey is forgotten, and the event becomes less an act of capture than a drunken revel in its own right (Plate XIII). As in Bonasone's print of Silenus before Midas, Silenus is supported by satyrs rather than peasants, but he nevertheless lurches forward among a crowd of people in modern dress. It takes a moment to realize that figures from classical mythology are here mingling with Rubens's contemporaries. There was no absolute distinction between the two – the dancing peasants

in *The Kermis* are the same figures as the dancing satyrs in *The Worship of Venus* – but it is also a reminder of mortality. And on an early seventeenth-century ivory tankard based on this composition, Georg Petel replaced one of the satyrs behind Silenus with the figure of Death.

The antique source for the figure of Silenus was a standing Silenus which Rubens drew twice when in Rome. To this figure, who is quite able to support himself, Rubens has added the satyrs who keep him standing upright in the painting. In contrast, the antique source for Poussin's painting is a sarcophagus relief of Bacchus and Ariadne. Poussin has used the drunken Hercules on the left as the model for the sleeping Silenus, and the Ariadne as the sleeping Bacchante, while Bacchus's cross-legged pose is clearly taken from that of the figure of Bacchus in the centre. However, in the relief Bacchus is supported by two satyrs, while in the painting he supports himself, his implied inebriation now merely a nonchalant elegance.

By supplying or suppressing details from their visual and narrative sources, Rubens and Poussin manage to transform a single myth into two wholly distinct images. In this respect the two paintings are representative of the artists' output in general. Despite painting more Bacchic scenes than any other artist in the period, Poussin omits Silenus from all the Bacchanals and satyric scenes for which he was responsible; he shows only Silenus's head in the *Triumph of Bacchus* (in which Silenus was usually such a prominent participant), and gives Silenus only limited prominence in the *Triumph of Silenus*. Rubens makes Silenus the chief subject of several canvases, gives him a role in *Nature Adorned by the Graces* and the Prado *Nymphs and Satyrs*, and shows him prominently, slumped forward over the neck of his ass, in the *Triumph of Bacchus*.

This division may reveal something of the artists' personal tastes, perhaps even a measure of identification with their respective protagonists, but it is also the outcome of a long process through which the physical attributes and iconographical significance of Bacchus and Silenus were differentiated. The attributes of beardedness and drunkenness became associated with Silenus, and also the capacity for suffering. Bacchus, who as Dionysus Zagreus was torn apart by Titans and then revived, was a dying and rising god who could be identified with Christ. Yet this episode was almost never shown, while representations of Silenus, captured, bound, falling, and mocked, drew freely on the iconography of the Passion, the garland of ivy becoming a crown of thorns as in Rubens's *Drunken Silenus* in Genoa. The identification of the physiognomy of Socrates with Silenus (first made by Plato)[21] helped to establish Silenus as another exemplar of wisdom, and of

unjustified punishment; Erasmus was not alone in comparing Silenus and Christ.[22]

As the physical incarnation of drunkenness, Silenus assumes the burden of culpability for his state, becoming the object of our pity, or, in the case of Ribera's Silenus, lying bloated on the ground looking up expectantly for another refill, of our disgust. Bacchus, however, is rarely shown in such a way as to invite our identification or sympathy. Unlike Silenus, he is a divine, and the intoxication he represents is a simulation of human drunkenness that defies gravity and lifts men heavenward, or at least to somewhere beyond the reach of any moral or physical consequences. The imagined locus of such carefree Bacchic inebriation was Andros, an island where the streams flow with an unlimited supply of wine, and the inhabitants do nothing but drink, dance, and sing. Described by Philostratus, it was painted by Titian for the *camerino* of Alfonso d'Este.[23] Alfonso would probably have used the room for relaxation rather than study, and the subjects chosen reflect this recreational purpose. None more so than *The Andrians* (Fig. 87). There is no narrative. Some of the Andrians are nude, others wear classical drapery, and others, notably the two women in the foreground, contemporary dress. None is identifiable. The pose of the sleeping female nude on the left is reminiscent of classical reliefs of Ariadne, but in this context she is surely a nameless Bacchante. The words of the music in the foreground leave little doubt as to the message the painting seeks to convey: '*Qui boyt et ne reboyt/Il ne scet que boyr soit*' ('Who drinks and does not drink again does not know what drinking is').

As Philostratus describes it, the painting of the Andrians depicts a world of wish-fulfilment. A world in which everyone is rich, powerful, generous, and tall, at least in their own intoxicated imaginings. It is also potentially a world of erotic fantasy. Referring to a similar Bacchic island Philostratus relates how a Bacchante, seized by Silenus, sees only Bacchus, her dream lover.[24] Titian reinterprets these possibilities for an aristocratic Renaissance viewer who has no need to fantasize about social status. His fantasies take him from a position of wealth and power to a place where all distinctions of rank, gender, and time are dissolved in a free erotic mingling. And whereas Philostratus describes Bacchus arriving at the island to join the revels, Titian does not show the island's proprietor, and the ship in the distance sails away. This island belongs not to Bacchus but to the patron. Patronage, like wine, allows you to make your dreams seem real. The patron is the one coming to join the fun; it is he of whom the voluptuous sleeping Bacchante dreams. Or at least, he dreams himself into her dreams

87. *The Andrians*, Titian

when, intoxicated by the painting, he imagines himself arriving on the island where all are free to imagine themselves as they will.

The influence of *The Andrians* was enduring. In the sleeping Bacchante, Titian created one of western art's most popular pin-ups, and in his depiction of the revelry – less frenzied than the Bacchanal in his *Bacchus and Ariadne*, more joyous than the drinking session in Bellini's *Feast of the Gods* (both of which were in the same room) – a new image of what a Bacchic celebration might be like. Most significantly, *The Andrians* offered a fresh apprehension of Bacchic space. In the ancient world, Bacchus came from the sea or the mountains, and in the engraving for Vigenère's Philostratus the Andrians are dancing on a beach while tritons sport in the water beside them. In the seventeenth century, Bacchus moves inland and downhill to meadows and wooded glades. Several factors influenced this relocation, but it was Titian's depiction of the Andrians that provided the best model. His Andros is a place of pleasure located somewhere between the classical dichotomy of the mountain and the city in which gods and men can drink and dance in perfect harmony. And it is in some version of this space, formed by reinventing Philostratus's island in terms of Giorgione's pastoral landscape, that many subsequent depictions of Bacchic scenes are located.

Bacchus's move into the landscape of pastoral did much to further his association with Pan, the god of shepherds and flocks. In classical sources, Pan is already part of Bacchus's entourage. Pans, like sileni, could be referred to in the plural, and there was little to distinguish them from satyrs. Lucian suggested that boys drink from the spring of the satyrs, men from the spring of Pan, and old men from that of Silenus.[25] But while Silenus is always old and satyrs are young, Pan is much more than just a middle-aged satyr. Unlike the others he is also a god in his own right, the tutelary deity of Arcadia, venerated in the form of statues and herms. And when, in the Renaissance, the Greek Arcadia was reimagined on the basis of Virgil's *Eclogues* as the site of simple pastoral pleasures and playful amorous pursuits, Pan became the presiding deity of this new landscape of the imagination.

There was one story in particular that took the fancy of artists. Syrinx was an Arcadian nymph who bore a marked resemblance to Diana, a god whom Pan is elsewhere said to have wooed with a gift of wool. When Pan caught sight of her, he pursued her to the banks of a river where, in answer to her prayers, she changed into a bed of reeds just as Pan lunged towards her. Finding himself with a bunch of reeds in his arms rather than the nymph, he contented himself with making the reeds into the Pan-pipes, or syrinx, which became one of his chief attributes. Although it was not

88. *Pan and Syrinx*, plate,
Fontana workshop

illustrated in early Italian editions, the story appears in the first book of the *Metamorphoses*, and from the early sixteenth century Pan can often be seen giving chase to Syrinx as reeds sprout from her head like a joke hairstyle (Fig. 88). In later representations of the subject it was the final lunge that artists chose to illustrate. One such composition, derived from Salomon's woodcut of 1557, enjoyed widespread circulation for a century, and thanks to Goltzius became common in seventeenth-century landscape painting. It shows Pan, with legs wide apart, stretching one arm around the reeds as the nymph throws up her arms in horror.

Depicted like this, there is little indication that one body is in the process of transformation into another, for Syrinx is usually shown as completely human. Artists may have shied away from showing her metamorphosis in favour of her double representation both as a nymph and as a bed of reeds because her physical transformation would have repeated a biformation already present in the figure of Pan. Although Pan was not being transformed from goat to man, early modern viewers were very conscious of his dual nature. All the mythographers dwell on Pan's biformation; according to Bacon it represented the duality of human nature itself.[26] For Marino, in *Musica*, the second book of his *Dicerie sacre*, the story of Pan and Syrinx becomes the opening motif in a long disquisition in which Pan's humanity represents his divinity while his goatish qualities paradoxically represent his humanity, so that the two stand for the incarnation of Christ.[27]

Although, like the satyrs, Pan represents bestial lust, he does not otherwise embody any clearly defined cluster of human qualities. Perhaps for this reason, the name Pan, meaning 'everything', was as much the source for reflection on the deity as any narrative. And Bacon made the clever but mythologically inaccurate point that since Pan was everything he could logically have no lovers except the nymph Echo, for whom (according to ancient sources) Pan had an unrequited passion.[28] The ancient link between Pan and panics remained a purely literary trope, but the Orphic doctrine that the body of Pan represented the whole of nature – his hair being the rays of the sun, and his horns the moon, and so on – was repeated by all the mythographers, and was represented in Signorelli's *School of Pan*.

In general, visual representations of the god stick to the narrative core of the myth rather than exploiting the speculative accretions to it. However, some early attempts at comparative religion had a direct impact on the visual arts. Despite the fact that the Christian iconography of the Devil included charac-teristics – horns, hoofs, a tail, and a bearded, goatish face – similar to, and probably derived from, those of Pan,[29] there is little to suggest that Pan was understood as a sinister figure. On the contrary, the equation of the death of Christ with Plutarch's tale of the sailors who, in the reign of Augustus, heard a voice crying 'Great Pan is dead'[30] meant that in the Renaissance Pan rarely had the demonic aspect he was later given in nineteenth-century literature. Marino's identification of Pan with the incarnate Christ may have been eccen-trically formulated but it was not unique, and Pan could be integrated into Judaeo-Christian history in other ways as well. Since the Vulgate could be taken as saying that Moses came down from the mountain with horns,[31] there were obvious analogies with Pan who was also horned, and who, according to Herodotus, had originated in Egypt.[32] For a learned seventeenth-century viewer, such as Loménie de Brienne, the infant in Poussin's *Finding of Moses* was not only Moses, but also Pan, Priapus, and a host of oriental deities.[33]

Herodotus could also be used to support the much more common idea that Moses was Bacchus. The theory was known in the sixteenth century and developed at length in the early seventeenth century by the Dutch theologian Gerard Vossius.[34] There were numerous parallels: Bacchus too was sometimes said to be horned and born in Egypt; Moses and Bacchus (who was thought to be the same as Osiris) were both placed in an ark; both were brought up in Arabia; both crossed the Red Sea; both were liberators (Bacchus on account of his identification with the Roman god Liber); Moses struck a rock with a staff to bring forth water, as did the Bacchantes with a thyrsus in Euripides' *Bacchae*, and so on.[35] It is difficult to know how widely

such theories circulated, but the use of seemingly inappropriate quotations from Bacchic sources in illustrations of stories from the life of Moses reveals that they were sometimes reflected in art. Poussin's inclusion of Titian's urinating putto from *The Andrians* in *Moses Striking the Rock* (St Petersburg) suggests the parallel between the Mosaic and the Bacchic striking of the rock, while his *Exposition of Moses* (Oxford), which includes a bow and quiver, the syrinx, the stick, and the cymbals, clearly refers to the identification of Moses and Bacchus/Osiris.[36]

A slightly different connection is suggested by Poussin's *Adoration of the Golden Calf*, where the dancers at the front are almost identical to the group in the artist's own *Bacchanal before a Herm of Pan*. The biblical text suggested there was something orgiastic about the festivities, and the idolatrous revels around the statue could also be identified as Bacchanalia on one of two somewhat contradictory hypotheses: that the calf represented the Egyptian bull-god Apis, with whom Bacchus was identified through the myth of his birth in Egypt, or – as Plutarch had first suggested – that the Israelites all worshipped Bacchus anyway.[37] So when, in a seventeenth-century German illustrated Bible, the engraver goes all the way and illustrates the *Adoration of the Golden Calf* by reproducing Titian's *Andrians* with a tiny golden calf added in the background,[38] it has to be taken not merely as a testimony to the success of Titian's imagery in summoning up the idea of moral abandonment, but as a reflection of the repeated scholarly attempts to interpret the Exodus in the light of pagan religion.

Another aspect of Pan's identity that was easily assimilated to a Christian context was his role as the god of shepherds.[39] This invited comparison with the Good Shepherd, and with other members of the Catholic hierarchy who exercised a pastoral responsibility. So Cardinal Richelieu could be celebrated in contemporary verse as akin not only to obviously heroic figures like David, Samson, and Hercules, but also to Pan. Hence, perhaps, among the Bacchanals executed for Richelieu's private château, Poussin's inclusion of the seemingly incongruous *Triumph of Pan*, an orgiastic revel in front of a red-faced herm.[40]

Depictions of the worship of Pan in the form of a herm become quite common in seventeenth-century Italian art, but they are frequently derived (as in Poussin's case) from illustrations of the worship of Priapus, a subject shown in several sixteenth-century engravings, though (probably for reasons of propriety) rarely illustrated in the more public medium of paint. Priapus, the guardian of gardens and orchards, alone retained the giant phallus with which Pan, and sometimes Bacchus, is equipped in Greek art. The narrowing of the phallic motif to the relatively unimportant figure of Priapus was due primarily to Christian

discomfort with the symbols of ancient fertility cults, but it also reflected the growing specialization of Bacchus's associates – Priapus became the sole bearer of the phallus rather as Silenus took on the role of the drunkard.

Within this scheme, Pan's function needs to be understood alongside the developments in the representation of other members of Bacchus's entourage. In Renaissance art, Silenus was essentially fully human; Priapus was bestial only in his genitalia, while Pan always had the legs, and sometimes also the facial features, of a goat. Satyrs and fauns (between whom no clear distinction was usually made) were a sort of servant class, and could take on varying mixtures of human or goatish qualities as required. This differentiation created a continuum between the human and the animal that was mirrored in the implied spatial location of those involved. Silenus is the one closest to human civilization, stumbling around the edges of inhabited areas; Priapus is the god of the cultivated garden, while Pan presides over uncultivated pasture. Together they form a bridge that leads all the way to the divine bestiality of Bacchus, and across which Bacchus approaches the human once more, not, as in the ancient world, through ritual madness, but in the drunkenness of Silenus, the lust of Priapus, and the pastoral revelry of Pan.

A story about Priapus did more than anything else to prompt the development of the Bacchanal as a subject in Renaissance painting. Giovanni Bellini's *Feast of the Gods* was the painting already installed in Alfonso d'Este's *camerino* which the other Bacchanals were designed to complement. Bellini used the 1497 Italian edition of the *Metamorphoses*, which recounts the story of how Priapus, rejected by the nymph Lotis, creeps up on her while she sleeps and is trying to pull off her covering when Silenus's ass brays and the nymph awakes.[41] In accordance with this interpretation Bellini first painted the protagonists as Theban rustics celebrating a feast of Bacchus, but the assembled drinkers were later given the attributes of various deities in accordance with Ovid's *Fasti*, where the event is described as a feast of the gods.[42] A depiction of rural debauchery was thus deliberately classicized and reworked before becoming part of a self-consciously classical series of Bacchanals, which also included three paintings by Titian – *The Andrians*, *Bacchus and Ariadne*, and *The Worship of Venus* – and an unidentified painting by Dosso Dossi.

It is revealing that a series that started out with a story from Ovid drew most of its other subjects from Philostratus. Despite the sequence that runs from the third to the fourth books of the *Metamorphoses*, Ovid was not a particularly rich source of Bacchic imagery. (For that reason Bacchic subjects also remained comparatively rare on maiolica, despite their obvious relevance to

the pleasures of eating and drinking.) Far more important, especially in the early Renaissance, was the material legacy of antiquity. Many of the reliefs known in the fifteenth and sixteenth centuries showed Bacchic triumphs or processions, and ancient gems frequently depicted satyrs and other revellers. These works yielded motifs rather than stories, but they ensured that Bacchic themes began to appear around the borders of illuminated manuscripts, on plaquettes, and in decorative friezes long before narrative subjects became common. Whether illustrations of long-lost works described by Philostratus, or reproductions of antique motifs, Bacchic art therefore frequently involved the recreation or reproduction of antique objects. Perhaps for this reason, it held a particular attraction for collectors and producers alike.

Over time, Bacchic themes moved from material to literary culture. One factor in this was the rediscovery of Nonnos's *Dionysiaca*, a fifth-century Greek epic that was unknown in the Middle Ages because the manuscript first came from Byzantium in the fifteenth century. Although it became known to Italian humanists like Poliziano, the edited Greek text was published in Antwerp only in 1569, and a Latin translation did not appear until 1605. But Nonnos's influence was eventually disseminated in the vernacular through the poetry of Marino, a French translation of 1625, and Heinsius's *Hymnus oft Lof-Sanck Van Bacchus* of 1616. Heinsius was a Dutch scholar who had written a commentary on the Latin edition of the *Dionysiaca* and had brought out an edition of Nonnos's other work, a paraphrase of John's gospel. His hymn to Bacchus was directly inspired by Nonnos and illustrated with a series of prints of a genial, squat little Bacchus by Jacob Matham after David Vinckeboons. It was the first time the life of Bacchus had received such comprehensive visual treatment, and the book directly influenced the representation of Bacchic themes by Dutch artists.

Matham's series began with Jupiter snatching the infant Bacchus from the dying Semele, followed by Mercury handing over the child to river-nymphs who reach out of the water to receive him. The double birth of Bacchus, from his mother's womb and then from the thigh of Jupiter, was described by Ovid and Philostratus, both of whom say that Bacchus was taken to a cave to be raised by nymphs far away from the jealous Juno. In Nonnos he is handed over to river-nymphs. The river-nymphs had first appeared in Giulio Romano's painting of the subject, but from the seventeenth century onwards this became the most common version of the scene. Heinsius freely appropriates the story by claiming that Bacchus was born on the Rhine, and in the French translation the story of Bacchus's arrival among the river-nymphs is the subject of one of Crispijn van de Passe's two engravings for the book (Fig. 89). In the dedicatory epistle, the translator

likens his new-born book to Bacchus consigned to the nymphs, a conceit that had also appeared in the dedication to the *Hypnerotomachia Poliphili*. Both Bacchus and the works in which he is depicted are objects of exchange.

In his *Birth of Bacchus* Poussin recast de Passe's composition in the light of Vigenère's Philostratus, and put Jupiter and his eagle in the sky rather than Juno and her peacock. At the same time, he relocated the scene to a pool sacred to the river-god Achelous, the very place where, according to Philostratus, Narcissus had gazed so longingly at his own reflection.[43] The mythographies are full of cross-references of this sort, but Poussin is unusual in his willingness to replicate them, and he is the only artist to show Bacchus arriving at his aquatic nursery while Narcissus wastes away on the bank. His preparatory drawing is also unique in showing Bacchus with what looks like a halo. This too has literary sources. Philostratus mentions Bacchus's brightness at his first fiery birth, and Nonnos points out that the radiance of his face also proclaimed his divine origin after his second birth. Nevertheless, in the painting Bacchus's halo is replaced with a garland of ivy, and the suggestion that the advent of Bacchus (or Poussin's painting) is a divine epiphany is lost as well.[44]

In the classical sources, Bacchus's birth is only the first of many occasions on which he is revealed to the world in a way that is unexpected and disquieting. The most dramatic of these manifestations is perhaps the tale of the Tyrrhenian pirates. According to the *Metamorphoses*, Bacchus was discovered by sailors in a deserted field on the island of Chios. The effeminate little boy, seemingly helpless, is considered something of a prize, and is brought back to the ship. The scene is evocatively depicted by Adriaen van Stalbemt, but it is what happened next that captures the imagination. Setting out to sea, Bacchus asks to be taken to Naxos. Despite the protests of Acoetes, the helmsman who alone recognizes the boy's divinity, the pirates steer in the opposite direction. But then the ship stands still, ivy starts to climb the rigging, and Bacchus appears in his divinity, garlanded and holding his ivy-wreathed thyrsus; the sailors, overcome by fear or madness, throw themselves overboard. As they do so, they start to change. Their jaws widen, their noses become hooked. Two of them can be seen in the print by Matham after David Vinckeboons (Fig. 90). One throws himself over the side of the ship snout first, like an animated gargoyle; another leaps from the prow, his head transformed into that of the dolphin he will soon become.

Of all the stories associated with Bacchus this is the most like a fairy-tale – a nightmare story of child abduction miraculously translated into a harmless fantasy as the child takes control and his erstwhile captors become dolphins

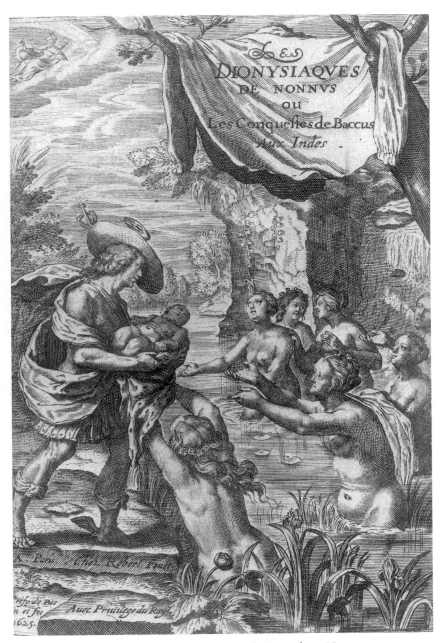

89. *Birth of Bacchus*, Crispijn van de Passe, from Nonnos,
Les Dionysiaques, 1625

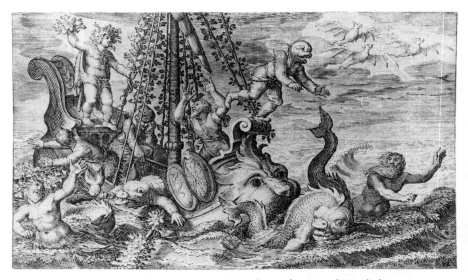

90. *Bacchus and the Pirates*, Jacob Matham after David Vinckeboons,
from Daniel Heinsius, *Nederduytsche poemata*, 1616

sporting in the waves. It appears in sixteenth-century illustrated editions of
Ovid, accompanied in early Italian editions by the explanation that the
sailors only acted as they did because they were blind drunk, and that they
thought the sails had become covered with foliage because to a drunk
man white often looks green. As a subject for artists it was less obviously
attractive. The metamorphosis it describes was perhaps too grotesque to
find its way into oils, although it appears in the fresco cycles of Boulanger
and Daniele da Volterra.

According to Philostratus, there were two ships: the ship of Bacchus, a
sacred vessel with a thyrsus for a mast, and the ship of the Tyrrhenians who
hoped to capture the Bacchantes for themselves and fob off the Pans with
she-goats. Here Bacchus's golden leopardess leaps at the pirates. She appears
in the engraving to Vigenère's Philostratus, crouching at the side of the boat
like a cat on the edge of a pond, terrifying the man in the water below. It is
pure comedy, but for some readers of Philostratus the ship of Bacchus also
had a serious meaning. In Jean Dorat's programme for the entrance of
Charles IX and Elizabeth of Austria into Paris in 1571 (mostly based on
the recently published Greek text of Nonnos), the sacred ship was depicted
with Bacchus and his mother Semele on board and was used to symbolize
Religion itself.[45]

*

It is a measure of Bacchus's ambiguous position in classical mythology that he, unlike the other Olympians, had to use a boat to travel to and from the islands with which he is associated. Early modern representations of Bacchus give little thought to such practicalities, or to the question of how Bacchus actually got to Naxos to rescue Ariadne. Few artists give any indication that Bacchus and his followers might have arrived by sea, but thanks to Vigenère's Philostratus French artists were less liable to forget that Bacchus travelled by boat than their Italian contemporaries. The 1614 edition also contains an engraving of Ariadne showing Bacchus climbing directly out of his beached vessel towards the sleeping girl. This in turn inspired Louis Le Nain's remarkable *Bacchus and Ariadne*, in which the sailors have just managed to draw up against the rocky shore and the god gingerly steps out of the boat to approach Ariadne along the gangplank that leads directly to her feet. But even when no debt to the engraving is evident, French artists remember where Bacchus has come from: Boulanger's depiction of the scene at Sassuolo makes the masts of Bacchus's ship prominent in the background, and Simon Vouet's painting of Bacchus crowning Ariadne (later also used for a tapestry) shows the hull of the boat on the right.

Italian artists rarely show Bacchus coming from the sea. Despite the fact that Boccaccio made clear that Bacchus had married Ariadne, *cassone* painters usually linked Ariadne to Theseus (who had abandoned her on Naxos) rather than Bacchus. When the theme of Bacchus and Ariadne did appear, the example of ancient sarcophagi suggested a relief-like composition in which Bacchus and Ariadne are drawn along together beside the shore, or else Ariadne is picked up by Bacchus as he cruises the beach in his luxurious tiger-powered car. Matteo Balducci's panel is an example of the former composition, while Cima da Conegliano's *Bacchus and Ariadne* in Milan and Peruzzi's fresco at the Villa Farnesina both deploy the latter.

In this context, Titian's *Bacchus and Ariadne* (Plate XIII), another of the Este Bacchanals, represented a new and dramatic alternative. The idea for the painting may have come from Philostratus, but the details are drawn from Catullus and from Ovid's *Ars amatoria*.[46] As Titian must have realized when apprised of the texts, there was more to the meeting than swinging by and pulling Ariadne on board the triumphal car. This is not another abduction in which the god, revealing nothing of himself, ravishes a woman before she realizes what is going on; it is simultaneously an epiphany and a seduction.

In order to appreciate Titian's approach to this subject it is important to remember that the classical sources characterize the meeting of Bacchus and Ariadne aurally rather than visually. There are two literary traditions: according to Philostratus, Ariadne is asleep and so the Bacchantes refrain

from clashing their cymbals; the satyrs put down their flutes, and Pan checks his wild dance. Even when Ariadne is shown awake, artists following this tradition usually try to paint the silence. They omit the more riotous members of Bacchus's entourage, and have him approaching Ariadne alone, or (as in Boulanger's fresco) with his followers strung out in single file behind. The position of Bacchus's feet is sometimes used to convey the stillness. In Boulanger, Bacchus self-consciously puts one foot forward at a time, suggesting something tentative and cautious in his approach; in Le Nain, the single foot feeling its way along the gangplank makes balance a metaphor for the precarious silence.

By contrast, Catullus, and also Ovid, describe a meeting in which Ariadne is bewailing her fate when her laments are drowned out by the Bacchantes' atrocious racket. Some 'beat timbrels with uplifted hands, or raised clear clashings with cymbals of rounded bronze, many blew horns with harsh sounding drone, and the barbarian pipe shrilled with dreadful din'. The insistent banging of the cymbals is conveyed more clearly still in the percussive alliteration of Catullus's Latin: '*aut tereti tenuis tinnitus aere ciebant*'. In Titian's painting, Bacchus surfs into Ariadne's consciousness on a wave of noise. At the upper level from which Bacchus comes, the surging motion of his followers is translated into a sequence of sounds: behind Silenus at the back is the harsh droning horn, next comes a Bacchante shaking a tambourine, and then, immediately behind Bacchus himself, the repeated clashing of the cymbals. In case the viewer should mistake the discordant tones for something more harmonious, the sound of each instrument has a visual equivalent – the braying horn is echoed by the ass; the tambourine by the shaken hunk of meat; the spine-tingling clashing of the cymbals by the satyr writhing with snakes.

According to Ovid, Bacchus leapt out of his chariot lest Ariadne be frightened by the tigers. But Titian does nothing to convey this idea. Far from terrifying the girl with their ferocity, the 'tigers' are two bored cheetahs having a welcome break. Bacchus's leap does not reassure the girl; it carries the barrage of noise all the way to Ariadne herself. Once again, it is Bacchus's extended foot that carries the weight of meaning. Unlike the single foot slid tentatively forwards that characterizes Bacchus's approach in later illustrations of Philostratus's text, Titian shows Bacchus jumping from the side of his car, his foot extended to take the full force of his landing. Ovid notes that the sand bore the imprint. In the painting, the impending impact of the foot on the ground anticipates the wave of sound breaking at Ariadne's side.

And yet the meaning of Titian's painting is not to be found in the brash orchestration of Bacchus's arrival, but in the quick silent glance that he exchanges with the fleeing girl. As Ariadne turns defensively away from the

91. *Bacchus and Ariadne*, Tintoretto

cacophany in which the god announces his presence, she turns to meet his eye: revealed in noise, the god seduces with his gaze. The texts say nothing of this. The artist has taken an epiphany in sound and painted within it a silent communion.

Surprisingly, Titian's *Bacchus and Ariadne* had less impact on subsequent generations of artists than either of his other Este Bacchanals. The painting that changed the way in which the subject was represented was Tintoretto's *Bacchus and Ariadne*, which owes nothing to Titian or his literary sources (Fig. 91). This painting, which is one of a group of four executed for the Doge's Palace, illustrates an episode of the story unique to Ovid's *Fasti*. Here, Bacchus had already met Ariadne but had subsequently left her in order to conquer India where, much to Ariadne's dismay, he acquired a new girlfriend. Bacchus makes up by suggesting that they go together to the heavens, and that Ariadne, who has already shared his bed, should now also share his name, becoming Libera to his Liber. In addition he offers to make the jewels of her crown into stars, 'the crown which Vulcan gave to Venus and she to you'.

Tintoretto's painting makes no reference to the troubled episode in Bacchus and Ariadne's relationship that Ovid describes, but nevertheless depicts their marriage along the lines suggested in the *Fasti*, with Venus swooping in

through the air to place the crown of stars on Ariadne's head and holding out Ariadne's hand to receive the ring Bacchus proffers. If the painting lacks the drama and psychological intensity of Titian's it is hardly surprising, for unlike Titian's work, which was destined for a small private space, this is a piece of allegorical public art, commissioned by the state. The protagonists are not individuals invested with the power and beauty of the gods, but abstractions whose relationship to one another has the elegant inhumanity of a corporate logo. According to Ridolfi, Venus's action in giving Ariadne a crown, declaring her to be Libera, and admitting her to the company of the gods, denotes 'Venice, born on the shore of the sea, through heavenly grace given an abundance not only of every earthly good, but also crowned with the crown of liberty by the divine hand'.[47] As an appropriation of a classical myth for the purposes of the state this is cleverer than most. The analogy between Ariadne and Venice, both stranded on the sea-shore, is clear enough, but the story in the *Fasti* also ties into two pre-existing elements in Venice's mythology: Venice was frequently shown being crowned, an event echoing the coronation of the Virgin, but also potentially analogous to the crowning of Ariadne (to which the coronation of the Virgin could be likened); and Venice was celebrated by her inhabitants as a free city, self-governing and independent; hence Libera, Ariadne's new name in the *Fasti*, could take on its literal meaning 'free'.

It was not, however, the iconographical content of the painting that was perpetuated in subsequent representations, but rather the pose of Ariadne herself, seated on a rock high above the sea, with one arm resting on a ledge at her side. Ariadne's position differs both from the classical model of a recumbent figure with one arm tossed dreamily behind her head, and from Titian's vision of a figure nervously pacing the shore, in that she is appropriately placed to receive the attentions of her suitor. In Tintoretto's painting, Ariadne is awaiting Bacchus because they have met before, but the image was almost instantly recycled as a depiction of their first encounter. A version of Tintoretto's composition, minus Venus and with Ariadne rather more comfortably propped up on a heap of cushions, appeared in Franco's engraving for Anguillara's Ovid in 1584 (Fig. 92). It was the first time the story of Bacchus and Ariadne had been illustrated in an Italian edition of the *Metamorphoses*, for the Latin text focuses on Ariadne's earlier relationship with Theseus (who had escaped from the Labyrinth with her help) and it was this aspect of the story that was depicted in earlier editions. But in an effort to rival Olimpia's lament in Ariosto's *Orlando furioso*, Anguillara had refocused the story by interpolating versions of Ariadne's lament from the *Heroides* and Venus's crowning of Ariadne from the *Fasti*.

Anguillara's account of Bacchus and Ariadne may have been a *tour de*

92. *Bacchus and Ariadne,*
Giacomo Franco, from
Ovid, *Metamorphoses,*
1584

force, but Orologi's allegory brought things down to earth. Following
Boccaccio, he suggests that the story shows how a woman who lets herself
be conquered by wine is easily overcome by lust, while the placing of the
crown in the heavens indicates that everyone will end up getting to hear
about it. It is a good example of the almost total lack of co-ordination
between image, text, and allegory, but there was more to come. Franco's
engraving was reused in other translations which followed the original text
of the *Metamorphoses* more closely. And in 1619 it even became the subject
of a Latin commentary in a German edition for which the illustrations (there
was no text) provided the subject-matter.[48] The author, J. L. Gottfried,
could have had no idea that the image he was explicating in terms of the
Metamorphoses originally illustrated lines from the *Fasti*.

Agostino Carracci's engraving of Tintoretto's painting also aided its
dissemination, but it was Guido Reni's variant of Ariadne's pose which

ensured that Tintoretto's version of Ariadne was reworked long into the eighteenth century. In Reni's first version, now in Los Angeles, Ariadne is shown seated on a draped rock with one arm resting on a ledge, with (in deference to the classical models) a hand supporting her head and the other extended towards Bacchus. The pose makes little sense, for Bacchus is standing at her side, his toes almost touching hers, while she is looking away, her eyes turned heavenward in Reni's trademark fashion. But when he returned to the subject in the later painting, commissioned for Queen Henrietta Maria, her pose is reversed and she turns in surprise to see her suitor presented to her by a woman who could be her twin.

This painting proved to be the single most enduring image of what the meeting of Bacchus and Ariadne was like. Although now lost, it is known from prints and copies (Fig. 93) which show Bacchus standing squarely in front of Ariadne as he does in the earlier painting, but with two identical women in front of him. The woman is Venus, yet this is not another version of Ovid's *Fasti*, nor even a reflection of Anguillara's version of the *Metamorphoses* in which Bacchus enlists Venus's help to salve Ariadne's pain at her lost love, but another version of the myth illustrated here for the first time (except in the print to Heinsius's *Bacchus*). Cardinal Francesco Barberini, on whose orders it was painted, was a friend of Marino, who had acquired the northern European taste for Nonnos while in exile in Paris, and not only modelled many passages of his epic *Adone* after it, but passed on his enthusiasm to others when he returned to Italy.[49] According to Nonnos, Venus led Bacchus to Naxos with Cupid beating his wings above. But Ariadne so resembles Venus that Bacchus at first thinks she is Venus. Even Cupid admired her and thought it was Venus lamenting on Naxos, for, as Nonnos observes, Ariadne's grief became her: the lamenting Ariadne was a match for the smiling Venus.

So when Reni depicted two nearly identical naked women side by side it was not in order to eroticize his subject, but to render the text as literally as possible. All the same, the nudity proved problematic: the Civil War prevented the painting going to England and it ended up in France, where it was soon to be destroyed by the purchaser's widow on account of its impropriety. Yet it may have been this aspect of the work that recommended it to later artists, who were probably ignorant of its literary source. The composition was reworked on numerous occasions – a variant even graced Dubois-Fontanelle's translation of Ovid's *Metamorphoses* in 1767 – and never more strangely than in a painting by Batoni and van Lint in which Reni's figure group is seen from above, and the main focus is a great herd of elephants (presumably brought by Bacchus from India) bathing peacefully

93. *Bacchus and Ariadne*, after Guido Reni

in an inlet. Yet at the centre, still leaning on her rock, is the now tiny figure of Ariadne that Reni had derived from Tintoretto.

The political appropriation of the story of Bacchus and Ariadne represented by Tintoretto's painting was unusual. Unlike Hercules, Bacchus rarely played a role in allegories of the state, and even in Venice it was Ariadne, not Bacchus, who represented the republic. The kind of people identified with Bacchus were artists and writers rather than princes, and there are self-portraits of the artists as Bacchus by Lomazzo and Hans von Aachen, among others. But although authors sometimes moved Bacchus to their own locality – Ronsard to the Loire, Heinsius to the Rhine – he was too much the outsider to be a local symbol. 'You can't be sure of tomorrow' was the refrain of Lorenzo de' Medici's Bacchic carnival ode.[50] It is hardly a political slogan, and it is no wonder that Bacchic imagery is rather more prominent in carnivals than triumphal entries.

Nevertheless, according to Diodorus Siculus, Bacchus had conquered the whole world, except England and Ethiopia,[51] and been the first to hold a triumph. Spanish writers made much of the references to Bacchus's conquest of Iberia in Pliny and Plutarch, suggesting that Bacchus had brought the arts of civilization to the peninsula and founded cities. So in 'Columbus before

Ferdinand the Catholic', one of the decorations for the entry of the wife of Philip IV into Madrid in 1649, the Spanish conquest of the Americas is symbolized by the celebrated conquerors Bacchus and Hercules standing behind the explorer as he kneels before the king.[52] Here, it is not Bacchus's conquest of Iberia that is invoked so much as his far more renowned conquest of India.

The association between Bacchus and India has no place in classical Greek mythology or art. It is the product of the Hellenistic era and arises from the conflation of the legends of Dionysus and Alexander the Great. Alexander identified himself with the god, with the ironic result that Alexander's conquests were subsequently attributed to Bacchus. Late antique sources contain many references to Bacchus's Indian expedition, but none was of great importance to artists, and of the sixteenth-century mythographers only Conti gives Bacchus's Indian campaign more than a mention. Nevertheless, the Indian triumph of Bacchus quickly found its way into the repertoire of artistic subjects because it was carved on Roman sarcophagus reliefs available to artists from the fifteenth century. It was frequently reworked in conjunction with the story of Ariadne, and the 'Triumph of Bacchus and Ariadne' became one of the most commonplace Bacchic themes in the visual arts. Yet the subject was essentially a novelty, without a clear literary source, and with limited precedent in ancient art. A slender textual basis for the theme can be constructed from the *Fasti*, which makes no mention of a triumph and claims that Bacchus returned to Ariadne after the conquest of India.[53] But it was through the combination of visual rather than literary sources that the subject developed. Two more or less distinct types of Bacchic sarcophagus reliefs were involved. One showed a Bacchic procession (not strictly a triumph) with Bacchus and Ariadne embracing in a car preceded by Silenus on his ass and/or dancing satyrs and maenads. The other, the Indian triumph, was usually a far more crowded composition, without Ariadne, and stocked with exotic animals – elephants, camels, and even a lion or tiger in place of Silenus's customary mount.[54]

There were two ways to integrate the two: one, which was followed in Raphael's lost drawing for Alfonso d'Este's *camerino*, simply involves reworking a relief (now at the Palazzo Pallavicini-Rospigliosi) while changing the sex of the figure alongside Bacchus in the triumphal chariot so that he becomes a she and thus, by implication, Ariadne. The alternative, followed in a drawing by Perino del Vaga, is to take the procession from the antique relief now at Woburn, and then add in the elephants and a sleeping Ariadne from another relief so that the entire Bacchic army is almost on top of her before Cupid and Silenus's ass can rouse her. Perino's drawing served as a design for the Farnese Casket (commissioned by Cardinal Alessandro

Farnese) and it was later used by Annibale Carracci as the basis for his ceiling fresco of the *Triumph of Bacchus and Ariadne* at the Palazzo Farnese. However, Annibale reworked Perino's drawing in the light of another antique source, not only freeing the overcrowded composition, but restoring Ariadne to her place alongside Bacchus and even giving her a chariot of her own.

In northern art, the union of Bacchus and Ariadne was sometimes celebrated with a feast rather than a triumph, notably in several paintings by Jan Brueghel the Elder and Hendrik van Balen. Meanwhile the triumph itself takes on a slightly different character. Ariadne is included less frequently, and the procession often moves from right to left rather than from left to right. Heemskerck's version is an extraordinary synthesis of classical motifs (Fig. 94). The antique foot in the foreground comes from the Portico of Octavia in Rome – a subtle reminder that Bacchus turns bodies into fragments. But there is also a distinctively northern emphasis on drunkenness, and the vomiting continues into the seventeenth century. One of Matham's triumphs for Heinsius's poem is derived directly from Heemskerck, except that here it is satyrs who turn somersaults and retch, but there is also another procession based more closely on Heinsius's text, in which armoured personifications of War and Violence walk to Bacchus's left; this in turn provided the basis for *The Triumph of Bacchus* painted by Nicolaes Moeyaert in 1624.

Bacchus had been the first to plant the vine and to discover its use. In Veronese's fresco at the Villa Barbaro at Maser, he is shown squeezing the juice from a bunch of grapes for the benefit of mankind. Among the loves of the gods woven by Arachne, Ovid describes how Bacchus seduced Erigone in the form of a grape – which meant that he had had to get her drunk first, early commentators said. The scene appeared in Caraglio's *Loves of the Gods* and in a painting by Reni. (Poussin was working up a similar idea, but changed the finished painting to show Bacchus holding a thyrsus and being crowned with laurels and ivy by Cupid – which is what happened when he won Pallene in the French translation of Nonnos.)[55]

Bacchus's link with the grape harvest was also the key to his identification with autumn. In the Renaissance, Bacchus continued to be the season's acknowledged deity, and Bacchic subjects or the figure of Bacchus himself served to illustrate the season in numerous contexts. Cycles of the seasons, for instance in the prints of Virgil Solis and of Pieter Coecke van Aelst, sometimes show Bacchus and his retinue as part of a procession in which Pomona is the central figure, preceded or followed by the figure of Abundance. Such illustrations may have helped to inspire Ronsard's 'Hymne de

l'Automne' in which Autumn, alone of all the seasons, is barren and pro-
ductive of nothing, until, following an unsuccessful visit to the House of the
Sun, Bacchus appears with his followers and makes her his wife, the Mistress
of Abundance. The description of Bacchus rescuing a forlorn maiden obvi-
ously owes something to the myth of Ariadne, but the structure of the plot
reflects Nonnos's *Dionysiaca* in which Autumn is barren and downcast
until she discovers that she will be united with Bacchus and become the
grape-bearing season.[56]

94. *Triumph of Bacchus*, Maarten van Heemskerck

In Ronsard's 'Hymne de Bacchus', Bacchus's power to transform the world is extended further. Here he becomes not merely the god of autumnal abundance but of all natural fertility and human civilization. This identification combines two fairly distinct themes: the trope of wine as a form of divine inspiration bearing people aloft, and the image of the triumphal procession celebrating natural abundance. United, they yield the poem's closing image of mankind being taken up to the heavenly banquet in Bacchus's triumphal car. Significant in this conjunction is the combination of

the Neoplatonic idea of individual inspiration with a wider vision of what Bacchus provides: music, laws, liberty, truth, religion. The salvation Bacchus offers is here more social than individual, and Bacchus is pictured as the world soul, the leader of the cosmic dance – an image also found in Marullo and the *Orphic Hymns*.[57]

Ronsard's vision of Bacchus's cosmic role, echoed in much late sixteenth-century French verse, offers an interesting counterbalance to the more traditional interpretation of Bacchus as the embodiment of the dangerous power that lies outside civilization and threatens anyone who, like Pentheus, strays beyond its borders. In Ronsard, Bacchus is imaginatively relocated. He is now on the inside: he is the one who gives peoples and towns their boundaries and their laws.[58] He is also the god of creativity, the leader of the Muses, and, alongside Apollo, the deity to whom the poet turns for inspiration.

Although the connection between Bacchus and the Muses was an ancient one frequently mentioned and sometimes illustrated in the sixteenth century,[59] other aspects of this vision of Bacchus remained a purely literary conceit with few visual parallels. Nevertheless, there is at least one artist in whose work parallel themes occur. In Poussin's *Dance to the Music of Time* (Fig. 95) the subject of Bacchus's relation to the seasons is illustrated in a way that parallels Ronsard's use of the same passages from Nonnos in the 'Hymne de l'Automne'.[60] Nonnos describes in some detail how the Four Seasons go to the Sun to reiterate old Father Time's request for the coming of Bacchus; they arrive as dawn is breaking, to be greeted by the twelve Hours who circle around the chariot of the Sun. His account of the seasons was particularly admired – imitated by Marino,[61] and recommended to painters wanting to depict the seasons in Vigenère's edition of Philostratus.[62] Poussin follows Nonnos's descriptions of the individual dancers as they are given in the French translations: on the left is Spring, with a garland of roses in her hair; at the back is Autumn, whose hair has been cropped by the winds but whose brow is wreathed with olive branches; Winter is next, with her bound hair and shadowed face, and at the front is Summer, dressed in white with ears of corn in the braids of her hair.[63]

The herm on the left is based on an antique double-herm of Bacchus which Poussin had already used in his earlier *Bacchanal of Putti*. Classical sources affirmed that Bacchus appeared as both a young and an old man, and although it was his youthful identity that generally appealed, there was also a well-known antique relief of Bacchus receiving hospitality in which he appears as an old man with a beard. The biform Bacchus conjoined this elderly Bacchus with the more customary youthful manifestations of the god, and so was taken to symbolize the passage of the sun through the four

95. Dance to the Music of Time, Poussin

stages of its life represented by the seasons. Poussin clearly identified Bacchus with the sun on other occasions, for the sun is shown careering through the sky in parallel to the triumphal procession in the Kansas *Triumph of Bacchus*, and rising behind the trees in the drawing of *The Birth of Bacchus*. And so here, the herm, the four seasons, and the chariot of the sun all denote the same thing – the dependence of the cyclical movement of nature through time on Bacchus, the sun.

The significance of these details was soon lost. Traces remain in Félibien's account of the painting as *The Dance of Human Life*, in which the figures simultaneously represent both the seasons and the four ages of man, but both Félibien and Poussin's other biographer, Bellori, describe the dancing figures as four women and give a seemingly unconnected allegory as the primary subject of the story.[64] On this account, the herm is Janus and the dancers represent the cycle of human fortune as it progresses from Poverty (autumn) through Industry (winter) to Riches (summer) and Luxury (spring), and thence to Poverty once more. This is a delightful moral conceit, but it can hardly have been the original subject of the painting, and none of the travellers who saw the painting in Rome in the following century ever

assumed the subject to be anything other than the dance of the seasons.

So how did a 'dance of the seasons' come to be reinterpreted as a moral allegory? One reason was the declining familiarity with Poussin's literary source: Nonnos enjoyed only a brief renown – the French translation was the last edition in any language for more than two centuries. Another was the new taste, developed within seventeenth-century Roman clerical circles, for reinterpreting contemporary works of art in allegorical terms.[65] The painting's patron, Cardinal Giulio Rospigliosi, had a particular enthusiasm for allegory, and it is therefore likely that he was the one responsible for reinterpreting the painting during or after its completion. The two meanings are not wholly unconnected, and it is possible to see how one understanding of the painting may have led to the other. In the French translation of Nonnos, when Autumn arrives with the other seasons at the house of the Sun, she complains to the Sun of her poverty.[66] From this self-identification of Autumn with poverty (a personification to which the figure in the painting bears no resemblance) may have arisen the idea that the figure actually represented Poverty, not in the sense of sterility, but in terms of the absence of money, and from this it would have been a relatively small step to invest the other figures with a complementary significance and so complete the cycle.

The allegorical reinterpretation of Poussin's Bacchic *Dance of the Seasons* in terms of the rise and fall of economic fortune was not merely ingenious but also revelatory. A myth about natural fertility has become an allegory about the economy, and the absence of the Bacchic spirit that made Autumn barren has become a shortage of cash; according to Ronsard, Bacchus made the world go round, but in the allegory of Poussin's painting, the power that turns the dancers is the power of money.

For the ancients, the only appropriate response to the power of Bacchus was to give way to the madness and join the dance of the Bacchantes. For early modern viewers, there were other ways of breaking with the confines of tradition; they could join Bacchus not in ritual madness but in the pursuit of freedom, conquest, and abundance. The underlying motivation for these quests, as for Poussin's allegorical dance, was identified by Bacon when he equated Bacchus with *cupiditas*, or desire. This is not sexual desire, but the desire for goods or gain, and Bacon's comments may have been inspired by Plutarch's essay on the desire for riches, 'De cupiditate divitiarum', in which it is noted that whereas Bacchic processions had once been simple rituals they had since become opportunities for the display of wealth.[67] Picking up Plutarch's point that, unlike other desires, the desire for riches is insatiable, Bacon notes that it is characteristic of *cupiditas* that whatever it seeks,

whether 'honour or fortune or love or glory or knowledge', it knows no limits, and it 'never rests satisfied with what it has, but goes on and on with infinite insatiable appetite panting after new triumphs'.[68] The ancient religion of frenzied destruction had become the economy of insatiable consumption. No modern Pentheus could contain it.

7

Diana

The one thing that seems to have exercised people about the sacrifice of Iphigenia is the way Agamemnon was depicted at the moment of his daughter's death. Lured to the Greek camp at Aulis believing she is to marry Achilles, Iphigenia discovers that her life is the sacrifice required to satisfy Diana and secure a favourable wind that will allow the army to sail for Troy. The needs of the state must take precedence over familial affection, and the sacrifice goes ahead. According to Pliny, when Timanthes painted the scene he showed Calchas, the prophet who first demanded Iphigenia's blood, as sad, Ulysses as sadder, and Menelaus as saddest of all. But Agamemnon was painted with his face veiled. Everyone had an opinion on this, both in antiquity and in the Renaissance. Alberti cited Timanthes' composition as a good example of the communication of emotion in an *istoria*, and suggested that concealing Agamemnon's reaction allowed the viewer to imagine his grief more effectively than depicting it. Sandys, following Quintilian, introduced a more cynical note: perhaps it was not (as Cicero had suggested) that 'no pencill could express so franticke a sorrow', but rather that Timanthes, 'having spent the height of his fantasie ... [and] despairing to finish the rest with like felicity ... forbore to proceed any farther'. Montaigne had a psychological explanation. The painter had given to each spectator the appropriate degree of sorrow but when he came to the father he had to deal with a grief that was too painful for a person physically to express. In other words, the painter concealed Agamemnon's face to conceal, but simultaneously to symbolize, the fact that Agamemnon's face showed no emotion at all.[1]

Rather than having any artistic motive, Timanthes may just have been following the text of Euripides' *Iphigenia at Aulis*, where Agamemnon is said to have wept and drawn his robe across his eyes.[2] Still, the discussion of his work is illuminating in that it was obviously thought to mark some sort of limit to the possibilities of art. If, as was widely held, art was about the representation of expressed emotion, then there might be some emotions

that were so profound as to be inexpressible, or unrepresentable, or, as Lessing later argued, simply too hideous to show.[3] What is interesting about this discussion is that nobody suggests that Agamemnon drew his robe across his face because he could not bear to watch his daughter killed. Only Domenichino's fresco at the Palazzo Giustiniani-Odescalchi at Bassano di Sutri makes the obvious inference. Everyone else accepted that what was unrepresentable was not the sacrifice itself, or the helpless terror of the victim, but the remorse of the perpetrator.

This strikes us as odd. But in early modern Europe people seemed to find it relatively easy to understand how someone might find themselves in Agamemnon's position. Such things happened in the Bible as well. According to Euripides in *Iphigenia in Tauris*, Agamemnon had once vowed to sacrifice to Diana the most beautiful thing born in the next year. Iphigenia was that thing. Similarly in the Old Testament, when Jephthah vowed to sacrifice the first thing that met him on returning home from his battles, it was his only daughter. Dante had devoted a whole canto of the *Paradiso* to working out what to do in just such cases – first, do not take vows lightly; second, keep the vow but exchange what you have vowed to give for something better and more suitable.[4] The idea that there might be something monstrous about religions in which such situations arose was not much canvassed. Lucretius had roundly condemned the whole business: it showed how misguided religious scruple could lead people to commit terrible crimes.[5] And in the notes to Anguillara's translation of Ovid, Orologi acknowledged that the story says something about the hold that religion has over people's minds. But you had to be as sceptical as Voltaire before you went as far as Lucretius. As the *Ovide moralisé* had pointed out, Agamemnon's sacrifice of his daughter paralleled God's sacrifice of his only son.

In the case of Iphigenia, tradition had it that Diana had, at the very last moment, substituted a hind. This is the moment depicted in illustrated editions of Ovid from Salomon onwards, with Iphigenia joining Diana in the safety of a cloud, while the hind burns on the sacrificial altar below. In Pietro Testa's engraving and painting of the subject, Iphigenia sits half naked, waiting to have her throat cut. The cloud is still there, though only to disguise the fact that Diana has a hind to take the girl's place (Fig. 96). Agamemnon covers his face (Testa, unlike the illustrators of Ovid, was mindful of Timanthes' example), but there are no other grieving men. In fact, apart from the little group on the left, Testa's composition is almost devoid of grief or sadness. The artist took his stoicism too seriously to indulge his own emotions or those of his viewers. And in any case, this composition is not about death so much as exchange. The urn that stands

96. Sacrifice of Iphigenia, Pietro Testa

to the right of Testa's print shows Diana and her nymphs hunting a deer, perhaps a reminder that Agamemnon had killed a deer sacred to Diana, and so Diana had demanded his daughter in return. A girl to take the place of the hind, who takes the place of the girl; as Racine implicitly acknowledged when in his *Iphigenia* it is another girl who dies in Iphigenia's stead, the two are interchangeable. Hence the care that Testa has taken to show that the deer is a real Bambi, as seductively innocent as Iphigenia herself.

Someone always has to die. In the classical sources, Diana is above all else the goddess of vengeance and death, the 'bloodthirsty goodess' as Euripides calls her. Like most of the Olympians, she is concerned primarily with sex and death, but, being a virgin, her only currency is death. The story of how she kept her virginity is told by Callimachus in his *Hymn to Artemis*. It is very rarely illustrated, but it is one of the series of Diana tapestries commissioned for the Château d'Anet by Diane de Poitiers around 1550. Callimachus pictures Diana as a little girl sitting on Jupiter's knee asking her father for her virginity, along with a new dress (knee-length, with an

embroidered border), toys (a bow and arrows), and new friends to play with (sixty nine-year-old daughters of Oceanus, plus twenty handmaidens). But in the tapestry, we are presented with a far more formal scene in which Diana, already an adult, kneels on the left and addresses her request not only to Jupiter but also to the other gods (Mercury, Juno, Minerva, and Mars) who have assembled to hear her plea. In the later version of the series, manufactured after designs by Toussaint Dubreuil at the end of the century, the setting has become more formal still, with Jupiter sitting in a portico of twisted Solomonic pillars, undulating like a forest of underwater plants.

Diana's renunciation of love was not considered to be merely a lifestyle decision. There was no such thing. Renunciation was opposition, and opposition was war. When Diana asked for chastity, she was in effect asking not to be free from lust, but to fight against it. (You can see the struggle in Perugino's *Battle of Love and Chastity*, painted for the *studiolo* of Isabella d'Este.) In a fragment from another of the tapestries in the French series, the battle has been won. *The Triumph of Diana* shows the goddess driving her victorious chariot followed by two captives: Venus tied hand and foot, and Cupid bound and blindfolded. But this Cupid was one of the lucky ones. A device the Florentine scholar and astrologer Gabriele Simeoni came up with during one of his three stays at the Château d'Anet showed Diana and Apollo shooting cupids out of the sky. The babies have not got a chance: slow, fat, and amorous (Fig. 97), they are no match for expert marksmen like Apollo and Diana. It is a turkey-shoot, a massacre.

In comparison, Francesco Albani's paintings of Diana disarming Cupid have real charm. The cycle of which they form a part is an artificial concoction that progresses from *Venus at the Forge of Vulcan*, to *The Toilet of Venus*, to *Venus and Adonis*, to *Diana's Nymphs Disarming Cupid*. Executed twice, once for Scipione Borghese and once for Ferdinando Gonzaga, the sequence offers a far less abstract portrayal of the conflict between love and chastity. The moral of the sequence is not difficult to follow. Vulcan was responsible for forging Cupid's arrows, one of which, according to Ovid, caused Venus's ill-fated passion for Adonis. In Marino's *L'Adone*, Adonis is presented as a follower of Diana, so when Diana disarms Cupid she is saving herself and everyone else from further loss. Seated in the clouds, the goddess leaves the task of disarming the sleeping cupids to her nymphs. Hovering over the infants, careful not to wake them, the nymphs gingerly divest the cupids of their weapons and clip their wings. The scene has a tenderness unusual in representations of Diana, and offers a rather more persuasive argument for the virtues of chastity than Perugino's psychomachy. Why not let the passions sleep uninjured in their landscape of dreams?

*

97. *Apollo and Diana Shooting Cupids*, from Gabriele Simeoni, *Illustratione de gli epitaffi*, 1558

Diana's motivation for chastity is often presented less as a desire to preserve innocence than as an attempt to specialize and refine other skills. According to the inscription on the tapestry for the Château d'Anet, Diana sought to preserve her chastity in order to devote herself to hunting. But the wildness against which she turned her bow was not just bestial, it was any 'unreasonable appetite'. And the desires she deemed unreasonable could involve anything that threatened to upset the social order. From the beginning, her story is all about making sure other people show proper respect and getting your own back if they do not. Diana's mother, a Titaness called Latona, knew the importance of this. Impregnated by Jupiter, Latona was prevented by Juno from finding anywhere to give birth until she arrived on the floating island of Delos. It is here that Diana Scultori's print (it is after Giulio Romano, but you cannot help noticing the engraver's name) shows her giving birth to her twins Apollo and Diana, sheltered only by an awning slung between two trees – undifferentiated in the print, a palm and an olive in legend. Yet this was only the beginning of her difficulties. She was now a single mother with nowhere to go, and she was at the end of her tether by the time she reached Lycia. Coming across a small lake, she stopped to refresh herself and her two hungry children. But the local peasants would not let her drink the water – and, just to make sure, they waded in to stir up the silt from the bottom. The scene was regularly depicted in illustrated editions of Ovid from Agostini's translation onwards, and from there

98. *Latona and the Peasants*, plate, Alfonso Patanazzi after Salomon

found its way onto pottery, notably that produced in Urbino. Unable to take any more, Latona prayed that her tormentors might live for ever in their precious water. Her request was instantly granted. We can see what happens on a late sixteenth-century plate from Urbino (Fig. 98). Some of the peasants are still on the bank, another stands thigh-deep in the water, sending muddy eddies swirling down to Latona, and two are already what the others will soon become – great frogs croaking their protests from the rushes.

Early Italian editions of Ovid piously claimed that Latona represented religion, Apollo wisdom and Diana chastity, and that the peasants were people who failed to support the religious with their charity. But it is hard to imagine this interpretation occurring to anyone eating off the plate on

which this scene was depicted. Indeed, despite the fact that the story is part of the sequence of divine punishments in Book 6 of the *Metamorphoses*, no one seems to have risked using it to make a serious point. At San Secondo, for example, the peasants do not appear among the mortals punished by the gods in the subsidiary scenes of the Sala dei Giganti, but on the ceiling of the Sala di Latona a few doors away. The subject only became common in the seventeenth century, when its comic potential was exploited. In painting, a new emphasis on the landscape setting develops alongside a tendency to show the peasants as village idiots. According to Sandys, these 'bawling Clownes' were a 'kind of halfe-sould men, as malitious as unmannerly', their clamouring 'an infallible signe of rusticity'.

Latona never abandoned her children and they repaid her care by protecting her reputation from the insults of Niobe. The whole story was depicted in Polidoro da Caravaggio's grisaille frescoes on the façade of the Palazzo Milesi in Rome, and later in Luca Cambiaso's cycle for the Palazzo Lercari-Parodi in Genoa. According to Ovid, the tragedy began when Manto, the daughter of Tiresias, proclaimed that the women of Thebes should go to the temple of Latona to worship the goddess and her children. Niobe objected, asking why anyone should worship the unseen goddess Latona when they could worship Niobe herself, a woman of nobler birth and the mother of more children.

In the *Metamorphoses*, the dispute is clearly confined to the realm of women, and concerns the respect that women give each other, a respect earned, at least in Niobe's mind, by fertility. But in Renaissance depictions of the scene, the most prominent devotees of Latona are men. The change can be partly explained by a failure of Italian translators to pick up the nuances of Ovid's vocabulary, but the sheer unfamiliarity of women's cults is surely another factor. In Polidoro's fresco Manto appears holding her prophetic books and illuminating the way to the shrine of Latona, but it is her father Tiresias (who plays no part in the classical versions of the story) who presides over the goddess's statue. In Cambiaso's version, Manto disappears entirely, and Tiresias himself points a group of male Thebans to the temple.

The effect of this transposition is that it makes Niobe's attempt to take the place of Latona in the eyes of women into an attempt by a woman to make herself the object of male veneration. For Alciati, Niobe symbolized the 'feminine vice' of *superbia*,[6] and Cambiaso shows Niobe standing in the temple portico with two of her daughters addressing a group of men, an imposing figure, silencing their protests with a regal wave of the hand. For

most commentators, however, Niobe's pride is not so much a pride in herself or her children as pride in her status and wealth (for which children are an emotive metaphor). The inscription on the tapestry of *The Blasphemy of Niobe* at the Château d'Anet calls it 'pride in the goods that God has given'. If the story of Latona illustrates the stupid meanness of the poor, the story of Niobe is about the vulgar presumption of the rich.

Affronted by Niobe's impiety, Latona turns to her children, now grown up and, in Polidoro's fresco, slouched like bored teenagers on Mount Cynthus. They respond with delinquent alacrity. Niobe's seven sons exercise their horses on a flat plain outside the city walls. In Cambiaso's cycle an entire painting is devoted to showing them riding out through the gates of the city, young bloods with plumed helmets on eager, prancing mounts. But Apollo and Diana are waiting for them, unseen in the clouds. According to Ovid, Apollo killed the sons, and Diana killed the daughters as they mourned their brothers. This posed a problem for artists who had to show the deaths of all the children at once, and none manages to convey the sheer relentlessness of the slaughter that ultimately makes Ovid's version affecting. Niobe, who had once boasted of her abundance, is eventually reduced to pleading for the life of her last remaining daughter. Ovid emphasizes the depletion of her family by repeating the number: 'one . . . just one'. Only Polidoro's frieze gives any sense of the sequence of loss (Fig. 99). We can count them down, from the sons slumped over their horses, to the youngest daughter, her head buried in her mother's lap. But where Apollo felt a twinge of pity after he had released the arrow that killed the last of Niobe's sons, Niobe's entreaties produce no corresponding emotion in Diana. Niobe's youngest daughter dies in her arms.

It is too much. Numbed by grief, Niobe turns to stone. Donne's epigram puts it well: 'By children's births, and death, I am become / So dry, that I am now mine own sad tomb.' In the visual arts, this metamorphosis is almost never depicted. For the artist, driven by the ambition to bring inanimate materials to life, the transformation went in the wrong direction. Curiously, the one real attempt to represent it is found in Holbein's marginal illustrations to Erasmus's *Praise of Folly*.[7] A passing mention by Erasmus (who claimed that some theologians were so lost in wonder at the complexities of scholastic arguments that they might have turned to stone) and the brief gloss in the commentary were all the artist had to go on. Unaware of the whole story, he shows Apollo shooting a couple of naked infants from a cloud while their mother's legs disappear into stone. Here, Niobe becomes a herm, like the Priapus to whom Erasmus alludes in the same sentence. And so although the commentary notes that for the Greeks

the sufferings of Niobe were proverbial, the image is decidedly comic.

In the mythological programme designed by Etienne Jodelle for the reception of the French king eight weeks after the taking of Calais in 1558, a painting of the slaughter of the children of Niobe was used to illustrate the humbling of English pride.[8] Alternatively, the arrows that killed the Niobids could signify the plague, and this was also the explanation offered by Sandys for the death of Chione. According to Ovid, Chione, the daughter of Daedalion, was so beautiful that she had a thousand suitors at the age of fourteen.[9] But Mercury and then Apollo got in before them and Chione simultaneously bore two sons to the two divine fathers. This did not strike early modern readers as impossible (Sandys cites the case of a Dutch woman in Southwark) but the story nevertheless barely makes it out of the pages of the *Metamorphoses*. Illustrators from Salomon onwards contrived to show every phase of the narrative in a single print, which was awkward since the story went through several twists. Having borne children to two of the gods, Chione thought that she must be more beautiful than Diana, but the goddess was no more willing to put up with this than she had been with Niobe's blasphemy of her mother: she shot Chione fatally in the mouth, straight through the

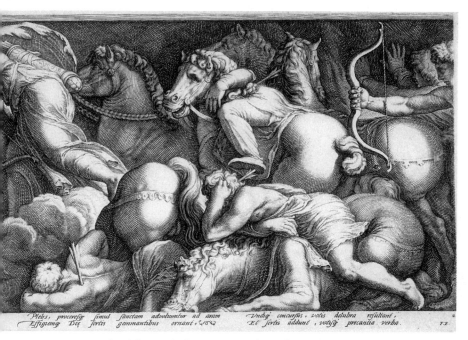

*Plebs, proceresᵹ simul sanctam advoluuntur ad aram
Effigiemᵹ Dei sortis gemmantibus ornant.*

*Undiᵹ concursus, votis delubra resultant,
Et sortis addunt, votisᵹ precantia verba.*

99. *Death of the Niobids*, Jan Saenredam after Polidoro da Caravaggio

tongue. Daedalion was so maddened by grief that he tried to rush into his daughter's burning pyre; driven back by the flames he just ran, and kept on running until he ran off the top of Mount Parnassus and became a hawk.

Chione did not feature in the original series of Diana tapestries for the Château d'Anet, perhaps because she shows the goddess in such an unforgiving light. But if Diana punished those who boasted of their beauty or fertility, she came to the aid of those who sought to preserve their virginity. Even men could benefit. Hippolytus, Theseus's son, rejected the advances of his stepmother Phaedra, who told Theseus that Hippolytus had tried to rape her. Theseus believed her, and in punishment Neptune (Theseus's father) sent a monstrous bull to frighten Hippolytus's horses as he drove his chariot by the sea. The crash in which Hippolytus died is depicted a few times in the early seventeenth century, notably in a dramatic painting by Rubens (which follows the description in Philostratus), but otherwise it never establishes itself as an artistic subject beyond the pages of Ovid.[10] Diana took pity on the chaste Hippolytus, revived him with the help of one of Aesculapius's herbal remedies, and took him off to safety in Italy.

The goddess intervened earlier in the case of Arethusa, a nymph who took no pride in her beauty.[11] Tired after hunting, she took off her clothes and slipped into the clear waters of the river Alpheus. Nakedness glimpsed through the water excited the ancients (Nonnos is full of such scenes) and the river-god cannot resist. Hearing him murmur, Arethusa starts to run, and the river-god gives chase. As she tires, Arethusa calls out to Diana for help. This is the moment depicted in illustrations to Ovid after Salomon, where Diana is shown lodged in the fork of the branching cloud of mist with which she shrouds Arethusa from her pursuer. In earlier works, Diana is given a less central role. The subject was particularly popular for Italian maiolica in the first half of the sixteenth century, and whether decorating salt-cellars, candlesticks, or plates, these paintings usually show Arethusa fully enclosed within a circle of cloud. As Alpheus prowls around the cloud, Arethusa begins to dissolve into water. Following Salomon, illustrated editions of Ovid show water springing up from her feet as she runs, but in maiolica only Baldassare Manara's painted dish of 1544 manages to convey the whole story. One of Arethusa's feet melts into an eddy of water, which then trickles down to join a larger stream that flows from the river-god himself. According to Virgil, Alpheus's waters mingled with those of Arethusa in the sea at Ortygia in Sicily.[12]

The story of Alpheus and Arethusa would have been an obvious subject for anyone who wanted to show Diana in a sympathetic fashion, but Diane de Poitiers's iconographical adviser disregarded Ovid's tale in favour of another subject from Callimachus, a far more obscure Greek text that had yet to be translated into the vernacular. Britomartis, who gave her name to one of Spenser's plucky heroines, was a Cretan goddess. According to Callimachus's *Hymn to Artemis*, Minos was so obsessed with her that he stalked her through the meadows, woods and clifftops of Crete for nine months. Finding herself cornered, Britomartis jumped into the sea. Callimachus and most other classical sources claim that she was saved by being caught in a fishing-net, and so acquired the name Dictynna ('she of the net'), but the tapestry tells a different story (Fig. 100). As the inscription makes clear, the fishing-net serves not to save her, but merely to haul her lifeless body out of the water. The motivation for this change is obscure. The tapestry enhances the role of Diana in the story by making her the inventor of the net: at the top of the design, she is seen handing it over to the fishermen. But it would obviously be more to Diana's credit if she had saved Britomartis through her invention, rather than (as the inscription claims) merely ensured her fame by retrieving the body and taking it to a holy place.

*

100. *Death of Britomartis*, tapestry, probably after Jean Cousin the Elder

It was not only virgins who benefited from Diana's protection. Cephalus and Procris were a pair of newlyweds repeatedly driven apart by their mutual jealousy. When Cephalus accused Procris of betraying him she was so upset that she ran away to the mountains to join Diana and the nymphs – an episode elaborated in Niccolò da Correggio's play *Cefalo*, and in Bernardino Luini's cycle for the Casa Rabbia in Milan executed around 1520.[13] Eventually the couple were reconciled, and Procris gave Cephalus the two gifts she had received from Diana when she joined her band of hunters – a javelin, and the hound Laelaps. According to Orologi, Diana's gifts signified marital virtues, the dog fidelity and the javelin the defeat of deceitful lust, which is perhaps why Claude shows Diana reuniting the couple in his landscapes on the theme. There was not to be a happy ending. Cephalus killed Procris by mistake when, motivated by groundless jealousy, she followed him on a hunting trip.

Something similar had once happened to Diana herself when she killed Orion. There are many versions of his death: some said he offended her by challenging her to a discus-throwing contest; others that he tried to touch her clothes. But in only one account is his death said to have been unintentional.[14] In the *Poetica astronomica*, Hyginus says that Orion loved Diana and that they nearly married.[15] Apollo was against it and frequently reproached his sister for spending time with the giant. Eventually Apollo saw his chance. Orion was swimming out at sea, his head just a dark blob on the water. Could Diana hit that target with one of her arrows? She rose to the challenge and unwittingly shot her lover through the head. Orion's body was washed ashore. At last, Diana realized what she had done; grief-stricken, she pleads with Jupiter to place Orion among the stars.

Becoming a constellation was not a bad end for someone who was conceived from the urine (or according to some versions, the semen) of Neptune that Jupiter and (versions differ here) Mercury or Apollo had sprayed onto an ox-hide. Unsurprisingly, it was only the eccentric Salvator Rosa who ventured to illustrate this unusual birth, described in Ovid's *Fasti*, in which Orion is born from the hide on which he was conceived.[16] But it was also referred to in Francesco Melosio's libretto for Cavalli's *Orione* (1653), a work of which the musical Rosa may at least have been aware. Poussin also developed an interest in the story at around the same time. His *Landscape with Orion* draws on Conti's view that Orion's birth indicated the presence of semen in all the elements, and that the giant's search for the rising sun was an allegory of this material commonality.[17] The painting therefore shows the transmutation of water by the sun and the wind into the storm clouds that are blown along the same path as the giant himself.

Diana, leaning nonchalantly on a cloud above, waits for him. This too comes from Conti, who interprets the story that Orion was killed by Diana as the influence of the moon on the formation of rain clouds. But Poussin's version of the natural allegory is not the first: in G. B. Fontana's print of Diana chasing Orion, Orion's hair vaporizes into cloud as he runs.

Another of the goddess's would-be suitors was Otus, a giant who, along with his brother Ephialtes, tried to rape Diana. She escaped their unwelcome attentions by running between the two of them in the form of a hind.[18] Both tried to spear the creature at the same moment and each killed the other instead. It was a subject added to the second series of Diana tapestries woven after Dubreuil. Here, the goddess has not yet changed her form, although one of the giants already has his javelin to hand. The subject is unusual (though it also crops up in Pordenone's paintings for the Palazzo Tinghi in Udine), and although the series of tapestries after Dubreuil proved to be very popular, this particular story did not catch on.

Even the subjects in the original Diana series (which included *Latona and the Lycian Peasants, Diana Asking Jupiter for her Virginity, The Death of Orion, The Sacrifice of Iphigenia, The Drowning of Britomartis, The Triumph of Diana, The Death of Meleager*, and *The Blasphemy of Niobe*) were occasionally unpredictable and obscure. Prints by Etienne Delaune inspired by the designs for the tapestries show that, without the inscriptions, people could not always work out what was meant to be happening: his rendering of Britomartis shows Diana herself jumping into the net and drowning, while his prints of the death of Orion try to make more sense of things by having Apollo, rather than Diana, shoot her lover.

Eclectic though the sources were, the tapestries were clearly designed to emphasize the goddess's capacity to intervene in events, to save and to punish, rather than to make her the protagonist in every scene. They were a celebration of power rather than visibility. This reflects the classical tradition in which Diana is the goddess of forests and the night, untouchable and elusive, but it may also be a function of Diane de Poitiers's role in the French court. The chief mistress of Henry II, Diane was a widow, more than twenty years older than the young king.[19] Her name linked her with the goddess, and allowed her widowhood to be interpreted as a virginity, and her (childless) relationship with the king to be mythologized as that of the divine siblings, Diana and Apollo. The subjects chosen for the tapestries are therefore those which emphasize either the partnership between two gods, or the independent authority of Diana. Notable by their absence are the two most commonly illustrated episodes in Diana's mythology, the stories of

Actaeon and Callisto. In both of these, Diana is shown with her nymphs – vulnerable to the male gaze, and just one among a bevy of bathing beauties. In so far as the iconography of Diane de Poitiers marginalizes these scenes (Diana and Actaeon appear only once in the château, painted over a door; Callisto not at all), it may be because she sought to emphasize her independence from her rivals (she was not the king's only mistress) and to define her allure in other terms.

Although Diana had played a minor role in royal iconography earlier in the century, the development of this personal mythology was, in part, fortuitous. The rebuilding of the Château de Fontainebleau, begun by Henry II's father Francis I, had introduced the nymphs of the local spring into royal iconography. There was a painting of Francis I and his entourage surprising the nymphs bathing, and a print, based on a drawing by Rosso, of the mythical discovery of the spring by a hound called Bleau, where the nymph of the spring was shown in a pose derived from Primaticcio's *Danaë*. Benvenuto Cellini completed a bronze relief as a lunette for the Porte Dorée showing the nymph of the spring embracing a stag (one of Francis's emblems) and accompanied by other animals (boars, deer, and hunting dogs) which, he explained, were just what you would expect to find in the forest around Fontainebleau.[20] Ten years later, the relief was moved and incorporated into the entrance portal at the Château d'Anet, where the figure was re-identified as Diana. This appropriation of a pre-existing visual image may have originated with Henry and Diane themselves: they must have seen the relief at Fontainebleau (where Diane had an apartment below that of the queen) and then perhaps invested it with a new meaning to which they sought to give expression at the Château d'Anet. Rarely can the symbolism of two lovers have had such an impact on the development of iconography. A statue of Diana and a stag, indebted to both Cellini's relief and Rosso's design, but with the woman now clearly identified as the goddess, was commissioned for a fountain at the château. Probably executed by the studio of Jean Goujon, the pose celebrates not the royal ownership of a particular place, but the love of Diana/Diane for her stag, the king. Both lovers seem to have identified with their roles. Diane, a middle-aged mother and widow, was portrayed as Diana the divine huntress, a youthful nude, striding purposefully through the landscape, her dog bounding along beside her (Fig. 101). Henry took to singing the forty-second psalm ('As pants the hart . . .') on hunting expeditions, and it is inscribed on the cartouche of the version of the portrait of Diane as Diana in the Spencer collection.

As an erotic strategy, Diane's remaking of herself as Diana was enormously

101. *Diana Huntress*, Fontainebleau School

successful. She kept the king's affection; the poets celebrated 'le Paradis d'Anet' in verse, and her iconography outlived her. At the same time as she divinized herself, Diane also humanized the bloodthirsty goddess. A new adjective was used to describe her: *alma*, meaning kindly, or nourishing. In classical Latin the word was routinely applied to Venus or Ceres, and it is used only once by Virgil to describe Diana's uncharacteristic kindness in reviving Hippolytus.[21] But at the Château d'Anet it appears on the inscription at the gate, and it is repeated in one of Simeoni's verses.[22] Diane's Diana is a softer, more Venusian deity than her classical models. Yet at the same time she became associated with a non-Venusian body-type based on the mannerist female nude rather than antique statues. Tall, gamine, and unselfconsciously exhibitionist, this image of the goddess became fixed in the erotic imaginary and survived to become the ideal of late twentieth-century femininity, its most famous exemplar another *alma* Diana: Diana, Princess of Wales, named after the Diana in the Spencer collection.

Of course, Diana did not have to look anything like this. Rembrandt, literal-minded as ever, dressed up the stumpiest of his models with a spear and a quiver of arrows, and called the resulting drawing *Diana*. A woman who lived out in the woods and devoted herself to hunting probably was not going to be anything like the elegant nymph of Fontainebleau. But for once, our image of a mythological figure is informed by the way women wanted her to look, for the influence of female patronage on the iconography of Diana is significant. Following Diane de Poitiers, other French royal consorts identified themselves with Diana, and Marie de' Medici was portrayed as Diana and Henry IV as Mars in the Galerie de Diane at Fontainebleau. From here, the fashion spread elsewhere. Amalia van Solms, the wife of Frederik Hendrik of Orange, was sometimes portrayed as Diana, and Marie's daughter Henrietta Maria took the identity with her when she married Charles I of England. Honthorst was the most accomplished painter of these Dianas of the northern courts, and in the case of Charles I's niece, Elizabeth of the Palatine, it is tempting to think that his portrait of her may have helped to form her sense of self. Only thirteen when she was painted as Diana, Elizabeth eschewed marriage, and later became the correspondent of Descartes and William Penn.

Princess Elizabeth ended up as the abbess of a Protestant convent, which was only appropriate given the analogy between Diana, the chaste mistress of the forest nymphs, and an abbess who chastely governed the nuns in her care. The idea goes back to the Middle Ages. Dante's son refers to it in his commentary on the *Divina Commedia*, and in Le Fèvre's version of the

Callisto myth, Diana is the abbess of the convent where Callisto hides from the attentions of Jupiter.[23] So when Giovanna da Piacenza, the abbess of the Convent of San Paolo in Parma, commissioned Correggio to decorate a room in her private apartments, it was natural that she too should be celebrated as Diana. For Giovanna, who fought a long battle with the ecclesiastical authorities to maintain the independence of her house, the goddess's resolute intolerance of male interference must have had a particular resonance. Diana appears above the fireplace in the Camera di San Paolo, and although the figure is derived from Diana's identification with the moon-goddess Luna (who, like Apollo, was depicted in ancient art driving a chariot) and probably comes from an Endymion sarcophagus, the room as a whole celebrates Diana as the mistress of a world of overwhelmingly female virtues (seen in the lunettes) and the leader of the hunt (depicted in the oval openings of the ceiling).

The significance of some of the lunettes, mostly based on antique coins, remains obscure, but the predominance of the imagery of Diana and the hunt is clear, and is confirmed by Parmigianino's adaptation of both the theme and the structure of the frescoes for the decoration of a room at the castle of Fontanellato a few years later. Here, however, the iconography relates to the story of Actaeon, the hunter who came across Diana and her nymphs bathing in the nude, was changed into a stag, and was devoured by his own hounds. It was a good story for someone to ponder in the bath, and the room at Fontanellato may have had this function. If so, a bather would have been able to look up at the mirror on the ceiling and contemplate the inscription that surrounded it: *Respice finem*, 'Contemplate the end.' The motto had a particular significance for the Actaeon frescoes, for Ovid introduces the story by noting that no one can count themselves happy until the end of life. Cadmus, Actaeon's grandfather, might have been thought a happy man blessed with healthy descendants, but his daughter Semele was killed by Jupiter's thunderbolt, and of his grandsons, Actaeon was killed by his own dogs and Pentheus by his female relatives. Lying in the bath looking at the frescoes on the ceiling, you might be tempted to amuse yourself by thinking about what might happen if someone peeped round the door, but the inscription surrounding the mirror stands as a warning against too much day-dreaming: who knows if Actaeon's fate might not foreshadow your own end as well?

Ovid described in unusual detail the scene that met Actaeon's eyes. It is midday. In a little valley wooded with pine and cypress, guarded by a natural arch in the tufa, is a spring and a little pool where Diana is preparing for

her bath. Only Frans Floris bothers to show the royal treatment that Diana receives from the nymphs: on the left, a nymph takes away her weapons, while another divests her of her robe, and a third kneels to untie her sandals. Behind the goddess a nymph, identified by Ovid as a Theban named Crocale, deftly puts up the goddess's hair; and on the right another brings a bowl of water. In Ovid's text, all these activities are enumerated with the same care that the nymphs bestow upon their queen. But artists almost never bother with them. It is not just laziness. All this activity, which in the text serves to build up the suspense and fetishize the unseen body of the goddess, detracts from the drama of the main event in the painting. Artists had no need of such devices to arouse interest in Diana's body; they could freely show the viewer what Actaeon had died for seeing.

It was doubtless this that made the subject one of the most popular of all subjects from Ovid. The painter who made fullest use of the opportunities the story presented was probably Cranach. In the Hartford version of *Diana and Actaeon* (Plate XIV) he manages to get in seven nymphs each in a different glamour pose, while Actaeon sits beside the pool half-undressed. He has already been transformed into a stag and is being bitten by the hounds, but the show is still too good to miss. Cranach was unusual in depicting Actaeon's metamorphosis so far advanced. In most representations of the scene he appears with only a stag's head and sometimes no more than antlers. And although some Italian maiolica makes Actaeon's approach appear blunderingly direct and even has him pointing to the nymphs, in many representations he inclines forward slightly with one arm graciously outstretched as though attempting to effect a courteous introduction. The vast majority of these images are light-hearted and playful. With a stag's head, Actaeon usually seems a comic rather than a threatening figure; the token efforts the nymphs make to conceal themselves from his gaze suggest that they may be rather pleased to have an onlooker, and Diana's action in splashing him with water seems to portend nothing more sinister than the start of a water fight. In Jean Mignon's engraving (later turned into a chimney-piece at Château d'Ecouen) Diana and the nymphs are bathing in an elaborately ornamented fountain, but the humour (the pool is fed by a urinating putto – whose aim, in some other treatments of the scene, is a little erratic) is much the same. 'Know your master', the inscription says. It is what Actaeon tries to tell his dogs when they tear him apart, but here it seems to be addressed to the nymphs who have failed to recognize their master in his wacky disguise.

The Actaeon fountains of mid-sixteenth-century Germany also exploit the centrality of water in the story, but according to Ovid, Diana used

water to defend herself only because she did not have her arrows to hand. Nevertheless, the effects were just as dramatic, because the action of the water started the metamorphosis. It was difficult to portray this lethal chemistry in visual terms, and showing Diana splashing water meant that (even if you wanted to) you could not simultaneously show the nymphs trying to protect her from Actaeon's prying eyes. Domenichino is one of the few artists to depict the nymphs taking the practical step of using a sheet to block Actaeon's view – the painting is paired with the sacrifice of Iphigenia, where Agamemnon uses his robe to similar effect.

Early Venetian illustrations of Ovid omit Diana's response and therefore show Actaeon as still fully human. The effect of this, combined with the fact that in Venice, as in the North, artists tended to show the nymphs bathing in a naturalistic setting rather than the artificial fountain, is to change the mood of the image. An armed man has stumbled across some women bathing naked in the woods, and it is uncertain what will happen next. Diodorus claimed that Actaeon had tried to make love to Diana. Out in the woods, anything can happen.

In England, Philip II of Spain's unsuccessful attempts to woo the Virgin Queen were likened to those of Actaeon, but there is no connection between this and Titian's famous painting of *Diana and Actaeon* painted for the king as one of the *poesie* (Fig. 102). Titian retains some of the openness of the Venetian illustrators, although here Actaeon's dramatic gesture as the red drapery is pulled aside conveys the suddenness of a revelation. But for a viewer accustomed to the depiction of naked nymphs and goddesses, how can the sight that meets Actaeon's eyes be surprising, let alone shocking? And how, when the nude potentially carries a multitude of meanings, can nudity be made to signify itself? Titian's solution is to make the unveiling of the scene a metaphor for the uncovering of the bodies, and to transfer the alien quality of the women's bodies to their setting. Beneath a ruined vault is a circular fountain that lists alarmingly to one side. What Actaeon sees is not the goddess, *fera bella et cruda* (as Petrarch had put it), but a world that is just as wild and beautiful and untouched as she is.[24] On top of the pillar, immediately facing Actaeon, is a stag's skull, Diana's proleptic trophy. It is a revelation, all right: for the flesh beneath the drapery, Titian has substituted the skull beneath the skin.

If Titian's painting is memorable because it aligns the viewer's experience with that of Actaeon, Rembrandt's late drawing of the same subject is unusual in showing the event from the perspective of the nymphs (Fig. 103). Iconographically the composition makes no sense, for Actaeon has a stag's head only after being splashed. Yet here he stands well clear of the water, a

102. *Diana and Actaeon*, Titian

Minotaur trapping the nymphs in their cave. His pose comes from a print by Tempesta, but silhouetted against the sky Actaeon's outstretched arm now serves to block off the entrance to the pool. The only precedent for this composition is an engraving after Paolo Fiammingo, but his Actaeon is just a lost boy compared with Rembrandt's. For once, we share the nymphs' alarm. It does not last. Although we do not notice at first, our viewpoint is also that of the hound on the right. She too is seeing Actaeon in a new and unexpected light. Actaeon's metamorphosis is here effected not through depicting changes in the hunter himself, but through the changing perspective of the viewer as it shifts from a nymph's eye view of a monster to the hound's eye view of its quarry. Behind Actaeon another dog circles, cutting off his escape.

In aligning the perspective of the women and the hounds Rembrandt was unconsciously restating an ancient conjecture. The parallels between

103. *Diana and Actaeon*, Rembrandt

Actaeon and his cousin Pentheus, torn apart by the maenads on whom he spied, had long been noted. Euripides claimed they both died on the same spot;[25] Conti suggested that there was a second Actaeon who was torn apart by Bacchantes, and Bacon paired Actaeon and Pentheus as examples of those whose curiosity was their downfall.[26] But this was by no means the only possible interpretation. The allegorizers had worked over-time on the Actaeon story.[27] Bersuire had all sorts of explanations: Diana was avarice washing in the fountain of prosperity, and Actaeon a usurer who preyed on others and then became rich and proud like a stag before succumbing to the hounds of the envious; or else perhaps Diana was the Virgin Mary and Actaeon the Son of God who became man (a stag) and was devoured by the Jews (the hounds); or maybe Diana was Fortuna, and Actaeon a rich man consumed by hangers-on, beggars, or, as Alciati later suggests, cut-throats.[28] For Dolce, Actaeon was a guilty man hounded by his conscience. Giordano Bruno developed the theme more positively: Actaeon is prey to his own thoughts because he has internalized the object of his quest; the hunter becomes the hunted because the kingdom of God is within us.[29]

Most people took the story far more literally. According to Palaephatus and Fulgentius, Actaeon was a hunter who gave up hunting but allowed his dogs to use up all his resources.[30] In consequence, Giovanni del Virgilio suggested, he became retiring and proud, and refrained from socializing

with rich people who might consider him a mere beast. Regius shifted the emphasis slightly, and said that it was actually because Actaeon was so obsessed with hunting that his hounds ate him out of house and home. This sort of euhemerist explanation was also a practical allegory, and at a time when many princes spent extraordinary sums on the hunt it had an obvious contemporary relevance. Versions of it are repeated by almost everyone, and so if viewers drew any moral from the story, this was probably the first that came to mind.

The curious thing about this interpretation is that it short-circuits the narrative by making the significance of Actaeon's death quite independent of his offence in seeing Diana. In this regard it helped make sense of a problem that had been discussed since antiquity. Was Diana right to inflict so terrible a punishment for what had been an unintentional mistake? Some authors tried to find a better explanation: Euripides claimed that Actaeon had boasted of being a better hunter; Lucian that Actaeon had seen that Diana was deformed; Diodorus that he tried to rape her; Nonnos has him engaging in prolonged voyeurism from the safety of a tree.[31] Alternatively, you could come straight out with it and say that Diana had been too harsh. In the Metamorphoses Ovid noted that some thought the goddess more cruel than just, and in the Tristia he identified his own undeserved exile with Actaeon's punishment – a reference that led Giovanni del Virgilio to speculate that he might have been exiled for seeing the empress in the nude.[32] The comparison with Tiresias, merely blinded for seeing Minerva naked, had been made by Callimachus and Nonnos, and was known early in the Renaissance through Poliziano.[33] Perhaps Diana was being unfair. The inscription at Fontanellato spells it out: Diana's anger was simply inappropriate.

Ovid actually devotes far more space to Actaeon's metamorphosis and death than he does to his discovery of Diana. He gives the Greek names of the hounds – names that echo with the cries of animals hunted centuries earlier. To most Renaissance readers they would have signified nothing. Latin commentaries explained what they meant, but the first translator to give all the names in the vernacular was Aneau: Morpelu, Dyamant, and Montaignard are the three who get ahead of the pack and bring Actaeon down. Naming them made a difference: Aneau was reminded of Brutus, Cassius, and Casca, who had turned against Julius Caesar and had assassinated him. There is no visual equivalent to this. In most representations of the subject, Actaeon's death takes second place and is either shown in the background of the main scene or suggested by the dogs gathering around him at the fountain. Titian, for whom all dogs were individuals, is one of the few to remember that three of the hounds got there before the others.

Later than his *Diana and Actaeon*, but probably begun as one of the *poesie* for Philip II, Titian's *Death of Actaeon* shows the end of the story in terms of the elements omitted from the earlier scene. Diana had used water to turn Actaeon into a stag only because her arrows were not to hand. Here her weapons are restored to her, and so we should probably assume that the arrow has the same effect as the splash of water – not causing Actaeon's death directly, but rather the metamorphosis which, as the painting shows, is only just beginning. One explanation for the dogs' behaviour was that they all had rabies,[34] but there are no foaming jaws here. Diana does not make the dogs attack their master: she transforms him and instinct does the rest.

In this respect, Rubens's oil sketch of the *Death of Actaeon* is closer to Ovid. Although Diana and the nymphs can be seen in the background, and Diana indicates the scene of Actaeon's death with an imperious gesture derived from Titian's *Diana and Callisto*, Rubens allows the drama to be played out in its own terms. The painting was one of the series for Philip IV's hunting lodge, the Torre de la Parada, and was similar to other paintings of Diana and nymphs hunting deer. Here, the challenge is not how to make the human Actaeon convincingly stag-like, but how to give this deer brought down by dogs a pathos that the others lack. If it is there, it is in the turn of the stag's head, the backward glance to the seven women whose vengeance is enacted by the seven hounds. But there is nothing to match Ovid's account of Actaeon's stream of consciousness as the dogs chase and devour him. Actaeon longs to see and not to feel what is happening to him, but the viewer only sees.

To see and not to be seen – it is a recurrent theme in stories about Diana, and nowhere more than in the story of Callisto. According to Ovid, it all began when Jupiter looked down from heaven and caught sight of her. She was Diana's favourite, and so she was not surprised to wake up from a nap in the woods to find the goddess leaning over her solicitously. This is the moment depicted in Rubens's painting in Kassel; not a lesbian love scene, but the prelude to a particularly nasty heterosexual rape. Callisto's gaze is already wary; there is something sinister about the way Diana's hands are lingering around her neck. As the presence of Jupiter's eagle reveals, this is not Diana at all. The rape itself is shown in the background in the first of the series of prints executed after designs by Goltzius. Callisto puts up a real fight, but to no avail.

The classical sources make no connection between the stories of Actaeon and Callisto, but the way in which both are illustrated in early Venetian

editions of Ovid (with Jupiter and Callisto, or Actaeon, in a wooded area to the left, and Diana and the nymphs bathing in the centre) may have suggested a link. Nevertheless Titian's pairing of *Diana and Actaeon* with *Diana and Callisto* was unusual. The painting shows the moment, nine months after the rape, when Callisto's secret is revealed. Diana and the nymphs are bathing in a stream, and Callisto alone refuses to undress. The other nymphs strip her and discover the truth: Callisto is pregnant. Diana is appalled and banishes her from their company. Titian's painting was influential, and this scene became the most commonly depicted episode in Callisto's story, despite the fact that it was frequently absent from illustrated editions of Ovid produced outside Venice. The pairing with Actaeon also proved attractive: Tempesta produced a pair of prints which juxtaposed the two myths in terms largely independent of Titian's example, and Rembrandt fused the two in a single painting in which Actaeon and Callisto are shown on two sides of a single pool. Rembrandt's Callisto is stripped in an extraordinary scrum, but his painting still lacks the drama of Titian's pendants. The effectiveness of Titian's pairing derives not so much from the continuities between the two paintings as from their thematic complementarity. The goddess discovered uncovers Callisto, and her embarrassment is assuaged by Callisto's shame. The one constant is the power of sight, the capacity of the unreciprocated gaze to make one squirm. None of Titian's protagonists return the viewer's look; heavily reworked but more loosely painted than his earlier pictures, the surfaces themselves seem to shift uncomfortably before the viewer's eyes. And yet, as Vasari noted, it is this embarrassed movement that makes them seem alive.

Callisto gave birth to a son, Arcas. For Juno, who may be the richly attired woman in Titian's painting of Diana and Callisto, this was the final straw. She caught Callisto by the hair and threw her to the ground, turning her into a bear to spoil her beauty. The scene is frequently shown in illustrated editions of Ovid, where Callisto, sometimes still with a human head, is shown as a furry figure on all fours meekly receiving a drubbing from Juno. She found her new life difficult: a rather timid creature, she felt unable to mix with the other bears, never took to life in the woods and remained petrified of wild animals, forgetting that she might be taken for one herself. It nearly cost her her life. One day she recognised Arcas, who had grown up and was out hunting. She approached him and tried to speak, but she could only growl. Her son was just about to kill her when Jupiter finally took pity on them both and turned them into constellations. Callisto became the Great Bear. Released at last from her torments, she flies through the heavens in Peruzzi's fresco on the ceiling of the Villa Farnesina. But even

104. *Elizabeth I in Diana and Callisto*, Pieter van der Heyden after Titian

here she is not free of Juno's jealousy. According to Ovid, Juno was outraged by Callisto's elevation and persuaded her foster parents Ocean and Tethys to prevent the Great Bear from setting in the sea, a scene depicted with great panache in the last of the Callisto prints after Goltzius.

The story of Actaeon is generally more common than that of Callisto, though the latter is popular in early seventeenth-century Dutch and Flemish painting. (Goltzius's illustrations to Ovid, which covered the story of Callisto quite well, had stopped just before they reached Actaeon.) Compared with Actaeon, however, Callisto gets little sympathy. Renaissance authors found it difficult to believe that Callisto was not in some way to blame for her own misfortunes – was not a fallen woman a bit like a she-bear anyway? The fact that Callisto was not synonymous with injured innocence is graphically illustrated by Pieter van der Heyden's engraving which shows Elizabeth I as Diana and the pope as Callisto incubating a brood of monsters (Fig. 104). The composition is borrowed from Titian, but the nymphs behind Diana here represent the Dutch provinces, while the figures uncovering the pope's swollen belly are now the allegorical figures of Time and Truth. Designed

to encourage English participation in the Dutch war, the print failed to achieve its purpose.

Van der Heyden's attempt to cast the English queen in the role of Diana was, of course, far from original. But although literary references to Elizabeth as Diana became increasingly elaborate towards the end of her reign, the visual iconography of the Virgin Queen was never as fully developed. There were several reasons for this. Not only were there competing iconographies, showing the queen as Minerva, or Virgo/Astraea, but (at least early in the reign) comparisons with Diana were suppressed in order to emphasize the queen's continuing marriageability. Jewelled crescent moons appear in Elizabeth's hair in Hilliard's miniatures of the 1590s; there is a crescent moon atop the headdress in the 'Rainbow portrait', and a few paintings of Diana which may refer to the queen. Unlike Diane de Poitiers and Giovanna da Piacenza, Elizabeth does not appear to have identified personally with the goddess, and her cautious, penny-pinching patronage did little to develop this iconography.

In so far as Elizabeth was identified with Diana, it was more on the basis of lunar imagery, and Diana's ancient identification with the moon-goddess Selene, than on her role as goddess of the hunt. One reason for this is that, unlike the earthly Diana, the moon-goddess was open to love. She was, for example, even said to have responded to the wooing of Pan. The classical source for this unlikely coupling was one of Virgil's *Georgics* which claims that Pan managed to lure Diana into the woods with a gift of snow-white wool.[35] The tale was slow to find its way into the visual repertoire, but it appears twice among Taddeo Zuccaro's frescoes in the Villa Farnese at Caprarola. In the Stanza dell'Aurora, looking for two loves of Luna to match those of Aurora, shown in the lunettes of the adjacent wall, Annibale Caro chose Pan and Endymion, whom both Boccaccio and Cartari had paired as lovers of Luna. So Pan is shown bent on one knee holding out some fleecy wool and looking up imploringly. A canny as well as a humble supplicant, he keeps some back: if she wants more she will have to come and get it. In the Stanza dei Lanefici, a room devoted to mythologies relating to wool, the subject reappears, with Pan leading Diana towards two baskets of wool. Probus's commentary on Virgil had suggested that Pan deceived Diana by offering her a choice between two parts of his flock – one of which looked whiter, but was actually inferior.[36] In the context of a room devoted to the iconography of wool this type of deception was more relevant than the amorous deceit depicted in the Stanza dell'Aurora. But the woods lie in the same direction.

A drawing by Annibale Carracci, now at Chatsworth, shows that he had Zuccaro's composition for the Stanza dell'Aurora in mind when working up ideas for the Galleria Farnese in Rome (Fig. 17, p. 55). The final painting is sited prominently on the ceiling beside the central scene of Bacchus and Ariadne, paired with Mercury bringing the apple of discord to Paris on the other side. But the drawing was in a horizontal format unsuitable for this position, so it could clearly have been otherwise. And there is no mythological motivation for including the subject here, simply the action itself: the exchange of tokens between the earthly and the heavenly protagonists that provides the link. Nevertheless, its very prominence ensured that the subject found its way back into more iconographically driven programmes. Domenichino synthesized motifs from both Annibale's painting and drawing when he came to paint the scene at the Palazzo Giustiniani-Odescalchi, where the subject is once again paired with that of Endymion. Here, however, we are in a room devoted to frescoes of Diana (Latona in the centre; scenes of Iphigenia and Actaeon on the long axis, Pan and Endymion on the short), a context in which the theme of Pan and the wool had never before been shown. It is there because Domenichino (one of Annibale's assistants at the Palazzo Farnese) knew the subject and knew how to compose it. Painting was beginning to impose its own traditions.

Unlike the story of Pan and the wool, that of Diana and Endymion is illustrated in numerous contexts from the end of the fifteenth century onwards. Described in Lucian's *Dialogues of the Gods*, but transmitted to Boccaccio via Fulgentius, the story of Diana and the sleeping herdsman inspired some of the most romantic imagery of the period. An unashamedly lyrical interpretation is one of the earliest: Cima's small circular panel showing Endymion, dressed as a soldier rather than a shepherd, sleeping in a landscape (Fig. 105). Some of the details correspond with Lucian's text (published in Venice in 1494), where Endymion is described as a hunter sleeping on his cloak with his right arm bent round his head, framing his face. In keeping with this, the animals are a hunter's quarry rather than a herdsman's flock, but they too can sleep undisturbed. Nothing moves in the moonlight.

Looking down upon her realm, the Moon sees this man sleeping, as innocent and defenceless as a child, and is overcome by love. Lucian says she crept quietly on tiptoe so as not to waken him. In the painting the crescent moon seems to be doing just that: like an upturned feather that floats down cradled by the air and rocking from end to end, the Moon is not just watching, she is slowly swaying down in time to his breathing. It is a rare moment in mythology: a woman's love for a sleeping man. Even

105. *Endymion*, Cima da Conegliano

though it is not in Ovid, many artists took a fancy to it, as they did to Tasso's story of Armida and the sleeping Rinaldo. The tricky thing was how to portray Diana's approach. At the centre of a panel by the Master of the Griggs Crucifixion, Diana is beamed naked into Endymion's dreams in an envelope of light. Peruzzi's fresco at the Villa Farnesina adopts a more naturalistic approach. Here Diana swoops down to Endymion who reclines on a tomb-like bed. There were ancient sarcophagus reliefs showing Diana stepping out of her chariot towards the sleeping Endymion, but Peruzzi's composition proved to be influential and most artists opted to show a moment of tenderness between the lovers. Cicero said that Diana kissed Endymion, but how much significance should be attached to that kiss is difficult to judge. According to ancient sources, Endymion had been offered a gift by Jupiter, and he chose eternal sleep. Cicero and others equated this sleep with death itself, and so the kiss which Diana bestowed upon her lover was associated by some Renaissance commentators with the kiss of death.[37] There is little evidence that painters interpreted it in this way, but the inference was there for the making.

The most strikingly divergent representation of the scene is Poussin's *Diana and Endymion* (Plate XIV) in which, far from being asleep, Endymion is kneeling in front of the goddess. Opinions have differed on the question of whether Poussin's *Diana and Endymion* in Detroit shows the meeting or the parting of the lovers. The time depicted in the painting is dawn, for as

Night draws aside the curtain, Apollo is shown, preceded by Aurora, driving his chariot across the sky. La Serre's *Amours des déesses* provides the explanation, for here the Moon's romance with Endymion is not a nocturnal tryst with a sleeping lover, but a daytime romance pursued in her free time. At night she has to start work again, and take over from her brother Apollo. It is in keeping with this emphasis on the Moon's daytime activities that Diana is shown with an arrow and a hunting dog, neither of which is associated with her role as the moon-goddess Luna. These attributes are not usually mentioned in the story of Endymion, but in La Serre's narrative Luna's first encounter with him takes place on a hunting expedition.[38] The idea that Poussin's painting shows the meeting rather than the parting of the lovers is confirmed by one of Poussin's possible visual sources, Crispijn van de Passe's engraving for Gombauld's *L'Endimion* (1624), and La Serre's account of Endymion's initial surrender to the goddess makes better sense of his pose (which can be compared with that of St Peter in the Edinburgh *Ordination*) than the supposition that the shepherd is bidding farewell to his lover at the end of the night.

In comparison, Pinturicchio's depiction of Diana and Endymion on the ceiling of the Libreria Piccolomini in Siena cathedral is not in itself particularly unusual. For once, Endymion seems to be caring for cattle rather than sheep (an echo of Theocritus perhaps), but the scene of Diana stepping out of her chariot and approaching the sleeping herdsman is derived from ancient reliefs. What is strange is its pairing with the rape of Proserpina, which is depicted in the same terms (Pluto carries off Proserpina in his chariot). The link between the two may come directly from Fulgentius, whose explication of the story of Diana and Endymion noted that just as the Moon ruled the woods as Diana, so she ruled the lower world as Proserpina. The two scenes therefore show a direct parallel: the Moon as Diana drawn down from the heavens to the earth by her love for Endymion, and the Moon as Proserpina drawn, rather more forcibly, from the earth to the underworld by Pluto. In the context of the Piccolomini library, this emphasis on lunar rule was part of the celebration of lunar imagery associated with the Piccolomini family whose symbol, the crescent moon, could be seen all over the library.

Fulgentius was unusual in making the link between Diana and Proserpina in isolation, but the threefold equation of Luna the moon-goddess with Diana the goddess of the woods and the goddess of the underworld was a commonplace. This, however, is more often the stuff of mythography, and in general, the goddess of the underworld was identified as Hecate rather than Proserpina. There are few visual equivalents to this save Leone Leoni's

106. *Diana*, Leone Leoni

medal of Ippolita Gonzaga (Fig. 106). Made for Ippolita when she was sixteen (and already married) the reverse shows the moon in the sky above, Diana striding through the landscape with dogs and a hunting horn, while behind her Pluto, Proserpina, and Cerberus can be seen in the entrance to the underworld. Her power is the same everywhere, the inscription states – a reference to the three realms over which Diana presides.

The three roles are more often represented separately than together. Portrayals of Luna are often found in the context of astrological decoration or in the representation of night. And in mid-sixteenth-century decoration, Luna driving her chariot often appears in the central panel of themed rooms – as at Landshut, and in Genoa. But the most refreshing portrayal of the goddess is probably Agostino di Duccio's relief in the Tempio Malatestiano in Rimini (Fig. 107). Her drapery billowing behind like a sail, Luna drives her chariot forward, using the upturned crescent moon to steer her solitary course through the uncharted vastness of the night. In representations of Luna derived from the *Libellus*, the goddess was shown accompanied by a ship in full sail – a reference to her sway over the tides, her use in navigation, and, as Pictor notes (citing the Venerable Bede on the subject), as a portent of changes in the weather.[39]

Representations of Hecate are less common. She appears beside the fireplace in the ballroom at Fontainebleau accompanied by Cerberus the three-headed dog of the underworld, paired with another Diana figure (both wear the crescent moon in their hair) seated in a chariot drawn by dragons.

107. *Luna*, Tempio Malatestiano, Rimini, Agostino di Duccio

Hecate herself could be shown with three heads, as she is in an illustration to Cartari. A goddess of crossroads, statues of her in antiquity frequently showed her with more than one head, so that she could look in several directions. In Cartari, however, she has the heads of a horse, a boar, and a dog, not on account of her association with crossroads, but as an embodiment of the threefold identity of Diana: the horse signifies the moon's swift course through the heavens, the boar alludes to Diana the huntress of the woods, and the dog to Cerberus and the goddess of the underworld.[40]

Hecate also enjoyed a reputation as a sorceress, and this may have contributed to the ongoing association of Diana with witchcraft. According to generations of witch-hunters, witches used to ride through the night with Diana and the souls of the lost on a *chasse sauvage*. Whatever the basis of these fantasies, they neatly conjoined Diana's three identities: as Luna she travelled through the night sky; as Diana she was mistress of the hunt; as Hecate she presided over the dead. However, representations of witchcraft rarely make the link with Diana, and there is little evidence that Diana was a frightening figure in sixteenth- and seventeenth-century Germany. People obviously enjoyed an easy intimacy with her. Figures of Diana accompanied by a dog or a stag are fairly common as pendants in southern Germany. And at the end of the sixteenth century Diana could often be seen seated on a gilt stag on wealthy people's dining tables (Fig. 108). She needed to hold on tightly because the stag was full of wine, and moved round the table powered by clockwork underneath. When the stag came to rest in front of a diner they took off his head and had to drink the wine inside in one gulp.

In Konrad Celtis's *Ludus Dianae*, a drama performed before Maximilian I in 1501, Diana comes to present her bow and arrow to the emperor. He may well have found the equipment useful, for the hunt had changed remarkably little since antiquity. Depictions of the hunt of the Calydonian boar, sent by Diana to avenge her honour when Oeneus, king of Calydon neglected her sacrifices[41] (Fig. 109), could have illustrated Xenophon's hunting manual written two thousand years earlier. Meleager and a band of heroes who went in pursuit of the beast use exactly the same techniques: hounds to flush it out, nets to prevent its escape, and a posse of armed men to kill it when cornered. Even the figure routinely shown lying prone in the foreground may not be dead, but rather following the ancient advice given to those unlucky enough to face a boar disarmed: fall on your face and cling to the undergrowth below – you should be safe because a boar's tusks curve upward.[42]

Whoever made the kill could apportion the spoils, which is why Meleager eventually presented the boar's head to Atalanta (although some thought

108. *Diana*, clockwork table ornament, Matthäus Wallbaum

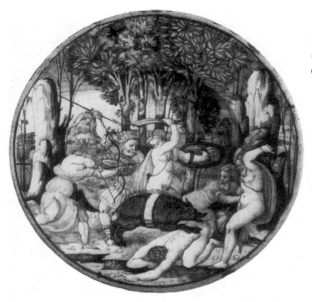

109. *Hunt for the Calydonian Boar*, plate, Orazio Fontana

she deserved it for inflicting the first wound). Diana can also sometimes be seen receiving trophies from the hunt, and in a strange painting by Paris Bordone she is presented with a stag's head. Spranger's *Diana after the Hunt* brings the scene right up to date. The nymphs are girls in pearls, and the figure who presents the recumbent goddess with a deer appears to be a native American with feathers in his hair. It is probably an attempt to give contemporary expression to the idea of the satyr, but real satyrs were less helpful. They thought Diana and the nymphs should be presenting them with goodies, not the other way round.

According to the *Libellus*, Diana actually presided over several distinct types of nymph: dryads, oreads, naiads, and nereids (respectively nymphs of the woods, the mountains, the fountains, and the seas), as well as the satyrs of the fields. However, the water-nymphs do not feature much (the bathing nymphs in the stories of Actaeon and Callisto have left the chase to enjoy some relaxation, they are not naiads stuck at home), and the relationship between Diana and the satyrs was uneasy, for she personified chastity and they lust. In Italy, their dealings are almost always antagonistic: in Pordenone's frieze at S. Maria di Campagna in Piacenza, Diana's nymphs hunt satyrs along with other game; in Cambiaso's painting over a doorway at the Villa di Tobia Pallavicino in Genoa, Diana herself has a real struggle to fight one off. But in the North, the *Libellus*'s emphasis on Diana's role as mistress of both nymphs and satyrs persists. Although Rubens painted a

110. *Nymphs at Rest Spied upon by Satyrs*, Frans Snyders and
Jan Brueghel the Elder

dramatic battle between nymphs and satyrs, in several other paintings by
the artist they seem to have come to some sort of arrangement.

In Rubens's *Return from the Hunt*, Diana and the nymphs come back
with dead game, to be greeted by satyrs with baskets of fruit. The proffered
exchange is potentially sexual as well as gastronomic. The juxtaposition of
dead meat and live flesh occurred to other artists too. Snyders collaborated
with Jan Brueghel the Elder, and possibly with Rubens himself, on several
paintings of nymphs being spied upon by satyrs while resting after the hunt
(Fig. 110). Conjoining the theme of spying with that of the trophies of
the hunt was a clever idea. Snyders's talent was, as Toby Matthew, the
representative of one of Rubens's English patrons, wrote, in representing
beasts 'altogether dead, and wholly without any action'. Now, the technique
could be applied to clumps of nymphs as well as heaps of dead animals. The
latter are more wanton in death than the former in sleep, but the bodies can
always be transposed – if the viewer is hungry enough.

It is reasonable to assume that this flesh-fest was not commissioned by a
woman, for there is a discernible difference between the subjects com-
missioned by male and female patrons. Paintings for women are usually
spectacles of power in which Diana appears alone, or with other mythologi-
cal figures as an independent actor, whereas in paintings for male patrons,
it is often the nymphs who steal the show. For example, Domenichino's

111. *Diana and Nymphs at Play*, Domenichino

Diana and Nymphs at Play (commissioned by one cardinal but pre-emptively acquired by another) is a sort of schoolgirl sports day in which some games are conveniently undertaken semi-naked (Fig. 111). The cruel sport with which the nymphs amuse themselves is an ancient one, described in the *Aeneid*, where, as in the painting, one arrow strikes the pole, another severs the cord with which the bird is tethered, and the third skewers the hapless target before it can fly away.[43] Diana stands in the centre in games-mistress mode, but the real star is the little Lolita bathing nude in the foreground. Uninterested in the game to which her companion is trying to draw her attention, or even in the peeping Toms in the bushes, she looks straight out of the picture at the viewer. The frankness of her gaze was rewarded. She soon reappears in the work of other painters, and in other contexts, including (appropriately enough for a girl accustomed to the admiration of cardinals) an anonymous *Susanna and the Elders* in Rome.

And yet it was often the taste for one sort of subject that fostered the appetite for the other. Scipione Borghese, who is said to have obtained *Diana and Nymphs at Play* by having Domenichino thrown into prison, looked into the possibility of acquiring a set of the Diana tapestries from France. Frans Snyders also collaborated with Rubens on a *Diana Crowned* that ended up hanging over the fireplace in the banqueting hall of Frederik Hendrik and Amalia van Solms's great house at Honselaarsdijk. In this context, it aligned the mistress of the house with the mistress of the hunt, but it was part of the same cluster of paintings that included Snyders's *Nymphs at Rest*. As every satyr knew, spectacles create voyeurs, and voyeurs need spectacles – though only a few artists provided them with a pair.

8

Apollo

Messages were sometimes relayed across the centuries from antiquity without anyone being there to receive them. The Renaissance did not make use of all the available information. A lot was just ignored. For example, in the Forum of ancient Rome there had been a statue of Marsyas standing with one arm raised and a wineskin over his shoulder. Servius said that such statues were placed in the centre of a city as a symbol of its freedom, and the statement was repeated by both Boccaccio and Cartari.[1] But although civic liberty is central to Renaissance political thought, no statues of Marsyas were erected in the piazzas of Venice or republican Florence. Marsyas had acquired this role on account of his link with Liber/Bacchus. Yet whereas Tintoretto's *Bacchus and Ariadne* exploits the association between Bacchus and liberty to celebrate Venetian freedom, Titian's *Marsyas* knows nothing of it. Why was one signal picked up and the other not?

Perhaps it was lost in the noise. There was almost too much information about Marsyas, derived not only from Ovid and other classical authors, but also from an unusually rich variety of antiquities including gems, statues, sarcophagus reliefs, and even paintings. In Book 6 of the *Metamorphoses*, the tale of Marsyas is the last in the series of divine punishments that also includes the stories of Arachne, Niobe, and Latona and the frogs. There is not much detail here, save that a satyr named Marsyas was skinned alive after he lost a musical contest with Apollo, and that the tears of satyrs and country people who wept for him became the river that bore his name. The background is filled out in the *Fasti* where Minerva describes how she invented the flute, but was so disgusted when she saw a reflection of herself puffing out her cheeks to blow it that she threw it away. The flute was picked up by Marsyas, who learnt to play it and challenged Apollo.

According to Fulgentius, Minerva had first tried to show off her invention at a banquet of the gods, and only realized how ridiculous she looked after being laughed off stage.[2] This is also the variant of the story described and illustrated in the Italian Ovid of 1497 (Fig. 112), where the narrative runs

112. *Apollo and Marsyas*, from Ovid, *Metamorphoses*, 1497

anti-clockwise from Minerva's performance at the top left to the display of Marsyas's skin in a temple at the top right (a detail derived from Herodotus). The woodcut established a formula that was reworked in maiolica, paintings, and also in subsequent editions of the *Metamorphoses*, even when (as with Dolce) they do not follow Bonsignori's description of Marsyas as a peasant rather than a satyr.[3]

Vernacular Ovids might offer a new approach to the subject based on a synthesis of classical authors, but artists in Rome were working directly from the ancient models. There were three main visual sources: a cycle of ancient paintings once visible near the Porta Salaria and recorded in the Codex Pighianus; sarcophagus reliefs visible in Rome from the fifteenth century; and statues of Marsyas bound to a tree, and of his executioner sharpening his knife, a figure known as the Arrotino. For once, they all more or less fit together – although the identity of the Arrotino was not generally recognized until much later – and provide the basis for a distinct Roman tradition in which Marsyas is tied to a tree with his hands above his head, Apollo is seated directing the execution, and the executioner kneels before the victim either sharpening his knife or choosing a spot for the first incision. It is seen to best effect in the print by the Master of the Die (Fig. 113). Other variants include Peruzzi's frieze at the Farnesina, Raphael's fresco in the Stanza della Segnatura, and Giovanni da Udine's decorations

113. *Apollo and Marsyas*, Master of the Die

for the Loggetta of Cardinal Bibbiena in the Vatican. From Rome, these models were carried elsewhere. Salviati's frescoes at the Palazzo Grimani near Santa Maria Formosa in Venice followed the ancient painting cycle, while a painting from the school of Patinir reworked the print by the Master of the Die.

Although both the Ovidian and the Roman models were widely disseminated, neither had a lasting impact because both remained too close to their sources. Somehow, the story came alive only when it developed its own logic and when, against all precedents, Marsyas was depicted upside down. The idea of inversion is not absent from the tradition; according to Apollodorus, Marsyas lost the competition when Apollo tricked him into trying to play his instrument upside down, as Apollo did the lyre.[4] But it is unlikely that Marsyas was hung head down from a tree as a reminder of his inability to play an inverted pipe. Butchered animals were hung upside down, and – initially at least – Marsyas was shown like this only when half-animal himself.

Despite Ovid's clear identification of Marsyas as a satyr, he was depicted as one largely as a result of his confusion with Pan. According to Book 9 of the *Metamorphoses*, Pan also challenged Apollo to a musical contest, which the judge, Tmolus, considered Apollo to have won. Midas, who had also been listening, complained about the verdict, and was punished by being given ass's ears. The obvious similarities between the two contests led to the suggestion that Midas had actually been the judge on the occasion of

Apollo's victory over Marsyas. The idea is found in both Hyginus and Fulgentius, from where it passes into the second Vatican Mythographer, and Landino's much reprinted commentary on Dante.

The confusion had a learned pedigree, but it emerged for the first time in the context of Giulio Romano's decorations for the misleadingly named Sala delle Metamorfosi at the Palazzo Te in Mantua, where the frieze is composed of little mythological scenes, some copied directly from the antique, alternating with poorly painted landscapes. It is unlikely that much thought was given to the content of such a decorative scheme, which may help to explain several of its iconographical oddities. Although the composition seems to reproduce the Roman formula in which Apollo holds the lyre and observes the executioner, here it is Apollo himself who leans over the satyr's body and peels away his skin while an assistant holds the lyre and the barbarian executioner the knife. To the right, Midas, whose judgement is depicted in another scene in the same room, covers his eyes, and a satyr approaches inexplicably carrying a bucket. At the centre is Marsyas himself, helplessly up-ended. His redundant syrinx hangs above him.

Titian's painting adds nothing to Giulio's iconography except a couple of bloodthirsty dogs, and so there can be no reason to suppose that it represents any understanding of the story not already present in Giulio's fresco. Titian's painting itself had little impact, but other Venetian artists also showed Marsyas head down, and whether or not he was depicted as a satyr this image of Marsyas remained popular for the next century. Intially at least its attraction can be explained by its use of inversion. Everyone was conscious that there was a huge divide between the rational and the bestial parts of biform creatures like satyrs and centaurs, and the up-ending of Marsyas parallels the satyr's own attempt to raise the bestial above the rational in his contest with Apollo. Marsyas wanted to turn the world upside down, so he only got what he was asking for.

In the *Ovide moralisé*, Apollo had been presented as Marsyas's evil superior exacting vengeance on a simple man for lack of deference. Sixteenth-century commentators had little time for this idea, and Marsyas fitted easily into the iconography of punishment. Upside-down, he became another Phaethon falling to earth. It is difficult to feel free if you are hanging head-down, so perhaps one reason no one picked up on the idea that Marsyas might be a symbol of liberty is that he was so obviously helpless. Such vulnerability was an invitation, and in the late sixteenth century the emphasis begins to shift from punishment to torture. The model for several paintings was Melchior Meier's print in which Nicolas Beatrizet's image of a flayed man holding his own skin is transformed into that of Apollo

displaying Marsyas's skin as a trophy to a group of onlookers that includes both Midas and Pan. Although tied to the tree by one hand, Marsyas's flexed legs give his body a disturbing post-mortem vitality that propels it into the viewer's space. Variants of the pose were used by painters like Ribera and Giordano, and also by Dirck van Baburen in Holland, and Johann Michael Rottmayer in Germany, while the print itself directly inspired an extraordinary ivory relief by Hans Ochs.[5]

As the tortures grow worse, there are signs of a creeping sympathy for the satyr. Jordaens turns Marsyas into a defenceless victim of the gods like the youth in Caravaggio's *Sacrifice of Isaac*. In Vouet's lost painting for the Hôtel Séguier in Paris, the satyr sits dejectedly awaiting his fate, his spirit as broken as the discarded instruments in front of him, the skin over his shoulders a reminder of the cloak draped over the tormented Christ. A similar emphasis is evident in German carvings of the subject, where the flaying of Marsyas is often assimilated to the crucifixion. Just as Christ's humanity is revealed in death, so in Adam Lenckhardt's ivory group (Fig. 114) is that of Marsyas. As Apollo cuts away the hairy goatskin to reveal a leg more human than bestial, Marsyas is redeemed from the animality that has condemned him to this terrible fate.

The conflation of the contests of Marsyas and Pan also had an effect on the musical instruments depicted. In both cases Apollo is shown either with an ancient lyre or its contemporary equivalent the *lira da braccio*, or viol. The instruments played by Marsyas are more variable. Strictly speaking, Minerva had invented the *aulos*, a pair of pipes which produced the raucous sound that had once offended the ears of Plato and Aristotle. Marsyas is sometimes shown with an *aulos*, but he is more often depicted with a single pipe, or even a shawm. The illustration to Bonsignori's Ovid has him playing a rustic bagpipe, and the instrument with which he is most commonly depicted from the mid-sixteenth century onwards is the syrinx, which had of course been invented by Pan rather than Minerva (although that did not stop Parmigianino crediting the goddess with the discovery).

The syrinx sometimes makes it difficult to tell whether the story represented is of Pan or Marsyas. The judges often provide a clue, for the appearance of Tmolus is a sure indication that the musician is Pan. He is most often to be seen in seventeenth-century Dutch painting, where scenes of the contest of Apollo and Pan outnumber those of Marsyas. Goltzius's great etching of 1590 was particularly influential: it was used as a model for paintings, and for de Passe's *Metamorphoses*, and eventually found its way to Portugal, where at the Fontena Palace in Lisbon it spreads out across

114. *Apollo and Marsyas*, Adam Lenckhardt

the tiles of a garden wall. As so often with Goltzius, you feel the composition was always waiting for a larger and blander public context in which to be seen.

However, the stories of Marsyas and Midas could be combined, as they are in Landino's commentary on Dante, and in Bronzino's painting on a harpsichord. Bronzino shows not only the flaying of Marsyas but also the discovery of Midas's embarrassing abnormality by his barber, who confides the knowledge to a hole in the ground from where reeds grow that whisper the secret of Midas's ass's ears in the wind. Unless you are following the story closely, the action of Midas's barber is inexplicable, and the barber is turned into a vomiting satyr in the engraving of Midas and Silenus (here depicted as a satyr) in the 1614 edition of Vigenère's Philostratus.[6]

So what kind of music did Apollo play? It is hard to say with any precision because, even if the Muses sometimes used a score, the god himself never needed one. In a sense, the lyre plays itself. Since antiquity, it had been associated with harmony. The Pythagoreans identified the strings of the lyre with harmonic intervals and with the seven planets, and so equated Apollo playing the lyre with the harmony of the spheres presided over by the sun. Taken up in Neoplatonism, and transmitted to western Europe via Boethius, the association of Apollo with harmony was a strong one, and Francesco Sansovino even suggested that his father's statue of Apollo on the Loggetta of San Marco referred to Venice's magistrates harmoniously united in the government of the city.[7]

According to Ficino, Apollo was responsible for serious music and Venus for lighter stuff.[8] But although Orpheus was the real pop-star of the ancient world, it is hard to believe Apollo is playing anything other than hits in Dosso Dossi's painting. And a lot of the time the Muses were just another girl group. The line-up was always changing, though you usually had Clio on trumpet, Euterpe on flute, Polyhymnia on the keyboard, and at least one Muse playing a viol. Apollo managed the band and played the lyre. Though they are not much in evidence on *cassoni*, the Muses are common in most other media, and (thanks to Ghisi's print which transmitted Penni's design very widely) they can even be seen decorating a shield. But they were really performers rather than pin-ups. They played at weddings, baptisms, and triumphal entries, and toured all over Europe.[9] At the coronation of Anne Boleyn in 1533, Holbein's drawing shows the Muses standing on top of an arch with Apollo enthroned in the centre (Fig. 115).

On such occasions the role of the Muses must often have been taken by actual female musicians. This can have done nothing to reassure people

115. *Apollo and the Muses*, Holbein

that the Muses were respectable, for they already had the wrong sort of reputation. When Boethius was lying sick in bed, the Muses of poetry had been there to comfort him before Philosophy turned up and shooed them away. According to her, they were little whores: sirens whose sweetness led to death.[10] Commentaries on this passage did little to redeem the Muses, and since everyone read Boethius in school they could hardly avoid thinking that the Muses were a bit fast. People tried all sorts of ways round the problem. The *Ovide moralisé* argued that the Muses had the true philosophy and their rivals the Pierides were involved with dubious poetry. Boccaccio suggested that there were actually two different types of Muse: the low-lifes

Philosophy had been talking about, and the better sort who hung out with Apollo at the Castalian spring.[11]

The idea stuck, and Apollo became the guarantor of the Muses' virtue. As Ficino had pointed out: 'The Muses do not sing well when the wanton son of Venus molests them; either they are silent or they shriek. The chorus of the Muses does not dance becomingly, but limps and falters, whenever its lord Apollo is far away.'[12] You can see what he meant in Lotto's *Apollo Asleep with the Muses at Play*. The god is neglecting his job and the Muses have thrown off their clothes and are running wild. In contrast, the graceful Muses in Mantegna's *Parnassus* are singing and dancing harmoniously (Plate XV). This was the first painting executed for the *studiolo* of Isabella d'Este. Previous *studioli*, like that of her uncle at Belfiore, had used the Muses as symbols of the pursuit of knowledge, and this is doubtless why they appear here as well. Yet this is also a painting about sex – Cupid's blowpipe makes a straight line between Vulcan's and Venus's genitals – so what on earth is going on?

The answer may perhaps be found in Ficino's *De vita*, not one of his philosophical works, but a series of three short treatises on health, the first of which is devoted to the health of scholars, first published in 1489. As Ficino explains in the first chapter of the first treatise, the path to knowledge is supervised by three heavenly guides: Mercury impels us to undertake the journey in search of the Muses; Apollo illuminates seekers with light so that they discover what they are looking for, and Venus embellishes the material. So Mercury provides the motivation, Apollo the illumination, and Venus the polish needed to make study pleasant and profitable.[13] These three figures are the most important in the composition and between them they enclose the area within which the Muses dance: Mercury closest to the viewer, Apollo on the opposite side a little further back, and Venus completing the triangle at the top of the rock arch.

But, as Ficino explains a few pages later, the path to knowledge is not easy. There are dangers to be negotiated on the way, and the first of these is sex. Sexual intercourse ruins the health, particularly if it is excessive. After all, did not Hippocrates say it was like epilepsy, and had not Avicenna calculated that loss of sperm was equivalent to losing forty times that quantity of blood? No wonder the Muses were virgins. To illustrate the point, Ficino quoted a Greek epigram he had picked up from Diogenes Laertius: 'When Venus threatened the Muses that, unless they celebrated the rites of love, she would send her son armed against them, the Muses answered, "O Venus, threaten Mars with such things, your Cupid does not fly among us." '[14]

We can now begin to understand the relationship, or lack of it, between the upper and lower halves of the painting. The hedge behind the Muses originally ran across the whole of the painting, effectively creating a barrier between the Muses and the figures of Venus and Mars behind them. Even without it, the Muses have nothing to do with the amorous couple or the antics of Cupid. He has turned his back on the dancing figures below, and is now directing his attentions to the hapless Vulcan. Meanwhile Venus has clearly heeded the Muses' advice and is enjoying the attentions of Mars. The theme is obviously an appropriate one for a *studiolo*, and it fits perfectly with those of the other two early commissions for the room – Mantegna's *Pallas Expelling the Vices*, and Perugino's *Battle of Love and Chastity*. Venus may be an ornament to scholarship only if she keeps Cupid from interfering where he does not belong. And just in case the viewer misses it, there are a couple of scourges available for the use of anyone taking the path towards the dancing Muses.

Mantegna's painting is a reminder that Apollo was by no means the only god associated with the Muses. Classical sources suggested that Hercules or Bacchus might also be their leader.[15] And in the *Metamorphoses* they are described as being in the company of Minerva on Mount Helicon, where Pegasus had created the Hippocrene spring by stamping his hoof. The scene was common in illustrations to Ovid, but otherwise little reproduced. One reason for this was that the distinction between Helicon and Parnassus (the mountain where the Muses resided with Apollo) was blurred, even in antiquity. By the sixteenth century, not even Ariosto knew which was which, though some remembered Servius's suggestion that Parnassus actually had twin peaks (visible behind the Muses in Holbein's drawing, Fig. 115) of which Helicon was one and the other Cithaeron.[16]

However, there are some images of Helicon that are clearly not Parnassus. For example, the fresco of Sagittarius at the Palazzo d'Arco in Mantua illustrates the story of the centaur Crotus who, according to Hyginus's *Poetica astronomica*, was a companion of the Muses on Mount Helicon before he was set among the stars.[17] And it was there too that the nine Pierides unsuccessfully challenged the Muses to a singing contest for possession of the mountain. Calliope took them on, and sang the story of Proserpina, accompanying herself on the lyre. The Muses won, of course, and the Pierides, who were bad losers, were changed into magpies. But in Caraglio's print after Rosso they have good grounds for complaint. The jury was stacked against them. Ovid makes the judges the nymphs of Mount Helicon, but Rosso has Apollo, Minerva, Mercury, and Bacchus in the audience.

Rosso's design must be one of the last occasions on which the Muses are nude (the Pierides, by contrast, are fully dressed). In illustrations to moralized editions of Ovid and other late medieval texts the Muses are routinely shown bathing naked in the Hippocrene spring, whereas in the Renaissance they are almost always clothed.[18] You can see the transition in Giraldi's little booklet about the Muses published in 1511. In the frontispiece they are playing their instruments nude in a fountain resembling the late medieval fountain of love (the design comes from Burgkmair (Fig. 116)), but inside they are all dressed. The Muses obviously found clothes inhibiting, so why did they have to get dressed when all the other gods were getting naked? It could be a tribute to antiquarianism – there were sarcophagus reliefs of the Muses in Rome in which they were clothed. But the main reason was that they had to go to work. By the time Guerrieri painted them for the Palazzo Borghese in Rome, they hardly had time to play their instruments, let alone go swimming in the Hippocrene spring.

In Guerrieri's painting, most of the Muses have attributes that reflect Ripa's account of their respective areas of skill: Clio, history; Melpomene, tragedy; Thalia, comedy; Euterpe, the flutes; Terpsichore, the psalterium (or sometimes dance); Erato, geometry (or else love poetry); Calliope, heroic poetry; Urania, astronomy; and Polyhymnia, rhetoric or mime. Knowledge of their specific competences came chiefly from a short poem then attributed to Virgil.[19] Giraldi had picked it up in his treatise of the Muses and fed it into the mythographic tradition, but there is no reference to it in Boccaccio or the vernacular editions of Ovid, and so for a long time there was considerable confusion about the iconography of the individual Muses. There were plenty of classical sources, but in few of these are their roles sufficiently individuated to form the basis of a distinct iconography. It is no wonder, then, that they (along with Hercules) are almost the only figures from mythology who are repeatedly the subject of little monographs. Giraldi's *Syntagma de Musis* (1511) was followed by Lomazzo's *Della forma delle Muse* (1591) and Boissard's *Parnassus* (1601).

In Italy, representations of the Muses first appeared in the princely courts of the north-east.[20] For the *studiolo* of Lionello d'Este at Belfiore, several Ferrarese painters produced paintings of the Muses based on advice given by Guarino Veronese. Guarino appears to have taken his descriptions of the Muses from the introduction to a Byzantine commentary on Hesiod, where some of the Muses have unusual attributes.[21] Polyhymnia, for example, is carrying a hoe because she initiated the cultivation of fields. Guarino's account also seems to have been used for the representation of the Muses at the Tempio Malatestiano in Rimini, but it is not much used thereafter,

116. Allegorical print, Hans Burgkmair

doubtless because the source was little known. It must, in fact, have been really obscure, because when Giraldi wrote his *Syntagma de Musis* he seems not to have known this interpretation of Polyhymnia (although he was aware of it by the time of *De deis gentium* in 1548).

Boccaccio had not attributed distinct areas of specialization to the Muses, for Fulgentius had said that they represented different stages in a single process of learning that proceeded from Clio to Calliope. His interpretation is repeated everywhere but it had little visual impact. And although the idea of a sequential ordering clearly lay behind the theologians' identification of the Muses with various ranks of angelic being, the order is quite different. In retrospect, it is evident that the newfound popularity of the Muses is associated with the shift from this vertical ordering to a horizontal distribution of roles. To achieve this the Muses had to displace the personifications of the seven Liberal Arts – the *trivium* of Grammar, Rhetoric, and Dialectic, and the *quadrivium* of Arithmetic, Geometry, Music, and Astronomy – derived from Martianus Capella. During the Middle Ages the Liberal Arts had largely taken the place of the Muses. But as interest in the Muses revived, people tried to make sense of the relationship between them by getting them matched up. Salutati's pairings were: Calliope, music; Polyhymnia, arithmetic; Euterpe, astrology; Erato, geometry; Urania, rhetoric; Melpomene, logic; Clio, grammar; Terpsichore, philosophy; and Thalia, natural capacity.[22] If only he had had the *Tarocchi* to hand, he could have played a card game with himself, including the planetary deities whom he (and others – in varying combinations) identified with the Muses as well. But he would never have managed to get them all in order, for the numbering of the *Tarocchi* gives Fulgentius's sequence of the Muses in reverse.

Apollo presided over all of this. You can get some idea of the scope of his activities from *Champ Fleury*, where Geoffroy Tory places Apollo within the letter O, circled by the names of the nine Muses, the seven Liberal Arts, the four cardinal Virtues, and the three Graces all radiating outwards like the beams of the sun.[23] The Virtues may be there to help make up the number of letters in the alphabet, but the Graces had been associated with the god since Macrobius explained that Apollo was shown with the Graces in his right hand and his bow in his left because he would rather save than do harm. He appears in just this fashion in Agostino di Duccio's relief in the Tempio Malatestiano, with the Graces bunched like flowers in a bouquet of laurel potted in a lyre. In late medieval illustrations to *Les Eschez amoureux* (and in Colard Mansion's Ovid) three naked ladies are shown dancing round a laurel tree beside Apollo. They look like the Graces, but

there is no textual justification for this, for Bersuire (on whom the text is based) clearly gives the role to the nine Muses, and in other versions of the subject there are more of them. Yet the possibility that there were three rather than nine Muses had been suggested by Varro, and the identification of the Muses and Graces was not unknown.[24]

Hans Burgkmair in his print of the imperial eagle arranges the world of knowledge rather more hierarchically than Tory. Flanked by medallions showing the seven days of creation and the seven mechanical arts, the fountain of the Muses arises in stages with the Judgement of Paris at the lowest level; the Liberal Arts arranged in the *trivium* and *quadrivium* with Philosophy seated above; then the basin, with the nine Muses playing their instruments in the waters of the Hippocrene fountain, and finally Maximilian I as Apollo, presiding over the whole ensemble and seated on the tripod. If you compare this print with Hans Kulmbach's woodcut of Parnassus (Fig. 117), it is tempting to see it as a retrograde late-medieval allegory of knowledge, in contrast with Kulmbach's scene in which mythological figures wander freely in a unified pictorial space. That would be misleading, for the programmes of both prints came from Konrad Celtis. And yet it is not entirely wrong, for the foreground and left of Kulmbach's print (Apollo, Muses, and bunnies included) is taken from a north Italian manuscript miniature.

Now, however, Apollo is seated between the twin peaks of Mount Parnassus amidst a teeming population. The figures on the left are predictable: Minerva, the Muses, Pegasus, and the Hippocrene fountain; but those on the right, in the shadow of the laurel, come straight from Celtis's *Ludus Dianae*, where Diana, the satyrs, the Oreads and Driads pay homage to Maximilian in the first act; Bacchus is crowned with laurels by the emperor in the third, and Silenus takes the stage in the fourth. The inscription above (which does not come from the drama) reminds the viewer of the scene's more traditional iconography in which the peak of Cithaeron is sacred to Bacchus and Helicon to Apollo, the female inhabitants are Muses (the Libetrides, Pierides and Thespiades are all types of Muse, although as Pictor, following Giraldi, pointed out, strictly speaking they came from different locations), and Pegasus (who had sprung from the Gorgon's blood, hence 'Gorgoneus') creates the fountain with his hoof.

It is an astonishing synthesis of sources – visual, literary, and mythological – and directly reflects Celtis's vision of himself.[25] In 1486 he had published his most famous poem, a call to Apollo and the Muses to take up residence in Germany. They came right away, and the following year the Nuremberg Chronicle records that Emperor Frederik III crowned the poet with the

117. *Parnassus*, Hans Kulmbach from Petrus Tritonius, *Melopoiae*, 1507

laurels of Apollo. Thereafter, there are frequent references to Apollo in imagery associated with the poet. He provided the inscriptions for the decoration of a room in Sebald Schreyer's house in Nuremberg with paintings of Apollo, the Muses, and ancient philosophers. A later print by Hans Baldung Grien offers a sort of parallel to the Parnassus, in which the poet is seated at his desk in the centre with the fountain of the Muses below, with (from the top) Minerva, Mercury, and Hercules stacked in niches on the left, and Venus, Apollo, and Bacchus on the right. The difference between Burgkmair's eagle and Kulmbach's Parnassus is, it would appear, less a matter of culture than of function. The eagle is hierarchical because it represents imperial patronage, the Parnassus a more informal scene in which the poet/Apollo gathers his friends around him for inspiration, just like Petrarch who had consecrated his own Parnassus to Apollo and Bacchus.

If humanists in general felt a sense of affinity with the god, there were also several distinct professions that could claim Apollo's patronage: musicians, for one. Apollonian themes sometimes appear on the reverse of their medals, and Sacchi's painting of the castrato Marc'Antonio Pasqualini shows the singer being crowned by Apollo while Marsyas lies bound in the background. But Apollo was also well known to be the god of medicine. According to Macrobius, it was because the warmth of the sun had healing properties that Apollo was said to be a healer; though the excessive heat that brought the plague was also signified by his arrows, the rays of the sun. The identification of medical men with Apollo was a commonplace, but there seems to be no visual equivalent to the verse invocations for the recovery of the sick written by Ronsard and others.

Prognostications of recovery or death were not the only kind that Apollo could offer. In antiquity, he was, above all else, the god of prophecy. His cult at Delphi was famous throughout the ancient world, and the oracles of his priestess writhing on her tripod a source of comfort and wonder. In the *Hypnerotomachia*, there is an illustration of the oracle of Apollo being consulted about Leda's mysterious eggs. But there is little trace of such practices elsewhere – although people often said that placing laurel, the plant sacred to Apollo, around your head before you went to sleep ensured the veracity of your dreams. Nevertheless, the memory of Apollo's prophetic role was kept alive in Neoplatonic thought. Plato had distinguished four types of divine madness: Apollo's prophetic inspiration; the mystical raptures of Bacchus; the poetic inspiration of the Muses, and Venus's erotic passion.[26] But in the Renaissance there was little attempt to keep them apart. In *La Lyre*, Ronsard enlists them all as the divine sources of his poetic

vocation, and suggests that poets have taken over the mantle of prophecy, while in the *Galeria*, Marino cites all save the Muses in his verses on the portrait of Anacreon.

In the seventeenth century, the inspiration of the poet became a distinct pictorial subject. Poussin produced two versions, both of which have the same basic elements: a Muse, Apollo, a poet, and putti bearing laurels. If Poussin thought he was as inspired as the poet, he did not show it, but other painters were less reticent. At the funeral of Michelangelo in 1564, a painting of the artist about to be crowned by Apollo and the Muses had been used to represent his achievements in poetry (as opposed to those in sculpture, painting, and architecture). But with Michelangelo on Parnassus, his fellow painters hoped to get there too. Vasari devoted a small room of his house in Arezzo to Apollo and the Muses, and at his house in Rome Federico Zuccaro invoked Apollo in the *Apotheosis of Painting*. Paolo Fiammingo showed poets, a sculptor, and a painter (hard at work on a portrait of Tintoretto) in his *Planet Apollo*. Pietro Testa's prints of *The Triumph of Painting* and *The Triumph of the Artist on Mount Parnassus* make the point explicit: painters belonged on Parnassus just as much as poets. And at the Schilderskamer of the Guild of St Luke in Antwerp, Jordaens and Boeyermans show poetry and painting as equal beneficiaries of the Hippocrene spring.

Painters may have climbed up to Parnassus, but unlike the poets they were never sufficiently at ease there to get paired off with the Muses. In Scipione Errico's comedy *Le rivolte di Parnaso*, for example, Thalia explains that she is with Ariosto, Urania is besotted with Tasso, and so on.[27] Baudouin, who is the first mythographer to give expression to this idea, offers a rather more serious list of the links between the Muses and the poets of antiquity in his version of Conti.[28] Poussin, whose *Parnassus* contains nine Muses and nine poets, was surely working with the same idea, though the list can hardly be the same (there is no Sappho, for instance) and there is no obvious way of matching them up. In the illustrations to Boissard's *Parnassus* Greek poets are all bearded and the Latin ones clean-shaven, so it is quite likely that in Poussin's painting there is only one Roman, and that the rest are all Greek and/or Italian.

Poussin's painting was modelled on the most famous Parnassus of them all – Raphael's fresco in the Stanza della Segnatura (Fig. 118). The room was originally a library and so each wall was decorated with a scene appropriate to one of the traditional disciplines: the *Parnassus* represented Poetry (which was not strictly one of them); the *Disputa*, Theology; *Justinian*

118. *Parnassus*, Stanza della Segnatura, Vatican, Raphael

Delivering the Pandects and *Gregory IX Delivering the Decretals*, Jurisprudence; and the *School of Athens*, Philosophy. There was a certain logic to their arrangement: Poetry stood opposite Jurisprudence, and Theology opposite Philosophy. But this was not a world that anticipated conflict between the faculties. On the ceiling, between the personifications of the disciplines were scenes that suggested the links between them: *The Fall*, between Theology and Jurisprudence; *The Judgement of Solomon*, between Jurisprudence and Philosophy; *Urania*, between Philosophy and Poetry; and *Apollo and Marsyas*, between Poetry and Theology. Giovanni del Virgilio's interpretation of the story, in which Marsyas represents error and Apollo the 'true knowledge' that comes from the heart, is obviously the relevant one here, for establishing the truth is also the theme of the *Disputa*.

However, the continuities between the *Marsyas* and the *Parnassus* are not stressed. Apollo was originally to have held a lyre (as in the *Marsyas* above) but a viol was substituted for the final painting. He sits in the centre of the composition, surrounded by the Muses, and the great poets of ancient and modern times. They are not all now identifiable, but Vasari names quite a few of them, although he spares adjectives for only four: Sappho, seated on the inside left, is *dotta* (learned); Dante, standing behind the blind Homer, *divinissimo*; Petrarch, third from the left, *leggiadro* (graceful); and Boccaccio, at the back on the right, *amoroso*. You cannot help remembering that description of Boccaccio when, a few pages later, Vasari describes Raphael as a '*persona molto amorosa*'.[29] And there is a sense in which Raphael's vision of Parnassus is more *amorosa* than *dotta*. There were originally to have been cupids flying though the air with laurels in their hands, and it is the Muses, not the poets, who are the focus of the composition.

Just how amorous things could get on Parnassus was, of course, a moot point. Perhaps some of Raphael's Roman contemporaries thought the papal Parnassus was more amorous than it ought to have been. In a satirical print from the same period the inhabitants of Parnassus participate in a wild orgy (even the trees are involved), while Pegasus flies off into the distance in disgust. There was always a danger that introducing the Muses to the Vatican might be misinterpreted. And comparing the pope to one of the pagan gods could be awkward. In fact, the only god to whom there is fairly consistent reference in papal panegyrics is Apollo. From the pontificate of Nicholas V onwards, popes were repeatedly compared to the sun-god. Like Apollo, they were both shepherds to their flocks and the source of divine illumination. They were patrons of the Muses, under whose benevolent rule a new golden age might be expected, just as predicted in Virgil's fourth

Eclogue. No wonder one poet imagined Sixtus IV entering Rome in triumph with the joyous people singing, 'You are the father of the people, our prince, the shepherd Apollo.'[30]

It never happened like that, of course (those epithets are from Macrobius), but such fancies were not without foundation. There was an old and much repeated tradition which suggested that the Vatican stood on the site of an ancient Temple of Apollo, and when Sixtus's nephew was elected pope as Julius II, the ancient link between Apollo and the *gens Julia* (the family of Julius Caesar) was reactivated. Were these concerns reflected in the decoration of the Vatican? The pope had appeared at the centre of the children of the Sun in the hexagons of the planets in the Appartamento Borgia, but the Apollonian imagery in Raphael's decorations for the Stanza della Segnatura is more ambiguous. It is doubtful if visitors glancing out of the window towards the Vatican hill would have made a connection between it and the Mount Parnassus depicted above, let alone identified the bearded warrior pope with the effete musician bowing his viol at its centre.

It would have been more appropriate if Raphael's *Parnassus* had been commissioned by Julius's successor Leo X, for his identification with Apollo was not merely circumstantial but personal as well. Since the laurel was one of their many devices, and their name lent itself to medical word-play, the Medici already had some basis for identifying themselves with the god, but it was only when Giovanni de' Medici was elected pope that Apollonian imagery became prominent. Because the star sign Leo was customarily identified with the sun-god, the new pope's *possesso*, an event never previously rich in mythological imagery, was turned into an extravagant celebration of his leonine and Apollonian qualities. In a series of arches Apollo appeared again and again: with the skin of Marsyas over his shoulder, and his quiver at his feet; opposite Perseus, holding the laurels in one hand and a lyre in the other; paired with Mercury in a tableau vivant in front of the house of Agostino Chigi. In the subsequent pageant for his Roman citizenship, his mother was even compared to Latona, another woman who had dispelled darkness by giving birth to a sun.[31]

Despite all this, the papacy of Leo X left few lasting traces, except for the Sala delle Muse for the papal hunting lodge, La Magliana. In contrast, Paul III's Sala di Apollo in the Castel Sant'Angelo was decorated by Perino del Vaga (and, after his death, Domenico Zaga) with an unusually comprehensive programme of Apollonian imagery unobtrusively integrated into the overall scheme of grotesque decoration (Fig. 119). In the central circle of the vault, around the arms of Paul III, Apollo can be seen flaying Marsyas,

119. Sala di Apollo, Castel S. Angelo, Rome, Perino del Vaga and assistants

guarding the herds of Admetus, giving the young Aesculapius into the care of Chiron, killing the Cyclopes, shooting Coronis, and competing with Pan (here iconographically distinct from the adjacent flaying of Marsyas). Small rectangular panels elsewhere on the vault show the death of the Niobids, Latona and the frogs, Apollo and Daphne, and Apollo and Neptune building the walls of Troy. The seven Liberal Arts appear in the lunettes, and on the walls each of the nine Muses can be seen within a little temple. It has all been quite carefully planned, but not in order to be noticed. Widely spaced among the grotesques and barely distinguishable from them, these narratives make little claim on anyone's attention (Fig. 24, p. 82). In the carnival of 1539 Paul III had been celebrated as the Apollo who had slain the Python of heresy, though there's no hint of that here.[32]

In the latter part of the sixteenth century there is less evidence of the use of Apollonian imagery by the popes, but interest was renewed by the election of the poet Maffeo Barberini to the papacy as Urban VIII. His *possesso* of 1623 was once again celebrated as the inauguration of a new golden age under the papal Apollo, and his verses were published as 'miracles of Apollo'. The papal tiara was likened to Apollo's laurels, the keys of St Peter

to the lyre, and so on. The pope seems to have warmed to the role, and Andrea Camassei painted a *Parnassus* for the Palazzo Barberini.[33]

The Casino of Pius IV, a summer-house in the Vatican gardens designed by Pirro Ligorio in the 1560s, was decorated with stuccoes of Apollonian themes on the façades of the Casino itself and of the pedimented loggia that faced it. But the papal Parnassus was not confined to the Vatican, and the laurel had already invaded the surrounding countryside. The learned men in the papal court liked to think that the Muses might show up at their gatherings. One guest at a humanist garden-party claimed to see there 'half of Athens . . . as well as the Muses, led down from Parnassus and Helicon and transferred to the Tarpeian and the Quirinal'.[34] Why leave these things to the imagination? Unlike the humanists, cardinals from princely families could afford to make such fantasies come true. Ancient statues of the Muses had been grouped together at the Villa Madama and the Villa Carpi, but it was at the Villa d'Este on the Quirinal that Curzio Maccarone created the first great fountain of Apollo and the Muses, with a statue of Apollo at the centre and the Muses in niches around it.

The springs of Helicon and Parnassus made them a natural subject for fountain imagery. And Boccaccio offered an etymology that had Muse coming from *moys*, which, he said, meant water. At Cardinal Ippolito d'Este's other villa at Tivoli, a fountain of Pegasus was positioned among the laurels planted at the top of the hill, and at the Villa Lante at Bagnaia a stream of water spurted from Pegasus's hoof as the nine Muses looked on. Apollo himself is absent from both these fountains, but at the Villa Aldobrandini at Frascati he presides over the Sala del Parnasso at one end of the Teatro dell'Acqua. Here he sits at the top of a stucco hill with the Muses and Pegasus below, with Domenichino's frescoes of his life around the walls. No wonder that Apollo announces in the inscription that he has migrated here and made this place his Delphi, Helicon, and Delos.

The subjects of Domenichino's ten paintings mostly overlap with those in Castel Sant'Angelo, but include Apollo sighting the head and lyre of Orpheus in the River Hebrus, Apollo and Python, and the metamorphosis of Cyparissus. The presence of these subjects, all of which are concerned with death, might suggest that the iconography of the room (which may have been devised by Agucchi) was meant to have some gloomy improving purpose. But they are all taken from Ovid – and in some cases directly from Tempesta – and the appearance of the patron's dwarf peering out from behind the 'tapestry' of Apollo shooting the Cyclopes puts their supposed

seriousness in perspective (Fig. 120). According to Passeri, a big party was held for the inauguration, and the dwarf was strutting his stuff in a Bacchanal when the curtain that had hidden his likeness was suddenly dropped and he saw himself ignominiously portrayed among the slops. He fled to his room and sulked for a whole day. Back at the party, everyone bellowed with laughter.[35]

We are way ahead of ourselves. Coronis was meant to be Apollo's girlfriend, but she was not faithful. One day, Apollo's raven caught her out and flew to tell him the news. In a jealous rage, Apollo shot Coronis dead with one of his arrows, only to discover that she was having his baby. He tried to save them both with medicinal herbs, but only the unborn child survived. Looking for someone to blame, Apollo turned the raven, the bringer of bad news, from white to black. The story is told in the second book of the *Metamorphoses*, but it does not receive much attention in Italian editions, and is correspondingly rare in most Italian painting and decorative art. However, in the second generation of illustrated editions of Ovid derived from Salomon, the death of Coronis was regularly included, and this tradition eventually bore fruit in a tiny but exquisite painting by Elsheimer (Plate XV). The colours reflect the artist's close attention to Ovid's text, for Ovid's contrast between the whiteness of Coronis's body and the red gore that pumps out when the arrow is withdrawn is here transferred to the flowers above, and the red and white drapery below. Her body itself seems almost untouched. She could almost be waiting for her lover (and the composition may owe something to Goltzius's version of the earlier scene) were it not for the funeral pyre being prepared in the background, even as Apollo searches for herbs in the grass.

The death of Coronis was just the first of a sequence of disasters for Apollo. One thing led to another (although on the ceiling of the Castel Sant' Angelo the scenes are not sequential). Coronis's child was Aesculapius, and Apollo entrusted him to the care of Chiron. The centaur taught Aesculapius well, and he grew up to become astonishingly gifted in the art of medicine. Unlike most doctors, he could even revive the dead. But after he resuscitated Hippolytus, Jupiter struck him down with a thunderbolt. Apollo was outraged, and took his revenge on the Cyclopes, who had made Jupiter's murderous weapon, and killed them with an arrow (which, according to Hyginus, later found a place in the heavens). This part of the story is absent from the Latin text of Ovid, and did not find its way into vernacular editions of the *Metamorphoses* until Anguillara, so its appearance in the Sala di Apollo at Castel Sant'Angelo is a fair indication that the Ovidian programme

120. *Apollo Killing the Cyclopes*, Domenichino

was devised on the basis of the Latin edition of the *Metamorphoses* where Regius's commentary fills in the gaps.

Bacon, who knew how government works, thought Apollo must have acted against the Cyclopes with Jupiter's tacit approval.[36] Ignoring the customary physical allegories, he suggested that the Cyclopes were like the bad guys a prince deploys to do his dirty work and then sacrifices to popular vengeance. But most people thought Apollo had stepped out of line, and Jupiter made him stand trial. He could have been thrown into Tartarus, but he was lucky. His mother Latona interceded for him and he got off with community service – a year serving a mortal man as a labourer. That is how he came to work for Admetus, looking after his cattle. He was not very good at the job, and the cattle were stolen by Mercury.[37]

According to some ancient sources, Apollo was distracted from his duties as a herdsman by a boy who had taken his fancy. This aspect of the story is not brought out in the visual arts, even in the seventeenth century when landscapes of Apollo guarding the herds begin to appear. But Apollo's love-affairs with boys were hardly a secret. Take Cyparissus. Apollo loved him, and Cyparissus loved a tame stag who wore pearl earrings. Out hunting one day, Cyparissus killed the stag by mistake. He was grief-stricken, and resolved to kill himself too. Now it was Apollo's turn to get upset. He turned the boy into a cypress tree so that he could always mourn, and be where others mourned. The story was illustrated in Italian editions of Ovid from 1497 onwards, and became a fashionable subject in Genoa. Yet no one had quite the right sensibility to carry it off. The woodcut in Wickram's Ovid is the best attempt (Fig. 121). There are no pearl earrings, but just look at that embossed peytral across the stag's chest!

Had it occurred to anyone, Cyparissus could have been one in a quartet of homoerotically themed stories from Book 10 of the *Metamorphoses* – the others being the death of Orpheus (said to have enraged the Thracian women by turning to his own sex after his upsetting experience with Eurydice), the rape of Ganymede, and the death of Hyacinthus. However, there is little distinctively queer iconography in the Renaissance. (The closest you get is probably Cellini's sequence of marble statues of Ganymede, Apollo and Hyacinthus, and Narcissus – although the link exists only at the point of production.) Nobody even seems to have thought of putting Cyparissus alongside Hyacinthus, the boy Apollo loved but accidentally killed with a discus. The story of Hyacinthus is actually rather more common than that of Cyparissus, even though it was not illustrated in Italian editions of Ovid before Tempesta. There, curiously, Hyacinthus is killed by an arrow rather

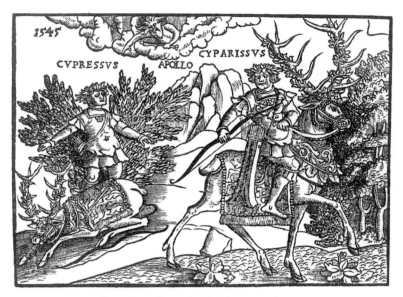

121. *Cyparissus*, from Ovid, *Metamorphoses*, 1545

than a discus. The confusion can be traced back to Salomon, who portrays Hyacinthus dying and seated beside an arrow or javelin. Tempesta knew no better, but Salomon's mistake is corrected in Rubens's project for the Torre de la Parada.

In Arachne's tapestries of the loves of the gods, Apollo appeared as a countryman, a hawk, a lion, and as a shepherd deceiving Isse. The reference to the rustic Apollo was taken to refer to his time guarding the flocks of Admetus, but no one (then or now) had much idea what Apollo might have got up to in hawk's feathers or lion's skin, and Isse was deeply obscure. In consequence, other loves of Apollo were substituted in listings derived from Ovid's. Boccaccio included Daphne, Leucothoë, and Clymene in *L'amorosa visione*, while Spenser opted for Daphne, Hyacinthus, Coronis, and Isse (whom he conveniently turned into Admetus's daughter).[38] In print, Apollo was paired with Daphne and Hyacinthus in Caraglio's series, and with Daphne and Pittura (an unusual allegorical touch) by Bonasone.

However, Ovid recounts several other love-affairs in the *Metamorphoses*, a couple of which involve the god disguising himself as an older woman. That is how he seduced Chione, and also Leucothoë, whom he approached in the guise of her mother while she sat spinning in her room. When he revealed himself as a god she submitted without protest. The story is not usually illustrated in Italian editions of Ovid, although in the North it

becomes a fairly explicit representation of domestic lust. In Salomon's illustration of the scene, Leucothoë was confused with her rival Clytie, the girl who (according to Ovid) betrayed Leucothoë and was eventually turned into a sunflower. This time the mistake was quickly rectified by Virgil Solis and others.

Apollo, the eternal youth, obviously had some sort of affinity with old women, for he also created the oldest of them all – the Cumaean Sibyl. Trying to get her into bed, he fulfilled her wish that she should live as many years as there were grains in a pile of sand. She kept her virtue and lost her youth, and so (according to Petronius) shrivelled up into a bottle – a counterpart to Tithonus, the consort of Aurora, who also missed out on eternal youth and was kept in a basket.[39] You can see Apollo talking to the Cumaean Sibyl in landscapes by Claude and Rosa. Ovid said that even after she had withered away the Sibyl kept her vatic voice, and it was her prophecy of a golden age that was repeated in Virgil's fourth *Eclogue*, although the commentators do not make the connection between the texts.

Numerous as they are, Apollo's love-affairs were never celebrated in the way that Jupiter's were. Apart from anything else they all ended badly, for the god never really recovered from his early setback with Daphne. Cupid had mischievously loosed one of his golden arrows at Apollo, and a leaden one at her. The god was filled with desire, and the nymph was not. As she fled, Apollo tried to explain who he was. How Jupiter was his father, and how he played the lyre really well, and that he was the one who had actually invented the art of medicine. That only made her go faster, her hair streaming out behind her in the breeze. She would have run for ever if she could, but exhaustion finally forced her to make a last desperate appeal to her father, the river-god Peneus. Her prayer was answered, and just as Apollo caught up with her she was transformed into a laurel. The god reached out to touch her, and realized he was embracing a tree. But she was his first love, and the laurel remained his symbol for ever.

Poussin had several goes at the subject: the first time, he showed a seated Apollo trying to embrace the standing nymph as her raised arms turn into laurel above her head. Apollo's pose comes from Raphael's *Apollo and Marsyas*. It might almost have worked, for there is an underlying sense in which Daphne's laurel bark is a second, thicker, skin. But Poussin got it all wrong – Apollo would never have sat down at the end of the chase, and his right hand looks as though it is searching for the best place for an incision rather than a caress. He was not the only artist to find the subject tricky. The forces of attraction and repulsion are here so finely balanced that were

it not for Daphne's exhausted transformation the two figures might be in perpetual motion. This made it hard to convey the movement and the metamorphosis simultaneously, and representations of the subject fall into two main types, depending on the extent of Daphne's transformation. In illustrations to moralized editions of Ovid, on *cassoni*, and in early painted mythologies like the Farnesina and Perugino's *Battle*, Daphne is rooted to the spot, a thin trunk with a human head which Apollo embraces with the chaste ardour of an environmentalist. It is an easy way to convey the meaning of the metamorphosis (and far more effective than the human trunk with a tree for a head found in illustrations to Christine de Pisan's *Othea*), but the result is rather static, not to say ludicrous. Artists soon realized that it would be better to show the metamorphosis taking place while Daphne was still in flight, and confine her transformation to her arms or hair. This approach is taken in illustrated Italian editions of Ovid and in those derived from Salomon, although only Salomon himself manages to suggest the metamorphosis without losing a sense of motion; he does this by twisting Daphne's body so that her legs appear to be moving even as she is rooted to the spot.[40]

Instead of trying to show stasis and movement in a single body, Bernini distributed the contradiction across two figures conceived as a unity (Fig. 122). His secret was the use of the Apollo Belvedere as a model for a running figure. This statue, which had been in the Vatican since the time of Julius II, was a celebrated treasure of the papal collection, and it is one of the few to have had a decisive influence on the representation of a deity. No one had previously used it in this context for the obvious reason that this Apollo is standing still; the possibility of motion is implied by the raised heel of his left foot, but it is a turn rather than a step that is in prospect. Bernini just pulls that heel a little further back, and transforms a static figure into a moving one. Apollo too is being metamorphosed, and as Daphne reaches up into the leaves, her right arm completes the movement begun by Apollo's left leg.

Although Apollo and Daphne were one of those couples (like Venus and Adonis, Bacchus and Ariadne, or Diana and Actaeon) whose story became popular everywhere (except, in this case, in seventeenth-century Holland), the subject is not found in all media. Apollo and Daphne often appear on *cassoni* and pastiglia boxes, but (unlike Marsyas) are rarely to be seen on Italian plaquettes, or in jewellery. The primary reason for this is that the classical sources are literary rather than material, but the relative absence of Apollo and Daphne from tapestry was a moral question. Marsyas and Phaethon were popular tapestry subjects because they were instructive tales

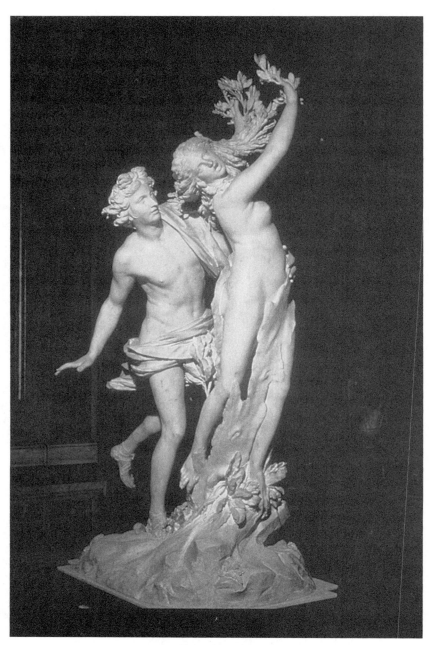

122. *Apollo and Daphne*, Bernini

from which the viewer could easily learn something useful, whereas the fable of Daphne is one of those frivolous stories whose interpretations bear no relation to anything that a viewer might actually see.

For example, according to Giovanni del Virgilio, Apollo is a chaste and modest person, Daphne is prudence, and chastity follows prudence rather in the way that Apollo follows Daphne. Boccaccio offers the inevitable physical allegory in which Daphne is the moisture on the banks of the river Peneus, and Apollo the sun whose warmth causes the seeds of the laurel to germinate.[41] More often, the focus of the allegory is the laurel itself. Dolce says the story shows how women who resist human emotions become barren like the laurel. Orologi takes a more positive view: the laurel is unchanging and resists fire in the way chastity resists love. But he also mentions the curious historical explanation of the story found in Regius in which Apollo is Augustus and Daphne Livia, who remained childless like the barren laurel.

More interesting are those interpretations that take into account the dynamics of the story, the sense of feedback. Cardinal Barberini's epigram on Bernini's group – 'the lover, pursuing the pleasures of fleeting forms, harvests handfuls of leaves and bitter fruit' – nicely conveys the idea that desire withers its own object. The motto on one of Louis XIII's devices tries to put everything into reverse: 'He who flees me crowns me' – a reference to the glory that accrued to the king from the flight of rebels.[42] What these two interpretations have in common is the sense that there is a dynamic relationship between the pursuit and its results. This perception surely derived from a particular type of illustration, for it would be impossible to think in these terms if Daphne's head were not turned back towards Apollo. That turn of the head appears quite early in the tradition and, as Albani sensed, it potentially conveys almost everything the viewer needs to know.

In Ovid, the story of Daphne follows immediately on that of Apollo's defeat of Python, and in early Italian editions they are both illustrated in the same woodcut. However, Python proved far less popular than Daphne. He was an enormous serpent spontaneously generated by the rays of the sun from the mud that remained after the flood. He terrified everyone, and so he died in a hail of arrows from Apollo's bow. Dragon-slaying was iconographically competitive, and Apollo had difficulty in establishing himself in the field. You can see why. Hitting a large target with a quiverful of arrows does not look as exciting as Hercules defeating the multi-headed Hydra with a club, or Perseus flying through the air to slay the sea-monster and rescue the bound and naked Andromeda. There was a difference, though. For Hercules and Perseus (not to mention Cadmus, Jason, Ruggiero, St George and the

rest) defeating the monster was a means to an end – a way to get the girl, or the golden fleece, or achieve immortality – whereas Apollo's defeat of Python is closer to the punishments meted out by the gods to rebellious mortals.

The physical interpretation of the myth, repeated by almost every commentator, was that Python was humidity and Apollo the sun drying up the moisture. (Variations of this interpretation were also used for the Cyclopes.) There was also a long tradition of moral and theological allegory. According to Fulgentius, Python is false belief and Apollo truth, while for the *Ovide moralisé* Apollo is Christ and Python the Devil. Such interpretations made it easy for Python to become confused with the three-headed snake described by Macrobius. The monster, who had the heads of a dog, a wolf, and a lion, was said to be the companion of the Egyptian god Serapis. However, in Petrarch's *Africa* it is given to Apollo instead. In both cases, the creature signifies time governed by the sun, and since Petrarch's account comes from his description of the palace of the Numidian king, he probably thought the three-headed serpent added a bit of local colour. For subsequent commentators, it was far too reminiscent of the beasts of the Apocalypse to remain Apollo's pet. In Bersuire and the *Libellus*, Apollo stands on his long-suffering companion, and the pair are depicted like this in manuscript miniatures, the woodcuts to Colard Mansion's Ovid, and Herold's *Heydenweldt* (Fig. 8, p. 24). According to Bersuire, the heads of wolf, lion, and dog no longer just represent time past, present and future (as in Macrobius), but treachery, injury, and flattery. For Lavinius, they are respectively greed, pride, and envy, and the monster (whom he conflates with Python) that crooked serpent, the Devil.

Although he enjoyed an independent career as an allegorical symbol, the three-headed monster had too dubious a pedigree to insinuate himself into the mythographers' accounts of Apollo (other than Pictor's), and in Cartari's he is finally returned to Serapis. His disappearance from Apollonian iconography left the field open for Python, who became increasingly prominent in the late sixteenth and early seventeenth centuries. Previously a wimpy sort of dragon, he grew larger with the spread of the heretical beliefs with which he was often identified. In the illustration to the 1561 edition of Dolce he attains monstrous proportions, and from Salomon onwards he no longer has to share a woodcut with the xylogenic Daphne. His most prominent role came in the Medici wedding of 1589. All the intermezzi had ancient musical themes. The second involved the Muses' defeat of the Pierides, while the third featured Apollo's victory over Python, a theme mentioned in Lucian's work on dance[43] (Fig. 12, p. 45).

One of those present at this event was the sixteen-year-old Marie de'

123. *Python*, François Chauveau from Charles Dassoucy,
Ovide en belle humeur, 1650

Medici, the future mother of Louis XIII. She could hardly have imagined that the next time Apollo slew Python the two protagonists would be her son and her friend Concini. But that is how it turned out. When Louis XIII authorized the murder of his mother's influential favourite in 1617, the young king's heroic deed was celebrated in a poem, *La Victoire du Phébus françois contre le Python de ce temps*, and also in prints and medals of the subject. Marie put her side of the story in Rubens's series of paintings of her life. Python's view went unrecorded. His revenge is seen in François Chauveau's illustration to Dassoucy's *Ovide en belle humeur* (1650). In a variant of one of the prints that portrayed Louis XIII as the slayer of the serpent, Python fends off arrows with a shield, and the sun-god has to resume his medical practice and administer a clyster instead (Fig. 123).

By killing Python Apollo proved to himself just what a skilful archer he was. And it was because he started boasting about his skills that Cupid, who also knew how to use a bow and arrows, let fly at Apollo and Daphne. The archers of Nuremberg were probably not thinking about that when they placed Peter Flötner's Apollo fountain in their shooting-yard. Flötner's figure is based on Jacopo de' Barbari's print of Apollo and Diana, which inspired numerous German imitations, including a drawing by Dürer in

which Apollo holds the sun in his hand. The substitution of the sun for a set of bow and arrows was not inappropriate, for the equation of the rays of the sun with the arrows of Apollo was standard, and Apollo had been identified with Helios, the sun-god, since antiquity. However, the two were not necessarily identical, for Helios, or Sol, could be identified with other deities as well. Macrobius had linked most of the male pantheon to the sun, and there was also a Christian tradition of solar imagery in which Christ was identified as the Sol Iustitiae mentioned in the Old Testament.[44] Sol himself has little independent identity in the Renaissance, and in practice the chief solar deities other than Apollo were Bacchus, Hercules, and Mercury, all of whom appeared on an ancient solar relief explicated (with the help of Macrobius) by Girolamo Aleandro in 1616. As usual, the logic of this was not transitive. Just because Apollo was the sun, and the sun was Hercules, it did not necessarily mean that Apollo was Hercules. This even applied to Bacchus, whom Macrobius identified directly with Apollo, for according to most mythographers Apollo, like his sister Diana, actually had a threefold identity – Sol in the heavens, Liber Bacchus on earth, and Apollo in the underworld. However, the infernal end of this was forgotten, and no artist bothered much with the rest of it save Poussin, who is fairly consistent in his parallelism between Sol/Apollo and Bacchus: in the preparatory drawing for *The Birth of Bacchus*, the rising sun in the heavens signifies the arrival of the infant god, and in *The Triumph of Bacchus*, the sun's chariot moves across the sky in parallel with that of Bacchus on earth.

As a matter of fact, this was not a sight to be taken for granted, for Apollo had almost given up driving the chariot after that disastrous time he let Phaethon borrow it. Grieving at the loss of his son, he had refused to get up and go to work. For a whole day the earth was in an eerie darkness, lit only by the fires still smouldering after Phaethon's fall. All the gods had to plead with him to drive the chariot of the sun once more. The scene is depicted by Cornelis van Haarlem, probably inspired by Goltzius, whose *Apollo before the Council of the Gods* was the last of six designs for the story of Phaethon. The number reflects the space devoted to the tale in the *Metamorphoses*, although illustrators before Salomon had not usually bothered with anything other than the scenes of Phaethon asking Apollo for the use of his chariot and the fall itself. However, outside the pages of Ovid the two episodes did not go together. Allegory divided the flow of narrative, and the fall of Phaethon became part of the repertoire of punitive Jovian imagery and a popular subject for ceilings, while Phaethon requesting his father's chariot remained a minor Apollonian theme. Its most elaborate rendition is a painting by Poussin that combines the augmented description of the scene

from Anguillara's *Metamorphoses* with a design based not on Raimondi's print of the Judgement of Paris but on the antique sarcophagus itself – except that here Apollo is on the throne rather than Jupiter.

The pose of Apollo in Albani's fresco for the loggia of the Palazzo Verospi in Rome is loosely derived from the same source, but here the sun-god is where we would expect him to be – within the circle of the zodiac at the centre of the planets depicted in the pendentives on either side, and between Dawn and Dusk who fly in the medallions beside him, adjacent to the personifications of Day and Night in the pendentives at either end. Some people have been tempted to link Albani's fresco with the recently promulgated heliocentric theory of the universe, but the centrality of the sun as the guiding influence over the planets was a commonplace of the old cosmology as well. Still, from the second decade of the seventeenth century in Rome, you cannot help noticing that Apollonian themes are everywhere. In 1614, Iacomo Cicognini's musical spectacle *L'amor pudico* included a splendid scene in which the golden age returned to Rome with Apollo and all the Muses. It was no more than the truth. In addition to Albani's solar ceiling, there was Orazio Gentileschi and Agostino Tassi's Loggia delle Muse, and Guido Reni's *Chariot of Apollo*, generally known as the *Aurora* (Fig. 124), at the Palazzo Pallavicini-Rospigliosi (then owned by Scipione Borghese). Over the next few years, Borghese patronage was also responsible for Francesco Guerrieri's *Parnassus* and Bernini's *Apollo and Daphne*, while Reni's painting was soon to be rivalled by Domenichino's *Chariot of Apollo* at the Palazzo Costaguti and Guercino's *Aurora* at the Casino Ludovisi. Out of town, Apollo and the Muses had appeared at the Villa Sora Boncompagni in Frascati and were soon to do so at the Villa Aldobrandini. And almost all this before the coming of the poet pope, Urban VIII.

Although well represented in illustrated editions of Ovid, Apollonian subjects had never appeared together in quite such profusion. It is tempting to look for a single explanation, but as usual there was more than one factor at work. Apollo, Parnassus, and the Muses were already established within Roman iconography, and any patron as ambitious as Scipione Borghese would have been drawn to them. From at least 1612 there are numerous verses celebrating him as 'our new joyful Apollo', and there is a print in which Apollo and the Muses are the supporters holding the cardinal's hat over the Borghese crest.[45] The new element in all this was the arrival of Apollo's chariot as a dominant motif in ceiling painting.

Representations of Apollo driving the chariot of the sun had been common since the fifteenth century, when they frequently appeared in depictions of

124. *Aurora*, Palazzo Pallavicini-Rospigliosi, Rome, Guido Reni

the planets modelled on Baldini. Although initially rather static, the chariot soon picks up speed. At the Villa di Tobia Pallavicino in Genoa, for example, the west and east loggias have matching frescoes by Castello (to reflect the rising of the sun and the moon) in which Diana's chariot is drawn by two nymphs (as in Baldini), but Apollo's careers along with the four horses harnessed in pairs, the first two tossing their heads in fear. It is conceivable that the Genoese taste for the subject reflects the fact that the chariot of Apollo was an *impresa* of Philip II of Spain. But his version, which also appeared on medals and jewellery, was derived from an antique cameo in the Medici collection. Milan was the chief source of this imagery, and it was the Saracchi family workshop there that produced a casket with rock-crystal intaglios for Caterina, Duchess of Savoy, to give to her sister the Infanta of Spain in 1593. A variant of their father's *impresa* (engraved by Annibale Fontana) appeared on the panel on the top of the casket, in which Aurora precedes the chariot of the sun-god strewing flowers as she goes (Fig. 125). It is not difficult to see the parallels between this composition and Reni's *Chariot of Apollo*, which adds the Hours around Apollo's chariot but is otherwise very similar (Apollo's billowing cloak and the position of Aurora's arms are particularly close). At the Palazzo Pallavicini-Rospigliosi, Scipione Borghese was in effect bringing together two traditions, one derived from his predecessors in the papal court, the other from the imagery of the Spanish royal court, where his uncle, Paul V, had been an ambassador before his election to the papacy.

The association of Apollo with royalty was not there at the beginning. In Hesiod, Zeus and Apollo are contrasted: kings are from Zeus, musicians from Apollo. That had changed even before Augustus, but his identification

125. *Apollo in Chariot*, rock-crystal intaglio, Annibale Fontana

with Apollo ensured that solar motifs became a recurrent feature of the imagery of empire. Yet they were by no means essential to royal iconography. The portrait of Francis I with multiple divine attributes (Fig. 18, p. 61) makes no reference to the king's Apollonian qualities, and the sun-god did not feature prominently in the original decoration of Fontainebleau. Only after Francis's death did Apollo come to play an increasing role in French royal imagery. But it remained a subsidiary one, and when thirteen Apollonian subjects finally appeared at Fontainebleau around 1600, it was thanks to their inclusion in the Galerie de Diane. Although Marie de' Medici was celebrated as Diana, her husband, Henry IV, was more often depicted as Jupiter, Hercules, or Mars.[46]

However, when Henry was likened to Apollo (as in several royal entries

337

in the mid-1590s), it was often the god's victory over Python that was evoked. Louis XIII established his claim to the role in the same way. He had already been celebrated as an Apollo Gallicus in 1616 at the time of his marriage to Anne of Austria, daughter of Philip III of Spain, and the following year he proved it by killing the Python Concini. He was only sixteen at the time (just like Apollo, who, some said, had been a mere child when he slew the mighty Python) and it was at this point that Apollo became the dominant mythological figure in French royal imagery. Louis's Apollonian qualities were celebrated in numerous media, and his entry into Lyons in 1622 became the entry of the sun into the sign of Leo – an event greeted with an explosion of Apollonian and leonine imagery, the like of which had probably not been seen since the *possesso* of Leo X a century earlier. In one place Apollo, 'wearing a diadem on his head in the likeness of the radiant Sun', could be seen riding a lion on top of a column (Fig. 126). The lion could submissively hold up a paw to display the anagram 'LOVIS DE BOURBON le Iuste/Seul obey du robuste Lyon', while on the bases the four horses of the sun are tethered to the mouth of a lion's head, rather like the listeners of a Hercules Gallicus.[47]

All the same, Louis was not just Apollo. For instance, he and Anne of Austria were also celebrated as Jupiter and Juno. It was this flexibility that allowed mythological imagery to be reused. In Puget de la Serre's account of his reign, *Les Amours du roy et de la reine sous le Nom de Iupiter et de Iunon*, Louis XIII's sister Henrietta Maria is identified as Diana. She was still Diana when married to Charles I of England and painted with her husband as Diana and Apollo receiving the seven Liberal Arts, presented by the Duke of Buckingham in the guise of Mercury. By the time Honthorst had finished the work in 1628, Mercury had been stabbed to death, and two decades later Apollo was decapitated in Whitehall. Diana alone survived, though not quite long enough to see herself demoted as Amphitrite on the far left of Louis Nocret's mythological portrait of the French royal family in 1672. Here the role of Diana is given to the oldest of the king's cousins, Anne Marie, 'la Grande Mademoiselle'. Louis XIV himself is Apollo while his wife is Juno – a telling reversal of the situation under Henry IV, when the king was Jupiter and Marie de' Medici Diana.

Charles I was not the only ruler who picked up French Apollonian imagery in the seventeenth century. In the Oranjezaal in Huis ten Bosch, Jacob van Campen's *Chariot of Apollo* presides over the Muses and the allegorical scenes of the education of Frederik Hendrik. And towards the end of the century, the Habsburgs started to use solar motifs as well, even though Apollo had not been particularly prominent in imperial propaganda since

126. Column for entry of Louis XIII into Lyons, from *Le Soleil au signe du Lyon*, 1623

127. *Apollo Tended by the Nymphs of Thetis*, Versailles, François Girardon

the reign of Maximilian I. In the Habsburg case, they were feeding directly off the iconography of the Sun King himself, Louis XIV.[48] For him, at least, there was no avoiding the Apollonian role. The heir to both French and Spanish royal solar imagery, he also shared a birthday with Tommaso Campanella, the heterodox Dominican whose *Civitas Solis* had fused the new heliocentric cosmology with Spain's royal solar imagery. A former adviser to one Apollo (Cardinal Barberini in Rome), Campanella was called in to cast the horoscope of another, and greeted the birth of the future Louis XIV with an eclogue that predicted a new golden age centred on a city that would be called Heliaca. A celebratory medal was struck commemorating the birth as the rising of the Gallic sun.[49]

From this beginning, there was no going back. Louis defeated Python in the rebellion of the Fronde, and confirmed his Apollonian identity by taking the role of the god in the ballet 'The Wedding of Peleus and Thetis' in 1654. But unlike his predecessors, Louis was not a part-timer: the sun rose when he got out of bed in the morning, and set when he went to sleep. The artistic expression of this total identification between king and sun-god was

Versailles, where the Salon d'Apollon (with Charles de la Fosse's ceiling of the sun-god coursing across the sky) was also the throne-room. It was probably the first time Apollo rather than Jupiter had presided over the throne, and the change highlights the way in which sovereignty, which had once been expressed as Herculean strength and then as Jovian omnipotence, was now conceived in terms of Apollonian splendour. The sequence is an acknowledgement that rulership required more than an ability to fight off the enemies of the state, or achieve a monopoly of power within it. Power also had a cultural dimension: the visible proof of the sun's ability to co-ordinate its numerous satellites was its ability to outshine them.

The iconography of Versailles does nothing to dispel the suspicion that there might be something mythologically decadent about such an ideal. The most striking Apollonian monument in the place was François Girardon's *Apollo Tended by the Nymphs of Thetis*, which originally stood in the grotto of Thetis (Fig. 127). It depicts Apollo being given a chair-bath after a long day driving his chariot, which signified the king who came to Versailles to rest after wearing himself out doing good to everyone. Looking at the group, you cannot help being reminded of Diana, who was being tended by the nymphs when surprised by Actaeon. That was a forbidden sight; this was more or less compulsory. And at Versailles, it was not the viewer who would eventually be devoured.

9

The Mirror

Once in a while, the gods all got together for a party. The excuse varied. Bellini's *Feast of the Gods*, the event at which Priapus disgraced himself, was a rustic feast in honour of Bacchus or Cybele. Weddings were usually big occasions. The banquet of Cupid and Psyche at the Farnesina was the prototype for many future celebrations. It is the end of the tale of Cupid and Psyche, but the scene doubtless owed its prominence on the ceiling of the loggia to the fact that Agostino Chigi, who hosted legendary parties, may well have dined in similar style. Bacchus served the wine, the Graces sprinkled balsam, the Muses sang, and Venus danced. But it was still more of a ritual than a party, which may be why, at the Palazzo Te, Giulio Romano just showed the sumptuous preparations and left viewers to have the party themselves. People must frequently have imagined themselves dining among the gods at such events. When Ficino wrote to Lorenzo de' Medici to thank him for his past hospitality at the feast of St Cosmas, he spoke of it as a banquet of the gods like that described by Apuleius.[1]

The Farnesina banquet and Giulio's scenes of preparation provided the models for later depictions of the scene in Italy and France. So when Spranger produced his great drawing of the wedding feast, the figures around the table resembled the arrangement at the Farnesina, while on the far left the figure of Vulcan with one arm outstretched directing the viewer towards the festivities is derived from the Palazzo Te. In the middle are large numbers of other gods resting on billowing clouds. It is unclear what purpose Spranger's drawing was designed to serve, but it was engraved by Goltzius, and then reworked by Wtewael in several paintings and drawings. A dramatic painting on copper is the composition closest to Spranger's design (Plate XVI). Here there has been an explosion, shooting crowds of putti high into the air, making the clouds spasm like intestines, and throwing Spranger's elegant gods and goddesses into confusion. On the right, instead of the stately procession bringing food for the table under the direction of Minerva, come Bacchus, Silenus, and a host of drunken revellers. Hercules, who according

to van Mander had been in charge of security at the earlier event, stands gesturing into the air. Below him Mars and Venus have left the table to party in private, and Saturn, who had been politely nibbling on the arm of one of his children, forgets his manners and turns to gorge himself on a more succulent sibling. The Muses, formerly playing under Apollo's direction, now play on without him, looking anxiously at each other as they try to keep time. Only Pan, the god of panics, keeps his cool.

This is no longer the banquet of Cupid and Psyche, but the wedding of Peleus and Thetis. Thetis was the nereid courted by both Jupiter and Neptune whom they decided to marry off to Peleus when they learnt that her son would outdo his father. Jupiter is there in the centre, downing a drink and making the best of it. Neptune, with shells on his head, is sprawled at the lower left. The bridal couple are presumably the pair under the Hour with the flowers, but no one is paying them much attention. There is an uninvited guest: Eris, the goddess of strife, whose sudden arrival above the table has alarmed the revellers. In her hand she holds the golden apple. For 'the fairest', she says, and throws it down among the goddesses. Through a break in the clouds on the upper left you can see the outcome. Three goddesses come to the shepherd Paris for judgement, and he gives the apple to the winner.

Wtewael's reworkings of Goltzius's print after Spranger were only a few of the many 'Feasts of the Gods' produced in late sixteenth- and early seventeenth-century Holland. Cornelis Cornelisz. van Haarlem, Hendrik van Balen and Abraham Bloemaert all produced one or more versions, and each in turn seems to have more food, more wine, and a generally lower standard of behaviour. The wedding of Peleus and Thetis was mentioned in classical sources, and, following Hyginus (who first made the connection with the Judgement of Paris), by the mythographers, but it was not much elaborated before the appearance of the *Ovide moralisé*.[2] This version was reworked in other texts, and also contributed to the extended account, leading into the Judgement of Paris in Jean Lemaire's *Illustrations de Gaule*. Neither Wtewael's appropriation of Goltzius's print nor other versions of the scene follow Lemaire's account directly, but without it the subject would never have established itself. Conversely, there was no established iconography for the scene before the appearance of Goltzius's print. It was the conjunction of the two, combined perhaps with the retrospective idealization of the marriage of William the Silent and Charlotte de Bourbon as the union of Peleus and Thetis in the golden age, that allowed the subject to develop in Holland in a way that it did nowhere else.[3]

*

343

It is one of the best-known stories in Greek mythology, but the Judgement of Paris is not found in Latin or Italian editions of the *Metamorphoses*. All the same, the story was well known in the Middle Ages in a version that derived from the pseudonymous Dares of Phrygia, and it was transmitted through the Trojan histories of Benoît de Sainte-Maure and Guido delle Colonne to Raoul Le Fèvre's popular *Recueil des hystoires de Troyes*.[4] According to this tradition, Paris was out hunting in the woods, but fell asleep and had a dream in which Mercury brought him the three goddesses; he decided in favour of Venus, because she promised him the most beautiful woman in Greece as his wife. The scene was frequently illustrated in manuscript and later in the woodcuts to Le Fèvre. Paris is shown asleep in full armour, either beside a fountain or else underneath the tree to which his horse is tethered. Mercury stands between him and the three goddesses, who are lined up in a row to the right. It was Guido's version of the story (translated into German in 1477) that inspired Cranach's many paintings of the subject, in all of which Paris is either reclining or sitting up looking slightly dazed. The goddesses themselves may be standard-issue Cranach floozies with interchangeable props from the dressing-up box, but Mercury puts on an extraordinary show – he always wears elaborate armour, and in one version has a little skirt made out of peacock's feathers, a reference to his defeat of Argus, whose eyes were transferred to the tail of the peacock.

Lemaire clearly thought he could improve on this version of the tale, for he also had access to the classical versions of the story to be found in Ovid's *Heroides*, where Paris describes the event in a letter to Helen, and in Apuleius's *Golden Ass*, in which the scene is recreated as a pantomime. It is not a dream any more – though Paris asks himself incredulously whether it might have been. Lemaire's version was reprinted and illustrated in *Le Grand Olympe*, replacing a version of the story inherited from the *Ovide moralisé*, and it found its way into both de Passe's Ovidian illustrations and van Mander's *Wtlegghingh*, where it was tacked onto the end of the story of Peleus and Thetis in Book 11. This was the usual point at which to interpolate the tale, though Renouard's French translation of Ovid is more respectful of the text and saves the story of the Judgement for a long appendix.

According to Lemaire and van Mander, it was Ganymede who came up with the suggestion that Paris should be the judge of the goddesses. This aspect of the story does not seem to have been illustrated, but Mercury also plays a significant role in the discussions, and according to Lucian (who is the first author to mention an inscription on the apple rather than an announcement), it was he who read out the inscription for everyone's

benefit. A painting by Jordaens, in which Mercury can be seen pointing to the inscription, may carry this implication. It makes you wonder how many of the goddesses could actually read. In Lemaire they read the inscription for themselves, but the rate of female literacy was probably higher in the Burgundian court than on Mount Olympus.

Although the story of the Judgement of Paris was available in some of the most popular classical texts, it did not become a major theme in Italian painting. Nevertheless it was extremely popular in the decorative arts, and especially common in the ornamentation of pastiglia boxes, where it often appears alongside the story of Pyramus and Thisbe. In the fifteenth century it sometimes provided the subject for ceramic inkstands where, following the northern tradition, Paris sleeps beside the fountain either with his horse tethered behind him or with the three goddesses gathered around (Fig. 128). Since Paris chose in the end to have the most beautiful woman in Greece as his bride, the subject was obviously attractive for *cassone* panels, where it is sometimes complemented by the abduction of Helen. However, the literary sources for these panels are not usually the Trojan narratives, but more often Boccaccio or the *Heroides* – where the passage describing the contest forms part of Paris's letter to Helen proposing marriage (and her cautious response describes her pleasure in having been chosen above the rewards offered by Juno and Minerva). In neither case is Mercury present for the judgement itself, and Boccaccio leaves him out altogether, saying merely that Jupiter sent the goddesses off for Paris's opinion.

This detail suggests that the scene by the Master of the Argonaut Panels, in which Jupiter points the way to Paris at one end of the panel, and Paris makes his choice at the other, may be taken from this source. But Boccaccio does not explain why one of the goddesses should have wings on her head. On this panel it looks as if she ought to be Minerva, though on several other *cassoni* she is undoubtedly Venus. Venus sometimes has large wings on her shoulders in early German art, but the pair on her head is too dainty to have flown upwards. Winged headgear like this is sometimes given to evil figures in medieval manuscripts, but in this context you cannot help wondering if it has been borrowed from Mercury. When he appears in his winged helmet, it is unusual (but not unknown) to find Venus with head-wings as well.

Whatever its origin, the motif spread widely, and although Venus does not appear like this in earlier northern representations of the subject she is represented in this fashion on a design reused for the title-page to the 1524 edition of Lemaire. Marcantonio Raimondi's earliest print of the subject also shows Venus with wings on her head, but after this the wings abruptly

128. *Judgement of Paris*, inkstand, fifteenth century, Faenza

disappear from Italian art. The ancient sarcophagus which inspired Marcantonio's print after Raphael redefined the treatment of the subject (Fig. 129). The print itself is a very free interpretation of the antique relief (Fig. 4, p. 10). The right-hand scene of the goddesses returning to Jupiter is omitted, and the focus is on the judgement alone. In the relief, the goddesses are all draped (and only one can be seen full length) but Raphael ignores his antique model in deference to the literary tradition, and presents nudes from three different angles – frontal, three-quarter, and rear views – an idea much imitated, and varied, by later artists. Marcantonio's print became his most famous work (it was especially popular with painters of maiolica), and by the time of Rubens certain elements of Marcantonio's version – Paris's Phrygian cap (the token of his barbarian origins), the idea that Minerva is the one pulling her clothes over her head, and Paris's distinctive pose – had established themselves in the iconography of the subject independent of the composition.

There were, however, some media to which this particular subject was not well suited. Because it required so many figures it was not easily tackled in any sculptural medium other than relief (though in seventeenth-century Germany there was at least one group of statuettes), while tapestry presented another kind of difficulty. The underlying problem here was the goddesses' nudity. Though only Venus, if any of them, appears nude in antique representations, classical literary sources made clear that all the goddesses had shown

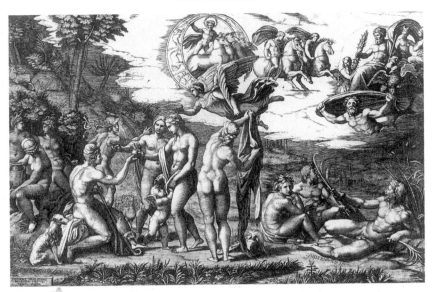

129. *Judgement of Paris*, Marcantonio Raimondi after Raphael

themselves to their judge completely naked. This tradition was respected, and though some of the early Trojan literature suggested that it was only Venus (who had ensured victory by flashing Paris on an earlier visit), Guido and his successors have them all naked. Yet despite the fact that Le Fèvre was a major source for tapestries produced in Flanders, the Judgement of Paris did not establish itself as an independent tapestry subject. Indeed, Allori's four tapestries for the Medici workshops are perhaps the only surviving sixteenth-century series devoted to the theme. He dealt with the problem of mass nudity by having one panel showing the goddesses starting to get undressed, and so still with all their clothes on, and another in which carefully positioned drapery preserves the modesty of Juno and Minerva, and Venus wears the light gown described by Apuleius, except that here the wind does not blow it aside in quite the provocative way the author describes.

In other media, the goddesses are more often nude in northern Europe than in Italy. Some *cassone* panels show all the goddesses fully clothed, while others have only Venus nude. In the latter case the artists may be following Fulgentius, who treats nudity as the attribute of Venus, alongside the veil of Juno and the crested helmet of Minerva – an iconography that can later be seen in Ghisi's print after Bertani and (although Juno is not veiled) in a painting of Elizabeth I at the Judgement. By the seventeenth century, the goddesses were pretty much always naked, though that did not

stop the Cardinal-Infante Ferdinand writing to his brother Philip IV of Spain to complain that the women in one of Rubens's many paintings of the subject were actually 'too naked'.[5] Venus was thought by some at the time to be a portrait of the artist's young second wife, though that would hardly explain why the painting was still kept behind a curtain at the Buen Retiro, where nobody would have known her, in 1653.

The allegorical understanding of the Judgement of Paris was founded on Fulgentius's interpretation in which the three goddesses represent three ways of life – the contemplative, the active, and the sensual – and the decision of Paris is, in effect, the choice between them. Minerva represents the contemplative life, for she is the goddess of wisdom, born from the head of her father Jupiter; Juno, the wife of the king of the gods, stands for the active life – the pursuit of power and wealth symbolized by the peacock, who is always trying to put on a show with its tail, and thereby exposing its behind; Venus is, of course, the life of pleasure. Fulgentius condemns all except the life represented by Minerva, even though the active live had traditionally been thought a necessary and acceptable alternative by the philosophers.

However, not everyone responded to the choice in the same way. Lemaire, who wrote for the edification of the young Charles V (whom he likened to Paris), made clear that Paris had made the wrong decision. Ficino thought all the goddesses had something worthwhile to offer, and suggested that Lorenzo de' Medici had selected the best from each: Juno's power, Minerva's wisdom, and Venus's poetry and music.[6] In contrast, a painting showing Elizabeth I of England approaching the goddesses holding an orb (instead of an apple) suggests that she could outdo the lot of them: Juno flees, leaving behind her slipper, Minerva is dumbstruck, and Venus blushes.

Princes might think they could have everything, but for most people the choices involved were real enough. Elsheimer produced three small panels (now known only from prints) showing the realms of each goddess: Venus belongs in that of nature, lying naked in the landscape accompanied by Cupid gathering flowers; Juno sits on a throne backed by a tapestry with various trading activities taking place behind her, while Minerva presides over a scene of intellectual activity, which includes a painter working from a model posing as Marsyas. This type of imagery reflects that of the planets, who were routinely shown governing realms populated with their 'children'. In fact the iconography had already been extended by Goltzius, who had shown Bacchus, Ceres, and Venus with their respective devotees as well.

*

130. *Four Seasons,*
Simon Vouet

The planets represented destinies, and the goddesses in the Judgement of Paris choices, but in other contexts the gods did not necessarily define their own territories. They were also routinely distributed among other divisions of the natural world, most commonly the four seasons and the four elements. There was no consistent iconography for either, though spring was usually represented by Venus or Flora; summer was almost invariably Ceres; and autumn was usually Bacchus, the god of the vine harvest, though it could sometimes be represented by Pomona with a basket of fruit. Winter was the season with the least constant iconography: often it was represented by Vulcan keeping warm by the fire, but it could also be Adonis, as in Vouet's painting of the *Four Seasons* (Fig. 130), or Janus, who faced both the old year and the new, or one of the wind-gods like Aeolus. Of the elements, Juno was the air, because Jupiter had suspended her in the air as a punishment; water was represented by Neptune, or Venus, who had been born at sea; earth could be symbolized by any of the fertility-gods like Cybele, Flora, Ceres, or Pluto, while fire was usually figured by Vulcan at his forge.

The gods could be fitted into other divisions as well. Herman Muller engraved a series of prints after Heemskerck which matched them with the four temperaments: Luna, phlegmatic; Saturn, melancholic; Mars, choleric; Jupiter and Venus, sanguine. Somewhat similar to this is Adriaen Collaert's series, after Maarten de Vos, in which the planets each preside over one of the seven ages of man, proceeding from Luna (infancy), through Mercury,

Venus, Sol, Mars, and Jupiter, to Saturn, extreme old age[7] (the same sequence is in Cortona's frescoes at the Palazzo Pitti). However, the other gods could be distributed in this fashion too. Matham's prints after Karel van Mander show them representing the four times of day: Aurora, morning; Apollo, noon; Venus, evening, and Morpheus (the god of dreams), night. And a painting by Paolo Fiammingo groups some as the five senses: Jupiter, sight; Venus, touch; Ceres, taste; Flora, smell, and Apollo, hearing. In both cases these are sensible identifications based on other associations of the gods. But unlike the planetary series, these are artificial constructs, for in neither case were the gods traditionally involved in these iconographies. More unusual still is the print by Leon Davent in which the gods appear holding branches of their respective trees: Jupiter, the oak; Apollo, the laurel; Minerva, the olive; Venus, the myrtle, and Hercules, the poplar – a notable absentee being Pan and the pine (Fig. 131).

If you were to put all these things together, would the result make any sense? In his *Heydenweldt*, Herold has a table in which each of the Olympians is matched up with their respective elements, bodily organs, birds, animals, fish, metals, star-signs, and months of the year.[8] But the results are not terribly informative, for some associations are traditional and others are just there to fill in the blanks, and there is no scope for more than one thing of the same type to be associated with any divinity, so Jupiter ends up with the stag and the dolphin, creatures usually seen with Diana and Venus respectively. Furthermore, sixteenth-century mythographies do not even pretend to tell us anything about the structure of mythological imagery in the Renaissance. Their subject is the ancient world, the stories, images, and rituals of the Greeks and Romans, not the stories, images, and rituals of contemporary Europe. There is no guide to the structure of mythological imagery in Renaissance Europe other than its own distribution, content, and use.

That pattern, if there is one, is the result of thousands of individual choices made by patrons (and their advisers) about what they wanted to see, and by artists about what they wanted to show. Twenty-three gods and heroes were described in the *Libellus*, but not all of them went on to become famous. Why did some make it and others not? The lack of good material to work with was a big factor. Aeolus the wind-god was little more than a personification, and although Vesta (Fig. 9, p. 25), Janus, and Aesculapius had all been cult deities of some importance in ancient Rome, Janus and Aesculapius only had walk-on parts in classical literature, and Vesta did not really have a role at all. In other cases, the gods had already been marginalized by the structure of mythology itself. That Jupiter, rather than his

ARBORVM GENERA NVMINIBVS SVIS DICATA
PERPETVO SERVANTVR VT IOVI ÆSCVLVS,
APOLLINI LAVRVS, MINERVÆ OLEA.
VENERI MIRTVS, HERCVLI POPVLVS.
·PLIN LIB XII·
·1547·
L·D

131. *Gods Holding Trees*, Leon Davent

father or two brothers, was the focus of interest in Renaissance culture is largely the result of his role in ancient myth. His father, Saturn, had already been packed off to exile in Italy, and so took little further part in mythological narrative, though he remained important as a planet, as the god who had presided over the golden age, and increasingly as a model for the allegorical figure of Father Time. In the division of the universe with his three brothers Jupiter also came out the winner. Neptune, god of the sea, was a common figure in fountains and, accompanied by other marine deities, in depictions of marine triumphs (Fig. 8, p. 24). Admirals identified with him, and he enjoyed a prominence in seafaring republics like Genoa, Venice, and Holland that he could not maintain elsewhere. As for Pluto, god of the underworld, he was even worse off, for there was limited visual interest in classical conceptions of the underworld when Christian ones were still so alarmingly vital. The rape of Proserpina and his interview with Orpheus in Hades were Pluto's two claims to fame, and the former is a common subject. But in general, mythological art was overwhelmingly concerned with this life rather than the next one.

The story of Proserpina was also pretty much Ceres' only source of narrative involvement, for she searched the earth for her daughter and left the earth barren until she was returned. Her role as the goddess of agricultural fertility was widely acknowledged and she frequently appears in allegories with ears of corn in her hair, notably in the seasons and when shown with Bacchus and Venus (Fig. 79, p. 220). Other fertility goddesses, like Cybele who was identified with Ops, the wife of Saturn and the mother of Jupiter, remained even more remote from narrative, though Cybele can sometimes be seen cheerfully wearing a castle on her head and driving along in a carriage drawn by lions. Rather more popular in the Renaissance was the younger, more attractive Flora, a Roman goddess of flowers and prostitutes who has no Greek ancestry and does not appear in either the *Libellus* or the *Metamorphoses* (though Ovid identifies her with the Greek nymph Chloris in the *Fasti*) (Fig. 72, pp. 202–3).

If the fertility goddesses were often swallowed by their own allegories, other gods lost out to a related deity whose qualities were more attractive. The god of nature himself, Pan, ends up as Bacchus's lieutenant, and Juno, who plays quite a prominent role in the *Metamorphoses* (and the *Aeneid*), is too dependent on Jupiter to attract attention in her own right. Vulcan's craft and culinary skills were useful, and he fitted the role of cuckolded husband very well, but nobody takes too much interest in his life-story (Fig. 9, p. 25). There was no way that Venus was ever going to be outshone by any of the men in her life, which meant that Mars suffered as well (Fig. 8, p. 24). A planet in his own right, albeit one like Saturn that was

acknowledged to have a malign influence, Mars lost out to Hercules (to whom he was sometimes compared) as well as to Venus. There were giant statues of him in Venice and Fontainebleau, but unlike Hercules he had few stories of his own. Generals and warrior princes identified with him, notably Henry IV in France, and Count Wallenstein, whose palace in Prague is decorated with a prominent ceiling painting of the god in his chariot. But Mars' unrestrained bellicosity meant that he had an ambiguous moral status; in sixteenth-century Florence, for example, he was considered to be an inappropriate model for a Christian militia.[9]

There are, however, two figures from classical mythology whose exploits were often represented: Orpheus and Perseus. In both cases, their stories were told in the *Metamorphoses*. With the help of Minerva, Perseus, the son of Danaë, killed Medusa, one of the Gorgons. From this feat he acquired the winged horse Pegasus (who sprang from her blood) and Medusa's head, which turned all who looked at it into stone. Equipped (in later representations of the subject) with these two supernatural aids he rescued Andromeda, an Ethiopian princess who had been chained to a rock as an offering to a sea-monster (Plate VIII). Later, at their wedding feast, he used the Gorgon's head to defeat Andromeda's former suitor, Phineas. Orpheus was a poet and musician whose skill was such that even wild animals came to hear him play the lyre (Fig. 132). When his wife Eurydice was bitten by a snake, he went to Hades and used his musical skill to persuade Pluto to let her go. The god of the underworld allowed her to return on condition that Orpheus did not look back on the way, but he could not help himself and so lost her for ever.

Of course, neither Perseus nor Orpheus was strictly speaking a god, though, according to Hyginus, both Perseus and the lyre of Orpheus were placed among the stars (which is why they appear in the astrological ceiling of the Villa Farnesina). The real difference between Perseus and Hercules, or Orpheus and Apollo, is that Hercules and Apollo appear repeatedly in a variety of narrative contexts, whereas Perseus and Orpheus are central only to their own stories. Orpheus, but not Perseus, was common on *cassoni* (some of which follow the version of the story found in Virgil's *Georgics*), and the story of Perseus was often illustrated in Genoese palazzi beginning with the Palazzo Andrea Doria. Perseus was also one of the mythological figures with whom the Medici identified (hence Cellini's statue in the Piazza della Signoria). In general, however, both he and Orpheus are typical of Ovidian subjects in that they are more common in maiolica and decorative friezes than tapestry, though paintings of Orpheus often decorated musical instruments as well.

In the case of two other gods, Mercury and Minerva, the situation is more

132. *Orpheus*, mosaic, Galleria Borghese, Rome, Marcello Provenzale

tricky, for both appear with great frequency in Renaissance art, and have a complex role within it. Among the most recognizable of the gods – Mercury with his winged sandals and sometimes his helmet and caduceus, Minerva with her breastplate, crested helmet, spear, and shield – they each stand for a different form of reason. Mercury is eloquence and calculation, Minerva wisdom, and they could be joined, Siamese twins of the intellect, in the two-bodied figure Hermathena (which Lomazzo recommended for the iconography of schools).[10] However, the very fact that their primary qualities were intellectual meant that they tended either to function as allegories or else to be instrumental in the actions of others. Mercury often appears in a secondary role with other gods, for, as Lemaire noted, his is a planet neutral in itself that takes on the character of others.[11] He was usually busy running errands for Jupiter, but he did some things on his own initiative, notably falling in love with Herse, and stealing the herds of Admetus from under Apollo's nose (both episodes in Ovid). He also invented the lyre, which he exchanged with the caduceus when he was forced to reconcile with Apollo.

Minerva was the Greek goddess Athena, and her contest with Neptune for dominion over Athens was one of her tapestry subjects when competing with Arachne in the weaving contest described, and occasionally illustrated, in the *Metamorphoses*. But weaving was just one of her accomplishments.

A warrior who did battle with giants, she also acted as the protector of the heroes Hercules and Perseus, and supervised the Muses on Mount Helicon. You might think all that was enough to secure her a room of her own in any palazzo, but Zucchi's cycle at the Palazzo Medici in Rome (which includes all these subjects and more) is one of very few, and even here she has to share the space with her protégé Hercules. It was probably the way she dressed. Although sufficiently good-looking to take part in the Judgement of Paris, she was usually to be seen wearing a long robe and unwieldy armour (Fig. 8, p. 24). Spranger's *Minerva Triumphs over Ignorance* (Fig. 133) is an astonishing make-over, and she never looks as glamorous anywhere else, though Scipione Borghese rather naughtily had Lavinia Fontana paint a picture of her putting on her clothes. Nevertheless, Minerva's un-sexy appearance made her well suited to the more serious sort of allegory. In the choice of Hercules, she is often shown personifying virtue, and she was much favoured by mature queens and civic corporations.

The six gods who really dominate Renaissance visual imagery are Hercules, Jupiter, Venus, Bacchus, Diana, and Apollo. Not all are equally prominent in every medium, but in simple numerical terms representations of these gods are more common than those of their fellows. Furthermore, each tends to be the dominant figure in the narratives in which he or she appears. On a simple head-count Mercury appears about as frequently as Diana, but usually in contexts (the Judgement of Paris is one example) where he is not the principal actor in the scene, and could be omitted if necessary. There are enough narratives connected with the most favoured gods for each one (with the exception of Venus) repeatedly to form the focus for the decoration of a room or a series of paintings or tapestries. Each enjoys widespread distribution, narrative centrality, and iconographical density.

If narrative interest were the sole factor determining an image's viability, then the stories told by Ovid should all have had a good chance of illustration and replication. But only a fraction of the stories from the *Metamorphoses* became common subjects in the visual arts. Giovanni del Virgilio had counted 244 separate transformations, but in the 1497 Italian edition there were only fifty-three illustrations (although some included more than one metamorphosis). Of these fifty-three scenes, fewer than half became established themes in other media. Those most rarely illustrated were subjects concerned not with gods and heroes but with the fate of obscure mortals like Minos and Scylla, Alcyone and Ceyx, Athamas and Ino, Triptolemus and Lyncus. The publication of Agostini's translation added many more popular subjects, including Jupiter with Io and Semele, Narcissus, Pyramus

133. *Minerva Triumphs over Ignorance*, Spranger

and Thisbe, and Latona and the peasants. But some of the other new scenes, like those of Caunus and Byblis, Iphis and Ianthe, Tereus, Procne, and Philomela, had little impact.

Omission from the *Metamorphoses* was not necessarily an obstacle to the illustration of a story. The list of popular subjects not illustrated in Italian editions of Ovid is a long one. Some – for instance the Judgement of Paris, the Birth of Venus, Leda and the Swan, Diana and Endymion, Jupiter and Danaë, and Cupid and Psyche – do not appear because their stories are absent or barely mentioned. Others – Venus and Adonis, Pomona and Vertumnus, Hercules and Deianira – remained unillustrated before Tempesta because publishers and artists were slow to respond to new emphases in the reading of the text. In some cases, however, new illustrations did reflect the popularity of subjects in other contexts. That is why the Muses appear in Agostini, the battle of the Giants in Dolce, and Bacchus and Ariadne in the 1584 edition of Anguillara.

There would seem to be two dynamics at work. Some descriptions of the gods in the *Libellus* include attributes with a narrative dimension – Ganymede and the Giants in the case of Jupiter, for example – but most do not. So, on the one hand, mythological imagery needs content – stories that are dramatic, funny, or surprising; on the other, narratives need visually recognizable figures with whose attributes and character viewers are familiar. When a selection of scenes from the *Metamorphoses* is used on a frieze or, later, in a set of tapestries, they always involve a disproportionate number of gods. It would be very surprising to come across a sequence consisting only, or even predominantly, of mortals, even though half the episodes in an illustrated edition of Ovid generally do not show the gods at all.

In this regard, being one of the planetary deities was a great benefit. It may help to explain why Diana/Luna becomes so much more prominent than Juno (who figures in many episodes in the *Metamorphoses*) and why Apollo, rather than Minerva, ends up with the Muses. Sometimes, too, bits of narrative gradually attach themselves to better-known figures. Someone like Theseus is squeezed on two sides – he gradually loses his central role to Hercules in the battle against the Centaurs, and Ariadne to Bacchus (though he only had himself to blame for that). Narratives that were similar could become fused – the battles of the Titans and the Giants against the gods, for example; and the contests of Pan and Marsyas with Apollo. And, in the visual arts, the multiplicity of gods with the same name quickly disappeared. Distinguishing between Apollo and Diana and their heavenly counterparts Sol and Luna was too confusing for most people, let alone trying to remember the difference between the three Jupiters discussed by Boccaccio.

Alongside this process in which narratives and deities fuse together and cohere around the most prominent gods, there are also certain constants. You cannot help noticing that the most popular subjects are those that involve a man and a woman in an erotic situation – the loves of Jupiter; Venus with Mars or Adonis; Cupid and Psyche; Bacchus and Ariadne; Diana and Endymion; Apollo and Daphne. Or a selection of female nudes – the Judgement of Paris; the Three Graces; Diana and Actaeon; the discovery of Callisto. Or else the presence of exotic animals – Hercules with Cerberus, the lion, the hydra, or centaurs; Bacchus with his tigers; Orpheus and the animals. Whether there is some phylogenetic explanation for this, who can say? But it makes it easy to see why Perseus and Andromeda with the sea-monster is so much more popular than any other episode involving the hero.

Given that six gods appear to be more central to mythological imagery than the rest, the easiest way to start mapping the field is by plotting their relationships to each other – not as they feature in the corpus of classical literature, but as they are represented in the Renaissance. On this basis, it is apparent that there are three clear alliances among the six gods: Jupiter and Hercules; Venus and Bacchus; and Apollo and Diana. Hercules is one child Jupiter rewarded with deification, and in Renaissance art both are closely associated with the idea of dominion, though Jupiter's is the more universal. Venus and Bacchus, too, are consistently allied, through '*sine Cerere et Baccho friget Venus*', and in their shameless love of pleasure. Apollo and Diana are brother and sister, the sun and the moon; together they avenge Niobe's insult to their mother.

If the alliances between the gods are relatively clear-cut, the oppositions and tensions between them are more complex. Venus and Bacchus are frequently condemned together, and in Tory's *Champ Fleury* there is a woodcut showing the triumph of Apollo and the Muses with Bacchus, Ceres, and Venus as captives in their train.[12] There were reasons for this hostility: Venus and Apollo had fallen out over the discovery of her adultery with Mars, and Venus and Diana are constantly at war over the question of sex. In Perugino's *Battle of Love and Chastity*, Diana is aided by Minerva and Venus by satyrs, while in Simeoni's *Illustratione* Apollo joins Diana in shooting cupids out of the sky (Fig. 97, p. 266). Bandinelli's allegorical print *The Battle of Reason and Lust* has Apollo leading Jupiter, Mercury, Saturn, Hercules, and Diana against Venus and Cupid and their armourer, Vulcan.

The way in which everyone picks on Venus and Bacchus helps to explain the ease with which the choices the hero is offered quickly collapse into just two or three alternatives. Where there are two possibilities, as in the choice

of Hercules, it is a straight choice between the easy but destructive path offered by pleasure, and the virtuous climb uphill. With three options in the Judgement of Paris, it is not so much that a third possibility is offered as that the paths of virtue are differentiated. Hercules is usually seen making a choice between Venus and Minerva (although Ficino thought of it as a choice between Venus and Juno), and Parnassus can sometimes be glimpsed as his destination – though in fact he ends up on Olympus. In the Judgement of Paris, those options are more clearly differentiated: Juno represents the worldly authority of Jupiter, Minerva the cultivated virtue of Parnassus, and Venus represents herself.

Although it is described as a choice between three women rather than two roads, the Judgement of Paris also plots the co-ordinates of a mythological landscape. Each of the protagonists is associated with a specific location: Juno with Olympus, where her husband presides over gods and mortals; Minerva with the Muses of Helicon/Parnassus; Venus with the forge of Vulcan, located underground and perilously close to Hades. Paris, their judge, of necessity belongs in none of those places. Just a shepherd, his realm is that of pastoral, a nebulous region populated by shepherds, nymphs, and satyrs, imagined in the Renaissance as Arcadia. Mercury is the one who brings them all together.

You can get a sense of this imaginary geography from two paintings by Albani. In one, *The Realm of Heaven*, on Jupiter's orders Mercury gives the lyre to Apollo to make up for his theft of the cattle Apollo had been guarding. But that is only the ostensible subject, for this is one of a pair (or perhaps a series) that also includes *The Realm of Earth*, which shows the gods and their respective locations. In *The Realm of Heaven* (Fig. 134) the three locations are indicated by the pointing fingers of Jupiter and Mercury. At the top, Jupiter and the other Olympians (from left to right: Hebe, Hercules, Venus with Cupid, Vulcan with his hammer, Mars eyeing Venus, Saturn, Jupiter, Juno, Minerva, and Diana) are all assembled on a cloud from which he has dispatched Mercury to the pastoral location where Apollo has been exiled. Mercury hands over the lyre, rather in the way that he hands the golden apple to that other shepherd, Paris, and points Apollo in the direction of a third location, his true home, Parnassus, where Pegasus and the Muses await him. The pendant to this painting, *The Realm of Earth* (Fig. 135), shows the other location: Cybele is seated in the centre, with Ceres and Flora to the left, and Bacchus and Pomona to the right. In the distance behind them satyrs gather fruit from the trees, and one – perhaps Pan himself – plays the pipes and guards the flocks. He cannot be far away from the place where Apollo sits guarding the herds in the other painting.

134. *The Realm of Heaven*, Francesco Albani

None of these are real places, but they help to map the relationships between the gods. All the gods reside on Olympus, at least some of the time, but it belongs, above all, to Jupiter, and it is to Olympus that Hercules, having made his choice at the crossroads, eventually ascends. In addition to Jupiter, some gods are always there, Juno, his wife, of course, and Hebe, his waitress, who was supplanted by Ganymede, and then married off to Hercules. But most of the other gods have a region of their own. Although Venus is up on Olympus in Albani's painting, she is more at home in the company of the fertility-gods in *The Realm of Earth*. The area where they live is a busy place. When the giant Typheus was crushed beneath the island of Sicily, flames shot out through his mouth at Mount Etna. Pluto wondered what was happening and came up from Hades to check. It was there that he saw Proserpina picking flowers and dragged her down to the underworld. The fires continued to burn, and they provided the heat for the forge of Vulcan worked by Cyclopes in a cave off Mount Etna.[13] (You can see Vulcan

135. *The Realm of Earth*, Francesco Albani

trying to get on with his work in the demon-infested entrance to Hades in one of Jan Brueghel the Elder's paintings, *The Element of Fire*.) This is the manufacturing base of the mythological world, but the area also has the most fertile farmland. Ceres is there looking for Proserpina, and Venus waiting for Adonis. Bacchus is present too, though nearer to Arcadia than the others, so all the gods of the seasons are in close proximity. One way or another, it is the site of extraordinary productivity. Pluto is the god of wealth.

Although Parnassus is a place of culture, it is also densely populated – the home of Minerva, the Muses, Pegasus, and various dead poets, as well as Apollo. The mythographers remembered that Bacchus was said to reside on one of the two summits of the mountain, but you hardly ever see him there. Apollo is, of course, even more strongly associated with Parnassus than Minerva, yet he also has dealings with the world of pastoral: he asserts his superiority over the musical pretensions of Pan, and becomes a shepherd himself when sent to guard the herds of Admetus. If Apollo belongs on the Arcadian side of Parnassus then he is close to his sister Diana, for that is exactly where she is in Kulmbach's print (Fig. 117, p. 315). But perhaps it would be better described as the Parnassian side of Arcadia, for she presides over nymphs and satyrs, not the Muses, and her lovers are the shepherds Endymion and Pan. In a painting of the Judgement of Paris by Lucas van Heere the scene is located beside a fountain with a bust of Diana, making

her an observer at the spectacle of her sister gods, who have come to her realm to show themselves off to a shepherd. The tutelary deity of Arcadia is Pan, somewhere below Diana, whom he enticed down with a basket of wool.

This geography is far too fluid to map with any confidence, but its basic co-ordinates can at least be plotted diagrammatically. The relationships between Olympus and Hades, on the one hand, and between Parnassus and Arcadia on the other, are clearly vertical ones of dominance and subordination, mediated through the opposition of culture and nature. Olympus and Parnassus are both mountains, but the former is the location of the throne of Jupiter, and used for councils and feasts of the gods, whereas the latter is devoted to cultural pursuits like music and poetry. In contrast, Arcadia and the area around Hades configure different types of nature: that of Arcadia is an uncultivated landscape of virgin forests and pasture, and that around Hades a place of prodigious fertility producing wheat, vines, and flowers. So if the vertical axis is that of dominant and subordinate value, the horizontal one seems to move between work and leisure. Olympus is the site of governance, Hades of production; Parnassus is the pinnacle of highbrow culture, Arcadia a place of natural ease.

Once you have got a sense of the basic co-ordinates, it is easier to see the patterns in the movement between them. Mercury has to be stationed at the crossroads, which is where he was depicted in one of Alciati's emblems.[14] From here, he visits all the other locations. He escorts Psyche to Olympus and brings messages from there at Jupiter's request. And he's just as likely to be found in Arcadia – stealing the herds of Admetus, and herding Jupiter and the cattle down to meet Europa. But he knows his way around Parnassus as well: you can see him standing with Pegasus in Mantegna's painting, and he was fused with Minerva in the figure of Hermathena. He also escorted people to the underworld, as he did Lara, and was no stranger to Venus: they conceived Hermaphroditus together, and he too was associated with the Graces.

Hercules' journey to Olympus from the crossroads was over the bodies of monsters rearing up from below. He repeatedly defeats the offspring of the gods below him: Cacus was Vulcan's son; Antaeus the son of earth, and the Hydra the offspring of Typheus; he even overpowers Cerberus, the guard-dog of the underworld. Because he goes from the crossroads towards Olympus, he does not have much to do with those diagonally behind him. You rarely find him talking to Diana, and unlike both Apollo and Cupid, he's never involved in a contest with Pan. Both Hercules and Orpheus went down into Hades, but they never met because they were coming from different directions. Orpheus went across from Arcadia, where he had enchanted the animals. His life was defined by his relationship to Apollo above, and with Hades on the other axis; he never got back from there to Arcadia, because the Bacchantes ripped him apart on the way. It is along the base of the diagram that you can plot the demographics of the Bacchanal, from Pan, to the satyrs, to Priapus, the god of gardens, to Silenus, who bumps into Midas travelling in the other direction to judge the contest of Pan and Apollo.

Below Hercules is Bacchus, a parallel figure in some respects. When Bacchus gets his act together he conquers the whole world, and when Hercules strays from the path of virtue he turns into Bacchus: a drunken, effeminate madman. But their trajectories are at right angles, for Bacchus travels diagonally as well, inspired by wine to attain the heights of Parnassus. Between them, they offer mortals two models of upward mobility, though Hercules' approach is perhaps the more reliable. The other gods mostly travel horizontally or vertically, and there is a lot of to-ing and fro-ing between Olympus and Hades on one side, and between Arcadia and Parnassus on the other. When things are thrown down from Olympus they tend to land around Hades. The Giants are only one example. When Jupiter

cut off Saturn's genitals they gave birth to Venus, and when Vulcan was tossed out he was brought back up again by Bacchus. But when Minerva threw away the pipes, she must have wandered into Arcadia, for the satyr Marsyas picked them up.

Those in each corner tend to be defined by their relationships on the two axes that meet there, and usually have little to do with those to whom they are diagonally opposite. The gods can potentially travel anywhere, and Jupiter sometimes even visits Arcadia to seduce the nymphs, but the lesser figures are more obviously confined to their locations. Satyrs may move horizontally to spy on Venus, or vertically to listen to Apollo and Pan competing (or even to sack Parnassus in Giovanni da San Giovanni's frescoes at the Palazzo Pitti), yet they don't often travel diagonally to Olympus. The Muses may go across to Olympus to sing at weddings, or down towards Arcadia to listen to Apollo's contest with Pan, but unlike Orpheus they do not sing in Hades, and Apollo strictly forbids them from consorting with Venus. Indeed, nobody from Parnassus visits Hades very much, although Apollo went to Vulcan's forge to shoot the Cyclopes. Bacchus and the Graces may separately visit Apollo on Parnassus, but you would be very surprised to find the fertility-gods there.

Is there a link between the relationships depicted in mythological imagery and the pattern of their distribution? This is a question that requires a cautious answer, but it is not difficult to see certain homologies between the structure of the field inhabited by the gods themselves – their alliances and antagonisms – and that of the European society that produced them. The sociology of Renaissance mythology is not especially interesting, for it almost always involves the richest members of society, usually princes, but its geography is more revealing. In the course of the sixteenth century mythological imagery becomes a pan-European visual language, potentially as comprehensible in Poland or Portugal as in Venice or Rome. However, the distribution is uneven, both in quantity and content. The dominant gods are heavily represented in the imagery of the princely state rather than in republics, and in each case the Habsburgs do much to aid their dispersal. The imagery of Hercules and Jupiter was disseminated throughout Europe by Charles V, and Philip II was the model for later sun-kings. In contrast, the imagery of the gods of production is more heavily developed by artists in places where a capitalist economy is beginning to emerge – Venus in Venice, Bacchus and the fertility gods in Antwerp and seventeenth-century Holland. The iconography of Diana and Apollo had multiple roots: it develops first in situations where dominance is mediated through the prism

of culture or gender; Apollo is the god of popes, and Diana of women who find themselves in dominant roles.

Even if there are broad homologies between the structure of myth and the structure of history, there is not necessarily any connection between them. However, people assumed that there ought to be, for it was a commonplace that the gods ruled in heaven as princes did on earth. Ovid had ended the *Metamorphoses* with a description of Jupiter governing heaven and Augustus the earth, and Aneau picked up the motif in his verse on Charles V, who had divided the universe with Jupiter so that he had jurisdiction over men and Jupiter over the gods.[15] The principle was assumed to be more widely applicable. As Vasari explained in the *Ragionamenti*, 'On earth, those who through divine gift have a great effect on mortals are called terrestrial gods, just as those up there in heaven have the name and title of celestial gods.'[16] Allegory is the glue that was liberally applied to hold these parallel worlds together. It was meant to explain the adventures of the gods in a morally edifying fashion and make them adhere to the structure of the historical conjuncture. According to Vasari, the actions of the gods in his paintings at the Palazzo Vecchio served 'as a mirror, enabling those who see them to learn how to live – especially princes, because such stories do not have to be a mirror for private citizens'.[17] But as he demonstrates when he tries to explain how all the mythologies of the upper floor relate to the Medicean histories in the equivalent rooms on the level below, it was very difficult to do this in a consistent and coherent manner.

Allegories were of several kinds, and not all had much adhesive. There are the traditional allegories derived from late antiquity that were endlessly repeated in commentaries on Ovid, and sometimes also by the mythographers. Their content is far from inventive, and allegories of different myths are often very similar: there are the euhemerist explanations in which the protagonists are ancient kings and queens; moral allegories in which gods and heroes subdue pride or lust; and the physical allegories, quite a few of which revolve around the idea that the heat of the sun burns up excess humidity. These allegories are almost never illustrated, but they are presumably the kind of thing that people were supposed to have in the back of their minds when glancing at a mythological frieze or ceiling.

Rather different are the various kinds of freely invented allegory. Although these often exploit traditional meanings, they are far more adventurous, and therefore very difficult to understand without an explanation. These include the allegories of the emblematists, which often rely on strange juxtapositions of symbols; complex moral allegories, like those devised for the *studiolo* of Isabella d'Este, and also the allegories that people sometimes

came up with to make an existing work of art sound more interesting. Finally there are contemporary allegories, designed primarily to establish connections between members of a princely court and the ancient pantheon, but sometimes also used to explicate the activities of other social groups. These worked through a variety of routes: sometimes, as in the case of Jupiter and the emperor, the links were structural (they held analogous positions in their respective realms) or historical (a similar relationship had existed between Jupiter and Augustus, and Charles V was Augustus's successor). In other cases it depended upon a genealogy, though this worked better in ancient Rome (where the gods were only a few generations back) than in Renaissance Europe; or else it rested on a name: Diane de Poitiers and Ercole d'Este I and II would not have developed their respective iconographies if they had they been called something else. Alternatively, identification could be mediated through some other symbol system such as astrology or heraldry; or it might be elective, for people could choose their *imprese* in a way they could not always choose their star-sign or their coat of arms, and this in turn opened up other possibilities.

In practice, these different types of allegory were often mixed up together. For example, in the Roman carnival procession of 1545 during the pontificate of Paul III, the district of Monti came up with a cart showing Prometheus tied to Mount Caucasus, along with Mercury (who had taken him there on Jupiter's orders after Prometheus usurped Jupiter's authority by creating Pandora and making fire) and the eagle who came daily to eat Prometheus's liver.[18] Prometheus represented the Turks who came from the region of Mount Caucasus, and who, being infidels, merited the same sort of punishment. The eagle signified the Holy Roman Empire ruled by Charles V, and Mercury, with his caduceus in his hand, the peace made with the king of France (and brokered by Paul III) which would allow the emperor and the Christians 'to eat the intestines of the Turks'. The mythological narrative is seamless, but the allegory works though a multiplicity of routes. Monti means 'mountains' so it was natural for the district to exploit this nominal association in their choice of subject. The identification of Prometheus with the Turks works through other routes – geographical proximity and an analogous impiety (although there's nothing very specific about the parallels here). The eagle is a traditional symbol, the attribute of Jupiter and the heraldic device of the Holy Roman Emperor. The caduceus, the attribute of Mercury, was traditionally interpreted as a symbol of peace. Put all these things together and you have a snapshot of contemporary politics.

Here mythology itself constitutes the narrative, while the allegory works on a vertical axis, taking individual protagonists and symbols and relating

them to something outside the text. Ideally, an allegory should be able to take all the people and symbols from within the narrative and form a parallel one that is just as plausible as the original. However, invented allegories sometimes work in reverse as well. Instead of turning the narrative into symbols, they could turn a set of symbols into a narrative. This allowed allegories to be created rather than illustrated, and so enabled the pagan gods to be incorporated into a unified visual language with enough terms to generate new stories. If you compare the way allegory works in the *Los Honores* cycle of tapestries completed for Charles V with Cortona's frescoes at the Palazzo Pitti, the differences are immediately apparent. In the *Iustitia* tapestry, figures from mythology, biblical and classical history are all mixed up together, yet linked only by personifications of virtues (Fig. 52, pp. 146–7). There is no narrative; figures are simply distributed according to their position in the allegory. In contrast, in Cortona's cycle a more coherent cast of characters forms a continuous narrative within the realm of the gods (Fig. 27, p. 90).

Rubens's series of paintings for Marie de' Medici may appear similar, but it works differently, for it takes a contemporary historical narrative and allegorizes it as mythology. Instead of using mythology as a text, or to construct an allegorical narrative, this is mythology as interpretation. The narrative content of *The Education of Marie de' Medici* (Fig. 136) is exhausted by the figure of Marie herself, who presumably learnt her letters back in Florence in the 1570s. What the painting provides is a mind-boggling mythological gloss on this rather ordinary event. Mercury dramatically points towards the young girl at Minerva's knee while the Graces crown her with rose and myrtle, and Apollo plays beside them in a litter of educational paraphernalia. The position of Mercury is well chosen, for he was the embodiment of reason who kept the liberality of the Graces within bounds, and when united with Minerva in the composite deity Hermathena, eloquence tempered by prudence. But the allegory probably is not that clever, for this is not a study in the nuances of rhetoric, simply a statement of the multifaceted nature of the virtues required of a princess. It is only slightly less literalistic than the manuscript portrait of Francis I which had shown him as a hermaphrodite in motley embodying the attributes of Minerva, Mars, Mercury, Diana, and Cupid (Fig. 18, p. 61).

It would be misleading to imagine that mythological imagery spreads solely through the desire of princes for aggrandizement, and that artists produced it just because that is what was asked of them. There were two sides to this. Antique art was popular with artists chiefly on account of its formal qualities,

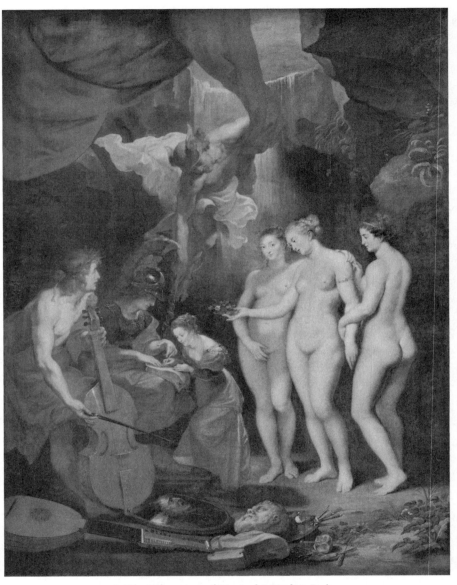

136. *The Education of Marie de' Medici*, Rubens

not its subject-matter. But classical art had dealt with mythological subjects, and emulating or surpassing the artists of antiquity involved doing so on the same terms. So although most artists worked primarily on religious, not classical, themes, the latter were disproportionately important to their sense of professional competence and autonomy. This was the main reason why artists turned to classical subjects when painting for themselves, which is not something they often did, except when they came to decorate their own homes.

From the mid-sixteenth century onwards, artists' houses often became showcases for mythological imagery.[19] Giulio Romano's house in Mantua not only displayed the artist's collection of antiquities but featured a large *salone* in which painted statues of the classical gods stood in niches presided over by the Capitoline Jupiter. A statue of Mercury stood outside. Charles V's favourite sculptor, Leone Leoni, created a house in Milan with an ostentatious façade supported by caryatids, and Vasari (who knew both these houses) used his own houses in Florence and Arezzo to make equally strong claims about the status and role of the artist. In both places there are depictions of Greek artists at work, and in Arezzo, one room is decorated with Apollo and the Muses.

The twin emphases on the example of the Greek painters, and the aspiration to join Apollo and the Muses on Parnassus persisted. At the Casa Zuccaro in Florence, Federico Zuccaro painted a *Calumny of Apelles* in which Mercury is brought in to succour the unfortunate artist, and on the façade of Rubens's house in Antwerp there was a frieze composed of his reconstructions of ancient paintings which included several mythological subjects – the sacrifice of Iphigenia, the drunkenness of Hercules, and Apollo and Marsyas. It was at the Palazzo Zuccaro in Rome that Federico gave full rein to his aspirational vision of the artist's destiny, devoting three ceilings to the theme of ascent: *Hercules at the Crossroads*, the *Ascension of the Virtuoso*, and in the largest room of the palazzo, *The Abduction of Ganymede*. Pietro Testa's allegories in which Painting is received with honours on Parnassus reflects this tradition, and so too does Jordaens's use of the Cupid and Psyche legend (a subject he had already painted for royalty) for the decoration of his own house.

Imagining yourself being taken up to Olympus, or, as was more often the case, Parnassus, is a good indication that you are coming from somewhere else. Zuccaro's *The Lament of Painting* (engraved by Cort after the painting from the Sala del Disegno in the Casa Zuccaro in Florence) shows Pittura making a plea to Jupiter among the gods on Mount Olympus (Fig. 137), illustrated by a picture which shows the Vices pursuing Fortuna (holding a

sail and standing on a ball) and putting the Virtues to flight. Below, the painter in his studio is hard at work on a painting showing the manufacture of Jupiter's thunderbolts, inspired by the vision of a naked woman identified as Truth. The upper half of the composition is rather like that later seen in Testa's allegories, but the lower half is modelled on scenes of Venus at the forge of Vulcan, except that here the seated painter himself takes on the role of Vulcan, the humble craftsman, in his workshop. It reveals rather more about the status of the artist than Zuccaro intended.

Needless to say, painters did not often care to identify themselves with Vulcan (though the portrait medal of the gem-engraver Jacopo da Trezzo implicitly did so), but their affinity with Bacchus was frequently acknowledged. Self-portraits of the artist as Bacchus were not unusual, and members of the Bent, a drinking-club for northern artists in seventeenth-century Rome, styled themselves worshippers of Bacchus and held pageants in his honour. A painting showing a neophyte's induction into the brotherhood features a tableau vivant in the background with Venus, Bacchus, and Cupid in the centre.[20] But it would be wrong to suppose that these artists disregarded the academic orthodoxies – at Sandrart's initiation there had been a tableau vivant of Apollo and the Muses; they just did not mind admitting that the trajectory of their profession led from the site of production to the heights of Parnassus.

To make that journey, artists needed more than the inspiration that Bacchus provided. Most of the artists who built and decorated their houses in the classical style did so on the basis of the financial security afforded by long-term court patronage. In such settings they could proudly receive studio visits from princely patrons just as the artists of antiquity had done. Such meetings were important, for there was an elective affinity between a particular set of craft skills (the ability to produce naturalistic figures all'antica), the themes that best exemplified this (mythologies), and the type of subject-matter required by princes to manifest their power. It helps to explain why, of all the various social and professional groups in Renaissance Europe, princes and artists are the two for whom mythological imagery was most important. Though not central to the lives of either, mythology played a significant role in the imaginative self-definition of both, and they needed each other to sustain it. So the relationship between artists and rulers was symbiotic, and by no means always initiated by the prince. Artists may sometimes have used mythological nudes as bait to ensnare important patrons. Rosso's drawing of Mars and Venus appears to have been presented to Francis I (and perhaps resulted in the artist's call to Fontainebleau); Titian sent an unidentified Venus to Charles V as a gift in 1548; and perhaps also

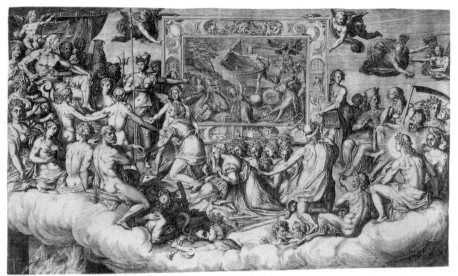

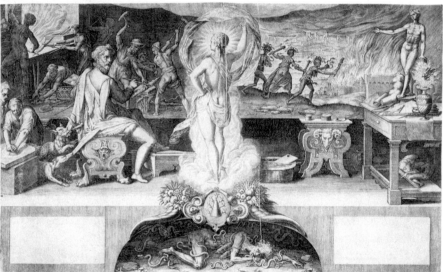

137. *The Lament of Painting*, Cornelis Cort after Federico Zuccaro

the *Danaë*, the first of the *poesie*, to Philip II. Aretino may have been involved in more than one of these transactions, and the erotic element in these promotional gifts speaks for itself, but the fact that they are mythological subjects is significant too – an invitation to participate in a patronage relationship based on the models of antiquity. When Titian later delivered

the two *poesie* of Diana to Philip II, he made this explicit when he compared himself to Apelles (who had also painted Diana with her companions) and the king to Alexander.

Titian might have thought of himself and Philip as Apelles and Alexander, but what would Apelles and Alexander have thought of them? The Renaissance supposedly represented the rebirth of the art of the classical world, so how would an ancient artist have seen it if he (there's not much evidence of women artists) had been reborn?[21] Framing the question like this immediately raises another: an ancient artist of what period? The classical world had lasted for over a millennium, though to the Renaissance viewer the surviving remains of antiquity were not easily differentiated. Other than in the case of coins and triumphal arches, which sometimes identified themselves, nobody was in a very good position to judge whether antiquities were Greek or Roman, or what period they were from. People were inclined to attribute works to the famous Greek sculptors of the fourth century BCE mentioned by Pliny. But in fact most of the sculptural works known in the sixteenth century were either sarcophagus reliefs from around the second or third century CE, or Roman statues based on classical or Hellenistic models. Although no one knew it at the time, the Renaissance was essentially a revival of a revival – the Hellenistic revival in Roman art that lasted from the first century BCE to the second CE. From the Augustan period onwards, the Hellenistic style was particularly associated with mythological themes, unlike the 'Roman' one traditionally used for scenes of civic and domestic life. In formal terms, this involved the idealization of portrait heads combined with an increased reliance on the expressive potential of the body. During the later empire, elements of the old style, characterized by stumpy bodies in heavy drapery, returned and they eventually developed into the Romanesque. In the Renaissance, people knew little of pre-imperial Roman art, and despised its later manifestations – Raphael thought the carvings on the Arch of Constantine were hopeless.

The Roman revival of Hellenistic mythological art had a political context. The breakdown of republican forms of government and the struggle for absolute power enhanced the significance of the customary associations between a patrician family and a divine ancestor or patron. In the battle between Octavian and Marc Antony, Marc Antony first exploited his descent from Hercules and then affected a Dionysian role, modelled on that of Alexander the Great, while Octavian relied on his descent from Venus, and cultivated an identification with Apollo. When successful, Augustus (as Octavian became) consolidated his rule through the dissemination of his

mythological imagery. Julius Caesar had revived the Hellenistic practice of having his portrait on the obverse of coins, and Augustus made full use of the opportunity to show deities associated with him on the reverse. Eventually he took on the role of Jupiter as well. The political forms associated with mythological art in the Renaissance – the idea of empire, the glorification of the prince as an individual – were also those that characterized the Hellenistic revival at the time of Augustus.

Although the Renaissance identification of princes with Hercules, Apollo, or Jupiter would have come as no surprise to a Roman of the imperial period, he might have wondered why the primary expression of this association came in the triumphal entry. Triumphs retained a republican flavour. Emperors were not usually celebrated as gods in this context, for theirs were meant to be the triumphs of citizen generals, not the Dionysian triumphs of a Hellenistic ruler like those celebrated by Marc Antony in Egypt or Nero on his return from Greece. But given the extravagant terms in which any old royal entry might be celebrated in the Renaissance, the lack of permanent triumphal arches would have contributed to the general impression of such imagery as a bit makeshift and phoney.

The relative permanence of Roman mythological imagery may be explained by the fact that in Roman times the ruler's identification with a god was intimately associated with the practice of public piety, and the context in which the god's images appeared was frequently religious. There were many temples in the centre of ancient Rome, and some, like Julius Caesar's Temple of Venus Genetrix, displayed coins, gems, and paintings, as well as sculpture. But in the Renaissance, mythological imagery was completely divorced from the religious practices and emotions – sacrifice, divination, prayer, the ritual-cycle of the year – which had once sustained it. Less obviously, perhaps, it was also remote from the established institutions of learning and education. There were many universities in Europe in the sixteenth century, but they play little part in the dissemination of mythological imagery. You were more likely to find antiquities and mythologies in the *studiolo* of an aristocrat who could barely read Latin.

If Renaissance mythologies were remote from religion and scholarship, they were equally divorced from another of their primary Roman contexts – the public celebration of physical prowess in the baths, the gymnasium, and the amphitheatre. Some of the most famous works of antique sculpture known in the sixteenth century, including the Farnese Hercules and the Niobe group, came from ancient Roman baths. Gymnasia and baths were associated, and so figures of Hercules and Venus, the exemplars of strength and beauty, were common in these locations. But in the Renaissance the

classical association between nude statuary and physical culture was lost. Hercules had been the patron of gladiators, and mythological pantomimes were routinely staged before the games in the amphitheatre. Pantomimes, carnival floats, and intermezzi were also central to the Renaissance appreciation of mythology, but they were firmly in the world of make-believe, whereas in Rome the distinction between pretence and reality was routinely blurred. You could see people fighting lions in the amphitheatre just as Hercules had done, and probably pornographic spectacles too, like the Judgement of Paris described by Apuleius. One subject that appears in Roman painting that makes no impact in the Renaissance, despite being the subject of the famous Farnese Bull discovered in 1545, is that of Dirce who was killed by being tied to the underside of a bull and dragged to death. It is a gruesome spectacle straight out of the amphitheatre. But compared with that of an ancient Roman, the Renaissance viewer's engagement with mythology was all in the imagination.

Unfocused private collecting was common to both periods, so a Roman viewer probably would not have been too worried to find figures from different periods of classical art juxtaposed in a single composition. The Renaissance's Roman models were already in hybrid styles, and the Romans also collected a combination of Greek originals and copies (as well as original Roman works). But whereas the Renaissance assumed that there had been a break in the classical tradition, there were many continuities between Greece and Rome. Martial knew someone who claimed to have a bronze statuette that had belonged to Hannibal and Alexander the Great. That is unlikely, but the links with classical Greece were real as well as imagined. Though Roman artists, like those of the Renaissance, tried to emulate the Greek masters by painting subjects on the basis of ancient descriptions, Greek artists also worked in Rome, and works of art both new and old were frequently imported. In comparison, Renaissance artists knew very little about the culture they were trying to emulate – which may be one reason why they tended to think that anyone whose work turned out well had 'surpassed the ancients'. In Roman times, you could easily take a trip to Greece to see the sacred shrines where the gods had appeared, and many people did so. In the Renaissance, antiquity was somewhere you could visit only in your dreams, a 'non-place' lacking all geographical specificity.

The haphazard survival of antiquities meant that the Renaissance knew almost nothing about the ways in which the Romans had actually displayed and used their works of art. With the exception of the Dioscuri, antiquities did not present themselves two-by-two, so Renaissance artists had no way of

knowing that many Roman statues, possibly including the Farnese Hercules, were often mirror images of one another displayed in pairs. This was more than a decorative gimmick. The entire visual rhetoric of Roman mythological art relied far more heavily on pairing and antithesis, which could involve thematic contrast, or the same work oriented in opposite directions, or else stylistic variants of the same subject. In the Renaissance, mythological objects tend to be singular, or arranged in a linear fashion (in a frieze or series of tapestries or prints) or else (in ceiling painting) in terms of centre and periphery, though by the seventeenth century pendants had become more common, and Titian's *poesie* had earlier exploited a variety of complementarities.

The most notable medium to have fallen into disuse was mosaic. There was a brief revival in seventeenth-century Rome, which included Marcello Provenzale's *Orpheus* for Cardinal Borghese (Fig. 132, p. 354) – a subject that had frequently been found in mosaic in the entrance halls of Roman villas – but more often than not the subjects of pavement mosaics were transposed to a painted ceiling. If you compare Albani's *Apollo and the Seasons* with the pavement mosaic of *Aion and the Seasons* from ancient Sentinum, the resemblance is almost uncanny. In Roman times, such mosaics often acted as the centrepiece in the decoration of villas in the countryside, where mythological imagery was more common than in the cities, just as it was later in the Renaissance. However, the Renaissance preference for using mythological paintings on façades and in loggias was new. Roman domestic architecture focused inwards, and a Roman might have felt as though the house had been turned inside out, exposing the household gods to the weather and the depredations of passing vandals.

But if the layout was novel, the basic structure of the iconography was not: heroic or dynastic themes for public areas, something a bit more relaxing for private ones, and erotic scenes for bedrooms. There were undoubtedly fewer classical statues in a Renaissance house than in a Roman one, and the most important mythological images now appeared on the ceiling, or a frieze just below it, rather than on the floor and walls. The most characteristic form of mythological painting in the Roman domestic interior was a series of three or four scenes, sometimes painted within fictive architectural settings, each centrally placed on one of the walls of the room. They occasionally represented a single story, but were usually juxtaposed on the basis of thematic or formal relationships so loose that the links are now difficult to establish. Some of these rooms may have been *triclinia* used by diners reclining on three couches arranged in a U-shape, in which case guests on each couch would have been facing a different image, and

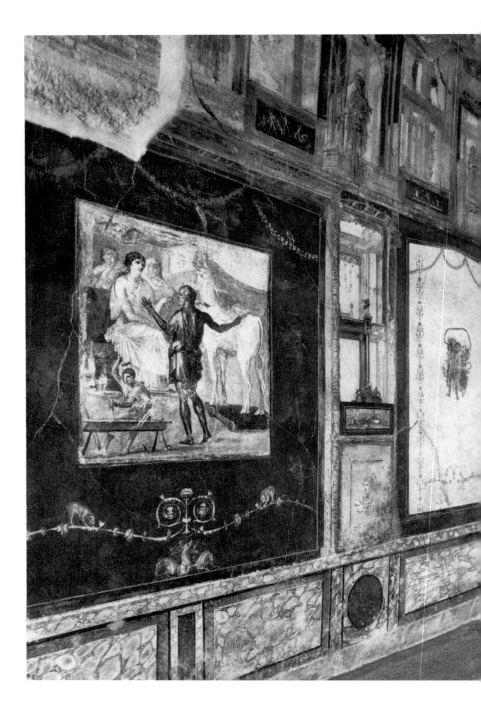

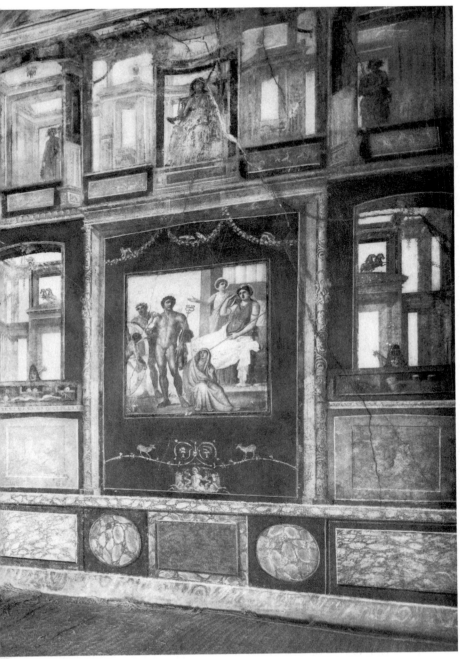

138. *Pasiphaë* and *The Torture of Ixion*, triclinium, House of the Vettii, Pompeii

comparisons between them would have been a natural topic of conversation (Fig. 138).

There was no equivalent to this arrangement in the Renaissance. Feasts almost invariably show tapestries in the background. Having three or four paintings distributed around a room to create an impression was something people might do in a *studiolo*, but this sort of confrontational arrangement in which images faced each other was almost unknown, and the pairing of the paintings of Perseus and Andromeda and Polyphemus and Galatea at opposite ends of the room of the Galleria Farnese was unusual. Both were common subjects for Roman panel paintings, but some of the scenes on the ceiling would have been unfamiliar to a Roman viewer, who might never previously have seen Ovidian favourites like Pan and Syrinx, or Diana and Callisto. And the amount of female nudity would have been a bit of a surprise, especially in the case of Diana, who in ancient times almost always wore a short tunic.

In general, however, the geography of mythology would have been familiar. According to Vitruvius, the location of the temples worked on the following system: Jupiter, Juno, and Minerva belonged at the highest point of the city; Mercury in the forum; Apollo and Bacchus near the theatre, and Hercules at the circus or the gymnasium. Temples of Mars, Venus, Vulcan, and Ceres were to be located outside the walls, for fear that citizens might contaminate the city with warfare, fire, or lust.[22] People in later centuries remembered these distinctions – when Petrarch complained that Bacchus and Venus had taken the place of Jupiter and Minerva in Rome,[23] he was not simply making a moral point, he knew from Vitruvius that it should have been against the planning laws as well. But in practice the zoning regulations were not enforced. Julius Caesar built a temple to Venus, and Augustus founded a temple of Mars Ultor (the Avenger) in the Forum, the first temple of Mars to be built inside the city. The more negative roles assigned to Venus and Mars in Renaissance art might therefore have troubled a Roman. After all, they were his ancestors: Mars the father of Romulus and Remus, Venus the mother of Aeneas. If he had lived early in the empire, he might have been surprised to see that Hercules seemed to have progressed from patron of gladiators to patron of emperors.

It was often the specifically Roman gods who suffered neglect or demotion in the Renaissance and so it is ironic that mythological art which, when it became popular in Rome in the first century BCE was often associated with Oriental luxury, should be thought of in the Renaissance as something distinctively Roman. Another eastern import, planetary astrology, only spread during the empire, and there is no record of depictions of the

planetary gods as a group before the first century CE. The centrality of the planets within Renaissance mythological art did not reflect antique precedent so much as the fact that people believed in the planets in a way that no one actually believed in the ancient gods themselves. Even in the fantasy world of mythology, faith made a difference. But how much? A Roman would have been astonished to find that Italians were all now the fanatical devotees of a Jewish sect which taught that the Roman divinities were demons. Renaissance mythological art might have its own structure and decorum, but it now existed within a wider culture whose assumptions were alien to it.

Epilogue

The gods had withdrawn when ancient Rome fell to the barbarians, but now that Agostino Chigi had restored its ancient splendour by building the Villa Farnesina, they would descend from the heavens once more.[1] That, at least, is what the poets claimed, but it did not happen quite as they imagined. Even as representations of the pagan gods proliferated, everyone continued to insist that they were alien and unwelcome intruders in a Christian society. And in a sense they were right, for the gods never regained the status they had lost. Though some people occasionally claimed to be their devotees, it was usually anti-clerical bravado rather than statement of fact. There is no symmetry between the destruction and revival of pagan antiquity. Christianity had set out either to destroy pagan imagery or else replace it with an iconography of its own. But in the Renaissance, mythological imagery was not really in competition with Christian art.

For one thing, there was not enough of it, and for another, mythological imagery was initially heavily concentrated in the decorative arts where no one took it seriously. From Savonarola onwards, some individual reformers, both Catholic and Protestant, sought to suppress it for its licentiousness, but overall its spread was remarkably unaffected by the religious upheavals of the sixteenth century. It was of marginal interest to Protestant iconoclasts, and even in the Counter-Reformation the chief concern was to keep mythological art in its place rather than suppress it altogether. To avoid giving the impression that they were encouraging idolatry, patrons did not usually display the gods in contexts where they might arouse such feelings. Statues and paintings of pagan deities are rarely to be found in churches, and the medieval vision of idolatry in which a naked statue of a god stands on top of a pillar in an urban setting was avoided as well. There was no attempt to provide pagan substitutes for the visual and spiritual experiences that sacred art provided. When Christianity replaced the religions of the ancient world, it converted temples into churches, and adapted the iconography of classical art for its own use. Nothing comparable happens in the Renaissance. Rather

than challenging Christian supremacy, mythology remains a relatively deracinated form of knowledge, with little institutional function and (unlike the cults of the saints) few local roots. If it replaced anything, it was earlier forms of secular decoration; relative to Christian art, mythological imagery functioned not as an alternative but a supplement.

Mythologies provided things that Christian imagery customarily lacked. The most important of these was the pleasure of making and seeing depictions of the same subjects that had delighted the ancient world. But there was more to it than that. The lack of significant overlap between the content of the two forms of imagery suggests a latent demand for certain types of subject which sacred art did not even attempt to satisfy. Though the stories of Bathsheba or Susanna could be, and often were, exploited for the prurient, and viewers could easily take an inappropriate interest in representations of Mary Magdalene or St Sebastian, the Scriptures and the lives of the saints were not a rich source of erotic imagery. A great deal of Christian art depicts sombre all-male situations – Jesus and the disciples, scenes from the lives of founders of monastic orders, and so on – and there are a significant number of older men – patriarchs, prophets, church fathers, hermit saints and the like. In contrast, mythologies show very few old people, almost no all-male occasions, and a disproportionate number of nude, or partially dressed young women.

Less obviously, perhaps, the lives of the saints are much closer to those of the Renaissance viewer. There are frequent references to the routines of daily life, and to economic activities like work and even taxation. Save for hermits, the saints usually live and die in cities, and urban backgrounds are common. Mythological scenes are often set in nature – a world without architecture where few people work and no one pays taxes. Although the stories illustrated in the Renaissance do not usually belong to the reign of Saturn, their setting retains the qualities of the golden age over which he presided. Then, men still lived peacefully in woods and caves; there were no cities, and the earth freely yielded all the necessities of life.[2] There was no poverty, and no charity either.

In mythological art, people may be killed, but they are rarely sick, and death is almost always sudden and violent. Anger does not have the sanction of law, and executions are unknown. There is little reason to mourn, except for Adonis, and despite the horrific punishments meted out to those who offend the gods, torture is relatively uncommon, especially for women. Lara has her tongue pulled, but you never see the nymphs having their breasts cut off, or their eyes gouged out. This reflects an underlying difference in attitudes to the body. In Christian art, the body is, in a very literal sense,

vulnerable. Christ displays his wounds, and the saints can often be seen with arrows or axes sticking in their bodies. In mythologies the body may be ripped into fragments (like that of Actaeon or Orpheus) or be transformed into something else; it very rarely sustains injury. One of the repeated complaints of Counter-Reformation art theorists is that the influence of classical art has prevented the full representation of the sufferings of Christ.

This insistence upon the integrity of the body is in keeping with the primacy of the visual in mythological art. The gods, looking down from heaven, see much better than mere mortals, and they are quick to spot a pretty youth. In religious art, the relationship between people's bodies is often tentative and tactile. People feel their way to knowledge: St Thomas is only the most striking example, but the hands often communicate more than the gaze or the body. Christian art is full of moments in which people reach out to one another – the Visitation, the meeting of St Francis and St Dominic – but in mythologies there are few forms of non-erotic or non-aggressive sociality. The *sacra conversazione*, one of the most character-istic forms of Renaissance altarpiece, in which saints stand on either side of the Virgin in meditative communion, has no mythological equivalent. It is rare to have multiple protagonists like this, and the print of gods with trees (Fig. 131, p. 351) is one of very few occasions when the gods assemble in anything like this order.

There are all sorts of other situations with which mythological art does not really bother. It cedes the afterlife to Christianity, and with it most of the events that mark the life-cycle. Though the Madonna might have the face of Venus, there is very little attempt to offer images of motherhood that compete with the cult of the Virgin. Venus and Cupid are a charming pair, but silence, stillness, and wonder are concepts they do not fully understand. Conversely, there were aspects of social life which Venus was better able to symbolize. There are many dignified and moving representations of the marriage of the Virgin, but they did not contain all that people were looking for in wedding imagery. To provide her husband with heirs a bride had to follow the example of Venus rather than the Virgin, and no one wanted the wedding celebrations to be too solemn.

It was not just in the area of sexuality and fertility that mythological art filled a gap. Christian imagery was also low on positive images of secular power. The saints themselves were usually engaged in passive resistance, and Christian art often portrayed secular authority in a negative or subordi-nate light. The Old Testament offered images of kingship, but only the pagan past provided models of absolute rulers unchastened by prophets or

priests. Much of the time, however, the appeal of mythological art resided in the fact that it had no particular function at all. Christian art could be quite emotionally demanding, and it was used for the serious business of securing your place in heaven through the intercession of the Virgin and saints; mythologies were easy on the eye and allowed you to relax.

The informal division of human experience between Christian and classical iconography is one reason why there are fewer borrowings and points of contact than might be supposed. Individual figures could easily be transformed. Too nude for the cathedral in Florence, Bandinelli's statues of Adam and Eve were turned into Bacchus and Ceres, and there were innumerable borrowings at the level of the individual motif, but modes of pictorial composition were so distinct that it was difficult to make wholesale transpositions. Where they do occur it is often because of an underlying compatibility of theme – Hercules and the lion, and the flaying of Marsyas, for example. It is revealing that the story with the most striking convergences is one in which the gods Jupiter and Mercury come down to earth disguised as mortals. Refused hospitality at a thousand homes, they are welcomed only by a pious old couple, Philemon and Baucis. They eat together, but when the wine starts to refill itself Philemon and Baucis realize these are no ordinary guests, and go out to kill their only goose for the table. The bird eludes them and seeks refuge with the gods. At last, the gods reveal themselves. They spare the goose, and preserve their hosts and their home from the flood that engulfs their inhospitable neighbours. Asking only that they might die at the same time, Philemon and Baucis serve at the temple into which their house has been transformed until they are finally changed into trees.[3]

Representations of the meal become increasingly popular from the second half of the sixteenth century onwards, and it is possible to trace the borrowings back and forth between the subject and its religious parallels – Abraham entertaining the angels, the supper at Emmaus.[4] What made this tale so assimilable was not just its resonance with Jewish and Christian stories of mortals entertaining divine beings unawares, but its insistent naturalism. Philemon and Baucis are a very ordinary couple, the house and their food are humble, and Jupiter and Mercury seem to be ordinary travellers who fit in with these surroundings. Rembrandt's famous painting in which Christ's head is silhouetted against the light (Fig. 139) is taken from a print after Elsheimer's *Philemon and Baucis*, where Jupiter is in an identical position. However, both the poverty of the setting and the drama of the lighting have been considerably enhanced. Looking at this painting, there is no way you could mistake it for a mythological subject. Except

139. *Supper at Emmaus*, Rembrandt

when Psyche discovers Cupid, the pagan gods are never revealed by light shining in the darkness.

Though the treatment of religious and mythological themes becomes increasingly uniform in the seventeenth century, for most of this period mythological art is slightly artificial in appearance, as it often participates less in the contemporary conventions of naturalism. This raises the question of its wider relationship to the Renaissance in art. Most accounts of the Renaissance in Italy follow Vasari in placing its origins in the fourteenth century and its culmination in the 'High Renaissance' represented by the work of Raphael and Michelangelo in early sixteenth-century Rome. The revival of interest in antiquity, including the return of the pagan gods, is generally supposed to have taken place during the same period, and much emphasis has been placed on the few surviving mythologies of fifteenth-century Florence. But the dissemination of mythological imagery does not fit this pattern or time-scale very well. On the contrary, by the time of Raphael's death in 1520 the revival of the pagan gods had only just begun.

The lack of synchronization between the artistic Renaissance and the return of the gods points to another disjunction – that between classical style and classical subjects. In fifteenth-century Italy, for example, it

is what some critics have called the 'pseudo-Renaissance' artists (Agostino di Duccio, Filarete, Botticelli), exponents of a 'fantastic style' in opposition to the 'rational style' of the true Renaissance, who produce the most famous works of mythological art.[5] Similarly, in the sixteenth century artists associated with mannerism, according to some an 'anti-classical' or 'anti-Renaissance' style,[6] are the ones responsible for the development of mythological decoration and sculpture: Giulio, Perino, Cellini, and Giambologna in Italy; Rosso, Primaticcio, and the Fontainebleau School in France; Spranger, Von Aachen, and Heintz in Prague; and in the North, the so-called Haarlem Mannerists – Goltzius, Cornelis Cornelisz., Wtewael. However it is defined, mannerism represents the only artistic style in which mythologies are so heavily represented. But what connection, if any, is there between mythological subject-matter and the artistic styles in which it first appeared?

In part, it is just a matter of medium and context. In the case of painting, most mythologies are in a horizontal format, either because they are *cassone* or *spalliera* panels, or else because they are to be found on friezes. One consequence of this is that they tend to lack the defining central axis so characteristic of Renaissance religious art, especially altarpieces. Similarly, mythologies are rarely to be found in positions where the viewer is likely to benefit from one-point perspective. With the outstanding exception of the Sala dei Giganti at the Palazzo Te, illusionistic mythological ceiling painting remains uncommon until the seventeenth century; before then, mythologies usually appear as *quadri riportati*, on the frieze or ceiling without pretending to extend the viewer's space. Compared with religious works of the same period, mythological paintings are often rather flat. If you compare Leonardo's *Last Supper* with *The Banquet of Cupid and Psyche* at the Farnesina, for example, the difference is striking.

The works that best exemplify the development of perspective (by Ghiberti, Masaccio, Piero della Francesca, and others) include no mythological subjects. Even in the case of a painter like Perugino, who liked to show off his accomplishment in this area, it was much easier to make effective display of his skill in religious paintings, for instance *St Peter Receiving the Keys* in the Sistine Chapel, which were set in urban environments with regular paving stones, than in a mythological allegory with a landscape background, such as his *Battle of Love and Chastity* for the *studiolo* of Isabella d'Este. The differences in the treatment between religious and historical subjects on the one hand and mythologies on the other can be seen in the Stanza della Segnatura. If you compare Raphael's *Parnassus* with the *Disputa* and the *School of Athens* on either side, it is immediately

140. *Triumph of the Cross*, Tommaso Laureti

apparent that whereas they depict a vast space in a dramatically rendered perspective, the *Parnassus* has little spatial depth (even in comparison with Raphael's other lunettes elsewhere in the Vatican) and allows the Muses to flatten the painting by standing in a row behind Apollo. Perspective was often used to make a theological point, and in Tommaso Laureti's *Triumph of the Cross* (Fig. 140), on the ceiling of the Sala di Costantino in the Vatican, it is used against idolatry: a statue of Mercury lies in ruins before the Cross, a symbol of the destruction of the ancient gods.

Perspective was only one of a variety of naturalistic devices that mythological art did not exploit to the full. It was also distinctly lacking in colour. A disproportionate amount of mythological art is monochrome, often in order to retain the *all'antica* look of its sources. Because sculptors were unaware that the ancients had painted their statues, there is no equivalent to the startlingly naturalistic polychrome sculpture that aroused popular religious piety, or to the *sacri monti* (holy mountains), where lifelike tableaux of sacred dramas unfold before the pilgrim. Even in mythological painting, the colours are rarely as rich or as costly as in religious art. Gold almost never appears, and the expensive ultramarine blue, often the pigment for the Virgin's robe, is used more sparingly. The planetary deities were all associated with particular colours,[7] but you do not see them wearing them because they are usually naked, and in any case strong colours are not always the best complement to the flesh and earth tones that predominate in mythological painting.

With its tendency towards monochromaticity, horizontality, and shallow depth, mythological art is often relief-like.[8] This doubtless facilitated the

use of antique sources such as sarcophagus reliefs and gems, though it is not altogether clear that these characteristics were initially derived from antique reliefs; they are equally likely to be found in works that show little trace of their influence, such as the woodcuts to early Italian editions of Ovid and the numerous decorative works derived from them. More than anything else, the stylistic limitations of mythological art are a result of the literal and symbolic marginality from which it emerges. All these formal qualities are already to be found in Filarete's bronze doors for St Peter's in Rome in 1445. They have Christian scenes in all the main panels, but around the borders, nestled among the acanthus leaves, are many tiny figures – animals and unidentified pastoral characters, but also scenes from Ovid, Aesop, and Virgil. There is some evidence that Filarete was influenced by contemporary manuscript illustration, but little trace of classical reliefs.

It is easier to read this paganizing margin in Girolamo da Cremona's frontispiece to the edition of Gratian's *Decretum* published in Venice in 1477 (Fig. 141). In the centre of the page is the text, a work of canon law, accompanied by a miniature of the twelfth-century author presenting his work to the pope within a carefully delineated interior. Around the edge is decoration of an entirely different kind: a border composed of engraved gems and jewels goes down to a base margin populated by naked satyrs, nymphs, and animals in a landscape. Here in microcosm is the world from which mythological art later develops. If Laureti's *Triumph of the Cross* shows the pagan gods within the triumphant perspective of Christianity, Girolamo's frontispiece places Christian history within the decorative frame of the classical past.

Function, medium, and the selective survival of antique art all played a role in distancing mythological art from the conventions of naturalism, and yet there was something more fundamental as well. Nobody really knew what the gods looked like. Renaissance artists could base their representation of the gods on the example of antique sculpture. But how had the Greeks known what they looked like in the first place? In the *Life of Apollonius of Tyana*, Philostratus tackles the question head on. Had artists like Phidias and Praxiteles gone up to heaven and drawn the gods from life? No, 'Imagination [*phantasia*] wrought these works, a wiser and subtler artist by far than imitation [*mimesis*]; for imitation can only create as its handiwork what it has seen, but imagination equally what it has not seen.'[9]

However, as Augustine pointed out, the faculty of imagination could be used to conjure up compound images of impossible beings that did not exist. This became both the standard proof of its power, and the index of its

141. Frontispiece to Gratian, *Decretum*, 1477, Girolamo da Cremona

unreliability. Horace's criticism of poetic licence in the *Ars poetica*, which had likened poetic extravagances to those of painters who came up with strange chimerical beings, was the point of reference for those who wanted to demonstrate the excesses of imagination and painting alike.[10] And when Christian writers sought to attack pagan imagery they often did so on the basis that the mythological hybrids it contained showed it all to be false. In the eighth-century *Libri Carolini*, a long catalogue of mythological narratives contrary to the Bible ends with the statement that if a painter puts one head on two bodies or two heads on one body, or paints hybrids such as the centaur and the Minotaur, that too is against Scripture.[11] St Paul had said that idols were nothing, which was often taken to mean that idols were images of things that did not exist, like tritons, sphinxes, and centaurs.[12] Imagination produced hybrids; hybrids were idols, and idols were nothing at all.

Views like this never cease to be repeated, and they are reflected in Michelangelo's late sonnet in which he speaks of *fantasia* having made an idol of his art. But early in the Renaissance a more positive view of *fantasia* emerges, in which the artist's capacity to produce unknown inventions exemplifies his intellectual creativity. According to Cennino Cennini, *fantasia* allowed the painter to discover unseen things, and so give visible form to what does not actually exist. For him, the fact that a painter can, by following his *fantasia*, compose a figure that is half a man and half a horse is not an indication of painting's capacity to fall into idolatrous error, so much as evidence of its creative equality with the art of poetry. Filarete accorded *fantasia* comparable importance in his treatise on architecture, and Leonardo made the painter's hand the servant of the mind, merely executing what was already in the painter's *fantasia*. It was through *fantasia*, for example, that Leonardo was able to see the garden of Venus, and the coast of Cyprus littered with the wreckage of ships. As Ficino said, the imagination is like Proteus, or the chameleon: it transforms the merely sensible and makes visible what is not there.[13]

It is clear, however, that while *fantasia* was the only alternative to drawing directly from life, and so a necessary part of all artistic invention, it was particularly associated with the creation of mythological art, which of its very nature could never be taken from life since its subjects were the false gods and impossible monsters of ancient myth. In the correspondence about the mythological allegories for Isabella d'Este's *studiolo*, *fantasia* is used for the subject of the painting as an equivalent to *invenzione* or *istoria*, but the word is less frequently used in this way when the paintings under discussion are religious or historical. There is a clear sense that some additional level

of imaginative input is allowable and desirable in this context: Bellini said he would provide a *fantasia* of his own, Mantegna that he would proceed with the painting of Comus when *fantasia* came to his aid, but it never did.

The multiple connections between imagination and mythological imagery are explored in Vasari's life of Piero di Cosimo. The eccentric artist was in the habit of looking at clouds and even a wall covered with spittle and seeing in the shapes he found there fantastic cities and battles. And it was on account of this aptitude that he was employed to design carnival processions, which he did in the manner of classical triumphs in which he included 'most bizarre *fantasie*'. At the house of Francesco del Pugliese he was employed to paint panels with various scenes, perhaps the Vulcan series, in which he included buildings, animals, clothes, various instruments, and other *fantasie* that came to his mind 'because the stories were fables'.[14]

Elsewhere, too, the plural form of the word, *fantasie*, is routinely used to designate inventions, both of subject and detail, in mythological contexts. As an example of the way in which painters and poets used one another's subjects, Dolce cited Raphael's *Galatea* at the Villa Farnesina, which paralleled the lines in Poliziano's *Stanze*, but he could have mentioned many of Raphael's other 'delightful *fantasie*'.[15] Michelangelo praised Ammannati's projected Juno fountain as a 'beautiful *fantasia*',[16] and Vasari himself uses the word repeatedly in this way. While working in Rome, Bandinelli is said to have produced bronze statuettes of 'Hercules, Venus, Apollo, Leda and other *fantasie*'; Giovanni Bernardi's rock-crystal engravings after Perino for the Cassetta Farnese included Meleager, a Bacchanal, a naval battle, Hercules and the Amazons, the 'beautiful *fantasie*' of the patron Cardinal Farnese; in the drawing for Marcantonio's print of *The Judgement of Paris*, Raphael had introduced the chariot of Apollo, various nymphs, and other '*fantasie*'; Giulio's decoration at the Palazzo Te was so full of *fantasie*, it was stunning.[17]

The word *fantasie* is less often used in this fashion where anything other than mythologies are involved. Even when no subjects are specified, it frequently appears in contexts where mythologies were the expected theme. Francesco di Giorgio advised architects to include in gardens secret places and other *fantasie* for the delectation of the patron, and Perino added mythological paintings to the walls of the garden of the Archbishop of Cyprus '*alla sua fantasia*'. Façade paintings too were often described as *fantasie*: Giorgione's lost Venetian façade paintings are also referred to in this way by Armenini, and Lomazzo indicates that *fantasie* are expected there.[18] Here, he may be referring to grotesque decoration rather than mythological narratives, and paintings that included exotic or monstrous

animals are often referred to as *fantasie*, irrespective of their subjects, which is one reason apocalyptic scenes occasionally attract the same designation. When Pinturicchio's contract to paint the ceiling of the Piccolomini specified *fantasie*, it referred to the grotesque decoration around the mythological panels. But the way in which the term is used interchangeably for grotesques and mythologies is revealing in itself. It is true that there was no clear division between the two: sometimes, as in the lunettes of the Sala delle Aquile at the Palazzo Te, mythological scenes are created from enlarged grotesque motifs; in other places, grotesques include miniature mythologies. Yet there was something else. When grotesque decoration spread, people immediately recognized it to be a manifestation of just that fantastic impulse that had so long been used to condemn mythology: 'What benefit will be gained by someone who admires a façade full of grotesques?' asked Cardinal Paleotti. 'What use is the metamorphosis of Daphne or Actaeon?'[19]

The way in which the word *fantasia* is used to designate a way of working, a type of subject, and a form of ornament, all of them associated primarily, if not exclusively, with the pagan past, suggests that there is a relationship between the content of mythological art, the way in which it is made, and its decorative function. Eventually the word is used to describe aspects of mannerist decoration. Federico Zuccaro describes the development of '*disegno fantastico*' from the work of Raphael's team in the Vatican Logge and the Villa Madama onwards, and Bellori characterizes the artistic situation in Rome around 1600 as being divided between Caravaggio's naturalism, which simply copied what appeared to the eyes, and the late mannerism of the Cavaliere d'Arpino, who worked '*alla fantasia*' following liberty of instinct without regard to nature.[20]

Bellori's dichotomy was not new. An unacknowledged contradiction lay at the heart of the Renaissance. Naturalism and classicism were meant to be inseparable; antique art was widely supposed to have excelled in the imitation of nature, and on this account to be worthy of imitation itself. The subject-matter of antique art was a different matter, for it dealt with gods who were really demons, and with monsters of many kinds unknown in nature. There was therefore an inescapable tension between classicism as naturalism and mythology as unreality. If art did not deal with the same subjects at which the ancients had excelled, it was not truly classical; if it did, it was not really natural.

At first, this conflict was only vaguely apprehended, but it came to the surface in late sixteenth-century Italian aesthetics. It was Tasso who eventually spelled out the problem. If you are writing a poem on a classical

subject, you have a choice: either you can include the pagan gods, or else you can leave them out. If you exclude them, you are sacrificing the opportunity to deal with the marvellous, because your poem will include nothing supernatural; but if you include them, your poem will not be lifelike or believable, for what the pagans accepted is simply incredible. In Tasso's opinion, modern epics should deal with Christian rather than pagan topics, because only then can you portray events that are both marvellous and lifelike.[21]

If anything, the difficulties were even more acute in painting than in poetry, and theorists struggled to find appropriate conceptual categories to describe a form of art that was increasingly widespread, but which did not seem to fit prevailing theories of imitation. Tasso's friend Gregorio Comanini used Plato's distinction between icastic and fantastic imitation – the former involves the representation of things that exist in nature; the latter, things that exist solely in the mind of the imitator, like Arcimboldo's much admired fantastic heads of Flora and Vertumnus. But while Giacopo Mazzoni (the literary theorist from whom Comanini had picked up the categories) had championed fantastic imitation in poetry, Comanini was reluctant to assert its primacy in painting: fantastic imitation was generally more suited to poetry, which delighted through its fabulous inventions, than painting, which displayed the skill of the artist through its capacity to imitate recognizable objects.[22]

Giovanni Gilio da Fabriano had taken a different approach in his *Dialogo* of 1564. One of the participants in the conversation points out that in antiquity many things that were neither true nor lifelike were introduced 'by the force of poetry', and cites a long list of hybrid monsters and metamorphoses (including those of Actaeon, Callisto, and Daphne) to prove it. Gilio's response is articulated through several sets of overlapping, though not exactly coterminous, distinctions. Troubled by those who seemed unable to distinguish truth from falsehood, history from poetry, Gilio insists on a clear distinction between *istoria* and *favola*.[23] Alberti had referred to all narrative paintings, including mythologies, as *istoria*, but during the sixteenth century other words were often used to refer to works with a mythological content. *Fantasia* was one; *favola* and *poesia* were others, both used almost exclusively for mythological narratives, though *poesie* (like *fantasie*) could also include things like grotesques. According to Gilio, some programmes are historical, others are poetical, and some are a mixture of the two. The paintings in the Sistine Chapel are in the first category; the loggia of Cupid and Psyche at the Farnesina is, as often, the chosen example of the

second, while Salviati's work at the Palazzo Farnese, which had combined Farnese histories with mythological and allegorical figures, belonged to the mixed group.[24]

Alongside this trinity, Gilio introduced another. An ancient treatise on rhetoric believed to be by Cicero had differentiated between the *historia*, which narrates actual events from the past, the *argumentum*, which relates fictitious but possible events, and the *fabula*, which was neither true nor probable.[25] Gilio reworked this in terms of the true (*vero*), the fictitious (*finto*), and the fabulous (*favoloso*). The true is what is, the fictitious is what is not but could be, while the fabulous not only is not but could never be. So Virgil's account of Dido and Aeneas is fictitious, while his claim that Trojan ships were transformed into sea nymphs is fabulous.[26] Although he does not use the term, Gilio here effectively divides the category of *fantasia*, which had been used for both the fictitious and the fabulous, by separating fictitious naturalism from unnatural fantasy. On this account, illustrations of the poets were allowable, provided that the merely fabulous (for example, grotesque decoration) is avoided, and painters do not try to pass off poetry as history, and falsehood as truth.

Gilio is often seen as a philistine driven by Counter-Reformation zeal, but his classification only brought into the open a cultural shift that other critics had been slow to acknowledge. The assumption of earlier Christian writers, and of some of the interlocutors in his dialogue, was that there was only a binary division between things that were true images and those that were false and so ought to be banned. To a remarkable degree, the ancient world and the Christian civilization that had emerged from it worked on the assumption that all cultural products were true – if not literally, then at some other level. Mythology had always posed problems in this regard, even in antiquity, but moral, physical, and historical allegory served to reassure the sceptic that, however improbable they might be on the surface, ancient fables nevertheless contained some kernel of truth. Boccaccio had taken this line in his defence of poetry at the end of his *Genealogia*. Poets are not liars. The word *fabula* just means conversation, and the poets only use fiction, as Christ used the parables, to convey some hidden truth. Against those who contend that whatever is not true is simply a lie, Boccaccio protests that fiction veils the truth.[27]

This is doubtless one reason why traditional allegories were repeated whatever their explanatory value. Their currency lay less in their intrinsic interest than in the fact that they guaranteed the fable in question was something more than pure fiction. Ligorio even claimed to be able to extract some sort of truth from grotesque decoration. But no one else was prepared

to swallow this idea, and if you accepted that grotesques were meaningless nonsense, then it seemed likely that some stories were too. In Comanini's dialogue, there is a distinction between the true *favola* and the false *favola*: the first contains some truth appropriately represented, whereas the latter has neither. The story of Achilles is an example of the former (his heel is a reminder of the weakness of the flesh), that of Venus and the rose (which Comanini, who was born in Mantua, may have known from the Palazzo Te) of the latter: it does not even tell us anything about roses.[28]

Whichever way you looked at it, the Renaissance had fostered a third category between the true and the false, namely that of images that were acknowledged to be false but were nevertheless permissible, provided they were sufficiently naturalistic or amenable to allegory. In addition, the false fables and the fabulous images condemned by the theorists did not go away either. Culture could no longer operate on the assumption that its content was true.

The return of the gods did not lead to their acceptance as deities, or to the rejuvenation of pagan religion, but rather to a steady increase in the fictive and the false. By the early eighteenth century, classical mythology had so expanded these categories that it furnished the stock examples of the unreal. As Hume noted, 'We have been so accustomed to the names of Mars, Jupiter, Venus, that in the same manner as education infixes any opinion, the constant repetition of these ideas makes them enter into the mind with facility, and prevail upon the fancy, without influencing the judgement.'[29] Hume is here echoing the sentiments of earlier French writers who, from Fontenelle onwards, had started to comment on a strange and relatively novel phenomenon. From an early age, people were now habituated to an entire culture whose content no one believed or even took seriously. As the Abbé Pluche complained, 'Men pass their youth among the gods. At their leaving the schools, they find them again on the stage . . . All publick shews repeat their adventures. You find them in your cantatas, songs, in the decorations of your apartments, gardens, and publick squares. Ingravings, pictures, poems, music, pleasant writings, learned dissertations, all in short conspire to show us under an honorable and pleasing outside, actions punished by the laws, and absurdities diametrically opposed to common sense.' None of this was designed to persuade the spectator of the reality of the events portrayed, for everyone accepted that mythologies were 'figures void of sense, and destitute of signification', and that Jupiter, Neptune, and Mars were nothing more than 'three puppets, fit at best to come down in a miraculous manner by a cord, to amuse children at the theatre'.[30]

Fontenelle himself was in a good position to evaluate the effect of such entertainments, for he had written the libretto to Colasse's opera *Thetis et Pelée*, staged in 1689. But as his essay *De l'origine des fables* revealed, he was already conscious that mythology was nothing but 'a mass of chimeras, day-dreams, and absurdities'.[31] From the time of the Greeks, it had been perpetuated through painting and poetry which, by giving expression to the imaginings of those who had invented the gods, fed the imagination of those who came afterwards. Even now, when no one believed in the fables of the Greeks, they were still maintained by means of poetry and painting. There was, he suggested, no better proof of the independence of reason and imagination than the fact that things about which reason is wholly undeceived may nevertheless lose none of their appeal to the imagination.

The idea that culture was composed of absurdities was fundamentally new in a Christian context, and there was something subversive about it. Noting the similarity of some classical myths to those of the indigenous population of the Americas, Fontenelle attributed the mythology of the ancients to their sheer ignorance. It was not that they knew the truth and concealed it in myth, they just did not know any better. Modern societies may no longer accept the same sort of nonsense, but they too know how to perpetuate their errors: 'All men resemble one another so much that there is no people whose foolishness should not make us tremble.'

But what of it? In his *Nouveaux dialogues des morts*, written a few years before, Fontenelle had imagined a conversation involving Herostratus, the man who in 365 BCE had burnt down the temple of Diana at Ephesus simply in order to make a name for himself. Herostratus now justifies his action by arguing that it is just as well that all the monuments of the ancient world are not still standing, because the moderns would not have anywhere to put theirs: 'If reason governed the world, nothing would happen. Sailors most fear tranquil seas where they are becalmed, and they want wind even if it brings a gale. Amongst men, the passions are the winds that put everything in motion, though they often cause storms.'[32]

Appendix

Principal Illustrated Translations of Ovid

The background to the first edition of the *Metamorphoses* printed in a vernacular language is revealing. In France, a tradition developed in the early fourteenth century that not only emphasized the moral meaning of Ovid's fables but applied them directly to Christian theology. The two chief works to do this were the *Ovide moralisé*, a long French verse paraphrase of the *Metamorphoses* which supplies allegories for every fable, and Pierre Bersuire's *Ovidius moralizatus*, a Latin prose allegorization preceded by a brief account of the appearance and attributes of the gods. The former was written with a courtly audience in mind, the latter for preachers looking for sermon illustrations. Together they proved to be of fundamental importance. There was no real tradition of miniature painting for the Latin text of Ovid or other classical poets, whereas there are illustrated manuscripts of the *Ovide moralisé* in verse and in its later prose redaction. Bersuire's work, which was frequently attributed to Thomas Walleys, was less frequently illustrated, but his iconographical introduction, translated into French, was combined with the *Ovide moralisé* in verse in an illustrated manuscript in Copenhagen. Illustrations from this manuscript were reworked in the Colard Mansion edition of 1484, which combined the texts of the prose redaction of the *Ovide moralisé* with translations from the *Ovidius moralizatus*. This edition, which reappeared as *La Bible des poetes* in 1493 and was reprinted under this title until 1531, was therefore in every respect reliant on pre-existing traditions.

In the first Italian edition of 1497, the woodcuts were new, but the text was Giovanni di Bonsignori's prose paraphrase of *c.* 1370, itself based on Arrigo Simintendi's earlier verse translation and Giovanni del Virgilio's allegories. This edition (like the *Ovide moralisé*) is a free paraphrase in which some details are omitted while other stories are filled out with additional information or elaborated for dramatic effect. Subsequent Italian verse translations, like Agostini (1522), Dolce (1553), and Anguillara (1561), do the same, often following the example of their predecessors

rather than the Latin text. They therefore constitute a distinct tradition, independent of contemporary classical scholarship, to which each translator adds or subtracts at will.

The Simintendi verse translation (which unlike Bonsignori's paraphrase follows the original Latin quite closely) had been quite widely disseminated in manuscript, sometimes with marginal drawings. But printing consigned his version to history. Publishers of early Italian translations did not think their readers wanted to follow a continuous text, and offered them pre-digested chunks of narrative followed by allegories and interspersed with woodcuts. Such books looked completely different from their unillustrated Latin counterparts which often had the Latin text in the centre of the page surrounded by the commentary in a small type. The first Latin edition to appear with illustrations was published in Venice in 1505 and used the woodcuts from the 1497 Italian edition; the slightly modified versions published by Tacuino in an edition of 1513 continued to appear in other illustrated Latin editions for the rest of the century.

Although vernacular translations were the ones most likely to be used by artists, and their illustrations had a direct influence on painters of all sorts, it was a long time before developments in the other arts had any reciprocal impact on the tradition of illustration. Only in the 1539 edition of *Le Grand Olympe* (a French translation first published in 1532, using the text, but not the allegories, of *La Bible des poetes*) does the illustrator display any real interest in classical antiquities, and it is not until Dolce's translation in 1553 that the illustrations start to incorporate motifs used in contemporary painting. One reason for this may be that until the mid-sixteenth century the number of illustrations was constantly on the increase, and publishers were not overly concerned about their quality, or even relevance. The same woodcut is often used repeatedly to illustrate stories whose themes are only vaguely related, and sometimes completely unrelated illustrations were taken from the publisher's stock. (The 1532 edition of *Le Grand Olympe* was illustrated throughout with woodcuts taken from an edition of Virgil.) All of this suggests that in early editions of Ovid the figures were ornament as much as illustration, and certainly not considered to be works of art in their own right.

In the second half of the century the approach changes. The decisive break came with Salomon's series of woodcuts, published in both French and Dutch editions in Lyons in 1557, and in Gabriele Simeoni's Italian version two years later. Virgil Solis's reworkings of Salomon's prints (in which the designs appear reversed) were published in 1563 in two separate editions by the same Frankfurt publisher. One had four-line summaries in both Latin

and German by Johann Posthius; the other, longer Latin verse summaries and allegories by Johann Spreng (subsequently translated into German). More ambitious still was Nicolaus Reusner's *Picta poesis ovidiana* (1580), which followed each of Solis's woodcuts with a small anthology of Latin verse, both classical (even Ovid is included) and contemporary (the former Vatican librarian Fausto Sabeo is the leading contributor).

Salomon's series, usually mediated by Solis, established the model for all the artists who subsequently produced prints of the *Metamorphoses*. However, they also fed off each other. Crispijn van de Passe's engravings (1602), which often follow Goltzius in the first three books, also include compositions derived from Tempesta and Solis, as well as from earlier artists (for example, Titian's *Diana and Callisto*). The sources of the accompanying verse summaries were just as eclectic. De Passe's engravings sometimes use either Estius's verses from Goltzius's prints or those of Posthius from Solis. Van der Borcht's prints were accompanied by Lactantius Placidus's Latin prose summaries, which were also in Spreng's version of Solis, and had often appeared in sixteenth-century Latin editions.

When full translations appeared in the mid-sixteenth century, most were eventually colonized by Salomon's or Solis's ubiquitous designs. François Habert's French verse translation of 1557 (the first French version to follow the original text) originally had no illustrations or allegories, but Salomon's designs were used in the edition of 1587. The first illustrated German edition was Jörg Wickram's revision of Albrecht von Halberstadt's Middle High German translation published in 1545. (Unlike other early translations based on medieval sources, this one came with a sober commentary by a contemporary scholar, Gerhard Lorichius.) By 1581, the woodcuts of the 1545 edition had been replaced with those of Virgil Solis. The first Dutch translation, by Johannes Florianus, appeared in 1552, and from 1566 appeared with illustrations based on Solis's woodcuts. Spanish translations included Jorge de Bustamente's of 1545, which in the edition of 1595 was illustrated with Solis's woodcuts, and that of Sánchez de Viana, which appeared in 1589 with illustrations based on the 1563 edition of Anguillara.

Commentaries offering a mixture of moral, physical, and historical interpretations began to appear in the Middle Ages, beginning with Arnulph of Orleans in the twelfth century. Giovanni del Virgilio's brief allegories, reworked in the 1497 edition of Bonsignori and in Niccolò Agostini's translation of 1522, did not contain specifically doctrinal interpretations. There were no moralizations at all in early editions of Dolce (and the later ones are very brief), or in the first edition of Anguillara's verse translation

published in 1561. When they returned, the tradition of spiritual allegory was already dead. Orologi's allegories in later editions of Anguillara were reserved for the end of each book, and this practice was continued by Renouard and Sandys. These later vernacular commentators were more eclectic than their medieval predecessors, and sometimes drew on mythographies, and recent Latin commentaries. But Sandys is the only one to try to make sense of the myths in terms of contemporary experience.

Whereas vernacular translations initially rely on medieval allegories, Latin editions are more scholarly at the outset, and only later pick up the allegorical method which they then feed back into the vernacular tradition. In 1493 Raphael Regius, a Paduan teacher of rhetoric, produced a commentary on the *Metamorphoses* largely devoid of allegory but full of historical and linguistic information of a kind absent from vernacular commentaries; to this commentary were added in 1510 Lactantius Placidus's summaries and Petrus Lavinius's historical allegorization of Book 1; in this form, Regius's edition remained the most popular Latin version until the 1580s in Italy, and until the 1520s in France. The most influential Latin commentaries of the second half of the century come from Protestant Europe. Johann Spreng's brief verse allegories for Solis's woodcuts expressed the moral implications of the story in Christian terms (although without much theological detail), while Georg Schuler (Georgius Sabinus), Melanchthon's son-in-law, offered a longer commentary rich in interpretations of every kind (save doctrinal exposition). Catholic restrictions on allegory were observed in the commentary by Jakob Spanmüller (Jacobus Pontanus), whose expurgated edition of Ovid was used in seventeenth-century Jesuit education.

The history of Renaissance editions of Ovid is a complex one in which translations, illustrations, and commentaries are constantly migrating and mutating independently of each other as they are recombined by enterprising publishers. Nevertheless some patterns are discernible. There is in general a positive correlation between vernacular translation and illustration and also between translation and allegorization, but a negative one between all three. This is, apart from anything else, a question of the economics of publishing. Mansion was financially ruined by his edition of 1484, and later publishers realized that the more illustrations there were, the less space for allegory, and vice versa. During the first half of the sixteenth century the trend is towards the multiplication of illustration and the reduction of allegory. In the latter part of the sixteenth century and in the early seventeenth, allegory returns to translations at the expense of illustration, but at the same time a new genre develops in northern Europe in which illustrations and summaries (and sometimes allegories) are united without the text.

Bold lettering indicates the name or title by which the edition is referred to in the text.

First Edition	Text	Allegories	Illustrations
ITALIAN			
Venice, 1497	Prose paraphrase **Giovanni di Bonsignori**	Based on Giovanni del Virgilio	53 woodcuts (Fig. 112)
Venice, 1522	Verse paraphrase **Niccolò Agostini**	Based on Giovanni del Virgilio	73 woodcuts
Venice, 1553 *Le trasformationi*	Verse paraphrase **Lodovico Dolce**	from 1561 edn., translator	95 woodcuts attrib. Giovanni Antonio Rusconi
Venice, 1561	Verse paraphrase **Giovanni Andrea dell'Anguillara**	From 1563 edn., summaries by Francesco Turchi and allegories by Giuseppe Orologi	15 woodcuts (some derived from Dolce). 1584 edn. has 15 full-page engravings by Giacomo Franco (Fig. 92)
FRENCH			
Bruges, 1484, published by **Colard Mansion**	Prose paraphrase *Ovide moralisé*	Based on *Ovide moralisé* and Pierre Bersuire's *Ovidius moralizatus*	34 woodcuts (17 of the gods in the introduction, and 17 full-page woodcuts) derived from Copenhagen MS Thott. 399 (Figs. 39 and 51). Some copies of the 1493 edn. also have painted miniatures throughout (Plate VIII)
Paris, 1493 *La Bible des poetes*			

First Edition	Text	Allegories	Illustrations
Paris, 1532 *Le Grand Olympe*	Prose paraphrase *La Bible des poetes*	–	187 woodcuts, mostly from Virgil. 1539 edn. has 238 woodcuts
Paris, 1557	Verse translation **François Habert**	–	1587 edn. Woodcuts from Salomon
Paris, 1614	Prose translation **Nicolas Renouard**	Translator	1617 edn. Franco; 1621 edn. Passe
GERMAN			
Mainz, 1545	Verse translation **Jörg Wickram** Revision of Albrecht von Halberstadt	Gerhard Lorichius	46 woodcuts; 1581 edn. Solis (Fig. 121)
DUTCH			
Antwerp, 1552	Prose translation **Johannes Florianus**	–	1566 edn., 178 woodcuts from Solis
SPANISH			
Amberes, 1545	Prose paraphrase **Jorge de Bustamente**	Translator	1595 edn., woodcuts from Solis
Valladolid, 1589	Verse paraphrase **Pedro Sánchez de Viana**	Translator	Woodcuts from 1563 edn. of Anguillara
ENGLISH			
London, 1632	Verse translation **George Sandys**	Translator	15 engravings, variants of Franco

First Edition	Text	Allegories	Illustrations
EPITOMES AND SETS OF PRINTS			
Lyons, 1557	French verse summaries; edns. in Dutch and Italian (1559)	–	178 woodcuts, **Bernard Salomon** (Fig. 7)
Frankfurt, 1563	One edition contains Latin and German verse summaries by Johann Posthius; the other, Lactantius's prose summaries and a Latin verse exposition by Johann Spreng	The Spreng edn. also includes his Latin verse allegories	178 woodcuts, **Virgil Solis** (after Salomon)
Antwerp, 1591	Latin prose summaries, Lactantius	–	178 etchings, **Pieter van der Borcht** (variants of Solis)
Late 1580s, published Antwerp, 1606	One-line Latin captions	–	150 etchings, **Antonio Tempesta** (See Plate III)
1589–1615, not published as a book	Latin verse summaries Franco Estius	–	52 engravings after **Hendrik Goltzius** (Fig. 54)
1602, published Cologne, 1607	Latin verse summaries (some from Posthius and Estius)	–	134 engravings, **Crispijn van de Passe**

NOTE: most of these works subsequently appeared in other editions, often with variations to the illustrations or text.

See Amielle (1989); Blattner (1998); Guthmüller (1997); Henkel (1922 and 1926–7); Moss (1982 and 1998); Sluijter (1986). Some sixteenth-century editions are available online in the University of Virginia's 'Ovid Collection', http://etext.lib.virginia.edu/latin/ovid.

List of Illustrations

Photographic acknowledgements are given in parentheses. Every effort has been made to contact all copyright holders. The publishers will be happy to make good in future editions any errors or omissions brought to their attention.

Black and White Illustrations

Colour Plates

Notes

The principal sources for the main narrative episodes involving each deity are given at the start of the notes to the chapter; there are no references to Renaissance editions of Ovid's *Metamorphoses*, for the relevant passages, and the commentaries upon them, can be found at the point corresponding to the reference given for the Latin text.

Prologue

1. Leonardo (1970), vol. 2, 214.
2. Fulgentius, *Myth.*, 2.1; Boccaccio, *Gen. deor.*, 3.23.
3. Boccaccio, *Gen. deor.*, 3, proem; 4, proem.
4. Tertullian, *De idolatria*, 24.1.
5. Bracciolini (1723/1969), 5ff.
6. Horace, *Odes*, 1.35; Cicero, *De officiis*, 2.6.
7. Boethius, *Consolatio*, 2.1; Patch (1927).
8. See Kiefer (1979).
9. Cf. Warburg (1999), 242.
10. Lucretius, *De rerum natura*, 2.1–4.
11. Krautheimer (1980), 200–201.
12. Quo. Buddensieg (1965), 50.
13. Alberti (1966), vol. 2, 441.
14. Ghiberti (1947), 32.
15. Greenhalgh (1989).
16. Quo. Buddensieg (1965), 47.
17. Ghiberti (1947), 56.
18. Boccaccio, *Gen. deor.*, 15, proem, and 11.

1. Sources

1. Vermiglioli (1807), 52.
2. Pater (1998), 118.
3. Baxandall (1971).
4. Cellini (1829), vol. 2, 256–7.
5. De Piles (1715), 25.
6. Baxandall (1963).
7. Lemaire (1882), vol. 1, 4 and 8.
8. See Fumagalli (1988), 10–11.
9. Lavin (1954).
10. Montefalchio (1525); Haurech (1543).
11. Aubrey (1982), 30.
12. e.g. Leone Ebreo (1929), 15v and 16v.
13. Bodin (1986), vol. 5, 43.

14. Lomazzo (1973–4), vol. 1, 344.

15. Montaigne, *Essais*, 3.10.

2. Objects

1. See Schubring (1915–23).
2. See de Winter (1984).
3. See Wilson (1987); Goldthwaite (1989); *L'istoriato* (1993).
4. See Campbell (2002).
5. See Jacquot (1956–72), and Mitchell (1979 and 1986).
6. See de Jong (1987).
7. Lomazzo (1973–4), vol. 2, 305.
8. See Talvacchia (1999).
9. Du Pérac (1908), 54–9.
10. See Errera (1920).
11. Vitruvius, *De architectura*, 5.6.9.
12. See Molinier (1886), and Weber (1975).
13. See Scher (1994).
14. See Syson and Thornton (2001).
15. See Hackenbroch (1979 and 1996).
16. See Hayward (1976).
17. See Lazzaro (1990).
18. See MacDougall (1978).
19. Alberti (1755), 185, 198.
20. Armenini (1587), 185 and 198.
21. Lomazzo (1973–4), vol. 2, 295–301.
22. Vitruvius, *De architectura*, 1.2.5.
23. See Morel (1997).

3. Hercules

Hercules's birth, labours, and death are covered in the *Libellus de imaginibus deorum*; Ovid, *Met.*, 9.1–323; Diodorus Siculus, *Library*, 4.8–58; Boccaccio, *Gen. deor.*, 13.1; Boethius, *Consolatio*, 4; Le Fèvre, *Recueil*, 1 and 2.
Hercules Gallicus: Lucian, *Heracles*.
Choice: Xenophon, *Memorabilia*, 2.1.21–34; Cicero, *De officiis*, 1.118; Silius Italicus, *Punica*, 15. 20–228.
Cacus: Virgil, *Aeneid*, 8.185–270; Livy, *Ab urbe condita*, 1.7.3; Ovid, *Fasti*, 1.543–78.
Omphale: Ovid, *Heroides*, 9.

1. Frati (1884), 172; see also Ettlinger (1972).
2. Dante, *De mon.*, 2.9.11.
3. Waldman (1994), 421 (translation adapted).
4. Vasari (1906), vol. 8, 80.
5. Annius (1498), sig. i 1r.
6. La Marche (1883–8), 43–4.
7. Jung (1966), 30–37.
8. Tuohy (1996).
9. Cruciani (1983), 159.
10. Rosenthal (1973).
11. Mitchell (1986); Yates (1975), 7–97; Checa Cremades (2000).
12. McDonald (1976).
13. Banach (1984).
14. Tate (1954), 10.
15. Angulo Iñiguez (1952).

16. Holman (1991–2).

17. Diodorus Siculus, *Library*, 5.24.

18. Tory (1529/1931), 2r.

19. See Jung (1966).

20. Vivanti (1967); Bardon (1974).

21. Bull (1995).

22. Polleross (1998), 39.

23. Bocchi (1574), n. 43; Valeriano (1556), 239r.

24. Panofsky (1930).

25. Tory (1529/1931), 63v.

26. Bagley (1996).

27. See Scott (1991), 204–6.

28. Apollodorus, *Library*, 2.5.1–12; Hyginus, *Fabulae*, 30.

29. Pictor (1532), 29v; Alciati (1550), 149–50.

30. Lenz (1924); Scaglia (2000).

31. Le Fèvre (1494), sig. m 1r.

32. Fulgentius, *Myth.*, 2.4.

33. Lucan, *Pharsalia*, 4.593–660; Philostratus, *Imagines*, 2.21.

34. Salutati (1951), 325; Landino (1970), 108.

35. Dante, *De mon.*, 2.7.10.

36. Salutati (1951), 221.

37. cf. Diodorus Siculus, *Library*, 4.12.3–8.

38. Boccaccio, *Gen. deor.*, 9.33.

39. Boethius (1501), 109r; Le Fèvre (1494), sig. n 2v.

40. Plautus, *Amphitryon*.

41. Theocritus, *Idylls*, 24.

42. McGrath (1974).

43. Palaephatus, *Incredibilia*, 18; Diodorus Siculus, *Library*, 4.26.2–4; Le Fèvre (1485).

44. Coffin (1979), 329.

45. Hyginus, *Poet. astr.*, 2.3.

46. Apollodorus, *Library*, 2.5.11.

47. See Shearman (1972).

48. Servius, *Comm. in Aen.*, 3.209, 240; Hyginus, *Fabulae*, 20.

49. Salutati (1951), 229.

50. e.g. Paris, BN, lat. 11856.

51. Philostratus, *Imagines*, 2.25.

52. Pausanias, *Description*, 5.1–2; Apollodorus, *Library*, 2.7.2.

53. Bacon, *De sapientia veterum*, 23.

54. Shearman (1972).

55. Forcella (1885), 75–6, 82.

56. Annius (1498), sig. a 2r.

57. Banach (1984).

58. McGowan (2000), 73.

59. Seznec (1972), 23.

60. Aubigné (1873–92), vol. 2, 226–31.

61. Bunyan (1965), 292.

62. Erasmus (1974), vol. 34, 167ff.

63. Philostratus, *Imagines*, 2.22.

64. Vigenère (1995), 784.

65. Alciati (1531), sig. B 1v–2r.

66. Valeriano (1567), 427v.

67. Servius, *Comm. in Aen.*, 7.697; see Partridge (1972).

68. Polydore Vergil, *De rerum inventoribus*, 3.6.

69. Philostratus, *Imagines*, 1.23.

70. Ovid, *Heroides*, 9.11.

71. Gregory Nazianzenus (Migne, 35.661); also Maier (1614) 222.

72. Hyginus, *Poet. astr.*, 2.14; Salutati (1951), 316.

73. Tasso, *Gerusalemme liberata*, 16.3; Statius, *Thebaid*, 10.649.

74. Ovid, *Fasti*, 2.303–58.

75. Hyginus, *Poet. astr.* 2.43; Giraldi (1696), 574.

76. Alciati (1550), 151.

77. Bocchi (1574), n. 140.

78. McGrath (1974), 198.

79. Giovio (1556), 122.

4. Jupiter

Saturn: Ovid, *Met.*, 1.113–14; *Fasti*, 4.197–210; Fulgentius, *Myth.*, 1.2; Macrobius, *Saturnalia*, 1.7; Boccaccio, *Gen. deor.* 8.1.

Punishments: Ovid, *Met.*, 4.456–63; Fulgentius, *Myth.*, 1.14–15.

Phaethon: Ovid, *Met.*, 2.1–400.

Giants: Ovid, *Met.*, 1.151–62; 5.319–31; *Fasti*, 5.35–44.

Loves: Ovid, *Met.*, 6.103–14.

Europa: Ovid, *Met.*, 2.833–75.

Io: Ovid, *Met.*, 1.588–688, 713–50.

Leda: Fulgentius, *Myth.*, 2.13.

Ganymede: Ovid, *Met.*, 10.15–61; Fulgentius, *Myth.*, 1.20.

Juno: Boccaccio, *Gen. deor.*, 9.1.

Semele: Ovid, *Met.*, 3.259–315.

Danaë: Ovid, *Met.*, 4.611; Fulgentius, *Myth.*, 1.19.

General: Lactantius, *Divinae Institutiones*, 1.11.

1. Statius, *Thebaid*, 4.514–17; Boccaccio, *Gen. deor.*, 1, proem, 3.

2. Boccaccio, *Gen. deor.*, 3.23.

3. Virgil, *Aeneid*, 7. 180f.; *Eclogues*, 4.6.

4. Ovid, *Fasti*, 1.235f.

5. McGrath (1984), 80.

6. Delmarcel (2000).

7. Statius, *Thebaid*, 2.596.

8. Horace, *Odes*, 3.4.65.

9. Diodorus Siculus, *Library*, 1.27.5, 1.25.2, 1.26.8; Annius (1498), sig. f, 1r–3v.

10. Lemaire (1882), vol.1, 46–52 (1.7).

11. Aretino (1997), vol. 1, 198.

12. Virgil, *Aeneid*, 6.620.

13. Callimachus, *Hymns*, 1.78.

14. Joukovsky-Micha (1967), 55–92.

15. Giovio (1556), 121.

16. Erasmus (1974–), vol. 28, 384; cf. vol. 12, 369.

17. Ovid. *Met.*, 10.149–54.

18. Boccaccio (1964–) vol. 3, 16–18.

19. Verheyen (1966); Leone Ebreo (1929), 47v–48v.

20. Talvacchia (1999).

21. Plutarch, *Life of Alexander*, 2.1–3.2.

22. Vasari (1906), vol. 9, 70.

23. Ovid, *Fasti*, 5.605–16; Horace, *Odes*, 3.27; Moschus, *Idylls*, 2; Lucian, *Dialogues of the Sea-Gods*, 15; Nonnos, *Dionysiaca*, 1.46–136. See also Achilles Tatius, *Leucippe and Cleitophon*, 1.1, and Boccaccio, *De claris mulieribus*, 9. See also Mundt (1988); Accidini Luchinat (2002).

24. Erasmus (1974–), vol. 85, 69 (*Epigrammata*, 27).

25. Erasmus, ibid.

26. Lucian, *Dialogues of the Sea-Gods*, 15.

27. Achilles Tatius, *Leucippe*, 1.1.

28. McGrath (2000).

29. Moschus, *Idylls*, 2.

30. Martial, *Epigrams*, 14.180.

31. Plutarch, *Of Isis and Osiris*; Diodorus Siculus, *Library*, 1.11–27.

32. Boccaccio, *Gen. deor.*, 9.1.12.

33. Verheyen (1966), 186.

34. Leone Ebreo (1929), 48r.

35. Ovid, *Met.*, 9.688–9.

36. Boccaccio, *Gen. deor.*, 11.7.1.

37. Dalli Regoli *et al.* (2001).

38. Bocchi (1574), n. 79.

39. Saslow (1986).

40. Leone Ebreo (1929), 48r.

41. Ovid, *Fasti*, 2.583–616.

42. Ovid, *Met.*, 3.316–38.

43. Bacon, *De sapientia veterum*, 16.

44. Nonnos, *Dionysiaca*, 7.145–55.

45. See Sluijter (1999).

46. Boccaccio (1964–), vol. 10, 9.

47. Santore (1991).

48. Le Fèvre (1494), sig. d, 5v.

49. Leone Ebreo (1929), 48r.

50. Erasmus (1974–), vol. 28, 396.

5. Venus

Venus, Mars, and Vulcan: Ovid, *Met.*, 4.169–257; Homer, *Odyssey*, 8.266–366.
Triumph of Cupid: Petrarch, *Trionfi*.
The Two Venuses: Plato, *Symposium*, 180D–181; Boccaccio, *Gen. deor.*, 3.22, 33; Ficino, *Commentary on Plato's* Symposium, 2.7.
Cupid and Psyche: Apuleius, *Golden Ass*, 4–6; Fulgentius, *Myth.*, 3.6.
Three Graces: Seneca, *De beneficiis*, 1.3.
Birth of Venus: *Homeric Hymns*, 'To Aphrodite', Fulgentius, *Myth.*, 1.2, 2.1.
Venus and Adonis: Ovid, *Met.*, 10.519–59, 708–39.

1. Lucian, *Dialogues*, 1.7.

2. Virgil, *Aeneid*, 8.370–85.

3. Ovid, *Ars amatoria*, 2.569–71.

4. Lucian, *The Dream, or the Cock*, 3.

5. Plato, *Symposium*, 196D (cf. Ficino, *Commentary*, 2.8).

6. Leone Ebreo (1929), 52r.

7. Aristotle, *Politics*, 1269b; Equicola (1525), 62v; Cartari (1996), 349; Plutarch, *Moralia*, 370D; see also Wind (1980), 86ff.

8. Plato, *Republic*, 390C.

9. Fulgentius, *Myth.*, 2.7.

10. Heraclitus, *Allegories*, 69, 12–14; Servius, *Comm. in Aen.*, 8.389.

11. Ronsard (1950), vol. 2, 704.

12. Lucretius, *De rerum natura*, 1.32–40.

13. Jones (1981).

14. Boccaccio, *Gen. deor.*, 5.26.

15. Parker (2000).

16. Lactantius, *Divinae Institutiones*, 1.11; Baehrens (1886), 407.

17. Panofsky (1972).

18. Virgil, *Eclogues*, 10.69; Boccaccio, *Gen. deor.*, 1.4.

19. Seneca, *Octavia*, 561–4.

20. Theocritus, *Idylls*, 19; see also Hutton (1941).

21. Colonna (1980), 41, 161.

22. Cartari (1996), 455–62.

23. Hesiod, *Theogony*, 120; Cicero, *De nat. deor.*, 3.60; Boccaccio, *Gen. deor.*, 1.15.

24. Merrill (1944); Wind (1980); Praz (1964); Panofsky (1972); Schreiber (1975); Hyde (1986).

25. Cicero, *De nat. deor.*, 3.59; Remigius, *Comm. in Mart.*, 62.11, quo. Chance (1994), 281.

26. Fulgentius, *Myth.*, 3.6; Boccaccio,

Gen. deor., 5.22; Martianus, *De nuptiis*, 1.7.

27. Cavicchioli (2002); Vertova (1979).

28. Equicola (1525), 66v.

29. Apuleius (1500), 134v.

30. Aristotle, *Nic. Ethics*, 7.4.2–5; Equicola (1525), 210v.

31. Gallo (1989), 10–97.

32. Schoon and Paarlberg (2001), 36.

33. Ovid, *Fasti*, 4.138; Boccaccio, *Gen. deor.*, 3.22; Pictor (1532), 18r; Homer, *Iliad*, 5.311ff.

34. Pliny, *Nat. hist.*, 19.44.154; Osborne (1987), 26.

35. Gombrich (1972).

36. Claudian, *Epithalamium*, 49–96; Philostratus, *Imagines*, 1.6.

37. Watson (1979), 82.

38. Warburg (1999); Dempsey (1992); Poliziano, *Rusticus*, 210–21; Lucretius, *De rerum natura*, 5.737–40; Ovid, *Fasti*, 5.193; Horace, *Odes*, 4.7.

39. Alberti (1972), 96–7.

40. Servius, *Comm. in Aen.*, 1.720.

41. Jeremiah 2.27.

42. Mertens (1994), 164; Seznec (1972), 240.

43. Lactantius Placidus, *Theb.*, 2.286; Boccaccio, *Gen. deor.*, 5.35.

44. Wind (1980), 73f.

45. Cartari (1996), 492; Pausanias, *Description*, 6.24.6–7.

46. Conti (1616), 221–3.

47. Poliziano, *La giostra*, 1.99; *Homeric Hymns*, 6.

48. Alberti (1972), 86–7.

49. Boccaccio, *Gen. deor.*, 3.23; Macrobius, *Saturnalia*, 1.8.8.

50. Ridewall (1926), 78; Boccaccio, *Gen. deor.*, 3.23.

51. Apuleius, *Golden Ass*, 4.31; Claudian, *Epithalamium*, 151–73.

52. Nonnos, *Dionysiaca*, 13.439–43.

53. Pliny, *Nat. hist.*, 35.91.

54. Ovid, *Fasti*, 4.141–4; Pontano (1948), 412–13.

55. Pictor (1532), 17v.

56. Colonna (1980), 63.

57. Polydore Vergil, *De rerum inventoribus*, 3.17.

58. Boccaccio, *Gen. deor.*, 5.35; Brant (1994); Fulgentius, *Myth.*, 2.1.

59. Santore (1997).

60. Claudian, *Epithalamium*, 97–108; Cartari (1996), 480.

61. Lorris and de Meun (1982), 41–2.

62. Colonna (1980), 36; see also Gombrich (1972), and Vescovo (1997).

63. Dolce (1547), 48v, and in Roskill (1968), 212.

64. Pontano (1948), 410.

65. Shakespeare, *Venus and Adonis*, 136.

66. Bion, *Lament for Adonis*.

67. Moschus, *The Dead Adonis*.

68. Macrobius, *Saturnalia*, 1.21.

69. Brant (1994), 36.

70. Alciati (1550), 85.

71. Terence, *Eunuch*, 732; Fulgentius, *Myth.*, 2.1; Albricus (1520), 3r.

72. Aneau (1552), 114; Haechtanus (1579), sig. D 3v.

73. Cruciani (1983), 397.

74. Rosand (2001).

6. Bacchus

Pentheus: Philostratus, *Imagines*, 1.18; Ovid, *Met.*, 3.511–4.30.

Death of Orpheus: Ovid, *Met.*, 11.1–84.

Silenus and Midas: Philostratus, *Imagines*, 1.22; Ovid, *Met.*, 11.85–145.

Andrians: Philostratus, *Imagines*, 1.25.

Pan and Syrinx: Ovid, *Met.*, 1.689–713.

Birth of Bacchus: Philostratus, *Imagines*, 1.14; Ovid, *Met.*, 3.255–315; Nonnos, *Dionysiaca*, 9.1–36.

Tyrrhenian pirates: Philostratus, *Imagines*, 1.19; Ovid, *Met.*, 3.572–700.

Bacchus and Ariadne: Philostratus, *Imagines*, 1.15; Ovid, *Met.*, 8.176–83, *Ars amatoria* 1.537ff., *Fasti*, 3.459–516, *Heroides*, 10; Catullus, *Carmina*, 64.251–64; Nonnos, *Dionysiaca*, 47.265–319.

Dance of the Seasons: Philostratus *Imagines*, 2.34; Nonnos, *Dionysiaca*, 11.484–12.187.

1. Euripides, *Bacchae*, 200–220; Vigenère (1995), 284.
2. Plutarch, *Moralia*, 451 C–D.
3. Conti (1627), 468.
4. Conti, ibid., 482.
5. Calenus (1591), 13.
6. Gesner (1600), sig. B 2 v.
7. Marcus (n.d.), 2.
8. Carpenter and Faraone (1993), 1.
9. Callistratus, *Descriptions*, 8.
10. Condivi (1553), 40.
11. Condivi, ibid., 40.
12. Pliny, *Nat. Hist.*, 34.19. 69.
13. Summers (1981), 265.
14. Callistratus, *Descriptions*, 4
15. Alciati (1531), sig. D 4r-v.
16. See Wind (1980), 177–90.
17. Screech (1980), 259–62.
18. Kren (1980).
19. Ovid, *Ars amatoria*, 1.543–4.
20. Virgil, *Eclogues*, 6.13–30.
21. Plato, *Symposium*, 215.
22. Screech (1997), 91.
23. See Holberton (1987), 57–66.
24. Philostratus, *Imagines*, 2.17.
25. Lucian, *Dionysus*, 6.
26. Bacon, *De sapientia veterum*, 6.
27. Marino (1618), 105 r and v.
28. Bacon, *De sapientia veterum*, 6.
29. Link (1995), 44–52.
30. Plutarch, *Moralia*, 419B.
31. Exodus 34:30.
32. Herodotus, *Histories*, 2.145–6.
33. Thuillier (1960), 213.
34. Vigenère (1995), 239; Vossius (1641), vol. 1, 224–34.
35. Exodus 17:1–7, and Numbers 20:1–13; Euripides, *Bacchae*, 704–5.
36. Bull (1999).
37. Plutarch, *Moralia*, 671C–72C.
38. Küsel (1968), n. 5.
39. Marino (1618), 105v.
40. Bull (1995), 6.
41. Fehl (1992), 51ff.
42. Ovid, *Fasti*, 1.391–440.
43. Philostratus, *Imagines*, 1.23.
44. See Bull (1998).
45. Yates (1956), 73.
46. See Thompson (1956), 259–64, and Holberton (1986), 347–50.
47. Ridolfi (1914–24), vol. 2, 43.
48. Gottfried (1619).

49. See Grubitzsch-Rodewald (1973); Marino (1911–12), vol. 1, 292; vol. 2, 75.

50. Medici (1912), vol. 1, 163–5.

51. Diodorus Siculus, *Library*, 5.21.2.

52. Orso (1993), 128.

53. Ovid, *Fasti*, 3.465–6.

54. Matz (1968–75), vol. 2, 78–93, 94ff.

55. Bull (1998).

56. See Bull (1998).

57. Marullo (1995), 64–75; *Orphic Hymns*, 53.

58. cf. Horace, *Epistles*, 2.1.5–10.

59. Mahé (1992), 217–19, 230.

60. Nonnos, *Dionysiaca*, 7.1–109.

61. Marino (1975), vol. 1, 415–16.

62. Vigenère (1995), 882–3.

63. Nonnos (1625), 201.

64. Félibien (1725), vol. 4, 86; Bellori (1976), 463.

65. Fumaroli (1994), 53–82.

66. Nonnos (1625), 203.

67. Plutarch, *Moralia*, 524D; Cartari (1996), 375.

68. Bacon, *De sapientia veterum*, 24.

7. Diana

Iphigenia: Ovid, *Met.*, 12.27–38.
Latona: Ovid, *Met.*, 6.157–381.
Niobe: Ovid, *Met.*, 6.146–312.
Actaeon: Ovid, *Met.*, 3.138–252.
Callisto: Ovid, *Met.*, 2.409–531, *Fasti*, 2.153–92.
Endymion: Lucian, *Dialogues of the Gods*, 19; Fulgentius, *Myth.*, 2.16; Boccaccio, *Gen. deor.*, 4.16.4, 9–10.
General: Callimachus, *Hymn to Artemis*.

1. Pliny, *Nat. hist.*, 35.73; Cicero, *Orat.*, 22.74; Quintilian, *Inst. Or.*, 2.13; Montaigne, *Essais*, 1.2.

2. Euripides, *Iphigenia at Aulis*, 1547–50.

3. Lessing (1985–), vol. 5.2, 28–9.

4. Judges 11; Dante, *Paradiso*, 5.

5. Lucretius, *De rerum natura*, 1.101.

6. Alciati (1550), 75.

7. Michael (1985), 422.

8. Demerson (1972), 522.

9. Ovid, *Met.*, 11.291–345.

10. Ovid, *Met.*, 15.479–546; Philostratus, *Imagines*, 2.4.

11. Ovid, *Met.*, 5.572–641.

12. Virgil, *Aeneid*, 3.696.

13. Ovid, *Met.*, 7.681–865; see Lavin (1954).

14. Fontenrose (1981).

15. Hyginus, *Poet. Astr.*, 2.34.

16. Ovid, *Fasti*, 5.534.

17. Gombrich (1972), 82–4.

18. Apollodorus, *Library*, 1.7.4.

19. See Bardon (1963).

20. Cellini (1829), vol. 2, 203.

21. Virgil, *Aeneid*, 7.774.

22. Bardon (1963), 48.

23. Wall (1988), 26–46.

24. Petrarch, *Canzoniere*, 23.149.

25. Euripides, *Bacchae*, 1290–91.

26. Conti (1616), 354; Bacon, *De sapientia veterum*, 10.

27. Moss (1998) has a selection of

Latin commentaries; Barkan (1980) surveys the literary texts.

28. Alciati (1531), sig. E, 6v.
29. Bruno (1995), 1.4.
30. Palaephatus, *Incredibilia*, 6; Fulgentius, *Myth.*, 3.3.
31. Euripides, *Bacchae*, 337ff.; Diodorus Siculus, *Library*, 4.81.4; Lucian, *Dialogues*, 18; Nonnos, *Dionysiaca*, 5.287ff.
32. Ovid, *Tristia*, 2.103–6.

33. Poliziano (1522), 94r–102r.
34. Pausanias, *Description*, 9.2.3.
35. Virgil, *Georgics*, 3.391f.
36. McGrath (1983).
37. See Wind (1980).
38. Bull (2001).
39. Pictor (1532), 22r.
40. Cartari (1996), 98f.
41. Ovid, *Met.*, 8.268–546.
42. Xenophon, *On Hunting*, 10.
43. Virgil, *Aeneid*, 5.485–518.

8. Apollo

Marsyas: Ovid, *Met.*, 6.382–400; *Fasti*, 6.696–710.
Midas: Ovid, *Met.*, 9.146–93.
Muses and Pierides: Ovid, *Met.*, 5.250–345, 662–78; Fulgentius, *Myth.*, 1.17.
Coronis: Ovid, *Met.*, 2.542–7, 595–632.
Cyparissus and Hyacinthus: Ovid, *Met.*, 10.106–42, 162–219.
Leucothoë and Clytie: Ovid, *Met.*, 4.190–273.
Cumaean Sibyl: Ovid, *Met.*, 14.129–53.
Daphne: Ovid, *Met.*, 1.452–567.
Python: Ovid, *Met.*, 1.437–49.
Sun: Macrobius, *Saturnalia*, 1.17.

1. Servius, *Comm. in Aen.*, 4.58.
2. Fulgentius *Myth.*, 2.10.
3. On Marsyas in Italian art, see Wyss (1996).
4. Apollodorus, *Library*, 1.4.2.
5. See Baumstark and Volk (1995).
6. Philostratus, *Imagines*, 1.22.
7. Sansovino (1587), 38.
8. Ficino (1975–99), vol. 2, 9.
9. See Bowles (1989).
10. Boethius, *Consolatio*, 1.1.
11. Boccaccio, *Gen. deor.*, 14.20.
12. Ficino (1975–99), vol. 4, 23.
13. Ficino (1989), 108–9.
14. Ficino (1989), 124–5; Diogenes Laertius, *Lives*, 3.33.

15. See Giraldi (1511), and Boissard (1601).
16. Quo. Lightbown (1986), 197; Servius, *Comm. in Aen.*, 7.641.
17. Hyginus, *Poet. astr.*, 2.27.
18. For a comprehensive overview, see Schröter (1977).
19. *Anthologia Latina*, C. 664.
20. See Mottola Molfino and Natale (1991).
21. Baxandall (1965).
22. Salutati (1891–1911), vol. 2, 345–54, and (1951), 45–53.
23. Tory (1529/1931), 28v.
24. Albricus (1520), 32v.
25. See Luh (2001).

26. Plato, *Phaedrus*, 265; Ficino (1975–99), vol. 1, 47–8.
27. Errico (1974), 67.
28. Conti (1627), 789.
29. Vasari (1906), vol. 4, 335, 366.
30. Quoted Schröter (1980), 220.
31. Cruciani (1983), 386–405.
32. Forcella (1885), 82.
33. See Fumaroli (1994), 97–101.
34. Quo. Rowland (1998), 190.
35. Passeri (1934), 26.
36. Bacon, *De sapientia veterum*, 3.
37. Ovid, *Met.*, 2.676–707.
38. Boccaccio, *Amorosa visione*, 19; Spenser, *Faerie Queene*, 3.11.

39. Petronius, *Satyricon*, 48.4.
40. See Stechow (1932), and, for literary interpretations, Giraud (1968), and Barnard (1987).
41. Boccaccio, *Gen. deor.*, 7.29.
42. Néraudau (1986), 46.
43. Lucian, *De saltatione*, 38.
44. See Kantorowicz (1963).
45. Quo. Negro (1996), 126 n. 10.
46. Bardon (1974).
47. *Le soleil* (1623).
48. Polleross (1987).
49. Néraudau (1986), 35–9.

9. The Mirror

Wedding of Peleus and Thetis: Catullus, *Carmina*, 64; Lucian, *Dialogues of the Sea-Gods*, 7; Lemaire, *Illustrations*, 1.28–30.

Judgement of Paris: Ovid, *Heroides*, 16; Lucian, *Judgement of the Goddesses*; Apuleius, *Golden Ass*, 10.30–32; Fulgentius, *Myth.*, 2.1; Boccaccio, *Gen. deor.*, 6.22. Guido, *Historia*, 6; Le Fèvre, *Recueil*, 3; Lemaire, *Illustrations*, 1.31–5.

1. Ficino (1975–99), vol. 2, 21.
2. Hyginus, *Fabulae*, 92; Fulgentius, 3.7; Boccaccio, 12.50.
3. See Grootkerk (1975)
4. See Ehrhart (1987) and, more generally, Damisch (1996).
5. Healy (1997), 123ff.
6. Ficino (1959), 1.920.
7. Veldman (1980) and (1983).
8. Herold (1554), sig. b 6v.
9. Scorza (1987) 74.
10. Cicero, *Ad Att.*, 1.4.3; Lomazzo (1973–4), 303.
11. Lemaire (1882), 249.
12. Tory (1529), 29v–30.
13. Virgil, *Aeneid*, 8.416–23.

14. Alciati (1531), sig. D 8v.
15. Ovid, *Met.*, 15.858–60; Aneau (1552), 116.
16. Vasari (1906) vol. 8, 86.
17. Vasari, ibid., 80.
18. Forcella (1885), 102–3.
19. See Leopold (1980).
20. See Kren (1980).
21. On mythological art and the Roman viewer, see Brilliant (1984); Clarke (1991); Elsner (1995); Gazda (1991); Simon (1990); Vermeule (1977); Zanker (1988).
22. Vitruvius, *De architectura*, 1.7.1.
23. Petrarch, *Canzoniere*, 137.

Epilogue

1. Rowland (1984).
2. Ovid, *Met.*, 1.89–112.
3. Ovid, *Met.*, 8.618–724.
4. Stechow (1941).
5. Zeri (1994).
6. Friedländer (1957); Battisti (1962).
7. Equicola (1536), 164r.
8. See Smyth (1992), and Wohl (1999).
9. Philostratus, *Life of Apollonius of Tyana*, 2.22. See also Bundy (1927); Kemp (1977); Summers (1981).
10. Horace, *Ars poetica*, 1ff.
11. Davis-Weyer (1986), 100–103.
12. 1 Cor. 8:4.
13. Quo. Garin (1985), 351.
14. Vasari (1906), vol. 4, 135, 139.
15. Roskill (1968), 168.
16. Heikamp (1978), 156.
17. Vasari (1906), vol. 6, 153; vol. 5, 373, 411, 541.
18. Armenini (1587), 205; Lomazzo (1973–4), 305.
19. Barocchi (1960–62), vol. 2, 386–7.
20. Zuccaro (1961), 237ff.; Bellori (1976), 32.
21. Tasso (1964), 93ff.
22. Barocchi (1960–62), vol. 3, 274, 257f., 285.
23. Barocchi (1960–62), vol. 2, 16.
24. Barocchi, ibid., 15.
25. Cicero, *Rhetorica ad Herennium*, 1.8.13.
26. Barocchi (1960–62), vol. 2, 100–101.
27. Boccaccio, *Gen. deor.*, 14.13.
28. Barocchi (1960–62), vol. 3, 324–5.
29. Hume (1951), 121.
30. Pluche (1740), vol. 2, 269–70, 207, 272–3.
31. Fontenelle (1989–), vol. 3, 187–202.
32. Fontenelle (1989–) vol. 1, 129–30.

Select Bibliography

The bibliography is confined to works directly referred to in the text and notes, and to recent secondary literature of general interest. It does not routinely include museum catalogues, or monographs and articles on specific artists and commissions. Classical texts appear only where an early modern edition has been cited, or where there is no Loeb edition (for the principal Renaissance translations of the *Metamorphoses*, see Appendix). Book titles are frequently abbreviated; the following abbreviations are used for journals: *BM* – *Burlington Magazine*; *JWCI* – *Journal of the Warburg and Courtauld Institutes*.

Essential reference works

P. P. Bober and R. O. Rubinstein, *Renaissance Artists and Antique Sculpture*, London, 1986.

G. Boccaccio, *Genealogie deorum gentilium*, ed. V. Zaccaria (vols. 7 and 8 of *Tutte le opere*), Milan, 1998.

V. Cartari, *Le Imagini de i dei de gli antichi*, ed. G. Auzzas, F. Martignago, M. P. Stocchi, P. Rigo, Vicenza, 1996.

P. Grimal, *The Dictionary of Classical Mythology*, Oxford, 1986.

A. Henkel and A. Schöne (eds.), *Emblemata*, Stuttgart, 1976.

Iconclass: An Iconographic Classification System (9 vols.), Amsterdam, 1973–83.

Iconclass Indexes: Italian Prints, Doornsdijk, 1987–; *Dutch Prints*, Leiden, 1994–; *Early German Prints*, 1995–; *Early Netherlandish Paintings*, 2002–; *Rembrandt and his School*, 2000–.

Lexicon iconographicum mythologiae classicae (8 vols.), Zurich, 1981–99.

H.-K. and S. Lücke, *Antike Mythologie: Ein Handbuch*, Hamburg, 1999.

J. D. Reid, *The Oxford Guide to Classical Mythology in the Arts, 1300–1990s* (2 vols.), New York, 1993.

G. de Tervarent, *Attributs et symboles dans l'art profane*, Geneva, 1997.

The Austrian Academy of Sciences has a useful online bibliography: *Bibliographie Zum Nachleben des antiken Mythos*, and other online resources, at www.oeaw.ac.at/kal/mythos.

General

C. Accidini Luchinat (ed.), *Il mito di Europa*, Florence, 2002.

L. Agostini, *Le gemme antiche figurate* (2 vols.), Rome, 1657–69.

L. B. Alberti, *The Architecture . . .*, London, 1755.

—— *L'Architettura* (2 vols.), Milan, 1966.

—— *On Painting and on Sculpture*, London, 1972.

Albricus, *Allegoriae poeticae*, Paris, 1520.

A. Alciati, *Emblematum liber*, Augsburg, 1531.

—— *Emblemata*, Lyon, 1550.

U. Aldrovandi, *Delle statue antiche*, Venice, 1556.

G. Aleandro, *Antiquae tabulae marmoreae solis effigie symbolisque exculptae accurata explicatio*, Rome, 1616.

D. C. Allen, *Mysteriously Meant: The Rediscovery of Pagan Symbolism*, Baltimore, 1970.

G. Amielle, *Recherches sur des traductions françaises des Métamorphoses d'Ovide illustrées et publiées en France*, Paris, 1989.

B. Aneau, *Picta poesis*, Lyon, 1552.

D. Angulo Iñiguez, *La mitologia el arte español de renacimiento*, Madrid, 1952.

Annius of Viterbo (Giovanni Nanni), *Antiquitatum variarum volumina XVII*, Rome, 1498.

Anthologia Latina, Leipzig, 1894.

L. Apuleius, *Asinus Aureus*, Bologna, 1500.

P. Aretino, *Lettere* (5 vols.), 1997–.

G. B. Armenini, *De' veri precetti della pittura*, Ravenna, 1587.

A. d'Aubigné, *Œuvres complètes* (6 vols.), Paris, 1873–92.

J. Aubrey, *Brief Lives*, Woodbridge, 1982.

F. Bacon, *De sapientia veterum*, London, 1609.

E. Baehrens (ed.), *Fragmenta poetarum romanorum*, Leipzig, 1886.

A. Bagley, 'Hercules in Emblem Books and Schools', in A. Bagley *et al.* (eds.), *The Telling Image: Explorations in the Emblem*, New York, 1996, 69–95.

B. Baldini, *La Mascherata della genealogia degl'iddei*, Florence, 1565.

J. Banach, *Hercules Polonus*, Warsaw, 1984.

F. Bardon, *Le Portrait mythologique à la cour de France*, Paris, 1974.

—— *Diane de Poitiers et le mythe de Diane*, Paris, 1963.

H. Bardon, *Le Festin des dieux*, Paris, 1960.

L. Barkan, 'Diana and Acteon: The Myth as Synthesis', *English Literary Renaissance* 10 (1980), 317–59.

—— *The Gods Made Flesh*, New Haven, 1986.

—— *Unearthing the Past*, New Haven, 1999.

M. E. Barnard, *The Myth of Apollo and Daphne from Ovid to Quevedo*, Durham, NC, 1987.

P. Barocchi (ed.), *Trattati d'arte del Cinquecento* (3 vols.), Bari, 1960–62.

F. Barocelli, *Ercole e i Farnese*, Milan, 1993.

P. Barolsky, *Infinite Jest*, London, 1978.

P. A. de' Bassi, *Le fatiche d'Ercole*, Ferrara, 1475.

E. Battisti, *L'antirinascimento*, Milan, 1962.

R. Baumstark and P. Volk, *Apoll schindet Marsyas*, Munich, 1995.

M. Baxandall, 'A Dialogue on Art from the Court of Lionello d'Este', *JWCI* 26 (1963), 304–26.

—— 'Guarino, Pisanello and Manuel Chrysoloras', *JWCI* 28 (1965), 183–204.

—— *Giotto and the Orators*, Oxford, 1971.

G. Bellori, *Le vite de' pittori, scultori, e architetti moderni*, Turin, 1976.

Benoît de Sainte-Maure, *Le roman de Troie* (6 vols.), Paris, 1904–12.

P. Bersuire (Petrus Berchorius), *De formis figurisque deorum*, Utrecht, 1960.

R. Black and G. Pomaro, *La consolazione della filosofia nel Medioevo e nel Rinascimento italiano*, Florence, 2000.

A. Blankert *et al.*, *Gods, Saints and Heroes: Dutch Painting in the Age of Rembrandt*, Washington, 1980.

E. Blattner, *Holzschnittfolgen zu den Metamorphosen des Ovid: Venedig 1497 und Mainz 1545*, Munich, 1998.

H. Blumenberg, *Shipwreck with Spectator*, Cambridge, MA, 1997.

G. Boccaccio, *Tutte le opere*, ed. V. Branca (10 vols.), Milan, 1964.

A. Bocchi, *Symbolicarum quaestionum libri*, Bologna, 1574.

J. Bodin, *Les Six Livres de la république* (6 vols.), Paris, 1986.

C. de Boer, *Ovide moralisé* (5 vols.), Amsterdam, 1915–38.

Boethius, *De consolatione philosophiae*, Strasbourg, 1501.

J. J. Boissard, *Parnassus cum imaginibus musarum deorumque praesidum Hippocrenes*, Frankfurt, 1601.

R. R. Bolgar, *The Classical Heritage*, Cambridge, 1954.

G. Bonsignori, *Ovidio Metamorphoseos vulgare*, Bologna, 2001.

B. van den Boogert *et al.*, *Maria von Hongarije*, Zwolle, 1993.

A. Boschloo, 'Images of the Gods in the Vernacular', *Word and Image* 4 (1988), 412–21.

A. de Bosque, *Mythologie et maniérisme*, Antwerp, 1985.

E. A. Bowles, *Musical Ensembles in Festival Books, 1500–1800*, Ann Arbor, 1989.

F. Bracciolini, *Lo Scherno degli dei*, Rome, 1626.

P. Bracciolini, *Historiae de varietate fortunae*, Bologna, 1969.

T. Bradshaw, *The Shepherds Starre*, London, 1591.

S. Brant, *Das Narrenschiff*, Baden-Baden, 1994.

R. Brilliant, *Visual Narratives: Storytelling in Etruscan and Roman Art*, Ithaca, 1984.

C. Brink and W. Hornbostel (eds.), *Pegasus and the Arts*, Munich, 1993.

H. Brummer, *The Statue Court in the Vatican Belvedere*, Stockholm, 1970.

G. Bruno, *Degli eroici furori*, Bari, 1995.

H. Buchthal, *Historia Troiana*, London, 1971.

T. Buddensieg, 'Gregory the Great, the Destroyer of Pagan Idols', *JWCI* 28 (1965), 44–65.

M. Bull, 'Poussin's Bacchanals for Cardinal Richelieu', *BM* 137 (1995), 5–11.

—— 'Poussin and Nonnos', *BM* 140 (1998), 724–38.

—— 'Notes on Poussin's Egypt', *BM* 141 (1999), 537–41.

—— 'Poussin's "Loves of the Goddesses" ', *Gazette des Beaux-Arts* 137 (2001), 61–70.

M. W. Bundy, *The Theory of Imagination in Classical and Medieval Thought*, Urbana, 1927.

J. Bunyan, *The Pilgrim's Progress*, Harmondsworth, 1965.

N. Calenus, *In detestationem, originem et ritum Bacchanaliorum oratio*, Marburg, 1591.

M. Camille, *The Gothic Idol*, Cambridge, 1989.

S. J. Campbell, *Cosmè Tura of Ferrara*, New Haven, 1997.

T. P. Campbell, *Tapestry in the Renaissance*, New York, 2002.

F. Cappelletti and G. Huber-Rebenich (eds.), *Der antike mythos und Europa*, Berlin, 1997.

T. H. Carpenter and C. A. Faraone (eds.), *Masks of Dionysus*, Ithaca, 1993.

V. Cartari, see Essential Reference Works.

G. B. Cavalieri, *Antiquarum statuarum Urbis Romae libri* (2 vols.), Rome, 1585–94.

S. Cavicchioli, *Le metamorfosi di Psiche*, Venice, 2002.

B. Cellini, *Vita* (3 vols.), Florence, 1829.

K. Celtis, *Ludi scaenici*, Budapest, 1945.

J. Chance, *Medieval Mythography*, Gainesville, 1994.

A. Chastel, *Art et humanisme*, Paris, 1961.

F. Checa Cremades, *Carolus*, Toledo, 2000.

C. Cieri Via (ed.), *Immagini degli dei*, Lecce, 1996.

J. R. Clarke, *The Houses of Roman Italy*, Berkeley, 1991.

D. R. Coffin, *The Villa in the Life of Renaissance Rome*, Princeton, 1979.

F. Colonna, *Hypnerotomachia Poliphili* (2 vols.), Padua, 1980.

A. Condivi, *Vita di Michelangelo Buonarroti*, Rome, 1553.

N. Conti, *Mythologiae*, Padua, 1616.

—— *Mythologiae* (tr. J. Baudouin), Paris, 1627.

E. de Conty, *Le Livre des eschez amoureux moralisés*, ed. F. Guichard-Tesson and B. Roy, Montreal, 1993.

L. A. Cornutus, *Theologiae Graecae compendium*, Leipzig, 1881.

F. Cruciani, *Teatro nel Rinascimento Roma 1450–1550*, Rome, 1983.

J. Cunnally, *Images of the Illustrious*, Princeton, 1999.

N. Dacos, *La Découverte de la Domus Aurea*, London, 1969.

G. Dalli Regoli, R. Nanni, A. Natali (eds.), *Leonardo e il mito di Leda*, Milan, 2001.

H. Damisch, *The Judgment of Paris*, Chicago, 1996.

Dante, *De monarchia*, Florence, 1950.

—— *La divina commedia*, Milan, 1991.

Dares of Phrygia, *De excidio Troiae historia*, Leipzig, 1873.

C. Davis-Weyer, *Early Medieval Art, 300–1500*, Toronto, 1986.

G. Delmarcel, *Los Honores*, Antwerp, 2000.

G. Demerson, *La Mythologie classique dans l'oeuvre lyrique de la 'Pléiade'*, Geneva, 1972.

C. Dempsey, *The Portrayal of Love*, Princeton, 1992.

W. Dietterlin, *Architectur von Portalen*, Strasbourg, 1594.

L. Dolce, *Il capitano*, Venice, 1547.

G. Du Choul, *Discours de la religion des anciens Romains illustré*, Lyon, 1556.

E. Du Pérac, *Roma prima di Sisto V*, Rome, 1908.

N. E. Edwards, 'The Renaissance *stufetta* in Rome', Ph.D., University of Minnesota, 1983.

M. J. Ehrhart, *The Judgment of the Trojan Prince Paris in Medieval Literature*, Philadelphia, 1987.

W. Eisler, 'The impact of the Emperor Charles V upon the visual arts', Ph.D., Pennsylvania State University, 1983.

—— 'Patronage and Diplomacy: the North Italian Residences of the Emperor Charles V', in F. W. Kent and P. Simons (eds.), *Patronage, Art, and Society in Renaissance Italy*, Oxford, 1987, 269–82.

J. Elsner, *Art and the Roman Viewer*, Cambridge, 1995.

A. Emmerling-Skala, *Bacchus in der Renaissance*, Hildesheim, 1994.

J. Engels, *Études sur l' Ovide moralisé*, Groningen, 1945.

M. Equicola, *Libro de natura de amore*, Venice, 1525.

—— *Libro di natura d'amore*, Venice, 1536.

D. Erasmus, *Collected Works*, Toronto, 1974–.

S. Erizzo, *Discorso sopra le medaglie*, Venice, 1568.

I. Errera, *Répertoire des peintures datées*, Brussels, 1920.

S. Errico, *Le rivolte di Parnaso*, Catania, 1974.

L. D. Ettlinger, 'Hercules Florentinus', *Mitteilungen des Kunsthistorischen Institutes in Florenz* 16 (1972), 119–42.

P. P. Fehl, *Decorum and Wit: the Poetry of Venetian Painting*, Vienna, 1992.

A. Félibien, *Entretiens* (6 vols.), Trevoux, 1725.

M. Ficino, *Commentary on Plato's* Symposium, Columbia, MO, 1944.

—— *Opera omnia* (2 vols.), Turin, 1959.

—— *The Letters of Marsilio Ficino* (6 vols.), London, 1975–99.

—— *Three Books on Life*, Binghampton, NY, 1989.

B. de Fontenelle, *Œuvres complètes*, Paris, 1989–.

J. Fontenrose, *Orion: the Myth of the Hunter and the Huntress*, Berkeley, 1981.

V. Forcella, *Tornei e giostre: ingressi trionfali e feste carnavalesche in Roma*, Rome, 1885.

P. Francastel, 'La Fête mythologique au Quattrocento', *Revue d'esthétique* 4 (1951), 376–410.

L. Frati, 'Cantari e sonetti ricordati nella cronaca di Benedetto Dei', *Giornale storico della letteratura italiana* 4 (1884), 162–202.

L. Freedman, *The Classical Pastoral in the Visual Arts*, New York, 1989.

—— *The Revival of the Olympian Gods in Renaissance Art*, Cambridge, 2003.

A. Friberg, *Den Svenske Herkules*, Stockholm, 1945.

W. Friedländer, *Mannerism and Anti-Mannerism in Italian Painting*, New York, 1957.

F. P. Fulgentius, *Opera*, Stuttgart, 1970 (tr. *Fulgentius the Mythographer*, Columbus, OH, 1971).

E. Fumagalli, *Matteo Maria Boiardo volgarizzatore dell' 'Asino d'oro'*, Padua, 1988.

M. Fumaroli, *L'école du silence*, Paris, 1994.

F. Gaeta, 'L'Avventura di Ercole', *Rinascimento* 5 (1954), 227–60.

K. Galinsky, *The Herakles Theme*, Totowa, NJ, 1972.

J. Gállego, *Visión y símbolos en la pintura española del Siglo de Oro*, Madrid, 1991.

E. Gallo, 'De viridiano Augustini Chigi', ed. M. Quinlan-McGrath, *Humanistica Lovaniensia* 38 (1989), 1–99.

E. Garin, '*Phantasia* e *imaginatio* fra Marsilio Ficino e Pietro Pomponazzi', *Giornale Critico della Filosofia Italiana* 5 (1985), 349–61.

E. K. Gazda (ed.), *Roman Art in the Private Sphere*, Ann Arbor, 1991.

A. Gentili, *Da Tiziano a Tiziano*, Milan, 1980.

S. Gesner, *Oratio de personis sive larvis . . .*, Wittenburg, 1600.

L. Ghiberti, *I commentari*, Naples, 1947.

F. Ghisalberti, 'Giovanni del Virgilio espositore delle *Metamorfosi*', *Il Giornale Dantesco* 34 (1931), 1–110 (contains the text).

C. Ginzburg, *Clues, Myths, and the Historical Method*, Baltimore, 1989.

P. Giovio, *Ragionamento*, Venice, 1556.

L. G. Giraldi, *Syntagma de Musis*, Strasbourg, 1511.

—— *De deis gentium*, Basel, 1548.

—— *Opera omnia*, Leiden, 1696.

Y. Giraud, *La Fable de Daphné*, Geneva, 1968.

J. Godwin, *The Pagan Dream of the Renaissance*, Grand Rapids, 2002.

R. A. Goldthwaite, 'The Economic and Social World of Italian Renaissance Maiolica', *Renaissance Quarterly* 42 (1989), 1–32.

E. H. Gombrich, *Symbolic Images*, Oxford, 1972.

J. L. Gottfried (J. P. Abelin), *P. Ovidii Nasonis Metamorphoseon plerarum historica naturalis moralis ekphrasis*, Frankfurt, 1619.

M. Greenhalgh, *The Survival of Roman Antiquities in the Middle Ages*, London, 1989.

Gregory Nazianzenus, *Opera*, Paris, 1857 (Migne, 35).

P. Grendler, *Schooling in Renaissance Italy*, Baltimore, 1989.

P. Grootkerk, 'The Wedding of Peleus and Thetis in Art and Literature of the Middle Ages and Renaissance', Ph.D., Case Western Reserve University, 1975.

H. Grubitzsch-Rodewald, *Die Verwendung der Mythologie in Giambattista Marinos 'Adone'*, Wiesbaden, 1973.

Guido delle Colonne, *Historia destructionis Troiae*, Cambridge, MA, 1936.

B. Guthmüller, *Ovidio Metamorphoseos vulgare*, Boppard am Rhein, 1981.

—— *Mito, poesia, arte*, Rome, 1997.

B. Guthmüller and W. Kühlmann (eds.), *Renaissancekultur und antike Mythologie*, Tübingen, 1999.

Y. Hackenbroch, *Renaissance Jewellery*, London, 1979.

—— *Enseignes*, Florence, 1996.

Haechtanus, *Mikrokosmos*, Antwerp, 1579.

F. Haskell and N. Penny, *Taste and the Antique*, New Haven, 1981.

A. J. Haurech (Aurelius Juianus) *De cognominibus deorum gentilium*, Basel, 1543.

J. F. Hayward, *Virtuoso Goldsmiths, 1540–1620*, London, 1976.

F. Healy, 'Bedrooms and Banquets: Mythology in Sixteenth-Century Flemish Painting', in H. Vlieghe *et al.* (eds.), *Concept, Design and Execution in Flemish Painting*, Turnhout, 2000, 73–96.

—— *Rubens and the Judgement of Paris*, Turnhout, 1997.

D. Heikamp, 'Bartolomeo Ammannati's Marble Fountain for the *Sala Grande* of the Palazzo Vecchio', in E. MacDougall (ed.), *Fons Sapientiae*, Dumbarton Oaks, 1978, 115–73.

D. Heinsius, *Nederduytsche poemata*, Bern, 1983.

M. D. Henkel, *De Houtsneden van Mansion's Ovide Moralisé*, Amsterdam, 1922.

—— 'Illustrierte Ausgaben von Ovids Metamorphosen im XV, XVI, und XVII Jahrhundert', *Vorträge der Bibliothek Warburg 1926–7*, Leipzig, 1930.

Heraclitus, *Allégories d'Homère*, Paris, 1962.

Hero of Alexandria, *Gli artifitiosi et curiosi moti spiritali*, Ferrara, 1589.

J. Herold, *Heydenweldt*, Basel, 1554.

P. Holberton, 'Battista Guarino's Catullus and Titian's *Bacchus and Ariadne*', *BM* 128 (1986), 347–50.

—— 'The choice of texts for the Camerino pictures', in G. Cavalli-Björkman (ed.), *Bacchanals by Titian and Rubens*, Stockholm, 1987, 57–66.

B. L. Holman, 'Goltzius's *Great Hercules*: Mythology, Art, and Politics', *Nederlands Kunsthistorisch Jaarboek* 42–3 (1991–2), 397–412.

C. Hope, 'Artists, Patrons and Advisers in the Italian Renaissance', in G. F. Lytle and S. Orgel (eds.), *Patronage in the Renaissance*, Princeton, 1991, 293–343.

—— 'Veronese and the Venetian Tradition of Allegory', *Proceedings of the British Academy* 71 (1985), 389–428.

—— 'Classical Antiquity and Venetian Renaissance Subject Matter', in F. Ames-Lewis (ed.), *New Interpretations of Venetian Renaissance Painting*, London, 1994, 51–62.

Horapollo, *Hieroglyphica*, Basel, 1518.

D. Hume, *A Treatise of Human Nature*, London, 1951.

J. Hutton, 'Cupid and the Bee', *PMLA* 56 (1941), 1036–58.

T. Hyde, *The Poetic Theology of Love*, Newark, NJ, 1986.

Hyginus, *Poetica astronomica*, Venice, 1502.

—— *Fables*, Paris, 1997.

[tr. *The Myths of Hyginus*, Lawrence, KS, 1960]

Isidore of Seville, *Etymologiae*, Leipzig, 1833.

J. Jacquot, *Les Fêtes de la Renaissance* (3 vols.), Paris, 1956–72.

R. Jones, 'What Venus did with Mars: Battista Fiera and Mantegna's *Parnassus*', *JWCI* 44 (1981), 193–8.

J. L. de Jong, *De Oudheid in Fresco*, The Hague, 1987.

F. Joukovsky-Micha, 'La Guerre des dieux et des géants chez les poètes français du XVIe siècle', *Bibliothèque d'Humanisme et Renaissance* 29 (1967), 55–92.

M.-R. Jung, *Hercule dans la littérature française du XVIe siècle*, Geneva, 1966.

E. H. Kantorowicz, 'Oriens Augusti – Lever du Roi', *Dumbarton Oaks Papers* 17 (1963), 117–77.

T. D. Kaufmann, *The School of Prague*, Chicago, 1988.

M. Kemp, 'From "Mimesis" to "Fantasia": the Quattrocento Vocabulary of Creation, Inspiration and Genius in the Visual Arts', *Viator* 8 (1977), 347–98.

F. Kiefer, 'The Conflation of Fortuna and Occasio in Renaissance Thought and Iconography', *Journal of Medieval and Renaissance Studies* 9 (1979), 1–27.

J. N. King, 'Queen Elizabeth I: Representations of the Virgin Queen', *Renaissance Quarterly* 43 (1990), 30–74.

R. Krautheimer, *Rome: Profile of a City, 312–1308*, Princeton, 1980.

T. J. Kren, '*Chi non vuol Baccho*: Roeland van Laer's burlesque painting about Dutch artists in Rome', *Simiolus* 11 (1980), 63–80.

M. Küsel, *Icones biblicae Veteris et Novi Testamenti*, Hildesheim, 1968.

Lactantius, *Divine Institutes*, New York, 1896.

Lactantius Placidus, *In Statii Thebaida commentum*, Stuttgart, 1992.

O. de La Marche, *Mémoires*, Paris, 1883–8.

C. Landino, *De vera nobilitate*, Florence, 1970.

J. Puget de La Serre, *Les amours du roy et de la reine*, Paris, 1625.

—— *Les amours des déesses*, Paris, 1627.

I. Lavin, 'Cephalus and Procris', *JWCI* 17 (1954), 260–87.

L. Lazzarelli, *De gentilium deorum imaginibus*, Lewiston, NY, 1997.

C. Lazzaro, *The Italian Renaissance Garden*, New Haven, 1990.

Le dodici fatiche di Hercole, Florence, 1567.

R. Le Fèvre, *Vergaderinge der historien van Troyen*, Haarlem, 1485.

—— *Recueil des hystoires de Troyes*, Paris, 1494.

J. Lemaire de Belges, *Œuvres* (2 vols.), Louvain, 1882.

H. Le Maitre, *Essai sur le mythe de Psyché*, Paris, n.d.

C. Lemmi, *The Classical Deities in Bacon*, New York, 1971.

O. Lenz, 'Über den ikonographischen Zusammenhang und die literarische Grundlage einiger Herkuleszyklen des 16 Jahrhunderts', *Münchner Jahrbuch der bildenden Kunst* 1 (1924), 80–103.

Leonardo da Vinci, *Literary Works* (2 vols.), London, 1970.

Leone Ebreo, *Dialoghi d'Amore*, Heidelberg, 1929.

N. S. Leopold, 'Artists' Homes in Sixteenth-Century Italy', Ph.D., Johns Hopkins University, 1980.

G. E. Lessing, *Werke*, Frankfurt am Main, 1985–.

Libellus de imaginibus deorum, in H. Liebeschütz, *Fulgentius Metaforalis*, Berlin, 1926, 117–28.

R. W. Lightbown, *Mantegna*, Oxford, 1986.

L. Link, *The Devil*, London, 1995.

L'istoriato: libri a stampa e maioliche italiane del cinquecento, Faenza, 1993.

G. P. Lomazzo, *Della forma delle Muse*, Milan, 1591.

—— *Scritti sulle arte* (2 vols.), Florence, 1973–4.

R. López Torrijos, *La mitología en la pintura española del Siglo de Oro*, Madrid, 1985.

C. G. Lord, 'Some Ovidian Themes in Italian Renaissance Art', Ph.D., Columbia University, 1968.

G. Lorris and J. de Meun, *Le Roman de la Rose* (3 vols.), Paris, 1982.

P. Luh, *Kaiser Maximilian gewidmet: Die unvollendete Werkausgabe des Conrad Celtis und ihre Holzschnitte*, Frankfurt, 2001.

W. C. McDonald, 'Maximilian I of Habsburg and the veneration of Hercules', *Journal of Medieval and Renaissance Studies* 6 (1976), 139–54.

E. MacDougall (ed.), *Fons Sapientiae: Renaissance Garden Fountains*, Washington, DC, 1978.

M. M. McGowan, *Ideal Forms in the Age of Ronsard*, Berkeley, 1985.

—— *The Vision of Rome in Late Renaissance France*, New Haven, 2000.

E. McGrath, 'Rubens's *Arch of the Mint*', *JWCI* 37 (1974), 191–217.

—— 'Pan and the Wool', *The Ringling Museum of Art Journal* 1 (1983), 52–69.

—— ' "*Il senso nostro*": the Medici allegory applied to Vasari's mythological frescoes in the Palazzo Vecchio', in *Giorgio Vasari tra decorazione ambientale e storiografia artistica*, Florence, 1985, 117–34.

—— 'Rubens's *Susanna and the Elders* and moralizing inscriptions on prints', in K. Vekeman and J. Müller Hofstede (eds.), *Wort und Bild in der niederländischen Kunst*, Erfstadt, 1984, 73–90.

—— 'Humanism, Allegorical Invention, and the Personification of the Continents', in H. Vlieghe *et al.* (eds.), *Concept, Design and Execution in Flemish Painting*, Turnhout, 2000, 43–71.

Macrobius, *Commentarii in somnium Scipionis* (2 vols.), Leipzig, 1963–70 (tr. *Commentary on the Dream of Scipio*, New York, 1952; *Saturnalia*, New York, 1969).

N. Mahé, *Le mythe de Bacchus*, Paris, 1992.

M. Maier, *Atalanta fugiens*, Oppenheim, 1618.

—— *Arcana arcanissima*, London, 1614.

K. van Mander, *Wtlegghingh op den Metamorphosis*, Haarlem, 1604.

C. Marcus, *Oratio de Bacchanalibus*, Altdorf, n.d.

P. Maréchaux, 'Les métamorphoses de Phaëton', *Revue de l'art* 90 (1990), 88–103.

G. Marino, *Dicerie sacre*, Vicenza, 1618.

—— *Epistolario* (2 vols.), Bari, 1911–12.

—— *Adone* (2 vols.), Rome, 1975–7.

M. de Marolles, *Tableaux du Temple des Muses*, Paris, 1655.

Martianus Capella, *De nuptiis Mercurii et Philologiae*, Leipzig, 1969 (tr. *Martianus Capella and the Seven Liberal Arts* (2 vols.), New York, 1971–7).

M. Marullo Tarcaniota, *Hymnes naturels*, Geneva, 1995.

F. Matz, *Die dionysischen Sarkophage* (4 vols.), Berlin, 1968–75.

L. de' Medici, *Poesie volgari* (2 vols.), London, 1912.

R. Merrill, 'Eros and Anteros', *Speculum* 19 (1944), 265–84.

V. Mertens, *Die drei Grazien*, Wiesbaden, 1994.

E. Michael, *The Drawings by Hans Holbein the Younger for Erasmus's 'Praise of Folly'*, New York, 1985.

B. Mitchell, *Italian Civic Pageantry*, Florence, 1979.

—— *The Majesty of the State*, Florence, 1986.

J. Miziolek, *Soggetti classici sui cassoni fiorentini*, Warsaw, 1996.

E. Molinier, *Les Bronzes de la Renaissance* (2 vols.), Paris, 1886.

J. Montagu, 'Interpretations of Timanthes's *Sacrifice of Iphigenia*', in J. Onians (ed.), *Sight and Insight*, London, 1994, 305–25.

M. de Montaigne, *Œuvres complètes*, Paris, 1962.

P. J. Montefalchio, *De cognominibus deorum opusculum*, Perugia, 1525.

P. Morel, *Les Grotesques*, Paris, 1997.

G. Mori, *Arte e astrologia*, Florence, 1987.

A. Moss, *Ovid in Renaissance France: a Survey of the Latin Editions*, London, 1982.

—— *Poetry and Fable: Studies in Mythological Narrative in Sixteenth-Century France*, Cambridge, 1984.

—— (ed.), *Latin Commentaries on Ovid from the Renaissance*, Signal Mountain, TN, 1998.

A. Mottola Molfino and M. Natale (eds.), *Il muse e il principe: arte di corte nel Rinascimento padano* (2 vols.), Modena, 1991.

B. Mundt, *Die Verführung der Europa*, Berlin, 1988.

Mythographi Vaticani I and II, Turnhout, 1987.

A. M. Nagler, *Theatre Festivals of the Medici*, New Haven, 1964.

A. Negro, *Il giardino dipinto del Cardinal Borghese*, Rome, 1996.

J. P. Néraudau, *L'Olympe du roi-soleil*, Paris, 1986.

Nonnos, *Les Dionysiaques*, Paris, 1625.

Orphic Hymns, Missoula, MT, 1977.

S. N. Orso, *Velázquez, 'Los Borrachos', and painting at the Court of Philip IV*, Cambridge, 1993.

A. Ortelius, *Deorum dearumque capita*, Antwerp, 1573.

J. Osborne, *Mirabilia Romae*, Toronto, 1987.

G. Ottonelli and P. Berrettini, *Trattato della pittura e scultura*, Treviso, 1973.

Palaephatus, *On Unbelievable Tales*, Wauconda, IL, 1996.

G. Paleotti, *Discorso intorno alle imagini sacre e profane*, Bologna, 1589.

A. Palladio, *I quattro libri dell' architettura*, Milan, 1968.

E. Panofsky, *Hercules am Scheidewege*, Leipzig, 1930.

—— 'Erasmus and the Visual Arts', *JWCI* 32 (1969), 200–227.

—— *Meaning in the Visual Arts*, London, 1970.

—— *Renaissance and Renascences in Western Art*, London, 1970.

—— *Studies in Iconology*, New York, 1972.

D. Parker, *Bronzino: Renaissance Painter as Poet*, Cambridge, 2000.

E. Parma (ed.), *La pittura in Liguria: il Cinquecento*, Genoa, 1999.

L. W. Partridge, 'The Sala d'Ercole in the Villa Farnese at Caprarola', *Art Bulletin* 53 (1971), 467–86, and 54 (1972), 50–62.

G. B. Passeri, *Die Künstlerbiographien von Giovanni Battista Passeri*, Leipzig, 1934.

H. R. Patch, *The Goddess Fortuna in Mediaeval Literature*, Cambridge, MA, 1927.

W. Pater, *The Renaissance*, Oxford, 1998.

M. A. Pavone (ed.), *Metamorfosi del mito: pittura barocca tra Napoli, Genova e Venezia*, Milan, 2003.

J. Perez de Moya, *Philosophia Secreta*, Madrid, 1585.

F. Perrier, *Segmenta*, Rome, 1638.

P. Petitmengin and B. Munk Olsen, 'Bibliographie de la réception de la littérature classique du IXe au XVe siècle', in C. Leonardi and B. Munk Olsen (eds.), *The Classical Tradition in the Middle Ages and the Renaissance*, Spoleto, 1995, 200–274.

Petrarch, *Canzoniere, Trionfi, Rime Varie*, Turin, 1958.

G. Pictor, *Theologia mythologica*, Antwerp, 1532.

A. Pigler, *Barockthemen* (2 vols.), Budapest, 1956.

R. de Piles, *Abrégé de la vie des peintres*, Paris, 1715.

Christine de Pisan, *Epistre Othea*, Geneva, 1999.

A. Pluche, *History of the Heavens* (2 vols.), London, 1740.

A. Poliziano, *Prose volgari . . .*, Florence, 1867.

—— *Stanze per la giostra*, Novaro, 1969.

—— *Miscellaneorum centuria una*, Basel, 1522.

F. Polleross, 'From the exemplum virtutis to the Apotheosis: Hercules as an Identification Figure in Portraiture', in A. Ellenius (ed.), *Iconography, Propaganda, and Legitimation*, Oxford, 1998, 37–61.

—— 'Sonnenkönig und Österreichische Sonne', *Wiener Jahrbuch für Kunstgeschichte* 40 (1987), 239–56.

G. Pontano, *Carmina*, Bari, 1948.

M. Praz, *Studies in Seventeenth-Century Imagery*, Rome, 1964.

F. Rabelais, *Œuvres complètes*, Paris, 1934.

R. Regius, *P. Ovidii Metamorphosis . . .*, Venice, 1493.

Remigius of Auxerre, *Commentum in Martianum Capellam* (2 vols.), Leiden, 1962–5.

L. D. Reynolds and N. G. Wilson, *Scribes and Scholars*, London, 1968.

A. Ricciardi, *Commentaria symbolica*, Venice, 1591.

P. W. Richelson, *Studies in the Personal Imagery of Cosimo I de' Medici*, New York, 1978.

J. Ridewall, *Fulgentius metaforalis*, Leipzig, 1926.

C. Ridolfi, *Le maraviglie dell'arte* (2 vols.), Berlin, 1914–24.

C. Ripa, *Iconologia*, Rome, 1603.

C. Robertson, 'Annibal Caro as Iconographer', *JWCI* 45 (1982), 160–81.

P. de Ronsard, *Œuvres complètes* (2 vols.), Paris, 1950.

D. Rosand, *Myths of Venice*, Chapel Hill, 2001.

E. E. Rosenthal, 'The Invention of the Columnar Device of Emperor Charles V at the Court of Burgundy in Flanders in 1516', *JWCI* 36 (1973), 198–230.

M. Rosichino, *Dichiaratione della pitture . . .*, Rome, 1640.

J. Rosinus (J. Rosen), *Romanarum antiquitatum*, Basel, 1583.

M. Roskill, *Dolce's 'Aretino' and Venetian Art Theory*, New York, 1968.

I. D. Rowland, 'Some panegyrics to Agostino Chigi', *JWCI* 47 (1984), 194–9.

—— *The Culture of the High Renaissance*, Cambridge, 1998.

C. Salutati, *Epistolario* (4 vols.), Rome, 1891–1911.

—— *De laboribus Herculis*, ed. B. Ullman, Zurich, 1951.

J. Sannazaro, *L'Arcadie*, Paris, 1544.

F. Sansovino, *Delle cose notabili della città*, Venice, 1587.

C. Santore, 'Danaë: The Renaissance Courtesan's Alter Ego', *Zeitschrift für Kunstgeschichte* 54 (1991), 412–27.

—— 'The Tools of Venus', *Renaissance Studies* 11 (1997), 179–207.

J. M. Saslow, *Ganymede in the Renaissance*, New Haven, 1986.

—— *The Medici Wedding of 1589*, New Haven, 1996.

F. Saxl, *Lectures* (2 vols.), London, 1957.

—— *La fede negli astri*, Turin, 1985.

G. Scaglia, 'Les *Travaux d'Hercule* de Giovanni Andrea Vavassore reproduits dans les frises de Vélez Blanco', *Revue de l'art* 127 (2000), 22–31.

S. K. Scher, *The Currency of Fame: Portrait Medals of the Renaissance*, New York, 1994.

P. Schoon and S. Paarlberg (eds.), *Greek Gods and Heroes in the Age of Rubens and Rembrandt*, Dordrecht, 2001.

E. Schreiber, 'Venus in the Medieval Mythographic Tradition', *Journal of English and Germanic Philology*, 74 (1975), 519–35.

E. Schröter, *Die Ikonographie des Themas Parnass vor Raphael*, Hildesheim, 1977.

—— 'Der Vatikan als Hügel Apollons und der Musen. Kunst und Panegyrik von Nikolaus V. Bis Julius II', *Römische Quartalschrift* 75 (1980), 208–40.

P. Schubring, *Cassoni, Truhen und Truhenbilder der Italienischen Frührenaissance* (3 vols.), Leipzig, 1915–23.

R. Scorza, 'Vicenzo Borghini (1515–1580) as Iconographic Adviser' Ph.D., University of London, 1987.

J. B. Scott, *Images of Nepotism: the Painted Ceilings of the Palazzo Barberini*, Princeton, 1991.

M. Screech, 'The winged Bacchus', *JWCI* 43 (1980), 259–62.

—— *Laughter at the Foot of the Cross*, London, 1997.

Servius, *In Vergilii carmina commentarii* (3 vols.), Leipzig, 1881–1902.

S. Settis, 'Danaë verso il 1495', *I Tatti Studies* 1 (1985), 207–37.

—— (ed.), *Memoria dell'antico nell'arte italiana* (3 vols.), Turin, 1984–6.

J. Seznec, *The Survival of the Pagan Gods*, Princeton, 1972.

J. Shearman, *Raphael's Cartoons in the Collection of Her Majesty the Queen*, London, 1972.

C. Siemienowicz, *Grand art d'artillerie*, Amsterdam, 1651.

G. Simeoni, *Illustratione de gli epitaffi . . .*, Lyons, 1558.

E. Simon, *Die Götter der Römer*, Munich, 1990.

E. J. Sluijter, *De 'Heydensche Fabulen' in de Noordnederlandse schilderkunst c. 1590–1670*, The Hague, 1986.

—— 'Some observations on the choice of narrative mythological subjects in late mannerist painting in the Northern Netherlands', in G. Cavalli-Bjorkman (ed.), *Netherlandish Mannerism*, Stockholm, 1985, 61–72.

—— 'Depiction of mythological themes', in A. Blankert *et al.*, *Gods, Saints, and Heroes*, Washington, DC, 1980, 55–64.

—— 'Emulating sensual beauty: representations of Danaë from Gossaert to Rembrandt', *Simiolus* 27 (1999), 4–45.

—— *Seductress of Sight*, Zwolle, 2000.

J. C. Smith, *German Sculpture of the Later Renaissance*, Princeton, 1994.

C. H. Smyth, *Mannerism and 'maniera'*, Vienna, 1992.

Le soleil au signe du Lyon, Lyons, 1623.

E. Spenser, *The Faerie Queene*, London, 2001.

W. Stechow, *Apollo und Daphne*, Leipzig, 1932.

—— 'The Myth of Philemon and Baucis in Art', *JWCI* 4 (1941), 103–13.

C. Stinger, 'Roma Triumphans: Triumphs in the Thought and Ceremonies of Renaissance Rome', *Medievalia et Humanistica*, n.s. 10 (1981), 189–201.

G. Stjernhjelm, *Hercules*, Stockholm, 1957.

D. Summers, *Michelangelo and the Language of Art*, Princeton, 1981.

L. Syson and D. Thornton, *Objects of Virtue*, London, 2001.

B. Talvacchia, *Taking Positions*, Princeton, 1999.

M. Tanner, *The Last Descendant of Aeneas*, New Haven, 1993.

T. Tasso, *Gerusalemme liberata*, Bari, 1930.

—— *Discorsi dell'arte poetica e del poema eroico*, Bari, 1964.

R. B. Tate, 'Mythology in Spanish Historiography of the Middle Ages and the Renaissance', *Hispanic Review* 1 (1954), 1–18.

Tertullian, *The Writings of Tertullian*, vol. 1, Edinburgh, 1869.

M. Thimann, *Lügenhafte Bilder*, Göttingen, 2002.

S. H. Thompson, 'The Literary Sources of Titian's *Bacchus and Ariadne*', *Classical Journal* 51 (1956), 259–64.

P. Thornton, *Interni del rinascimento italiano*, Milan, 1992.

J. Thuillier, 'Pour un *corpus pussinianum*', in *Nicolas Poussin* (2 vols.), Paris, 1960, vol. 2, 49–238.

H. Torrentinus, *Elucidarius poeticus*, Venice, 1547.

G. Tory, *Champ Fleury*, Paris, 1529.

A. Tritonio, *Mythologia*, Bologna, 1560.

G. Trottein, *Les Enfants de Vénus*, Paris, 1993.

T. Tuohy, *Herculean Ferrara*, Cambridge, 1996.

P. de Tyard, *Œuvres poétiques complètes*, Paris, 1966.

P. Valeriano, *Hieroglyphica*, Basel, 1556.

—— *Hieroglyphica*, Basel, 1567.

G. Vasari, *Le Opere* (9 vols.), ed. G. Milanesi, Florence, 1906.

O. van Veen (Vaenius), *Q. Horati Flacci Emblemata*, Antwerp, 1607.

I. M. Veldman, 'Seasons, planets and temperaments in the work of Maarten van Heemskerck', *Simiolus* 11 (1980), 149–76.

—— 'De macht van de planeten over het mensdom in prenten naar Maarten de Vos', *Bulletin van het Rijksmuseum* 31 (1983), 21–53.

P. Vergil, *De rerum inventoribus*, Nieuwkoop, 1997.

E. Verheyen, 'Correggio's *Amori di Giove*', *JWCI* 29 (1966), 160–92.

C. C. Vermeule, *Greek Sculpture and Roman Taste*, Ann Arbor, 1977.

G. B. Vermiglioli, *Memorie Fr. Maturanzio*, Perugia, 1807.

L. Vertova, 'The Tale of Cupid and Psyche in Renaissance Painting before Raphael', *JWCI* 42 (1979), 104–21.

P. Vescovo, 'La tintura delle rose e la morte di Adone: Tra Poliziano e Sebastiano del Piombo', *Lettere Italiane* 49 (1997), 555–71.

A. W. Vetter, *Gigantensturz-Darstellung in der Italienischen Kunst*, Weimar, 2002.

E. Vico and A. Zantani, *Le Imagini con tutti i riversi*, Venice, 1548.

B. de Vigenère, *Les Images ou tableaux de platte-peinture de Philostrate*, ed. F. Graziani, Paris, 1995.

E. de Villena, *Los doze trabajos de Hércules*, ed. M. Morreale, Madrid, 1958.

B. de Vitoria, *Teatro de los Dioses de la Gentilidad*, Madrid, 1620.

C. Vivanti, 'Henry IV, the Gallic Hercules', *JWCI* 30 (1967), 176–97.

G. J. Vossius, *De theologia gentili* (4 vols.), Amsterdam, 1641.

L. Waldman, '*Miracol'novo et raro*: two unpublished contemporary satires on Bandinelli's *Hercules*', *Mitteilungen des Kunsthistorischen Institutes in Florenz* 38 (1994), 420–27.

K. Wall, *The Callisto Myth from Ovid to Atwood*, Montreal, 1988.

H. Walter and H. J. Horn (eds.), *Die Rezeption der 'Metamorphosen' des Ovid in der Neuzeit*, Berlin, 1995.

A. Warburg, *The Renewal of Pagan Antiquity*, Los Angeles, 1999.

J. Warden (ed.), *Orpheus: the Metamorphoses of a Myth*, Toronto, 1982.

M. Warnke, *The Court Artist*, Cambridge, 1993.

P. F. Watson, 'Virtù and voluptas in cassone painting', Ph.D., Yale University, 1970.

—— *The Garden of Love in Tuscan Art of the Early Renaissance*, Philadelphia, 1979.

I. S. Weber, *Deutsche, niederländische und französische Renaissanceplaketten, 1500–1650* (2 vols.), Munich, 1975.

R. Weiss, *The Renaissance Discovery of Classical Antiquity*, Oxford, 1988.

T. Wilson, *Ceramic Art of the Italian Renaissance*, London, 1987.

E. Wind, *Pagan Mysteries in the Renaissance*, Oxford, 1980.

P. M. de Winter, 'A little-known creation of Renaissance decorative arts: the white lead pastiglia box', *Saggi e memorie di storia dell'arte* 14 (1984), 7–42, 103–31.

H. Wohl, *The Aesthetics of Italian Renaissance Art*, New York, 1999.

A. Wright, 'The Myth of Hercules', in G. C. Garfagnini (ed.), *Lorenzo il Magnifico e il suo mondo*, Florence, 1994, 323–39.

E. Wyss, *The Myth of Apollo and Marsyas in the Art of the Italian Renaissance*, Newark, NJ, 1996.

F. Yates, 'Poètes et artistes dans les Entrées de Charles IX et de sa Reine à Paris en 1571', in J. Jacquot (ed.) *Les Fêtes de la Renaissance*, vol. 1, Paris, 1956, 61–84.

—— *Astraea*, London, 1975.

P. Zanker, *The Power of Images in the Age of Augustus*, Ann Arbor, 1988/1990.

C. Zelle *et al.*, *Herakles/Herkules* (2 vols.), Basel, 1994.

F. Zeri, 'Renaissance and Pseudo-Renaissance', in *History of Italian Art*, Cambridge, 1994, 326–72.

F. Zuccaro, *Scritti d'Arte*, Florence, 1961.

J. Zucchi, *Discorso sopra li dei de' gentili*, Rome, 1602.

Index